Popkiss

Popkiss

The Life and Afterlife of Sarah Records

Michael White

Bloomsbury Academic
An imprint of Bloomsbury Publishing Inc

B L O O M S B U R Y
NEW YORK · LONDON · OXFORD · NEW DELHI · SYDNEY

Bloomsbury Academic

An imprint of Bloomsbury Publishing Plc

1385 Broadway	50 Bedford Square
New York	London
NY 10018	WC1B 3DP
USA	UK

www.bloomsbury.com

**BLOOMSBURY and the Diana logo are trademarks of
Bloomsbury Publishing Plc**

First published 2016
Reprinted 2016

Library of Congress Cataloging-in-Publication Data
White, Michael (Michael Stuart), 1970-
Popkiss : the life and afterlife of Sarah Records / Michael White.
pages cm
Includes index.
ISBN 978-1-62892-218-9 (pbk. : alk. paper) 1. Sarah Records–History.
2. Sound recording industry–England–Bristol–History. 3. Indie pop music–
Great Britain–History and criticism. 4. Sarah Records–Discography. I. Title.
ML3792.S27W55 2015
781.6409423'93–dc23
2015013367

ISBN: PB: 978-1-6289-2218-9
ePUB: 978-1-6289-2223-3
ePDF: 978-1-6289-2220-2

Typeset by Deanta Global Publishing Services, Chennai, India
Printed and bound in the United States of America

For the departed Mathew Fletcher, Keith Girdler and
Simon Westwood.
And for Yen. Can we go outside now?

Author's Note

When Sarah's founders, Clare Wadd and Matt Haynes, gave me their blessing to write this book, my initial intention was to tell the label's story chronologically. But this soon proved impossible. In addition to the inevitably Byzantine nature of an eight-year period that involved the simultaneous – and often intersecting – experiences of more than thirty bands and hundreds of people, I discovered during the early stages of research that the vast majority of people involved with Sarah simply couldn't recall with sufficient accuracy when most events took place. I was particularly astonished when Wadd and Haynes told me they hadn't documented Sarah's release dates, chart positions or sales figures. But when I took into consideration how terrifically young everyone was then, it made sense. When Sarah began, Haynes was twenty-four, Wadd nineteen and the bands usually somewhere in between. Never mind that very few people of that age group think about the future in anything but the most abstract sense; they never could have imagined that someday there would be a reason for which it might have been helpful to make note of everything they were doing. Like youth and young adulthood, Sarah was meant to exist in a fleeting moment and then be put away. Of the many people who are surprised that Sarah Records – a quarter century after it ended – has been judged historically significant enough to merit a book (and, not long before this, a documentary film), possibly none are more surprised than Wadd, Haynes and the bands themselves. Fortunately, some of them did hold onto a good deal of fascinating paraphernalia, too little of which you'll see in these pages. Business diaries, tour dates, the number of copies pressed of a particular single – these are the concerns of people thinking about next week, month, year. But, Sarah – and here I hope Wadd and Haynes will forgive

me for making an allusion to a dippy flower-power anthem – lived for today. My solution was to break down the Sarah story in an admittedly arbitrary way, giving the bands whose histories are especially lengthy or intriguing their own chapter and grouping others according to various themes, and taking occasional detours to examine some facet of the label that was key to its character.

Inevitably, some of you especially intense Sarah obsessives will resent there not being more revelations about a band that only made one flexi, or cryptic disclosures concerning the disillusioned inner life of the half-cousin of the man who operated the lathe that cut the label's vinyl. Wadd and Haynes have always tried to discourage a trainspotter approach to Sarah and pop music in general, and I've aimed to do right by that here. In keeping with the spirit of what they did, think of this book as a selection of short, sharp seven-inch singles, rather than a deluxe twenty-fifth-anniversary ten-CD box set with bonus-material download code.

Contents

Acknowledgements

Clare Wadd and Matt Haynes had little reason to trust me to tell their story when I proposed this book to them, very much out of the blue, in August 2011. More than twenty years had passed since the single hour we'd spent in each other's company, and all they knew of my work was the notes I'd written for Cherry Red Records' reissues of the Blueboy catalogue. Sincerest thanks to them for coming back to me quickly and saying, in Clare's words, 'If you want to do this, we're certainly not going to stand in your way – and we'll help as much as we can.' You certainly did do that, especially during the tense final months when I was sending countless frantic emails inquiring about some arcane fact or other. Very few others, I think, would have been so patient and accommodating.

This book began without a publisher, nor any guarantee that it would find one. When I interviewed Ric Menck of the Springfields, he suggested I contact David Barker, who had commissioned Ric's book about the Byrds' *The Notorious Byrd Brothers* for Continuum's 33 1/3 series. David had since returned to London from his long-time home of New York in order to work at Bloomsbury, which had acquired Continuum; he was no longer commissioning music titles, but he was (and is) still a music fanatic, and to this day I can't believe he responded to my unsolicited Facebook message with such enthusiasm. His cheerleading of the book more or less single-handedly convinced his colleagues at Bloomsbury – who nowadays have much bigger fish to monger – to throw their weight behind this little passion project. So, thank you for that, David. And thank you, Ric, for putting him on my radar; had you not done so, I don't know when – or if – *Popkiss* would have found a decent home.

My editor at Bloomsbury, Ally Jane Grossan, has simply been a mensch throughout. I couldn't do what you do, Ally Jane, dealing with the neurotic likes of me all the time. I owe you many drinks and an equal number of apologies.

Thanks to everyone who contributed to my crowdfunding campaign, the proceeds of which allowed me to fly to the UK to interview some of the musicians featured in these pages. And to my friend and former fellow Vancouverite, Vanessa Rockel, who graciously moved to London and took possession of an amazing flat with a guest bed. I might've had to sleep in the streets (or worse, at a Premier Inn) if not for you.

The Toronto Reference Library and the central branch of the Vancouver Public Library were invaluable resources, but not as much as Philip Ball, Alistair Fitchett, Dave Harris, Matt Haynes, Stuart Huggett, Wendy Stone, Chris Tighe and Harvey Williams, each of whom went to the trouble of scrounging up and scanning photos, reviews and interviews I otherwise never would have known existed. (If I've forgotten anyone else who did this, please forgive me – it's been a hell of a long three and a half years.)

For talking me off the ledge at various times and for various reasons, endless gratitude to John Burns, Melanie Copple and Kenji Kitahama (and once again to Ally Jane and David).

Needless to say, thanks to everyone – whether musician, producer, writer or general eyewitness – who took the time to answer my questions. The events we discussed were a long time ago, I know. I'm impressed you remember anything at all.

And finally, thanks to my family and to my partner, Yen, who for much too long had to hear about (and, in Yen's case, bear witness to) the full extent of my doubt, anxiety, fatigue, impatience, irritability and general inclination to be a glass-half-empty crybaby when a deadline was looming and ideas weren't forthcoming. I'll be much more fun now. You believe that, don't you?

Introduction

My introduction to Sarah Records – not its music, but its existence – arrived in the guise of a warning. Or, perhaps more accurately, an assassination attempt.

To explain: When I was seventeen, it was a very good year, because I'd discovered *Melody Maker*. During the late 1980s, *Melody Maker* was, alongside *New Musical Express* (the *NME*) and *Sounds*, one of Britain's three weekly music newspapers. I was of the opinion then – and still am today – that it was, at that time, the greatest music publication in the world. (The very idea that a country geographically smaller than the Canadian province in which I was growing up could sustain three *weeklies* devoted exclusively to new music was, itself, dizzyingly impressive.)

Melody Maker's ragtag pool of writers – among them the erudite Simon Reynolds, now a highly regarded veteran music journalist; and a pair of caustic shit-disturbers who penned under the name the Stud Brothers, current whereabouts unknown – bore little resemblance to the measured, unsentimental scribes who appeared in the pages of *Rolling Stone* and most other North American music magazines, which continued to hold the classic-rock canon in inestimable regard and viewed punk as something still worthy of suspicion.

Variously as intellectual as philosophy majors and as guilelessly excitable as children, the people who comprised the masthead at the self-described 'caring, sharing *Maker*' seemed to feel not so much a duty as a moral obligation to the future of music. (The past, when it was mentioned, tended to only be regarded in terms of how it fed into the *now*.) Their mission was to seek out and, using as effusive a vocabulary as their thesauruses allowed, spread word about the

best undiscovered bands. It was this rigorous curiosity (and reckless disregard for the disastrous impact it might have on news-stand sales) that led to *Melody Maker* being the first major magazine anywhere that devoted covers and multi-page features to My Bloody Valentine, Pixies, Sonic Youth, the Sugarcubes, Dinosaur Jr. and many other sonic trailblazers whose stealth influence would echo through the underground and the mainstream for years to come.

Throughout the late 1980s, *Melody Maker* was my entertainment, my educator and, during the more frustrating moments of adolescence, my view onto a more interesting world. And this was how it introduced me to Sarah Records, via an August 1988 review of two of its singles:

> *More fringes and horizontally striped tee-shirts than anywhere else on the planet, Sarah Records encourage the secrecy of this movement which is actually bereft of any movement. Their records* loll. *Loll, loll, loll, they go, as you float upon the hot air of their enterprise, sick of the prurient little pop martyrs. Winsomely windy, wimpy fey and laughable these all appear to be twee-fellas, preachey-peachy keen to have a bad time at our expense.*
>
> *This week also sees the release of much by The Sea Urchins and The Golden Dawn, the sound of all the paranoia previously exhibited inside 'Are You Scared To Get Happy' fanzine and endurable only in its hatefulness, it is the dreg end, largely unnoticed, of the kiddie-pop fiasco, the sound of old hands clapped out.*
>
> *You see, to Sarah, commercial reality is unlawful, if not actually Satanic. … There is room for everything in pop these days, including these tiresome, old fashioned* feebs, *and if anyone has the right to complain it is us.*
>
> *Indie land has been poisoned.*

Thus wrote Mick Mercer in his assessment of Another Sunny Day's 'I'm in Love With a Girl Who Doesn't Know I Exist' and the Springfields' 'Sunflower' – Sarah Records' seventh and tenth releases, respectively. (The offhandedly mentioned Sea Urchins and Golden Dawn singles were numbers eight and nine.)

Note that Mercer didn't 'review' the records, as such. There was no mention of their merits in terms of songwriting, performance or production; only a

vague allusion to them being emblematic of certain negative character traits ('wimpy', 'fey', 'twee'), and the insinuation that they constituted some sort of pitiable regression ('bereft of any movement', 'old hands clapped out', 'old fashioned'). Any reader who wasn't equipped with a pre-existing knowledge of Mercer's esoteric references and the wider context in which he was making his point would be lost.

I, having been a *Maker* reader for over a year at that point, knew exactly what was going on.

Anyone who aims to enact a revolution defines his quest in accordance with what he seeks to destroy as much as what he seeks to create. Although Sarah would attract a small number of supporters among the British music press (future Saint Etienne co-founder Bob Stanley, writing for the *NME*, made the aforementioned Another Sunny Day, Springfields and Sea Urchins records joint Single of the Week), for the most part its army of self-appointed revolutionaries considered Sarah an enemy. Its music, its overarching aesthetic, the world view encompassed in the lyrics of the songs it pressed onto vinyl (and *only* vinyl) – everything about Sarah was seen to represent a retreat from the future, an admission of surrender or indifference in the face of political, cultural and technological upheaval. If its naysayers were to be believed, Sarah was a betrayal of music's principal obligations. Shortly before Sarah's emergence, Simon Reynolds was given two full pages in *Melody Maker* to lambast the label's spiritual predecessors for their collective failure of nerve. Terming their music 'regressive rock', he wrote:

> Burdened by hindsight, by a chronic fear of becoming bloated and self-indulgent, this indie generation tries to freeze-frame [popular music's] development at the point just before 'it all went wrong' and so turns its back on the few things that went right. … Regressive rock is ANOREXIC, reduced and confined by its anxious deference to punk's creed of minimalism and under-production. … [It] fears accomplishment, privileges INCOMPETENCE, or at least demands the active concealment of skill.

My reaction to this series of stern admonishments, these indignant manifestos, was to seek out the music in question as quickly as possible.

Little more than a year before the above-quoted review was published, the style of music with which Sarah was closely identified – broadly defined as 'indie-pop' – was still liked by the British music press. Very definitely apart from indie-*rock*, indie-pop began life as a notion of punk that maintained some of punk's primary characteristics – back-to-basics instrumentation (guitar, bass, drums, maybe some rudimentary keyboards), the ranking of enthusiasm and character above technical skill – but replaced punk's anger and discordance with melody and romanticism. The genre's earliest exponents (among them the bands Television Personalities, Marine Girls, Orange Juice and the Pastels) were spurred into action by the do-it-yourself spirit of punk, but were equally seduced by the optimism and tunefulness that characterized the pop music of their 1960s childhoods: the Byrds, Motown, Phil Spector, bubblegum. Emerging at the end of the 1970s, it was exactly what many people wanted to hear: a new interpretation of the punk ethos, and also a respite from punk's increasingly humourless, avant-garde inclinations. Indie-pop continued to furrow its own small path throughout the first half of the 1980s, spawning many subtle variations of its template sound that were alternately harder and daintier, more ramshackle and more sophisticated. It might have remained forever in the margins if not for the Smiths, who became the genre's unwitting ambassadors to the UK mainstream and the rest of the world.

Which is where I came in. The Smiths, whose records I loved and were readily available in Canada, served as a jumping-off point. To my indescribable joy, I soon discovered that their musical progeny had overrun the UK underground. Through *Melody Maker* and the knowledge of a few kindly record store clerks in nearby Toronto, I set about uncovering as many of them as I could.

Biding my time in a small, unremarkable city in southern Ontario, British indie-pop seemed, to my obsessive teenage ears, both unimaginably exotic and peerlessly beautiful. It was *my* punk rock – a decidedly teenage sound, but idealistic and benevolent, not nihilistic and threatening. It was an evocation in song of my overarching desire to move away, find love and cultivate an exciting life, whereas the music my hometown's punk kids were listening to (the Clash, the Sex Pistols, various hardcore and Oi! bands) struck me as the sound of staying put, expecting nothing and receiving exactly that.

In the summer of 1986, the *NME* compiled a mail-order cassette titled *NME C86*, which was meant to serve as an exciting, multifaceted overview of the nation's up-and-coming indie bands. It proved so popular, the Rough Trade label released a vinyl edition – twenty-two tracks and over an hour of music crowded onto a single LP. When a slightly more on-top-of-it friend gave me a copy in January of the following year, I thought it was the most revelatory music I'd ever heard. The opening track, Primal Scream's 'Velocity Girl' – eighty-two seconds of lovesick rapture expressed in chiming twelve-string guitar, and an effete vocal that somehow sounds both ardent and blasé – struck me as perfect. Almost as thrilling were the songs from Shop Assistants, the Bodines and Miaow. And while the likes of Stump, Big Flame and Age of Chance seemed stranger and coarser, and their members each seemed to be playing a few disparate songs at once, they were at least unlike anything I'd been exposed to before. And furthermore, who *were* these people – these unseen, hitherto unheard-of bands from a continent I'd never been to, with their audacious, ridiculous band names and short, urgent songs about all manner of youthful bewilderment? Had it ever crossed their minds that their music could potentially reach, transport and consume the mind of a frustrated seventeen-year-old Canadian boy? Did they know they were brilliant? Surely they did.

Yet while I was rapidly falling head over heels for this mysterious music from far away, in its faraway homeland it was rapidly falling out of favour. In fact, *C86* itself was cited as a major contributing factor of indie-pop's critical overthrow. Shortly after its release, the *NME*'s rival papers took the album to task for presenting a myopic, unflattering representation of contemporary British indie music: overwhelmingly white and guitar-based, low-budget and bumbling, and disproportionately in thrall to carefully chosen moments from pop's past instead of the limitless possibilities of its future. All of these criticisms were inarguable, but it was a matter of opinion as to whether they negated the music's right to exist, its ability to impart joy. Before 1986 was finished, the *NME* itself had largely retracted its enthusiasm for the bands it had only months before championed in an advert for *C86* as 'the year's most crucial contenders'.

Throughout 1987 and into 1988, virtually any band that was thought to be a proponent of the music made (in)famous by *C86* was a target of the music

press' increasingly fierce antagonism – such as the *Melody Maker* hatchet job that put Sarah Records on my radar. Not even a year old at the time of that review, Sarah was already perceived as out of time, late arrivals to a party that was not only over but that hadn't been any good in the first place.

Almost a year passed before I finally found a Sarah record – the Field Mice's debut EP, *Emma's House* – sitting unobtrusive and unwanted in the racks of a shop in Kitchener. It had been released the previous autumn, so had probably been lingering there for some time. Its cover art, I thought, begged for its fate: a simplistic illustration of a boy and girl in silhouette, rendered in orange against a yellow background; the text looked like it had been laid down with the sort of peel-and-stick vinyl letters commonly used to make bake-sale flyers. Inside was a fold-out poster featuring, for no discernible reason, a crayon drawing of a cowboy wielding a lasso. Even by the slapdash standards of most late-1980s indie sleeve designs, this looked exceptionally minimalist and hasty. Had I not already read about the Field Mice, I might've passed it over like so many others had undoubtedly done before.

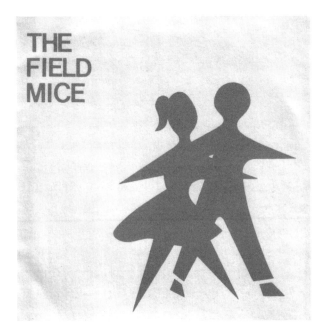

Figure 0.1 *The cover of the Field Mice's debut EP,* Emma's House, *released in 1988. (Courtesy of Bobby Wratten and Sarah Records)*

When I played the record, I was again taken aback by the degree of economy on display. Although the indie-pop records I'd been bringing home for the better part of eighteen months almost always bore the sonic hallmarks of having been made very cheaply (which was a large part of their aesthetic and their appeal), the four songs that make up *Emma's House* sounded uncommonly sparse and amateur, as if they had been recorded in a bedroom instead of some cut-price studio. As opposed to bright, jangling guitars, snapping drums and buoyant, off-key vocals, there were dry, muted guitars, a meekly chugging drum machine (a *drum machine* – a flagrant breach of indie-pop's purist rulebook!) and a singer who imparted his words in a shy, confiding near-whisper. And, oh, the words he was singing! These were some of the saddest lyrics I'd heard in my young life: sighingly resigned laments for the unpleasant fate of a gentle psyche in a brutal world. Two of the songs, 'When You Sleep' and 'The Last Letter', sounded so bereft of hope, I wasn't sure I wanted to hear them again.

And yet, for reasons I now can't recall, I returned to this disappointing, confusing record. Maybe, having spent so many months waiting to find physical proof of the elusive, hated Sarah Records, I felt I needed to try harder to extract satisfaction in return for my investment of patience. Whatever the case, a few more listens acclimated me to its contents, and within a week I was playing it every day. The sheer intimacy of its sound and the honesty of its verse (it must have been honest. How else could the writer so convincingly articulate such heartbreak?) seemed indications not of spinelessness – as *Melody Maker* would almost certainly have it, had they reviewed it – but remarkable bravery. Surely even Morrissey, the decade's crown prince of declarative ennui, would not have submitted for public scrutiny such a naked statement of vulnerability without one of his trademark witticisms providing a get-out clause. I soon realized the drum machine, whether employed out of necessity or by design, made sense after all – live drums would only have intruded upon the songs' tone of crushing melancholy.

In short order, I wrote to Sarah to inquire about mail order, received a surprisingly lengthy handwritten reply from the label's co-founder Matt Haynes ('We still find the whole idea of these little records whizzing all round the world in great big 747s faintly ludicrous. But if you *insist* …'), and later took delivery of a copy of the compilation album *Shadow Factory*, accompanied by

a letter from Sarah's other half, Clare Wadd, which ended with an endearing inquiry as to whether my hometown was 'crap.' (Sort of.) My interest in Sarah grew so intense that during my first visit to England the following summer, I arrived at Clare and Matt's doorstep in Bristol. Invited inside, I discovered two of the quietest, nicest people I'd met to date, living a bare-bones existence in a very small, low-ceilinged flat. While their records were travelling around the world by jet, the two of them considered local taxis a rare luxury.

It would be another twenty-two years before I saw or spoke to Wadd and Haynes again, at which time we sat around the former's dining table in her suburban London house (which was sizeable and well lit, and had a garden and a gentle old cat). Matt dropped by from central London, his home for many years. Sarah Records had ceased to exist seventeen years prior, yet there the three of us were discussing as much of the label's history as we could over a weekend. (Countless emails followed throughout the following two-plus years.)

When we first met, in the summer of 1990, it would have been inconceivable to any of us (or, indeed, to anyone else) that Sarah Records would cultivate and sustain enough interest to justify a book about it a quarter-century later. Despite having started to generate modest success at the time of our first meeting, Sarah was still seen by most observers beyond its fiercely loyal cult as a sad, final repository for a type of music whose moment had long since passed. But it persisted, surviving and flourishing at a safe remove while years of rapid-fire music trends – Madchester, shoegaze, grunge, Britpop – arrived and departed. The label's output transcended the stereotypes initially ascribed to it (although, to those paying attention, it never fully deserved them), and a few former detractors eventually conceded that Sarah was releasing excellent records that bore little obvious debt to whatever else was going on at the time.

What's more, fierce loyalty was an uncommonly frequent reaction among listeners. As was the case with me, it wasn't enough to simply enjoy whichever Sarah releases one chanced upon. For thousands of devotees, Sarah's very name became a seal of quality: every new record was anticipated (some mail-order customers would send a lump sum, to be applied towards whatever came next) and older, deleted titles were anxiously sought out. At the label's peak of

popularity, Wadd and Haynes would receive dozens of letters every week, and they endeavoured to write a handwritten reply for each of them. Those who never got a letter still had the opportunity to learn a great deal about them through their fanzines and newsletters, and the self-written inserts enclosed with each seven-inch single. Not simply a record label, Sarah had become shorthand for mutual interests and outlooks, shared among an international network of people at a time before the internet made global communication instant and effortless.

But Sarah's eight-year lifespan, from 1987 to 1995, is only part of the story to be told here. When Wadd and Haynes symbolically shut the label down after fulfilling one-hundred releases in its primary catalogue sequence (despite the fact that business was good enough to continue indefinitely), Sarah's perennial outsider status suggested it would quickly fade into history, too idiosyncratic to become even a footnote. Sarah was such an anomaly in 1995 – when Britpop was reaching its fevered peak, and critical consensus had deemed electronica the next great revolution in music – it had all but disappeared into the fringes from which it had sprung, a comfortably established cottage industry that never expected (nor necessarily wanted) to be in the spotlight. And yet…

And yet. Sarah refused to fade away, although Wadd and Haynes made no efforts to maintain a posthumous profile. Its music was discovered by contemporaries who had missed it the first time around, and by successive generations who were either too young (or, increasingly, not yet born) when Sarah was operational. Oblivious to the prejudices that dogged it initially, Sarah's latter-day fans have simply responded to music that strikes them as unique and mysterious, and have spent countless hours trying to connect the dots between the scarce shreds of information available. Indeed, a huge reason for the existence of this book is because those who have grown up online, accustomed to being able to find out virtually anything they want to know about anything at the click of a mouse, have been tantalized by the dearth of information about Sarah – almost no major interview features, very few photos and even fewer video documents have seen the light of day. (The internet has at least been useful in terms of making Sarah's music easier than ever to hear, although that hasn't stopped many people from paying as much as several

hundred pounds to acquire original pressings.) Hopefully, this book answers many of the questions that have been niggling at them for years.

As much as this, though, my hope is that those who have no prior knowledge of Sarah, or who never cared for it, will find something of interest here. Apart from its music, Sarah is the story of an exceptionally personal enterprise that achieved far more than those involved in it could have foreseen – on their own terms and, most of the time, without the support of those who were in the greatest position to lend it.

And finally, this book is a document of a way of making and disseminating music that is gone forever. The seismic changes that have happened to the music industry and communication in general mean Sarah and independent labels like it – which had to be rigorously sought out or discovered by accident, and whose music was shared among like minds with a combination of communal generosity and proprietary possessiveness – are lost to history.

If there is any drawback to this book, it's that it finally ruptures the mystery that, for most people, has always surrounded Sarah and its music. But I, for one, wanted to know what happened. The earthbound, everyday realities that led to the existence of all those beloved songs can never match the romantic fictions I conjured in the bedrooms of my late teens and early twenties. But my much older self is happy to report that no amount of recently acquired knowledge has blunted the fascination I felt then. Sarah Records fascinates me as much now as the day I was first implored to avoid it.

1

Songs of Innocence and Inexperience: The Roots of Sarah

Songs that have come to be regarded as revolutionary tend to share something in common: they sound authoritative, sure of themselves, as if their historical destiny is a foregone conclusion. The twin snare cracks that open 'Rock Around the Clock'; the disorienting kaleidoscope of tambura drone, stumbling rhythm and curious sound effects that herald 'Tomorrow Never Knows'; Johnny Rotten's maniacal, tongue-trilling '*R-r-r-r-ight* ... now!' clarion call in the opening seconds of 'Anarchy in the U.K.' – each of these game-changing moments are, in their own way, startlingly confident. Listeners have never had a choice but to shut up and pay attention.

But some songs acquire outsize status in spite of themselves. When the members of Orange Juice walked into a studio for the first time – the least expensive one they could find, at the outskirts of their native Glasgow – their foremost goal was to record the three songs earmarked for their debut single before they ran out of time and money. Although they projected considerable self-belief (which many who had seen them live felt was undeserved), their playing betrayed their lack of experience, perhaps even their nervousness. Rhythm section Steven Daly (drums) and David McClymont (bass) had yet to lock into each other, their attempts to channel a fluid Motown groove as precarious as the first steps of a newborn fawn. Frontman Edwyn Collins sang

as though he were a breath away from breaking into embarrassed laughter – a not unreasonable response to his wavering pitch and mouth-full-of-cake phrasing. His guitar-playing and that of James Kirk sounded anxious, tense, like fingers scrambling for an itch that can't be reached. When the session finished, the quartet handed over £98 to the studio's owner/engineer, who was accustomed to working with accordion bands. They weren't terribly pleased with the job he had done – especially his random decision to move Daly's kick drum to the forefront of the mix. But what could they do? They hadn't the resources to start again.

And yet, what Orange Juice created that day in December 1979 is a revolutionary record, more so for the fact that it tries its damnedest to not sound like one. True, the two B-sides – both instrumental, each a slight variation of the other – seem, to this day, like a hasty solution to a ticking clock. But the A-side proved to be the beginning of something still playing out in the music of new bands around the world. The song's name is 'Falling and Laughing', and its opening lyric is this:

You must think me very naïve/Taken as true/I only see what I want to see…

When, since the advent of rock, had such language ever found its way into a pop song? Compared to the alpha-male proclamations about sex, certainty and control that had come to define masculine expression in popular music, at the dawn of the 1980s this was the equivalent of a chivalrous bow and a bashful 'How do you do?' Edwyn Collins had immediately exposed himself as the opposite of the archetypal boy in a band. He was deferential and self-deprecating, and his unashamedly strong grasp of language suggested he spent plenty of time in the library. Further into the song, he admits being inclined to 'avoid eye contact at all cost' when he sees his beloved, and that the only possible solution to his loneliness is to 'learn to laugh at myself'. 'Fall, falling, falling again/Because I want to take the pleasure with the pain', he concludes. 'Falling and laughing'. All the while, he and his bandmates are creating a benevolent racket that combines the morning-has-broken joyfulness of early Byrds with the thin, minimalist rhythmic attack of the Velvet Underground's 'What Goes On'. The combined result is technically crude but viscerally as charming as being handed a bouquet of flowers.

Within four minutes, Orange Juice answered a question no one had thought to pose before: What would it sound like if punk rock had sought not to set fire to society, but to fill it with love?

For the most part, the first generation of British punk bands was visually and conceptually electrifying but musically an anticlimax. The Clash, Sex Pistols, the Damned – stripped of their fashions and occasionally provocative words, what were they but hard-rock outfits playing at twice the speed and with a fraction of the competency of the rock dinosaurs they were meant to wipe out? Punk only began fulfilling its promise of a new beginning for music when it grew out of the shock theatrics of its early years and dedicated itself to pushing sonic envelopes in every conceivable direction. Beginning in 1978, the notion of 'post-punk' emerged, and it was thrilling precisely because it had no formal definition; its only rule was that there were no rules. The result was that the post-punk impulse manifested in dozens of ways, from the dense, rhythm-led experimentalism of Public Image Limited and the Pop Group, to the frigid electronic soundscapes of Cabaret Voltaire and the Human League, to the unprecedented collision of resourceful amateurism and feminist worldview exemplified by the Raincoats and Delta 5. Popular music had never before been subject to such intellectual rigour: the sense of a shared mission to free it from the creative cul-de-sac of rock governed every artist who claimed to be operating outside of the mainstream.

As the 1980s began, the term post-punk wore out its welcome, but its guiding principles could still be heard everywhere. Orange Juice's 'Falling and Laughing' was released in February, and although it bore no resemblance to anything that had previously been described as post-punk, it somehow made sense within the genre's amorphous boundaries. In fact, the timing of its arrival was perfect. The dark side of post-punk had recently plumbed its blackest depths with Public Image Limited's *Metal Box* and Joy Division's *Unknown Pleasures*, two albums whose unremitting bleakness made hard work of trying to marvel at their startling aural innovations. Critics and record buyers alike began to feel starved for joy, for the reassurance that music could challenge mainstream conventions yet still deliver the unselfconscious rush of pop. When Joy Division's 23-year-old singer, Ian Curtis, committed suicide

in May, the need to retreat from post-punk's increasingly dominant mood of deathly seriousness seemed not just advisable, but urgent. Orange Juice, without meaning to, proposed a new dawn exactly when it was needed.

The radical proposition of Orange Juice was that it could be infinitely more rebellious to flaunt one's sensitivity and intellect and humour, and to make melodic music that celebrates romance and optimism, than to be yet another doomsaying noise merchant. 'It's not subversive to be aggressive anymore', said Edwyn Collins in a 1981 interview. 'It's the sensual that matters now.' Coming from a member of a top 40 band, this might not have raised an eyebrow, but Orange Juice clearly were the product of alternative tastes. As well as the Byrds and the Velvet Underground, they had in fact been affected by early punk – albeit two of its most cerebral, least masculine groups, Buzzcocks and Subway Sect, whose initial incompetence and, in Collins's words, 'very witty, very camp' presence convinced them they could try their hand at music, too. Orange Juice were one of the first explicitly curatorial groups, piecing together their sound with various elements culled from Motown, Creedence Clearwater Revival, the Lovin' Spoonful, even disco (they worshipped the elegance of Chic's clipped guitar-playing and taut bass-and-drums interplay, although they struggled to match it themselves). Their look, too, was a meticulous pick-and-mix sourced from charity shops: fringed suede jackets, plaid shirts and plastic sandals, sharp Mod blazers. Collins would take to the stage wearing a coonskin cap, his lopsided fringe impishly shielding one eye.

In keeping with the spirit of post-punk-era Britain, Orange Juice had their own label, Postcard Records, founded in conjunction with their friend and de facto manager, Alan Horne. The formation of Postcard was largely practical: stranded in remote Glasgow, where most of the local population considered them a joke, no one else would have taken the band on. But Horne, a young man of exacting tastes and with a well-developed megalomania complex, seized upon the opportunity to mould the label's visual style to his strict specifications. 'Falling and Laughing', Postcard's first release, was packaged like most low-budget independent singles at the time: wrapped in a hand-folded, self-designed paper sleeve. Unlike the austere, monochromatic visual style of the day, however, 'Falling and Laughing' announced its aural idiosyncrasies with a sleeve depicting the band against a candy-pink background,

surrounded by a border of foliage. In the photo, Collins grins madly while pretending to be seconds from smashing his Grestch Country Gentleman guitar onto James Kirk's head. Included with the vinyl were a bonus flexidisc (bearing the consolation-prize label name I Wish I Was a Postcard) and an actual postcard. The cherry on top of this whimsy parfait was Postcard's logo: an illustration, taken from a turn-of-the-century children's book, of a kitten playing a marching drum. Horne, a Warhol fanatic, had fashioned his own loveable *objet de pop art.*

Before the end of 1980, Postcard released five more singles – two from Orange Juice, two from Edinburgh's Josef K and one from Brisbane, Australia's the Go-Betweens. Horne consolidated the label's image with a slogan ('The Sound of Young Scotland') and a series of playful sleeve motifs such as bucking broncos and kilt-wearing Scotsmen. Despite his inclination to antagonize virtually everyone who was in a position to help him – including music journalists; BBC DJ John Peel; and Geoff Travis, whose Rough Trade enterprise manufactured and distributed Horne's records – Postcard became the most feted new label in the land. Meanwhile, Orange Juice advanced by leaps and bounds, their musicianship improving (but not *too* much) and Collins establishing himself as the most literate and original lyricist of the new decade, as well as the most fearless advocate for bringing an end to rock's entrenched hyper-masculinity. As if to affirm his commitment, he confessed to *Sounds* that 'Simply Thrilled Honey', Orange Juice's third single, was inspired by his refusal to have sex with a willing woman because he didn't love her. Many assumed Collins to be gay, but he was simply a gentleman in a culture that was bereft of them.

Orange Juice weren't, in fact, the first band to interpret punk as permission to make perky pop music despite very limited skills. The Monochrome Set and Television Personalities, both from London and mutually possessed of an English wit as dry and bright as their sound, released their first records in 1978. And Brighton quartet the Chefs, led by singer-bassist Helen McCookerybook, were singing ecstatic playtime odes to food and puppy love before 'Falling and Laughing' had even been put to tape. (Much further back, in the early 1970s, Jonathan Richman had all but created the template for a character such as Collins.) But Orange Juice, together with Postcard, offered an enchantingly complete package – music and words, style and attitude – and whether as a

result of their influence or simply a matter of there having been something in the air, soon there were scores more bands who, in overt and subtle ways, were pursuing a similar calling. Before Postcard met an untimely demise, it acted as a springboard for one more group: Aztec Camera, led by Roddy Frame, an East Kilbride sixteen-year-old whose lyrics suggested the life experience of an eighteenth-century Romantic poet and whose guitar-playing evoked a budding Django Reinhardt. The Go-Betweens, having settled in London, moved on to Rough Trade Records, where founding members Robert Forster and Grant McLennan began laying the groundwork for their future reputation as a post-punk Lennon/McCartney, their somewhat disparate personalities (Forster awkward and oblique; McLennan incurably sentimental) converging to produce lovely, eloquent pop songs that view life from an uncommonly adult perspective. In Liverpool, the Pale Fountains held their acoustic guitars high and made plain their passion for the fanciful, Spanish-inflected psychedelia of Love circa *Forever Changes*; from Norwich, the Farmer's Boys sounded as if life for them was a never-ending countryside picnic; the upstart Newcastle-based Kitchenware label discovered numerous bands in quick succession – Hurrah!, the Daintees, Prefab Sprout – whose music was erudite, clever and as melodic as anything in the charts.

Alas, none of this stood a chance of actually charting. Too rough and transparently low-budget for mass audiences, and without the promotional resources of major labels behind it, like most post-punk music it appeared only in the independent (or 'indie') singles and albums charts – separate listings created in 1980 specifically for the purpose of showcasing the contextual popularity of the dozens of independent records being released every week. Like an avant-garde, alternate-reality microcosm of the mainstream charts, a record could be a top-five 'hit' on the indie charts as a result of just a few thousand sales – not nearly enough to penetrate the 'real' top 40. Orange Juice, who, despite their esoteric roots, craved proper fame and fortune, acquired intimate knowledge of this dichotomy when their fourth single, 'Poor Old Soul', rose to the top spot of the indie singles tally but barely dented the top one hundred of its all-encompassing counterpart.

The dual saving graces of the marginalized post-punk multitudes were the weekly music papers, which were dependent upon the constant discovery of

new acts to fill their pages, and John Peel, the most musically insatiable on-air personality in the history of British radio, who filled his late-night broadcasts with virtually every strange and obscure sound that didn't stand a chance in hell of being played by his daytime colleagues. He not only spun the records; beginning in the late 1960s and for the rest of his life, he created a cultural institution through inviting bands into the BBC studios to record exclusive sessions for his programme. For a certain type of music obsessive, life revolved around Peel broadcasts and the weekly arrival of new editions of the *NME* and *Melody Maker* (and, to a lesser extent, *Sounds* and *Record Mirror*).

One of those obsessives was Matt Haynes, a shy, inquisitive London teen who had been born slightly too late to experience the initial punk explosion, but was of exactly the right age and disposition to be seduced by post-punk – especially the strand exemplified by Orange Juice and their pro-pop progeny. 'For me, Postcard was the turning point', he says. 'That's when I stopped thinking of music as something I heard on John Peel and started thinking of it as something I could actually be involved with. My formative years were spent listening to what we now think of as post-punk: weird bands with weird names who'd never be heard anywhere outside of Peel's show, and former Peel bands that became almost pop stars: Echo and the Bunnymen, the Teardrop Explodes, Joy Division. I loved all those bands, but it never occurred to me that it was something I could be part of. It was Postcard where I actually identified with the imagery they were using – the aesthetic aspects of the label – and I just felt, these are people I have a lot in common with and I would like to be a part of the scene that involves these people.'

In her 2013 autobiography, *Bedsit Disco Queen*, Tracey Thorn writes:

> In the musical melting pot that constituted early post-punk, everything had been allowed for a while and it was acknowledged that many bands, though sounding nothing like each other, shared a common pool of inspiration and intent. But that didn't really last long, and soon a kind of rock orthodoxy reasserted itself, especially within the music press, and [post-punk's] musical experiments began to be seen by some as being reactionary rather than progressive.

The trajectory of Thorn's music-making at the beginning of the 1980s is a case study of post-punk's rise and fall. She began as part of Marine Girls, a wondrous teenage trio whose minimalist songs – only guitar, bass and occasional hand percussion – combine the artless romanticism of Postcard with an understatedly forthright feminism inspired by the likes of Young Marble Giants' whisper-quiet vocalist Alison Statton and the all-woman frontline of Delta 5. Amateur enough to make Orange Juice seem like Julliard show-offs, Marine Girls became astonishingly popular (their two albums sold in the tens of thousands), in large part because the musical climate of the time allowed for it. But unlike her two bandmates – indeed, unlike most people involved in post-punk – one attribute set Thorn apart: to her own surprise as much as anyone, she happened to be a natural-born singer. While Marine Girls were still together, she paired up (both musically and romantically) with fellow singer-songwriter Ben Watt under the name Everything But the Girl, and almost instantly it became apparent that their combined talents had the potential to appeal to the masses. Thorn and Watt considered themselves post-punk-bred subversives, but they also loved bossa nova, British folk, and the Great American Songbook, and their shared ambition could not be contained by post-punk, which was constitutionally averse to the mainstream. It occurred to them that they should at least *try* to be successful – especially if it meant they could subvert the mainstream from within, using Thorn's marvellous voice and Watt's jazz-calibre musicianship as twin Trojan horses. So they signed to a major label and, come early 1984, they had a top-twenty debut album (and not the indie top twenty either).

Similar scenarios played out at roughly the same time across the post-punk vanguard. Artists whose sensibilities had been shaped by punk and post-punk, but who aspired to a proper career rather than mere underground success or noble failure, embraced the concept of 'entryism': aligning oneself with the tools of mainstream pop (major labels, music videos, managers, stylists) in order to make mainstream pop *better*, rather than remaining at a principled but impotent remove. Bands who had once been proud to exist at the margins radically overhauled their sound and image (or simply persevered until they improved), and for some it worked like a charm. The Human League, Scritti Politti, even Strawberry Switchblade (a Glasgow duo who were friends with

Orange Juice and looked like Boy George's Wiccan daughters) – they all became top-ten stars, however fleetingly. The journalist Paul Morley, writing in the *NME* in late 1980, had coined an appropriately hopeful term for this aspirational movement: New Pop.

But this tactic didn't appeal to everyone. For every entryism convert who craved the opportunity to gatecrash the charts, there were many more who considered the very idea a betrayal of everything punk had set out to achieve. And there were others whose argument was no more complicated than celebrity and a music career simply didn't interest them. Tracey Thorn's former compatriots in Marine Girls, sisters Alice and Jane Fox, had bristled at the suggestion of becoming more professional; instead, they remained with indie label Cherry Red, relaunched themselves as Grab Grab the Haddock (eventually voted all-time worst band name in a BBC Radio poll), and made music that sounded just like Marine Girls, which they played for miniscule club audiences while Everything But the Girl sold out theatres and toured the continent. And they were perfectly happy doing so.

As the 1980s progressed, the widening gulf between the haves and have-nots (so effectively exacerbated by the Thatcher government) became reflected in the gulf between those who had bought into the New Pop dream and those who remained loyal to small-scale independence. New Pop had initially been thrilling, exactly the creative reboot Paul Morley hoped it would be. But success corrupted and cut short its mission, and decadence for its own sake took over. Visionaries begat opportunists: instead of conceptually and technically immaculate hits like ABC's 'The Look of Love' and Heaven 17's 'We Don't Need This Fascist Groove Thang', there was the high-gloss nonsense of Kajagoogoo's 'Too Shy', and the increasingly overcooked output of Duran Duran and Culture Club. As agreeable and uncontroversial as a helium balloon, New Pop – if, indeed, it still deserved that idealistic name – became evermore skyscraping in its sound and stance. Partly in response to this, and partly because there was nowhere else to go, the resolute evangelists of post-punk scripture dove deeper underground.

Initially, there was no name to represent the *post*-post-punk guitar bands that began springing up in the wake of (and, in many cases, in tribute to) Postcard,

which folded in 1981 amidst much drama and mismanagement. The scene at the club nights where these bands played couldn't be aligned with any genre or trend. For some on stage and in the audience, there were typical sixties signifiers like suede jackets, white Levi's and striped T-shirts. Others looked vaguely goth, or like stubborn punk holdovers. Many were altogether nondescript. Their only common denominator was that none of them appeared to have any money, and the humble rooms in which they gathered to play or to watch – the back rooms of pubs, little community and student halls – were consistent with an overarching sense of austerity.

One such home to this vague scene was a club night called the Living Room, launched in 1983 and held in the small upstairs room of a pub in central London. Its founder was Alan McGee, a transplanted Glaswegian. The bands he booked tended to be too unknown and/or out-of-fashion to play anywhere else; some, like Television Personalities and the Nightingales, had been scrabbling around in obscurity for some time, but most of them were very new. From his native Scotland, McGee put on the Jasmine Minks, the Pastels and Primal Scream (whose singer, Bobby Gillespie, was his best friend). The Loft and the June Brides were made up of Londoners. Razorcuts came from nearby Luton. McGee had his own band, Biff Bang Pow!, which, like many of the other groups that played the Living Room, would soon make records for his fledgling label, Creation. Everyone felt good about the fact that the club was full every week and that its patrons enjoyed each other's company, but the room's capacity was only sixty. Notwithstanding that McGee had a reputation for allowing up to twice as many people inside, the 'popularity' of what was going on was very much a matter of scale.

It was the beginning of something, though. Similar club nights were emerging around the United Kingdom, all of them playing host to the fast-growing groundswell of bands that mixed up sixties pop, punk and psychedelia in myriad ways. The music weeklies took notice (some of the *NME* writers became Living Room regulars), and in the absence of anything better to name this music that was exclusive to indie labels and the indie charts, it became known simply as indie-pop. 'I remember feeling quite negative about it', says Stephen McRobbie of Glasgow group the Pastels, whose original guitarist was Alan Horne's flatmate. 'As an abbreviation, I thought it sounded a bit rubbishy

and patronising in contrast to "independent", which is a very clear statement of intent. As a genre, I never liked it as a descriptor and I felt it was so vague it was meaningless.'

To those who were making this music, it was simply pop – and, in their estimation, a vastly superior version at that. (When Razorcuts got around to releasing their debut single in 1986, the sleeve insert bore the proclamations 'commercial!' and 'top 40 is not where it's at, anymore'.) But compared to the multi-million-selling acts who truly ruled pop in that moment – Madonna, Dire Straits, Wham! – the indie world constituted a rogue nation of conscientious objectors, seeking refuge from an incompatible decade in the gathered sounds and styles of decades past. Yes, the Smiths had proven it was possible – granted the good fortune of an absurdly gifted guitarist and one of the most distinctive frontmen in the history of pop – for an indie band to compete in the big leagues, but they were the lone exception. As for the rest of them, it would take some doing to descend further underground. At least if they huddled together, they could generate enough heat among them to survive.

In late 1985, *NME* staff writers Neil Taylor and Adrian Thrills were tasked with compiling a cassette of new music that would be sold to readers via mail order. This had been done many times before to great success – one of the most lucrative and well-reviewed tapes had been 1981's *C81*, an eclectic overview of post-punk's wide-ranging landscape. The latest one, to be titled *C86*, would update the concept for the coming year, casting a net far beyond the capital to capture an up-to-the-minute snapshot of independent music across the United Kingdom. As was explained in the Introduction chapter, it inadvertently set off a fearsome critical backlash, but whatever negative impact it had on the bands involved tends to be overstated. Of the twenty-two featured on *C86*, more than half a dozen subsequently accepted deals with major and major-affiliated labels, and many carried on for several more years – three of them, in various configurations, to this day. The album itself sold in the region of twenty-five thousand copies and has become one of the most iconic compilations of all time, and was reissued as an expanded three-CD box set in 2014.

Whatever its shortcomings, which have always been a matter of debate, in the short term *C86* served to give a scattered, indefinable movement a focus

and a national platform, and as 1986 rolled on there was a stronger network through which like-minded bands, promoters and writers could find each other. It also underlined the oft-overlooked fact that a grassroots coalition of musicians had established itself almost entirely undetected by the all-seeing eye of London writers. 'I think the aloofness of London-based media was instrumental in the growth of indie-pop', says Martin Whitehead, whose Bristol-based Subway Organisation label put out the earliest singles from *C86*-associated groups Shop Assistants and the Soup Dragons (as well as scene favourites Razorcuts and his own band, the Flatmates). 'Most of the bands on *C86* were from outside of London. Indie-pop was very much a provincial thing in the mid-'80s. As far as we were concerned, *C86* was eighteen months behind what was happening.'

To be fair to the weeklies, a few writers *had* been making the effort to review or interview many of the participating bands before *C86* was released – co-compiler Neil Taylor, in particular, was a genuine enthusiast and a voracious scavenger for under-the-radar talent. But the minor brouhaha of *C86* prompted wider coverage than before, although much of it was either negative or highly sceptical. More so than the music, considerable interest developed around what many of the bands wore and how they behaved. As Orange Juice (and countless other post-punk youth) had done, the current indie-pop musicians cobbled together their style from second-hand items, partly because it allowed them to cultivate a unique, expressly anti-mainstream appearance, and also because it was affordable. The garments they chose tended to date back to the 1960s and 1970s, and so included anachronisms such as turtlenecks and cardigans, plenty of corduroy and stripes, and – most ubiquitous of all – children's anoraks. A degree of androgyny figured in both sexes: everyone was stick-thin, hairstyles (bowl cuts, eye-covering fringes, shapeless mops) had unisex versatility. A few observers remarked that the look was prepubescent, seemingly wilfully evocative of childlike innocence. This had precedence – almost any Velvet Underground or Ramones album sleeve proved it – but never before had it defined a subculture. In tandem with their gleefully primitive music, this finding gave rise to new pet names for the bands: cuties, shamblers, anoraks. Each of them carried the scent of a playground taunt. *Record Mirror* devoted a three-page photospread to the mini-phenomenon under the headline 'If You're

a Cutie, Say "Crummy"', which delineated the history of the tribe's greatest offenders, from Buzzcocks and Orange Juice through to Primal Scream and the Pastels: 'Completely SOFT! Dead YOUNG! Eating ice cream all the time, and never having SEX! The girls don't wear make-up, and the boys? Well, the boys are just absolute WIMPS!'

Simon Reynolds, new to *Melody Maker* at the time, approached the subject with immeasurably more thought in a lengthy 'soft celebration' essay titled 'Younger Than Yesterday'; he correctly identified indie-pop as a rejection of the (subjective) emptiness of modern chart pop, although his suggestion that an unconscious racism informed the genre's absence of black influences surely rattled a few.

Reynolds concluded that indie-pop was something worth continuing to monitor, although it was '*obviously* … no threat to the outside world', by which he meant the mainstream. And, by and large, he was right. In the end, bands who align themselves with a movement that defines itself against the dominant culture – as post-punk had done – usually face a choice of either evolving in such a way that they can ensure their survival (see: New Pop) or keeping their purity intact by way of either bowing out or remaining subterranean. In 1986 and into 1987, it seemed as though every indie-pop band that had emerged in the preceding few years had started making those choices, and the result in this instance was that most of them didn't have much time left. But if there's one thing that has always been true of underground scenes, it's that when one depopulates, there's always another just around the corner to take its place.

2

'Let's Just Communicate!':
The 1980s Fanzine
Underground

Kevin Pearce loved pop music – or, rather, his specific notion of pop music –
so much, he scarcely knew where to begin. Or end. So when he chose the
medium of the fanzine to broadcast his love to whomever beyond his bedroom
walls might want to know about it, he divulged *everything*. Or so it felt to the
reader.

There had been no shortage of fanzines in Britain since the dawn of punk.
Sniffin' Glue, the first punk-oriented 'zine to attract widespread attention,
so captivated a public eager to learn whatever it could about the music and
lifestyle that was threatening to corrupt a nation's youth, its circulation soared
to 15,000 in less than a year. No other title matched its sales, and its founder,
Mark Perry, citing boredom and the fear of imminent compromise, ceased
publication in 1977 after twelve issues. But the very idea of fanzines had taken
root, and they were everywhere. Hand- or typewritten, decorated with photos
jaggedly clipped from elsewhere, photocopied and then stapled under the ray
of a desk lamp – to its creators, fanzines were a vehicle of free expression and a
means with which to reach (and maybe befriend) like minds. To readers, too,
it was social: a communication from someone of like taste and values, who
might know about something – a record, a film, a book or another fanzine –
that mainstream media was too indifferent or aboveground to acknowledge.

Independent record shops such as Rough Trade and Small Wonder had stocked fanzines from the beginning; it was their customers who were making them, after all. Quickly, however, the likes of HMV and Virgin – whose relationship to the counterculture was restricted to whatever they thought they could sell – cleared rack space for 'zines. Virtually any teenage misfit could walk through the door, leave half a dozen consignment copies and walk out dreaming of changing some strangers' lives – or at least their minds.

But Kevin Pearce, a twenty-year-old from Kent, didn't write quite like any other fanzine writer, and his tastes generally didn't jibe with them either. It was 1984, and music had moved on and mutated countless times since punk. But fanzines, by and large, hadn't: most of them were championing the same music and roaring the same impotent rhetoric as seven years before. Not even the numerous Mod 'zines, which could still attract Pearce's curious eye, seemed to have resigned themselves to the fact that the Jam had split. Nor had they absorbed the example of Paul Weller when he walked away from the most popular band in the country: that Mod itself was about moving forward, opening oneself to unexplored territory, embracing the daunting thrill of the unknown. Pearce didn't identify as Mod – he was too omnivorous to identify as anything – but its creed meant everything to him.

He named his fanzine *Hungry Beat*, after a song from the Edinburgh post-punk band Fire Engines, whose frantic, ecstatic 'background music for action people' perfectly mirrored his anxious prose. Its first issue is actually somewhat backward-glancing. In the temporary absence of much new music that excited him, he wrote about older sounds that were new to his own ears – Love; the Lovin' Spoonful; Subway Sect and its mercurial leader, Vic Godard – mostly discovered from exploring the influences his modern favourites had spoken of in interviews. 'Postcard Records, Dexys Midnight Runners, the Jam, the Teardrop Explodes – they opened the door onto the past's treasures', explains Pearce. 'It seemed very important to be exploring pop history, expanding horizons, use everything that was there. And I believed it all fitted together.'

Subsequent editions of *Hungry Beat* flaunt the evangelical fervour of someone who has discovered more treasure than he knows how to process. 'It just so happened that as I was putting that first issue together, a new wave of

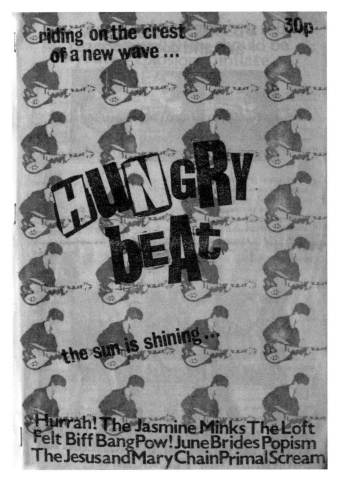

Figure 2.1 'riding on the crest of a new wave. ...' *The inspiring* Hungry Beat *fanzine. (Courtesy of Kevin Pearce)*

groups was emerging – ones that shared similar ideas and taste and roots to me: the Jasmine Minks, the June Brides, the Loft, the Jesus and Mary Chain. It was very exciting and unexpected.' It had been the first issue that carried the declarations 'riding on the crest of a new wave...' and 'the sun is shining...' upon its cover, but it was in Pearce's later writing that his words transmitted a complementary tone of bearing witness to an emerging golden age. Pearce writes in a stream-of-consciousness style that feels breathless, his extended paragraphs punctuated only with ellipses and exclamation marks, while block capitals are frequently employed for emphasis. Throughout its pages,

he recurrently emphasizes how 'it all fitted together', the bounties of the past leading to a present that inclusively makes room for everything.

> How do you spell pop music?
> How do you spell punk rock?
> NO NO NO … I knew you'd say that … talk about a bad education – god! We've got a fight on our hands here – LISTEN! – pop music/punk rock – it's the same thing right? – yeah, so note this – you can say it's spelt J-O-S-E-F-K or V-E-L-V-E-T-U-N-D-E-R-G-R-O-U-N-D … but the new and better way of spelling it goes like this … H-U-R-R-A-H! …

Few writers made use of the word 'punk' in 1984 for any reason other than to reference the past or to describe a band whose music was an explicit throwback to 1977. But to Pearce, 'punk' was a crucial catchall that applied to virtually any music imbued with a certain youthful spirit and raggedness. The June Brides, Hurrah! and the Loft may have been melodic, and more inclined to sing about love and reverie than rage and anarchy, but in his estimation they were punk. It was a radical concept, and it appealed greatly to those like him – many of whom were aspiring to form a band or write their own fanzine – whose ideal revolution involved building up, not tearing down.

Pearce's vision for his fanzine wasn't born in a vacuum, however. He was greatly inspired by the dense, impassioned writing of the *NME*'s Paul Morley and Dave McCullough at *Sounds*. But had he not discovered another fanzine a year earlier, *Hungry Beat* either would have been very different or might not have existed. *Communication Blur* was published by Alan McGee, partly as a vehicle to promote his efforts at the Living Room club and for his brand new Creation label, but also as a forum in which he could discharge a turbulent inner monologue of excitement and disgust: excitement that plenty of great music was being made, disgust that the masses were ignoring it in favour of assorted mediocrities; excitement that punk's lessons of active engagement were still available for all to act upon, disgust that more people weren't making use of them:

THE AFTERBIRTH OF PUNK ie A DEFATED GENERATION – WASH THEM AWAY AND BRING TO THE FOREFRONT THE PEOPLE WHO

STILL CARE ABOUT MUSIC. WE MUST BUILD FOUNDATIONS
ie START GROUPS, CLUBS, FANZINES, LABELS – LET'S JUST
COMMUNICATE!

Pearce took him up on it. 'Alan's rhetoric was really inspiring, and his message
was very much, "If you don't like what's around, get up and do something
yourself." I made contact with him.'

Through McGee, Pearce met other figures from the developing Creation
universe, including Primal Scream's Jim Beattie and Bobby Gillespie; the latter
would contribute to *Hungry Beat* under the pen name Pete Whiplash. McGee
became so admiring of Pearce's empathic text, he strategically positioned a
copy of the 'zine in the cover photo of the first Biff Bang Pow! album.

Pearce may have been spurred into action by McGee, but it was Pearce's efforts
that found a larger audience. McGee quickly abandoned the printed word to
devote himself fully to Creation, while *Hungry Beat* radiated out into the indie
coterie, gradually acquiring the status of sacred texts and key templates. Soon
there were scores of new titles that, to varying degrees, laid bare its textual
and visual influence: *Baby Honey*, *Trout Fishing in Leytonstone!*, *Adventure
in Bereznik!*, *Turn!* (exclamation points were a compulsory feature of fanzine
discourse).

Simultaneously, dozens of young guitar groups emerged across the UK
whose principles and aesthetic components were in keeping with the criteria
celebrated in *Hungry Beat*. Ironically, Pearce, who kept a low profile and was
careful to write only when he felt sufficiently inspired, loathed most of them. But
in his absence, a symbiotic relationship developed between the bands, Pearce's
illegitimate fanzine progeny, and readers who enjoyed both. Mutually ignored by
the mainstream, together they formed an intimate network: 'zine writers could
go to a gig, sell their wares to fellow audience members (possibly exchanging
addresses and phone numbers for future socializing), then interview the band.

'Fanzines were quite a sociable enterprise', says Amelia Fletcher, whose
band Talulah Gosh was highly revered among the indie-pop crowd.

Everyone would buy them from each other and you'd talk to the people
you'd bought them from, you'd comment on what they'd written – it became

a way in which everybody discussed anything with anybody else. I think that's why Talulah Gosh was in them all; it's partly they were documenting a scene and we were pretty important in that scene, but also we were, as people, at all the gigs in that scene, and therefore we were really easy to interview. We would end up chatting to the people who were writing the fanzines and kind of befriending them. It was, in a way, insular, but I think the fanzines made it less insular because they created this medium by which new people could come in and make sense of it. If you were new to the scene, what you'd do is you'd set up a fanzine and you'd start selling it, and then people would start talking to you.

One of the many eager participants who suspected a fanzine could be his entrée to the scene was Matt Haynes. Having moved from London to study at the University of Bristol, he and his halls-of-residence friend Mark Carnell read about *Hungry Beat* in the *NME*. 'There was a picture of it, and on the cover there were the names Hurrah!, Felt – bands that I knew and that I liked,' says Haynes. 'This was the first time I'd ever seen a fanzine that was writing about those sorts of bands, so I sent off for a copy and that was the inspiration for the fanzine I did myself.'

Like Pearce, Haynes was especially passionate about Hurrah!, from Newcastle upon Tyne. A long-suffering quintet whose anthemic pop songs consistently failed to find a sizeable audience, their finest moment was 1983's 'Hip Hip', a rousing hymn to optimism that ends with the repeated inquiry, 'Are you scared to get happy?' That lyric spoke deeply to Haynes's frustrations. It was a question that, given the chance, he would ask of everyone who seemed to wilfully make choices – voting Tory, buying vacuous chart pop, working solely for material reward – that thwarted their own capacity for joy. Thus, he titled his fanzine *Are You Scared to Get Happy?*, and its first issue was, by his own admission, 'a complete rip-off of *Hungry Beat*'.

'I did feel slightly embarrassed at the time,' he continues, 'but that was our model. We'd not seen any other fanzines of that sort. That was our entry into this world of actually being actively involved in creating things and being part of a scene, because until then it would have just been the case of listening to stuff on John Peel alone in your bedroom, and thinking you were the only person who liked this music.'

Getting back to basics... **35p**
a punk rock fanzine

are you scared
to 9et hAppy?

HURRAH!
JASMINE MINKS
MICRODISNEY
BIFF BANG POW!
JULIAN COPE
PRIMAL SCREAM
ST. CHRISTOPHER
JUNE BRIDES

Figure 2.2 *The first issue of Matt Haynes's fanzine, a 'complete rip-off of* Hungry Beat', *he admits. (Courtesy of Matt Haynes)*

While his fanzine had yet to establish its own identity, *AYSTGH* did give Haynes the means to interact in a more meaningful way with like minds. He had stood among them numerous times at gigs; now he had an excuse to initiate conversation, although his profound bashfulness often conspired to foil his efforts. 'I remember how astonishingly shy and reluctant to talk he was, and contrasting that with his amazing writing,' says Razorcuts' Gregory Webster. 'He seemed a character, and that was cool.'

'Just the idea of actually producing something seemed really, really exciting,' says Haynes. 'I don't think it really went much beyond that. I mean, the big fanzine-selling scene was in London, where there were gigs happening and

you could go round and sell them. In Bristol you couldn't really do that because there weren't enough gigs, so we had no idea how we were gonna sell them. We just printed three-hundred copies and put some in the local record shop and then sold the rest by mail-order.'

Yet while Pearce issued only one more edition of *Hungry Beat* and then disappeared for a time, Haynes felt suitably emboldened by the creative fulfilment of *AYSTGH* to begin producing them at a fairly prolific rate. What's more, beginning with issue number two, in 1986, the publication assumed a look and a point of view that was both divested of the debut issue's slavishness and vastly more eye-catching and absorbing than any of the competition. Haynes and Carnell reproduced the pages in a rainbow of primary colours, and presented their words in a knowingly slapdash yet incredibly dynamic collision of typewriter text and fat graffiti-like scrawl. The cumulative effect is overwhelming to the eye – simultaneously provocative and disarming – and the sheer wealth of words, arranged at odd angles around randomly placed images, makes for what must have been one the most immersive reading experiences of its day.

One sense in which *AYSTGH* continued to bear the influence of *Hungry Beat* was its absence of interviews. Historically, one of the primary incentives for people to write a fanzine has been to meet and have an extended personal audience with the bands they love. Pearce vowed to avoid that from the outset. 'There was a depressing fanzine orthodoxy based around awful Q-and-A interviews, dated reviews, local coverage. I hated all that and wanted to do something different,' he says. 'I could easily have done interviews – the groups I liked were hardly over-exposed – but my view was the groups had their opportunity to express themselves in their music, and I wanted to capture something of the impact the music had on me. And there was a very real sense of wanting to present writing about music that was part of the whole experience, like the best sleevenotes are an integral part of the pop listening process.'

Haynes agreed with this approach. ('By and large, most interviews aren't that interesting,' he says.) Pearce's method was to establish a wider cultural context in which the music he loved could be understood – literature and cinema were favourite points of comparison. Increasingly, though, Haynes stepped

even further from convention and imbedded his music references in rambling reveries that encompassed ideas about politics, relationships, capitalism – the very aspects of everyday life that, he felt, threatened or enhanced one's ability to 'get happy'. (In)famously, he once broke down – with the aid of a diagram – why a recent Soup Dragons release that contained barely six minutes of music exemplified how the music industry used the twelve-inch-single format to cheat consumers. 'HOW DOES IT FEEL TO BE SHAT UPON?' he asked of those who would condone such a thing.

Haynes's efforts didn't go unnoticed. *AYSTGH* sold in ever-greater numbers, and he combined forces with three other fanzines to produce flexidiscs of up-and-coming bands that would then be bundled inside. His success dovetailed with the release of *NME C86* – suddenly, *AYSTGH* and its ilk were recognized as part of an identifiable movement. *Melody Maker*, which generally paid little notice to fanzines, wrote a short feature about Haynes. 'Call him a shambler, call him a jangler, call him the dreary little prat that he clearly is at times,' wrote the unidentified correspondent, 'but his dedication to the purest pop ethic of all (what makes the strings of your heart go PING!) is undeniable.'

'There was an incredible feeling when I finally got around to taking the fanzines to London and going to gigs,' says Haynes, 'and that feeling of walking around knowing you've got something people want and they're going to give you money for it and they're going to talk to you about it. There was one – I think the fourth issue – and I remember taking that to a 14 Iced Bears gig and just sort of standing there and not really having to move around and approach people. They just kept coming up to me the whole time.'

Among a certain small community, Haynes was becoming someone to know. A new student who arrived at the University of Bristol from Yorkshire in autumn 1986 decided to make a point of seeking him out.

3

'How Much Do One Thousand Flexidiscs Weigh?': When Matt Met Clare

There's been a big break between this and the last issue, I suppose mainly due to the BIG MOVE – my move from Harrogate and school down to Bristol and University, my adjustments to my new way of life, my new situation, and of course to Bristol's venues, which don't favour fanzine sales to say the least.

Thus, nineteen-year-old Clare Wadd welcomed readers to the sixth issue of her fanzine, *Kvatch*, which arrived almost a year after its predecessor. Plenty had happened to her in the interim, some of which she disclosed – relocation to Bristol; finding her feet as a student; local clubs' aversion to the hawking of fanzines among audience members (unlike in Leeds, her previous favoured stomping ground) – but some developments were either too personal or seemingly too trivial to share. Among them, she had recently been introduced to a former University of Bristol student. He, too, published a fanzine, and had also joined forces with some friends to put on bands like Razorcuts

and Talulah Gosh at a city centre pub under the club name EEC Punk Rock Mountain. Her first conversation with him had taken place merely because she knew few people in Bristol and their respective publications made plain that they shared similar interests. She was shy and he, despite being a few years her elder, was even more so. Romance would come in time, but first he would have to explain to her the logistics of transporting a box of flexidiscs roughly one hundred miles.

A few years earlier, in her bedroom in Harrogate, Wadd had been listening to Kid Jensen's evening radio programme when talk turned to fanzines. 'I'd never seen one,' she says. 'But I liked music and I liked writing, and I instantly wanted to put the two together, so I started making a fanzine when I was sixteen. I don't think I actually knew what kind of music I liked, and I wasn't part of a scene. I started gathering fanzines as a kind of research project, to see how you do it. I can't sing, I'd never wanted to *play* in a band, I never wanted to be on stage, but it was a way of getting involved.'

The simultaneous discovery of John Peel introduced Wadd to a world of music that had previously eluded her (when a schoolmate had mentioned that he was 'into Orange Juice', she questioned how someone could be 'into' a beverage), but she remained admirably untainted by genre allegiances, perceiving no conflict in loving the Smiths and also the critically reviled Welsh folk-punk band The Alarm. She sought out advice about fanzines from an eighteen-year-old Leeds boy named James Brown,[1] who published *Attack on Bzag*; he showed her how to lay out pages, and how to use liquid correction fluid to eliminate photocopy shadows. And musicians proved only too happy to be interviewed by her. 'I used to interview them after gigs. I'd just go backstage. Maybe they wanted to talk to sixteen-year-old girls. I certainly didn't think that at the time, but you look back and think that could've opened the door.'

[1] Following stints as a contributor to the *NME* and *Sounds*, in 1994 Brown founded the pioneering (and highly controversial) 'lads' magazine *Loaded*. He has since become a colossus in British media, working in print media, television and online.

Wadd interviewed a then little-known Housemartins, poet Ivor Cutler and folksinger Ewan MacColl, and did her part to establish her left-wing credentials with editorials about Greenpeace and Amnesty International. All in all, it was a very fulfilling hobby, and one she hoped to continue despite the demands of university.

Shortly after arriving in Bristol, she attended a gig at the Bierkeller. The headliner that night was Julian Cope, but she was more interested in the support act, Primal Scream. As she had been doing for the better part of two years, she used the time before the band took the stage to try to get her fellow concertgoers to part with 35p in exchange for a copy of *Kvatch*. Eventually she approached a

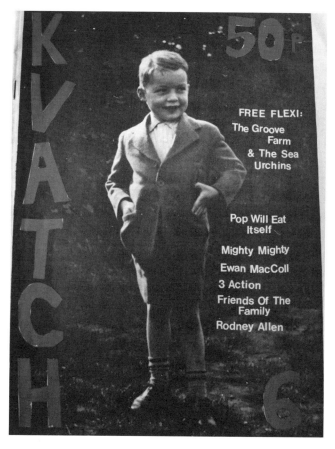

Figure 3.1 *The sixth and final issue of Clare Wadd's fanzine,* Kvatch. *(Courtesy of Clare Wadd)*

tall, thin boy whose blonde fringe hung well below his eyes. 'He said, "No, thanks. I've already got it. You must be Clare", Wadd recalls, 'He wasn't terribly friendly'.[2]

And this, of course, was Matt Haynes – not being dismissive but characteristically taciturn. He already had the issue of *Kvatch* that Wadd was flogging because she had sent it to him in late summer as part of an effort to connect with other fanzine writers before her arrival in Bristol.

Thinking nothing more of the encounter, Wadd continued to piece together *Kvatch* number six whenever she had a spare moment. Someone in her halls of residence, learning about her passion project, suggested she convince a couple of bands to donate tracks to a flexidisc that would be included with the next issue. Flexis – inexpensive to make and lightweight enough to require little more postage than a letter – had become a popular bonus item in countless fanzines the world over.[3] Wadd was delighted to discover that a thousand of them cost less than £250 to manufacture. A local band, the Groove Farm, whose self-released debut EP had recently been championed by John Peel, offered her a brand new track, recorded with a minimum of fuss directly onto cassette; the Sea Urchins, a new Birmingham group, welcomed her to pick a favourite from a recently completed two-song demo. Wadd was set. One potential obstacle, however, was that flexis were manufactured in London. They could be delivered, but a day trip to the capital seemed a more attractive option. A single flexi weighed next to nothing, but what of a thousand?

In this instant, Wadd thought of Haynes, the boy who had seemingly brushed her off while they stood waiting for Primal Scream. She knew that his

[2] Andrew Jarrett, singer and guitarist of Bristol band the Groove Farm, remembers Wadd and Haynes meeting under very different circumstances, at one of his gigs. Jarrett had got to know each of them individually, and after his band finished playing, he stepped out into the audience to pass along a cassette to Wadd. Haynes was standing next to her, although they hadn't spoken. 'I handed the cassette to her', he says. 'Matt was standing on one side of me, and Clare the other. I remember it well. We were all a little bit quiet and shy. "This is Matt. This is Clare." Awkward silences. Shortly after this they seemed to always be together.'

[3] Flexidiscs had been in production since the early 1960s. Their use in pop music had mostly been as fan-club releases (the Beatles mailed one to their club's members each Christmas) and as bonus items given away with magazines. Their popularity waned in the 1990s alongside regular vinyl records, and the last manufacturing plant shuttered in 2000. However, dovetailing with the vinyl resurgence of recent years, a San Francisco-based company started making them in 2010. Like vinyl, though, they're now viewed as specialist collectors' items and are priced accordingly.

fanzine, *Are You Scared to Get Happy?*, had not only included flexis in several of its issues; they had been disproportionately popular. In conjunction with three other 'zines – *Simply Thrilled*, in Glasgow; *Trout Fishing in Leytonstone*, in London; and *Baby Honey*, in Kent – he had formed an actual flexidisc label, Sha-la-la, and its releases were distributed with each of the titles. The success of their shared enterprise was, given the archaic format, impressive: each flexi had sold in excess of two thousand copies, and the *NME* and *Melody Maker* had even seen fit to review some of them in their singles review columns, the latter going so far as to make a track from one of them – Baby Lemonade's 'Jiffy Neckwear Creation' – Single of the Week. If anyone among her acquaintances knew whether it was possible to single-handedly carry hundreds of them home from north London, it was him.

Haynes had long since moved out of the residence where Wadd now lived, and was occupying a claustrophobic £80-a-month basement flat in the suburb of Clifton, near the top of Upper Belgrave Road. She stopped by unannounced early one morning – the flat was on her way to classes. 'I went to stick a note through his door, which he then opened, which made me jump,' she says. 'The essence of my note was, "How much do one thousand flexidiscs weigh and can I carry them on the coach back from London?"'

Haynes would eventually recall that day, with poetic economy: 'She never really left.' In actual fact, she saw out the rest of the semester on campus, but when summer break arrived, Wadd moved into the flat. Its low ceilings, windowless kitchen and unpredictable climate (stifling in summer; freezing in winter, as there was no heating) constituted a step down from the modest but acceptable comforts of her residence room, but the company was better. 'That summer of 1987', she wrote years later, 'we took the train to Severn Beach for the day for what turned out to be our first date – 6th June, the Saturday after my first-year exams finished. We both fell in love with Bristol, or Matt showed me Bristol and I fell in love with it and him.'

Haynes not only answered Wadd's question about flexis, he placed the orders for both of theirs during his next trip to London. ('I actually wrote him a cheque for all my savings, having probably met him twice at that point,' she recalls.) To their mutual surprise, they discovered that they had been perhaps

Figure 3.2 *The entranceway to the garden flat where Sarah Records was born. (Courtesy of Sarah Records)*

the only people in Bristol who possessed the Sea Urchins demo. Of its two songs, Haynes had selected for his Sha-la-la flexi the one that Wadd passed over. This made it easy for Haynes to place the orders: both tracks were on the same reel-to-reel master.

Before too long, their thoughts of the Sea Urchins prompted a conversation about how the two of them might be of greater use to the upstart bands they were discovering who were without a record label and, more often than not, without the means to release their own music. Sharing the Sha-la-la flexi with the Sea Urchins was a Glasgow group named the Orchids who were similarly adrift, making music that, to Wadd and Haynes, was as exciting as

anything they'd heard in ages, but that would be doomed to obscurity without the intervention of people who had the resources and the drive to grant it exposure. Flexis could only accomplish so much, and in any case Haynes felt Sha-la-la and *Are You Scared* had probably fulfilled their purpose. He was out of school, unemployed and on the dole. It was time to be more ambitious. 'Sha-la-la never officially finished,' says Haynes. 'There was no conscious decision that it was going to stop. We just all felt we'd enjoyed what we did and now we were going to do other things.' He and Wadd discussed launching a record label. She would be returning to university in the fall, but given that they were now living together, she could make an equal contribution.

Mutually intense and brimming with the idealism they had broadcast in the pages of their fanzines, much philosophical conversation followed about what their label should be like. They had grown up in awe of independent labels whose aesthetic was based not only in music but also on the records' visual presentation, the proprietors' politics, how they did and didn't promote themselves, and with whom they did and didn't align. To Haynes in particular, Postcard had been close to perfect, albeit tragically short lived. Factory had established an unmistakable identity and was fiercely loyal to its home base of Manchester, rather than being beholden to London – qualities which forgave the fact that neither of them liked most of the records. In Bristol itself, Martin Whitehead had proven with the Subway Organisation that one person could single-handedly oversee a label and bring great bands to national prominence. And Creation's early onslaught of releases had been as immeasurably inspiring to Haynes as *Hungry Beat*.[4]

But they had also observed the labels they loved make decisions that, to them, represented serious betrayal. 'One thing we did at the start was list in our heads all of the things that other labels did that we didn't approve of and then say, We are *not* going to do that,' says Haynes. He seemingly could never exhaust his rage about indie labels releasing singles in both seven- and

[4]Haynes retroactively suspects that anarchist punk band Crass's eponymous, self-owned label had a 'subliminal' influence on the incorporation of politics into Sarah's releases and literature. Although musically dissimilar, Crass regularly enclosed impassioned written manifestos with its records, and ensured the records' affordability by enforcing maximum retail prices on their sleeves (i.e. 'Pay No More Than £3.00').

twelve-inch formats, using one 'bonus' track to entice fans to pay two or three pounds more for the latter, or assigning exclusive B-sides to each format, thus compelling them to buy both. Compact discs – still a relatively new technology in 1987 – were affordable only to deep-pocketed consumers and marketed accordingly. These things would be avoided.

'There seemed to be a lot of treating the fans – the customers – with contempt, that we very much didn't want to do because the point was we *were* the fans,' says Wadd. 'Our initial drive was obviously to do with good music, but also the value-for-money side of it. It was political with a small "p" – caring about the buyer of the records and not setting out to get the most money out of them, to try to give them something they would like to own that was nice in as many ways as it could be and that had care taken over it. The backdrop to this was very much Thatcher's Britain: you either aligned yourself with the left or with the right. We felt that it was contradictory to align yourself in your head and at the ballot box with the left, but then do all the things as a label that the right would do, albeit on a smaller scale.'

It was an unusually cerebral approach to putting out records, to the extent that it risked not being any fun. But the couple felt certain they could strike a balance between pop and politics that emphasized the former, leaving the latter to be discovered, says Haynes, 'by osmosis. One day they'd suddenly stop and think, "Hang on. Why do I have to spend £3.49 on this Pastels twelve-inch from Creation when the Sea Urchins seven-inch on Sarah only costs £1.49 and they both have three songs on?" And then they'd set fire to the Houses of Parliament.'

The formula, such as it was, was simple: seven-inch singles only, with three or four tracks on each, in colourful hand-folded sleeves and with added bonuses such as posters and postcards – all of it priced equal to or less than the releases of larger labels. The likelihood of the idea lifting either of them out of their current impoverishment was minimal, but they'd never known wealth. So...

Wadd wrote a letter to the Sea Urchins and Haynes to the Orchids outlining their proposal. What did any of them have to lose?

4

'Come to My World': The Sea Urchins and the Beginning of Sarah

The Sea Urchins' sartorial commitment was peerless. Everyone whose eyes fell upon them knew this to be true. As if a random assortment of zealous shoppers had unwittingly stepped through a space–time portal, transporting them from 1966 Carnaby Street to 1986 Birmingham city centre, they bestrode their territory without fear of rivalry or ridicule.

'Cravats, Beatle boots, purple polo necks, corduroy trousers, leather jackets, white Levi's – we wore all of them regularly,' says Robert Cooksey, their lead guitarist. 'Two of my favourite items of clothing were an original orange paisley Mr. Fish shirt and a purple Jon Wood button-down, usually worn with sky-blue Levi's cords, Beatle boots and a suede jacket.'

He and his bandmates developed their daring fashion sense without first-hand knowledge of the era in which it originated. They were only seventeen and eighteen years old – the whole of the 1960s predated the births of most of them – so they spent years scavenging until their wardrobes fully complemented the contents of their record collections, in which contemporary favourites (Television Personalities, the Smiths, most of the Creation catalogue) were increasingly being dwarfed by the front runners and also-rans of the mythic, impossibly exotic sixties: the Velvet Underground, Love, the Left Banke, the golden roll call of 'B' acts (Byrds, Beatles, Buffalo Springfield, Beach Boys).

In short, the Sea Urchins had studied hard and were eager to broadcast their amassed knowledge to passers-by whenever they stepped out into their hometown of West Bromwich, five miles from Birmingham. Luckily, the close quarters of their environs were a plus for esoteric show ponies such as themselves. Bridget Duffy, who played organ and tambourine in the band, and spent untold hours in charity shops until she cultivated 'a car-crash look between Dusty Springfield and Rita Tushingham', recalls Birmingham during the 1980s as 'a small place, so everyone would end up in the same clubs. There were small pockets of young people looking for something away from the norm, and sometimes, by chance, they created their own scenes.' At club nights such as Sensateria and the Click Club, one had the opportunity, whether on stage or in the audience, to reap approving glances from every scene-maker whose opinion mattered.

Yet among many of the people who heard them during their early days, the Sea Urchins' aesthetic commitment was second only to their undeserved sense of accomplishment. 'The Sea Urchins were something of a local joke,' Pete Paphides, a Birmingham-based teenager at the time, reminisced in a 2014 essay. 'They were terrible live and habitually paraded around the Click Club like superstars.'

'We did like playing up and being mischievous,' acknowledges singer and guitarist James Roberts. 'It was funny – and kind of the point when you're eighteen, in a band, skinny as hell and with a good haircut. It would be remiss not to!'

It was therefore additionally vexing to those who considered them the emperor's new clothes horses that good fortune smiled upon them almost from the beginning, before they had earned the right to so much as consider themselves a band. In early 1986, Cooksey made the acquaintance of Hugh Harkin, the Morrissey-esque frontman of up-and-coming local group Mighty Mighty. Harkin proved to be indispensable: he not only introduced the embryonic Urchins to Bridget Duffy (Mighty Mighty had used her as the cover model for their debut single); he tipped off *NME* writer Neil Taylor about them. And so, without having played a gig or entered a studio, the Sea Urchins were the subject of a small feature in the *NME*'s front-of-book *Thrills* column. Taylor enthused that the Urchins 'have only ever played in their bedroom!'

and further noted that they 'are heavily into anoraks, chocolate bars, Korky the Cat, and hazelnut yoghurts…' ('I seem to remember most of the quotes were made up,' says Cooksey, 'but we were pleased nonetheless.') It was mentioned in closing that the band were still looking for a drummer, but Taylor didn't report that this was because Duffy had failed the audition. 'I sat behind the kit eating an apple,' she reveals of her try-out. 'I realised it was more of a challenge than being Mo Tucker and playing one snare drum' – as she had done alongside Harkin in a short-lived Velvet Underground covers act, the Velvet Underwear. 'I admitted defeat. Despite this, I joined the band: tambourine woman. I didn't feel demoted; only relief.'

After the Urchins completed an early line-up (the drum vacancy having been filled by James Roberts' younger brother, Patrick), they began gigging. Wadd and Haynes discovered the band separately, before they met. Wadd was persuaded by a friend at the University of Birmingham to journey down from Yorkshire especially to see them. 'They'd been amazing,' she remembers. 'Matt had seen them, as had everyone else in Bristol, and they'd been awful.' (Haynes's introduction to the band had been at the Thekla. Standing among a stunned audience, he watched while, as the Urchins turned in a ramshackle set, one of the band's drunken friends performed a slow striptease until only his underwear remained. His task completed, and with no better idea of what to do next, he then dressed at an equally glacial pace.)

The Urchins so impressed Wadd that she introduced herself to James, and an exchange of letters carried on throughout 1986. The upshot was that she became among the first to hear a demo the band recorded in October. Committed to tape in six and a half hours, it contained two songs – one fast, one slow, both as guileless and affecting as teenage life itself. Seemingly no one saw it coming: the provocative dandies, whom many among their circle had dismissed as being literally all trousers, revealed themselves to have beating hearts beneath their fastidiously maintained attire. 'Cling Film' contemplates adolescent heartbreak and its morass of emotion, James sullenly inquiring 'Why weren't you special?' while his sibling's torpid drumming suggests someone too dejected to get out of bed. Contrarily, 'Summershine' is blissful naivety, boundless optimism for every conceivable possibility in love and fortune – in short, the sound of the song's title. Wadd immediately proposed

including 'Cling Film', her favourite of the two, as part of a flexi to be given away with the next issue of *Kvatch*.

Meanwhile, in Bristol, a copy of the demo fell into Haynes's hands, courtesy Pete Williams of *Baby Honey*. Unaware that anyone else in the world had a similar goal in mind, he too committed to placing one of the songs onto a sheet of wobbly plastic. Fortunately for all concerned, 'Summershine' won his vote.

It was early summer in 1987 when Wadd and Haynes decided to retire their fanzines and co-launch a record label. Although fans would come to assume every facet of Sarah was the product of great deliberation and complex significance, their enterprise was mostly borne of impromptu, matter-of-fact decisions. The name Sarah was proposed by Wadd while she and Haynes sat over cups of tea at the kitchen table. It came to her instantly – from nowhere, as far as she can remember – and the idea of a woman's name appealed to both of their feminist sensibilities. But to this day she can't account for why Sarah, specifically, suggested itself. And in terms of the Sea Urchins launching them, Wadd says the band were 'an obvious first choice, rather than the inspiration for the label'. They were their common denominator – the entity that brought them together – and no one else had stepped forward to claim the band since the release of the flexis.

But that wasn't strictly true. Hugh Harkin, whose Mighty Mighty had self-released their first two singles (under the asking-for-it name Girlie Records), was considering a new label of his own, and he offered the Sea Urchins the chance to be its inaugural signing. It was a tempting offer – Harkin and the rest of his band had continued to be very good to them. In addition to giving them support slots, Cooksey was asked to grace the cover of Mighty Mighty's second single, while Duffy's nine-year-old sister posed as a bubblegum-blowing Swinging Sixties hipster for the third. In the end, Wadd and Haynes won out. 'We felt it was the better option,' says Cooksey. 'We were sure they had a readymade fan base that had bought their fanzines and flexis, and we thought they were genuine fans. We liked them and were excited to be the first release on their label. I remember thinking it was going to be the new Postcard or Creation.'

Wadd and Haynes certainly were as unskilled and as destitute as Horne and McGee had been when they started. Haynes was unemployed, having quit his stopgap job as a car-park attendant, while Wadd was at university. Neither came from money, and it wouldn't have occurred to them to ask their families to risk their savings to invest in small-fry pop records. So they walked cap-in-hand through the door of Revolver, a record shop that had grown into the Bristol hub of the nationwide Cartel music-distribution network. Wadd and Haynes knew that in addition to sending Sarah's releases to shops around the country, Revolver, if it so chose, could offer to pay their manufacturing costs upfront and recoup them against the sales that – fingers crossed – would surely follow. This was their only conceivable chance, and they were in luck. Revolver's managing director, one Mike Chadwick, knew of Sha-la-la from its Single of the Week accolades and the sell-out sales that followed. Wadd recalls the meeting's astounding lack of complication:

> We walked in and said, "We're planning to start a label. *Will* you take us on *and* will you pay for the manufacturing *and* deduct it from the later sales?" And they just went, "Yes." But they did that because of Sha-la-la. And looking at it from their point of view, if you're sat there as an indie distributor and you see all these flexis getting Single of the Week that you're not even getting a look at distributing because they were sold with fanzines, that must have been incredibly frustrating.

Chadwick, a no-nonsense presence whose interest in indie-pop was more or less limited to whether it could turn a profit for Revolver, had only one other short-term question: 'You're not gonna put them in those stupid plastic bags like Subway, are you?'

Wadd and Haynes moved fast to ensure Sarah's first release would be in shops before the end of the year. When the Sea Urchins entered Birmingham's charmingly named Rich Bitch Studios, in August, their regularly fluctuating membership seemed to have finally firmed up, the Roberts siblings, Cooksey and Duffy having been joined by bassist Darren Martin and long-time ally Simon Woodcock, who settled into the role of guitarist after flitting between various instruments. Tasked with recording three songs, they made even more

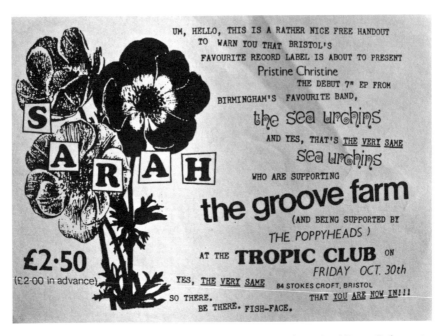

Figure 4.1 *Haynes and Wadd promoted the imminent launch of 'Bristol's favourite record label' by handing out this flyer at a gig by local band the Groove Farm, where the Sea Urchins were supporting. (Courtesy of Sarah Records)*

efficient use of their limited time than when they had laid down the demo tracks, walking out satisfied after eight hours.

And when their sceptical public – in Birmingham and elsewhere – heard the result issuing forth from vinyl in November, they could scarcely believe it. The notoriously undependable live proposition, whose collective self-belief was so very disproportionate to their abilities, had produced something that justified their swagger. If the inarticulate mission of indie-pop has always been to combine the thrill of punk's untutored coarseness with the chimerical romance of 1960s pop, 'Pristine Christine' was as perfectly imperfect a manifestation as any band had delivered. Its sound wasn't without precedent – many compared it favourably to Primal Scream's 'It Happens' and 'Velocity Girl', two of the genre's benchmarks. But few had done it so well, and not even Primal Scream appeared likely to duplicate the frayed magic of their early recordings again. The authentically pubescent whine of James Roberts singing 'Come to my world' seemed an impossible

invitation to resist. (One of the two B-sides, a lysergic, heavy-lidded summer daydream called 'Everglades', is even better.)

Belatedly, at the beginning of January, the record was given its public due. Bob Stanley, a writer recently promoted from the fanzine world into the pages of the *NME*, made it Single of the Week. 'I'd previously written this lot off as third division copyists,' he wrote, while several dozen readers nodded in empathy, 'but this is musical menthol. … Fresh air and bracing breezes, only The Razorcuts and My Bloody Valentine can drift this gracefully. A softcore acoustic delicacy, purchase at once.'

Thanks to the review, coupled with airplay from John Peel and Janice Long, everyone duly did. Within weeks, it seemed impossible to find. A customer

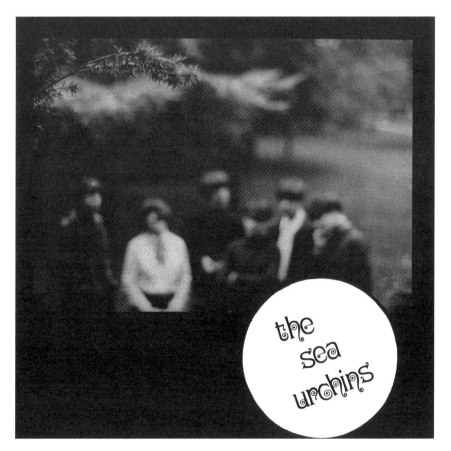

Figure 4.2 *The sleeve of 'Pristine Christine', Sarah's first release. (Courtesy of Sarah Records)*

at a London record shop thrilled one of the staff when he asked for a copy. Standing behind the counter was none other than Robert Cooksey, who had recently moved to London with his girlfriend of late: Bridget Duffy, self-described 'tambourine woman'.

'It seemed such a big deal to us,' James Roberts says of the reception for 'Pristine Christine'. 'But obviously it was all still on a pretty low-key basis. We were still just this little band from the Midlands on a tiny indie label, so it was hardly life-changing in terms of profile. We were able to get gigs at little indie clubs around the country rather than just locally. It did open things up, but only in the constraints of what was a pretty small scene.'

Cooksey, however, remembers that the Urchins' already outsized egos needed no further encouragement to swell to even more unwieldy proportions – although their notions of mischief weren't about to rival those of their heroes from rock's Babylonian heyday. 'An arrogance quickly started to develop within the band,' he says. 'We were quite young, after all, and now we were very minor pop stars. It was a shock to be asked for autographs and constantly told how great we were. Behaving outrageously seemed to be justified in some of the members' eyes.'

'When we supported Talulah Gosh at the ULU in February, Patrick and Darren threw food everywhere in a classroom that was doubling as our dressing room, including onto the blackboard. When somebody from the college entered the room, they asked "Are you animals?" to which everyone replied with animal noises – clucking, barking… . It seemed funny at the time, but looking back now I think we were starting to gain a reputation that wasn't exactly favourable.'

Meanwhile, in their dark, sparsely appointed flat, Wadd and Haynes were coming to grips with the reality that Sarah might have a long-term future. The label's release schedule was expanding into the months ahead, and the beginner's luck of 'Pristine Christine' resulted in letters and demo tapes arriving within the first weeks of 1988. Nevertheless, their lives had immediately assumed an unprecedented frugality; Wadd withdrew judiciously from her student grant to pay for bare necessities while Haynes enrolled in the Enterprise Allowance Scheme, a Conservative government programme that offered enrollees an initial weekly stipend of £40 to fund their own business. 'I think we fudged

it slightly because, technically, Sarah already existed when I applied,' he says. 'But it was a grey area: I could say I'd been doing it as a hobby and now it was doing business.'

The couple became exemplary spendthrifts. 'We would never have a cup of tea in a café,' says Wadd. Haynes recalls 'going down to Sainsbury's every morning when it opened to buy the bread that had been left over from the day before because it was half price. That made a heck of a difference.'

Their caution also extended to Sarah – among the initial rules for the label was that it should never operate in the red – but their inexperience with regard to the finer details of record manufacturing quickly betrayed them. 'We wanted to put the records in plastic bags not because of some indie ethic, but because they were so much cheaper,' explains Wadd. 'But what we hadn't bothered to research was how we printed the labels on the first ten records.' She and Haynes had agreed it would look good if one label was black and white, while the reverse side's would be two colours. Unbeknownst to them, this required exorbitant surplus charges for extra printing plates. Thus, the labels, in Haynes's estimation, 'were more expensive than the pressing of the records *and* the recording'.

'If we'd just talked to Martin Whitehead at Subway for ten minutes', Wadd rues, 'I'm sure he would've told us. But it was almost as if learning from others would take the thrill of discovery out of it.'

As had been the case for 'Pristine Christine', the Sea Urchins were allotted a budget of £300 to record their second single. Their debut had been credited to a producer named Shel Gomelsky, a fictional amalgam of sixties' hit-makers Shel Talmy (of Who and Kinks fame) and Giorgio Gomelsky (the Yardbirds) – in reality, the session had been overseen by Hugh Harkin. No such fabrications would be required for the follow-up: recent Birmingham transplant Joe Foster had agreed to the job. One of the co-founders of Creation Records, Foster was also the label's de facto in-house producer – scores of the Urchins' favourite Creation releases, from Primal Scream to The Jesus and Mary Chain, bore his name. He had also been a member of Television Personalities, for whom his skewed pop-art instincts had been the guiding force behind the unhinged sound of their psychedelic masterpiece, *The Painted Word*. Foster was a great enthusiast – his vast record library had been instrumental in shaping the tastes

of Alan McGee – although his opinions were notoriously indelicate. 'He was very sweet, but he said I was playing the organ like Frankenstein,' says Duffy. 'I imagine he meant the monster, not the scientist. A comment I shall never forget.'

What Foster captured that April day was a band seeking to, if not exactly 'rock out', at least prove it was within its realm of capability to do so. 'Solace' fades up from a squall of feedback and then careers breathlessly towards its finish, while an attention-seeking guitar solo evokes the moment when Mod began sliding inexorably towards psychedelia. It was fitting that the photo chosen to decorate the sleeve features a motorcycle. In giving the Urchins another Single of the Week honour, though, Bob Stanley ignored 'Solace' entirely, saving all his praise for the flip, 'Please Rain Fall'. He had a point: exquisitely sad and, given the age of its author, astonishingly nuanced in its introspection, it established that James Roberts's greatest forte was ballads. But like 'Everglades', the song reveals that the foremost object of his affection isn't another person but the beauty and awe-inspiring vastness of nature: 'Like no wind across a sea/But all things stirring underneath/And sending ripples right into my head/And all around me' – rare was the eighteen-year-old writing such things so affectingly. 'It still doesn't explain why they're excruciating live, though,' Stanley hastened to add.

The months that followed were eventful, although not always for the right reasons. A short summer tour of Scotland was spent in the hospitable presence of the Orchids, a Glaswegian group who were the second to join the Sarah fold. Their hosts' company aside, though, it was a series of misfortunes. The car carrying Cooksey, the Roberts brothers and a mutual friend across the border was involved in a minor collision; everyone escaped unharmed but they arrived hours late. Then Cooksey's prized Baldwin Vibraslim guitar, which he had made a point of cradling in some recent photographs, was stolen from outside the venue. As well, each of the tour dates lacked the vital contributions of Bridget Duffy: she and Cooksey had broken up, and so, as per the unwritten rules of teenage relationships, they had to disappear from each other's lives immediately. 'I was getting ready to do the Scottish tour and it became evident that Robert had given me the wrong dates,' she says. 'It was the final indignity;

at that point I had to step back and realise that my Taylor would have to do a Burton. Never go out with the guitarist.'

Then there were the sort of random encounters and star-crossed overtures that often happen to indie bands perceived to be at the cusp of a breakthrough. 'At some point during the year we had serious interest from Silvertone Records,' says Cooksey. 'It was a new offshoot of Jive Records, a major mainstream label that was known for Samantha Fox, which was enough to put us right off even though they were very keen. Major labels were treated with great suspicion then.' In terms of promising young guitar bands, then, Silvertone would have to make do with its other recent signing, the Stone Roses. Almost simultaneously, the Damned's Captain Sensible appeared at a gig in Brighton and 'was very enthusiastic about signing us to his Deltic label and arranging light shows for us'. It amounted to as little as Alan McGee's alleged interest in signing the Urchins to Creation. 'Darren related a story to us of how he got talking to Lawrence from Felt in a Birmingham club. Apparently, Bobby Gillespie protested, saying Primal Scream would leave Creation if Alan signed us. I do remember Alan's sister coming to see us in Birmingham in 1987, and Bobby saw us at least three times in Birmingham, London and Brighton, so there was obviously interest.'

Not even the rumour that the Urchins were joining Joe Foster's burgeoning Kaleidoscope Sound label panned out (although Sarah reported it as a certainty in one of their occasional fanzines). For the time being, the only other label with which the band would affiliate itself was Fierce, a one-man concern in Swansea, Wales, which had the dubious distinction of specializing in limited-edition novelty records targeted to the indie cognoscenti. (Its most notorious early release was *Riot*, an audio document of the audience brawl that took place after a 1985 Jesus and Mary Chain concert. The elaborate packaging included a syringe and a chocolate bar.) Cooksey, Woodcock and James Roberts recorded a magnificent folk-pop lullaby in owner Steve Gregory's house, and Fierce released it early in 1989 as a one-track, one-sided seven-inch. The song has never been given a title.

The year 1989 began with a high and a low taking place within minutes of each other. The Sea Urchins played their first live set of the year at Aberystwyth

University, their friend from Fierce looking on as they turned in one of their best and most well-received performances. Afterwards, Darren Martin, whose drinking was yielding ever more disruptive behaviour, came to blows with his band-mates. The bassist was fired, Woodcock took over the vacancy and the Urchins were suddenly a quartet, a third of their membership gone in roughly half a year.

Primal Scream, whose cupid's arrow coupling of sunburst melodies and post-punk brashness had become one of the most beloved sounds in UK independent music, were becoming the subject of horrified whispers among their following. Having parted ways with Rickenbacker-wielding Jim Beattie in 1988, the guitarist evidently took with him all of the band's aural and visual trademarks. In his wake, the rest of the group grew their hair out, developed a serious fondness for distortion pedals, and within what seemed like weeks had transformed themselves into something between MC5 and a garden-variety boogie band. To an audience whose ideological framework was in direct opposition to such clichéd rock behaviour, this was scandalous.

Without having crossed paths or being informed of each other's activities, the Sea Urchins somehow began moving in a similar direction, although it was the likes of the Stones and Hendrix, rather than the Stooges and the New York Dolls, that was guiding them. Whatever the case, it was received with more or less equal enthusiasm to Primal Scream's new sound and look. 'In some ways I do think it was our reaction against the perceived Sarah sound,' acknowledges Cooksey. 'We lost our jangle and certainly became heavier live – by late-'80s indie standards, anyway. After a show in London, someone scrawled "Black Sabbath" over our name on the poster outside, which I thought was a bit over the top.'

Wadd and Haynes responded with similar bemusement when, more than a year after the release of 'Solace', the Urchins handed over the three songs that were to make up their third single. 'Day Into Day', which the band proposed for the A-side, had been inspired by the Beatles' 'Paperback Writer'. In truth not much more rambunctious musically than 'Solace', it finds James Roberts stridently exhorting, 'Oh, brother, don't tell lies to me/Oh, sister, remember what we mean', while Cooksey slashes out Townshend-esque power chords. As

it reaches its conclusion, Roberts, overcome with the frustrated inarticulacy that has gripped so many singers throughout rock history, can only scream 'Yeah! Yeah! Yeah!' to the point of hoarseness.

Wadd was tasked with the diplomatic task of telling the band that she and Haynes didn't want to release it. The conversation served to underline what had always been a challenging relationship for the label. 'I remember spending an hour on the phone to the Sea Urchins once explaining why we didn't like one of their records,' she recalled in a 2002 interview with the website Pennyblackmusic. 'They were really fantastic at winding us up. They were trying to get me to put my finger on why I didn't like it. … Finally, after an hour they got it out of me. They really made us fight for everything.'

The couple did, however, approve of the two other songs the Urchins recorded, both of which confirmed the band hadn't entirely strayed from the plaintive jangle of past glories. In fact, 'A Morning Odyssey' dated back to 1983, and had been mentioned in Neil Taylor's *NME* feature by its previous title, 'Show Your Colours'. Featuring a piano-playing Simon Woodcock, a mood of autumnal contentment, and a rambling, ravished coda, it remains perhaps their most moving song. 'Wild Grass Pictures' is Roberts alone with an acoustic guitar, reaching for falsetto while he again contemplates the mysteries of the universe. If Wadd and Haynes's personal rejection of 'Day Into Day' had instead been an impartial A&R decision, they could be commended for their professional instincts. Left to stand alone, the other two songs make for a superb 45.

But the fact that the single wouldn't be released for almost another year, in the summer of 1990, made plain that relations between the Sea Urchins and Sarah had broken down. Once the label's most obvious contenders, they had been conspicuous in their absence from the label's release schedule for the better part of two years, and sly barbs about them would occasionally find their way into Sarah literature ('The Sea Urchins used to write to "Clare & Matt" – that's about the only fond memory I have of them,' Wadd wrote in a 1989 fanzine). 'Maybe they thought we were turning into the kind of band that was the antithesis of what Sarah was about, and they weren't prepared to be a platform for that kind of stuff,' says James Roberts. 'We probably *did* turn into that band, too.'

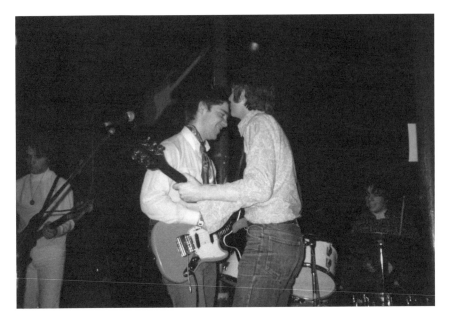

Figure 4.3 *The Sea Urchins onstage at the Fleece in Bristol, April 1990. (Photo: Wendy Stone)*

Cooksey speculates that the Urchins also grew frustrated over Sarah's refusal to fund or release albums – something the band were desperate to do. He also cites a Bristol gig in April 1990:

> I don't think they were at the show, but they probably got to hear about it. The four of us drank far too much and it was mostly pretty appalling musically. Patrick and Simon both got into scuffles with audience members, and Simon actually got thrown out of the venue at one point during the performance. It's a shameful episode and, considering the reasons for Darren's dismissal a year before, disrespectful to all concerned. I think it may have happened because Matt and Clare failed to show up, which would definitely have put our noses out of joint.

So, when their longtime friend Vinita Joshi offered to usher them over to her new label, Cheree, where they could do as they pleased, they were only too happy to defect. Subsequently, the Sea Urchins only featured in Sarah's discography one more time: *Stardust*, a compilation of the flexis and singles,

and the rejected 'Day Into Day'. When it was released, in the middle of 1992, the Sea Urchins had long since broken up, having only done one single for Cheree. But they were plotting their return as Delta – a name taken from a David Crosby song. Musically, and in their developing wardrobe of baseball boots, American T-shirts and fur-collared jackets, they had begun moving into the 1970s.

5

'A Constant Source of Bemusement and Wonder': The Orchids

The disintegration of Glasgow's Postcard Records was as unceremonious and anticlimactic as its rise had been momentous and effervescent. The endurance of its legend – and the extremity of affection it commands to this day – tends to obscure the fact that the label didn't live to celebrate its second birthday. Postcard's discography spans a mere seventeen months: Its debut, Orange Juice's 'Falling and Laughing', was released in April 1980; the swan song, Aztec Camera's 'Mattress of Wire', in August 1981.

Founder Alan Horne's mission to revitalize, subvert and transform pop music with his notion of 'The Sound of Young Scotland' ultimately consisted of only eleven singles, plus a lone album, Josef K's *The Only Fun in Town*. The singles were, almost without exception, lavishly praised, but at least one prominent critic and Postcard champion, Paul Morley, deemed Josef K's long-player a profound disappointment. 'I am appalled,' he wrote in his *NME* review, bemoaning the record's sparse, brittle sound and oddly disengaged performances, which he perceived as a cowardly retreat from the greater success the band surely could achieve if it wanted it. 'Josef K have cheapened themselves and cheated the world.' Sales of the album, for which Horne held a great deal of nervous hope, were healthy despite the assessments of Morley and his peers. But this actually proved to be a problem. Frontman Paul Haig, fearful

of the obligations success would soon bring (included a mooted American tour), announced to his bandmates that he was quitting. While their album was still in the upper reaches of the indie charts, Josef K had ceased to exist.

It was the final straw for Horne. He could see that he would soon lose Orange Juice – his flagship band, and the only Postcard act for which he harboured unreserved affection – to a major label, and his admitted lack of interest in bookkeeping meant Postcard's finances were in disarray. There was no formal announcement to the press, no public speculation from Horne as to what he would do next. Postcard merely stopped, and Horne disappeared from view.

The next few years visited both fortune and folly upon Postcard's central characters. In late 1983, Horne was coaxed out from hiding and brought onboard at the major label London Records, where he was given his own in-house imprint, Swamplands and virtual free rein in terms of both A&R direction and budgets. He effectively treated it as an experiment to find out how much money and how few work hours he could invest in the enterprise before London cried foul. In the end, he was shown the door after bringing fewer than ten flop singles to market in two years. Pocketing a parting gift of £25,000 for his troubles, he then vanished once more.

After signing to Polydor and releasing a marvellous but commercially underperforming debut album, *You Can't Hide Your Love Forever*, Orange Juice radically reconfigured their line-up and sound. When their second album, *Rip it Up*, appeared in November 1982, its cover photo revealed that only Edwyn Collins and bassist David McClymont remained from the previous year. Within its grooves, the charming ineptitude that had been the band's trademark was replaced with a sound that – Collins's perpetually wobbling vocals aside – was modern, groove oriented and thoroughly professional. Postcard purists were aghast, but the title track netted Orange Juice a top-ten hit, a *Top of the Pops* appearance, and entrée to the pages of *Smash Hits*. It was a cruelly short-lived golden age, however. Despite continuing to make great records, none of their subsequent singles breached even the top 40. Latterly reduced to a duo of Collins and drummer Zeke Manyika, Orange Juice broke up in January 1985 after playing a miners' strike benefit alongside Aztec Camera, whose own post-Postcard career had taken them first to Rough Trade, then to WEA, where they too made a bid for mainstream fame.

To this day, the importance of Postcard to the evolution of Scottish pop can't be overstated. Not only has its singular aesthetic influenced decades of musicians within and beyond the country's borders; more significantly, it forever changed Scottish artists' estimation of their own global potential. Its galvanizing effect in the early 1980s was immediate: within months of Postcard's launch, new Glasgow bands who were in thrall to the label attracted the attention of major London-based record companies (whose A&R men had begun flying north to look for hot prospects). In the short term, Altered Images and the Bluebells were the highest-profile beneficiaries, signing to CBS and London Records, respectively, and scoring significant mainstream hits. (Altered Images' 'Happy Birthday' rose to the giddy heights of number two on the UK singles chart in October 1981.)

Duglas T. Stewart was barely out of his teens when he co-founded BMX Bandits in 1985. Initially savaged in the press for their Orange Juice-*in-extremis* manner – seemingly magnifying Edwyn Collins's faux-naif tenderness to the extent that their songs resembled children's music – the Bandits eventually became one of Scotland's longest-running musical institutions, its revolving-door membership serving as incubator and launching pad for Norman Blake (Teenage Fanclub), Eugene Kelly (the Vaselines) and many others. Stewart remembers that Postcard's influence was still pervasive throughout Glasgow four years after its closure. 'It was very important to my generation of music-makers,' he says. 'Those records were what Norman and I bonded over, and from that we started to make music together. It wasn't that long after punk rock, but it didn't have the "destroy" attitude that punk had, and it embraced wider influences. It felt much more positive than what had gone before. [Orange Juice] seemed multi-dimensional and not too alien to our world. They encouraged us to think that perhaps we could do it, too.'

Meanwhile, five teenage school friends had begun meeting up in Penilee, a suburb in the city's southwest, to try to transform themselves into a band, despite neither being able to play very well nor having any idea how to make their disparate influences cohere. All of them were in agreement about Postcard, as well as the later bands whose debt to the label was apparent (Lloyd Cole and the Commotions, the Pastels, Friends Again), but each of them brought a raft of seemingly incompatible enthusiasms to the table. Their bassist was a

come-lately punk, trying to live out the 1977 flashpoint he had been too young to experience first-hand; one of the guitarists idolized the effulgent fretwork of Charlie Burchill from world-conquering hometown heroes Simple Minds; their parents' record collections begat whispered affection for the likes of the Carpenters and Bread.

They did have one advantage that few bands of their age and inexperience could claim: a space in which to make noise to their hearts' content, free of charge and without the interference of annoyed elders. Their guitarist, John Scally, had lived with his grandmother, who died when he was sixteen; she left her council house to him and, inevitably, it almost immediately became a rehearsal space and party headquarters. At the same time, the older brother of drummer Chris Quinn gifted him a drum kit and some amplifiers from his own band. 'That was our formative years,' recalls Scally. 'Spent in the back bedroom, Saturdays and Sundays, seven hours at a time, just thrashing at tunes.' Initially, the nameless collective included two neighbourhood girls who played keyboards and saxophone. Soon deemed unsuitable, they were dismissed, leaving Scally and Quinn in the company of rhythm guitarist Matthew Drummond, singer James Hackett and bassist James Moody.

Keen readers of fanzines and the British weeklies, the newly solidified quintet – who, in tribute to an Aztec Camera song, had decided to call themselves the Boy Wonders – were aware of other Postcard-indebted bands who regularly played at venues in the city centre: the Pastels and BMX Bandits, of course, plus the increasingly notorious Jesus and Mary Chain, as well as visitors from south of the border such as the June Brides and the Bodines. Their ages usually prevented them from gaining entry to the pubs and clubs where most of the gigs took place, but occasionally a doorman would take pity on them. Allowed inside to watch a triple bill of the Mary Chain, Primal Scream and Biff Bang Pow!, they were instructed to remain in a dark corner of the room and not order alcohol. (They got drunk anyway.) Watching these groups – who had achieved the remarkable feat of releasing a record or two, and then attracted literally *dozens* of people to watch them play – the fledgling quintet noted that none of the people onstage appeared to be much older than themselves, nor were they much more skilled with their instruments. Hackett considered that it might not be a problem that his bandmates couldn't play

guitar remotely as well as Roddy Frame, the fleet-fingered teenage prodigy who fronted Aztec Camera. 'They weren't that proficient either, but they'd been playing a lot longer than we were,' Hackett says of the other groups. 'They kept it simple: a three-chord structure and a melody overtop. It doesn't take rocket science to do that, so we thought, "We'll have a go."'

Among the Glasgow bands they admired, Primal Scream seemed to have acquired the status of figureheads within the microcosm of the UK indie underground. Frontman Bobby Gillespie's former membership in the Mary Chain certainly was a contributing factor, as was his textbook-perfect bowl haircut and virginal babyface, but Primal Scream were more revered for having formulated a sound that, perhaps more than that of any other group at the time, epitomized the indie-pop ideal of the Eternal Teenage Summer (the summer in question having taken place in 1966). To the collective awe of the kids in Penilee, Primal Scream's own rehearsal space, in the home of then-drummer Tam McGurk, was just a few doors down from Scally's. They would sometimes catch sight of Gillespie – resplendent in his the-world-is-my-stage wardrobe of leather trousers, winkle-pickers and striped tee – walking to and from the house. Thanks to the fact that McGurk also happened to be Scally's cousin, the latter was able to get ahold of the former's rehearsal tapes, on which he could hear Primal Scream songs that hadn't been released. Among them was 'Gentle Tuesday', which Scally and his friends agreed was great. They also agreed that its title would serve as a much better name for their own fledgling group. And so it became such – at least until the duly christened Gentle Tuesday buttonholed Alan McGee at another Biff Bang Pow! gig, in March 1987, and thrust a recently completed demo into his hands. He looked at it and informed the young pups gathered expectantly around him that 'Gentle Tuesday' was scheduled to be Primal Scream's next single – their first for a new, McGee-curated boutique label funded and distributed by WEA. In short, it was to be the band's inaugural bid for the big time.

McGee departed with the tape, and although the would-be Gentle Tuesday never heard from him again, they felt sufficiently buoyed that the demo had impressed a few local promoters enough to give the band – now rechristened the Bridge – some warm-up slots. One of those promoters was Karen McDougall, who booked a club night called Texas Fever (named,

naturally, after an Orange Juice EP). In April, she invited the Bridge to open for McCarthy, a London-based quartet who were noteworthy for combining pretty twelve-string melodies with lyrics that obliquely espoused a Marxist worldview. Partly because it was a Sunday night, both bands played to an almost empty room, but McDougall was charmed enough to pass the Bridge's demo along to two fanzine publishers she knew – Jim Kavanagh of *Simply Thrilled* and Matt Haynes of *Are You Scared to Get Happy?* – accompanied with a note pointing out that the band whose music they were about to listen to had changed their name (yet again) to the Orchids. Fortuitously, both Kavanagh and Haynes had been looking for new bands to bring to Sha-la-la. A track from the Orchids' demo, 'From This Day', was selected to share the fifth Sha-la-la flexi with 'Summershine' by the equally rookie Sea Urchins.

But there was a problem. Although the Orchids had committed to their new name for long enough to use it when they designed their half of the flexi's foldover sleeve, they quickly regretted it and decided they would rather be known as the Splendour. An urgent phone call was placed to Williams, who was overseeing the printing. He replied that it was too late; the finished sleeves were already in his possession. The band suspected he was lying, but no matter – they would have to be the Orchids now. It proved to be an appropriate name in the short term, at least: 'From This Day', despite an anxious rhythm section that seemed to be compensating for the energy the rest of the song's components lacked (and which ensured the song was finished in two minutes flat), was clearly the work of sensitive boys in search of sweethearts to whom they could shyly offer flowers. It also exemplified the Sha-la-la mission of 'throwaway pop' that should be forgotten in as much time as it takes to be heard. Having been paired with the Sea Urchins' 'Summershine' – a thrilling rush of low-budget Byrds that Primal Scream would have considered the jewel in their crown, had they written it – it sounded all the more mild.

The Orchids' ambitions were modest enough that the Sha-la-la flexi seemed a tremendous victory, so they were overwhelmed when Haynes got in touch a few months later to say he had co-founded a proper label and wanted to put the band onto actual vinyl. Admitting upfront to being short of cash (it had mostly been spent on the Sea Urchins' forthcoming debut single, and

some was being kept in reserve for another signing), he proposed using two further songs from the demo, 'Apologies' and 'I've Got a Habit'. 'I know these are "old" songs,' Haynes wrote in a letter to drummer Quinn, 'but they really are <u>SUPERB</u> – would you let us release them, and are you happy with the recordings as they stand?'

As it happened, they weren't, although they let 'Apologies', of which they were thoroughly tired, go out into the world as it was. A newer, faster attempt at 'I've Got a Habit' as well as a newer song, the inscrutably but wonderfully titled 'Give Me Some Peppermint Freedom', was laid to tape at a studio in nearby Paisley. The total cost to the Orchids for both sessions was £120. Wadd and Haynes wanted the three-song EP's lead track to be 'Apologies', a sprightly love song whose chorus unintentionally called out to the band's previous benefactor: 'All the time we never seemed to realize how happy we can be/Sha-la-la… '. The band argued for – and were victorious in – giving 'I've Got a Habit' top billing. It was a curious decision: ramshackle and nervous where 'Apologies' and 'Peppermint Freedom' are confident enough to unfold in their

St. Michaels Hill
Bristol
Photograph by Huntley Hedworth. Code P7

Figure 5.1 *Wadd and Haynes's succinct critique of 'I've Got a Habit', the Orchids' debut single and Sarah's second release. (Courtesy of Chris Quinn)*

own time, it remains the only tune of the three that sounds like a product of the same dilettantes who made 'From This Day'. It does, however, hold the distinction of being home to what may be the band's most quoted lyric: 'I'm drinking Irn-Bru and I'm thinking of you.' It was as explicit a statement of national pride as the Orchids would make in song.

Although the record betrayed the band's greenness, it didn't betray any of the obvious influences so prevalent at the time among the legion of groups that had formed in response to Postcard's soft revolution. Fragile but not gauche, romantic but not milquetoast, the Orchids' nascent sound seemed simply to be the result of a collective who aspired to a sophisticated idea of pop that, as yet, they could articulate neither technically nor theoretically. 'We started recording before we were actually proficient enough to be doing so, because we were so eager,' explains James Hackett. 'That inexperience, that naiveté, brought out the sound that was the initial Orchids.'

Released with the catalogue number Sarah 2 in February 1988, 'I've Got a Habit' won the approval of John Peel, who played it twice. It wasn't unrealistic of the Orchids to expect this (Peel had played the Sea Urchins' single several times), but they were entirely unprepared when a snatch of their song was featured on the nationally broadcast TV programme *The Chart Show* during a rundown of that week's indie top ten (it placed at number eight). Later that evening, Hackett poured a full drink over the head of a schoolmate who approached the band and sarcastically inquired, 'What's it like to be a pop star, then?'

Having been assured by Sarah that they could soon record another EP, that same month the Orchids left the environs of their hometown and travelled by rail to London for their British live debut. Some of the band had never been to the capital before. 'It was kind of big for us,' recalls Quinn, 'because we'd started in my bedroom, not being able to play, and all of a sudden we've got a record out and playing in London. What's happening here?' At the Portlands club, where they opened for neo-psychedelic group the Hangman's Beautiful Daughter, the Orchids met Wadd and Haynes for the first time, all prior communication having been done by post. Bob Stanley, already established as Sarah's foremost champion at the music weeklies, wrote glowingly in the *NME* about the '*very* nervous' fivesome, describing them as 'a logical extension to

the pure pop sounds of The Turtles, The Association and pre-bloat-out Primal Scream'. About a new song, which he referred to as 'Underneath the Kitchen Sink', Stanley wrote, 'If this ever becomes a record it will make you cry.'

Coming home afterwards, the boys' sense of arrival was compounded when they spotted fellow Glaswegians the Soup Dragons – whose singles had become regular fixtures of the indie chart – on the train. Suddenly, the world that the more successful band inhabited – whatever it might have consisted of – didn't feel so unattainable.

When the time came to make their next record, the Orchids decided to take a chance with a two-year-old Glasgow studio whose whimsical name, Toad Hall, belied its actual premises: a small, bare-bones room above a video-rental shop. It was owned by one Ian Carmichael, an experienced producer and engineer whose past clients included the commercially driven local bands Del Amitri and Texas, both of which were on their way to mainstream fame. When the Orchids arrived for their session, which required completing four songs over a weekend, Carmichael was introduced to a dichotomy that would baffle virtually everyone who made their acquaintance: five lads who seemingly took neither themselves nor the act of music-making seriously, yet who would consistently create songs of uncommon delicacy and melodiousness.

'I didn't know what to think of them,' says Carmichael. 'Most bands planned and micromanaged everything in the studio with a critical eye, and had been saving for months to be able to afford the session. The Orchids were completely nonchalant. Whereas other bands supported and encouraged each member through the recordings, the Orchids were positively denigrating toward each other. But by the end of the weekend, I knew they had something special. I couldn't believe that such a disorganized, disorderly bunch could produce something so beautiful. I was instantly hooked.'

The results of their session with Carmichael, released in November, shared its title with the song that had so seduced Bob Stanley's ears: *Underneath the Window, Underneath the Sink*. The four-song EP maintained two patterns: it was a significant leap forward from its predecessor, and it came wrapped in a sleeve that confirmed the band needed to consider passing along the responsibility of artwork to a capable designer. Its first track, 'Defy the Law', characterized what would become Sarah's customarily unobtrusive manner of expressing political

dissent. Speeding past in less than two minutes, carried upon a drift of major chords emanating from a rinky-dink keyboard, it could easily be mistaken for a tale of spurned love ('Why do you want to take away from me?' Hackett sings in a tone that suggests fear of an answer). In fact, it was written in protest against the Poll Tax, also known as the Community Charge – a diabolical flat-rate tax conceived by the Thatcher government that placed particular burden upon the poor. Perhaps recognizing that their message was lost amidst the song's merry melody, the band instructed to have the words FUCK THE POLL TAX engraved in the record's run-out groove, and they packaged it with a poster collage that reads 'The Orchids say don't pay the poll tax.' The tax eventually led to riots in London, became a key reason for the Iron Lady's subsequent resignation, and was scrapped. How much of a role 'Defy the Law' played in this chain of events remains unclear. The song's topicality generated the most attention in the short term, but those who listened closer to the EP found more to talk about in 'Tiny Words', a seductively languorous love song so enthralled with itself that it seems reluctant to end, its fade-out lasting more than a minute.

Although their work diary for 1989 would have been considered moderate to most bands, it was a relative whirlwind for the Orchids, whose professed lack of worldliness and aversion to long-term planning meant every minor development felt like a gift from above. Early in the year, they convinced Wadd and Haynes to loosen Sarah's singles-only policy and allow them to make something longer. A combination of limited money and the couple's resolutely perverse business acumen meant a full-length album was out of the question. Instead, the parties met halfway: the Orchids' first 'long-player' would be an eight-song mini-album released exclusively on ten-inch vinyl, an uncommon format that an annoyed Revolver Distribution pointed out had a tendency to get lost in the album racks amidst full-sized LPs. Alas, as with Sarah's plastic-bagged sleeves and oblique press releases, Wadd and Haynes wouldn't be swayed from their aesthetic principles.

To everyone's delight, the resultant artefact, *Lyceum*, was a watershed for the band and the label, bringing Sarah into the top ten of the Indie Albums chart for the first time and drawing an eight-out-of-ten rating from the *NME*. (The

ever-reliable Bob Stanley, having defected to *Melody Maker*, called it 'a minor classic'.) The Orchids' musical and lyrical vocabulary seemed to have acquired at least two years of growth in the ten months since *Underneath the Window* – presumably their hard-earned reward for constant gigging, and writing and rehearsal sessions fraught with intense self-analysis. Actually, remembers Ian Carmichael, to whom they had returned for *Lyceum*'s customarily clock-racing sessions, whatever new-found maturity the Orchids' new music suggested extended no further than the songs themselves.

> They certainly rehearsed and arranged the tracks prior to recording, but I remember during *Lyceum* remarks like, "Is that what you're playing? It's shite," on more than one occasion. There was no sense of gravitas in any Orchids proceedings; they cajoled each other throughout. I always thought that the end product with them was somehow always accidental more than considered. They were a constant source of bemusement and wonder.

It was a remarkable deception. *Lyceum*'s opening track, 'It's Only Obvious' – a first-morning-of-summer declaration of intent to some elusive object of affection – announces the self-assurance of a band that has defined its corner. Hackett's high, tremulous voice remains an evocation of adolescent bashfulness throughout the record, but it perfectly complements the songs' general preoccupation with love pursued, denied and lost. Other than the conspicuously rollicking 'Caveman', *Lyceum* is staunchly committed to a mood of exquisite heartbreak. Carmichael would often suggest the Orchids were more interested in beer than music, but they couldn't conceal the poetic souls obscured by their pubescent alcoholic bluster.

The success of *Lyceum*, and the establishment of Sarah as (somewhat reluctant) figurehead of the post-*C86* cult, meant the Orchids were thrust into a scene with which they had no history and little understanding. Although the group's admiration for indie-pop was genuine, they had no interest in trying on for size the accoutrements that had become the genre's unofficial uniform. In short, there wasn't an anorak, bowl haircut or pair of Chelsea boots among them. Theirs was a non-image of unselfconscious ordinariness – which more of their audience would have known about if any of the record sleeves had featured a photo, or if the low-budget video for 'What Will We Do Next?'

(released as a single the same day as *Lyceum*) had received more than a single airing in the middle of the night. 'There were several cases where we'd show up [to gigs] and I'd see the disappointment on people's faces', says Hackett, chuckling. Among them, future music critic Alexis Petridis, then a teenage Sarah fan, recalls being taken aback the first time he saw the Orchids live: 'They looked like just a random bunch of people waiting for a bus.'

As well, the Orchids' association with Sarah led journalists to make predictable assumptions not only about their music but their character. 'That we would look twee, talk twee… ' says Hackett. 'But I didn't even know what that word *meant* at the time. And the word "fey" was used a lot, and I had to go and look that up in the dictionary. We were just five boys who liked to make a bit of noise and we'd go out and have a beer. That was a big eye-opener for us.'

Similarly, the eyes of their labelmates were opened wide whenever they found themselves in the company of the indecorous Glaswegians, whose authentically hardscrabble upbringings had bred in them a fondness for mischief and hard partying that few others in Sarah's orbit shared. In the first weeks of 1990, the Orchids travelled to Paris with the Field Mice, St. Christopher, Another Sunny Day, and Wadd and Haynes. The reason for the journey was unprecedentedly prestigious: a wealthy French advertising executive with no knowledge of music promotion had taken it upon himself to organize a Sarah festival, going so far as to publicize it with a full-page advert in the legendary film magazine *Les Cahiers du Cinema*. Out of their element in the homeland of their host (who passed around charcuterie and bottles of expensive wine in his sprawling flat) and grateful for his generosity, everyone went out of their way to be considerate guests. Except the Orchids, who spent the early morning hours after the gig drunkenly celebrating in their hotel room. When the door lock broke, trapping them inside, they kicked open and broke it. Wadd was roused from sleep at 4.00 am to make peace with management, and later she and Haynes had to help a chambermaid clean up the mess to prevent her from throwing the band's possessions out the window. (Returning to the City of Light the following year, they once again stoked the wrath of their label, running up exorbitant long-distance charges from their room and then slipping away before check-out.)

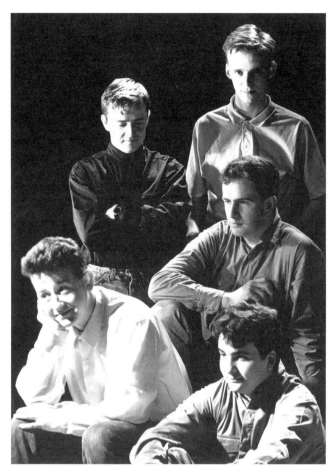

Figure 5.2 *The Orchids pause for a photo session at Toad Hall, the Glasgow studio where they recorded all of their Sarah releases, in 1990. Clockwise from top left: John Scally, Chris Quinn, Matthew Drummond, James Hackett, James Moody. (Photo: Ali Wells)*

The last new song heard from the Orchids in 1989 was 'Yawn', the nominal B-side of 'What Will We Do Next?', but a track that many who heard the single thought was deserving of greater attention. A barely coherent soundscape that evokes the lethargic mind-state of its title, it was spontaneously created in a moment of desperation when the band made it known to Carmichael that they hadn't written a third track to fulfil Sarah's requirement for an EP. Throughout its seven and a half minutes, a programmed rhythm track takes

the place of Quinn (who had surrendered to a hangover) while ambient guitar squalls and Hackett's half-conscious voice weave around a bassline not unlike Public Image Limited's 'Poptones' at half speed. The band expected their label to reject it; on the contrary, Wadd and Haynes pressed one side of the record at 33 rpm to accommodate its exceptional length. Although the Orchids never released another song quite like it, it was an indication of the uncharted territory they would begin exploring in earnest in the new decade. In February 1990, another single, 'Something for the Longing', confirmed the band's nascent experimental bent. A gorgeous, classically constructed ballad whose military verses burst into a widescreen chorus that may be the most explicitly tender moment in their discography ('We could walk for hours and hours…'), the song is bookended with a recording of an electronic pulse, like ascending helicopter blades, that Scally brought in to the session. 'They were starting to think ahead,' says Carmichael.

There would be no other music from the Orchids that year – at least not on Sarah. Bob Stanley had recently launched the Caff Corporation, a small-scale label very much in the Sarah mould, whose highly collectable releases (each was limited to 500 copies) mostly consisted of older cast-off recordings from bands who were contracted elsewhere. The Orchids gave him two otherwise unwanted songs whose sessions dated back more than three years. Stanley had learnt much about the industry during his short tenure at the music weeklies, and was more sociable and outwardly ambitious than the introverted iconoclasts in Bristol. He suggested that the Orchids might like to make a permanent home at another label he was developing, for which he had grand plans. And for some time they seriously considered it. Surely a London label run by a well-connected journalist would better advance their careers. And maybe then they could finally escape the pigeonhole of twee that so dogged them. (Never mind that Stanley's retired fanzine, also called Caff, and a high percentage of his music preferences revealed him to be no small *C86* acolyte himself.)

In the meantime, the band continued to cultivate their creative relationship with Carmichael, who believed in them enough to start donating free studio time in exchange for an ongoing producer credit. Together they spent a good part of 1990 honing the tracks that would become *Unholy Soul*, the first bona

fide twelve-inch album to bear both the Orchids' and Sarah's name (apart from compilations). Released in May 1991, it solidified the Orchids as Sarah's most critically feted band. '[It] is – I kid you not – Sarah Records' answer to The Beach Boys' *Pet Sounds*!!' wrote Dave Simpson in *Melody Maker*. (The double exclamations were his own.) Undoubtedly an overstatement, there was nevertheless some truth to his breathless declaration. Never before had a Sarah record exhibited such a spirit of freewheeling experimentation, in which a band whose artistic parameters were previously assumed to be quite limited were clearly revelling in defying expectations – those of their detractors, their supporters, maybe even themselves. Amidst the stylistic curveballs of 'Bringing You the Love' (an old-time country shuffle paired with a percolating drum machine), 'Frank de Salvo' (some strange, half-asleep notion of psychedelic rock) and 'The Sadness of Sex (Pt. 1)' (shoestring dance-pop featuring an incongruous Gregorian chant sample), most surprising of all is 'Peaches'. Boasting a glorious disco/gospel chorus in which vocals are handed over to Carmichael's friend Pauline Hynds (whose exhortation to 'Get yourself high, feed your soul, set yourself free' was very in keeping with the neo-hippie spirit of the lingering house revolution), fans new and old thought the band were foolish to not release it as a single. Its chances of crossover success were virtually nil – Quinn's beat lagged too much for the clubs; Hackett's voice demurred too much for daytime radio – but its place among the Orchids' best-loved songs was immediately assured. It was also a portent of the music Carmichael would soon make with his own project, One Dove, which signed to a major label and breached the top 40 twice in 1993. In time, some would suggest Carmichael used the Orchids' sessions as testing grounds for ideas he would eventually employ himself – especially when a sample of Hynds singing 'high' was peppered throughout the One Dove single 'White Love'. 'I've heard accusations that I changed the Orchids' sound, but I think all I did was enable them to change their sound,' he says. 'I mostly took my lead from their references. The vocal production of "Peaches" was my work, but the idea for the female vocal definitely came from James Hackett. A lot of the changes stemmed from the technology that was becoming available to us; after they discovered my Akai S950 sampler, I was inundated with a plethora of disparate sounds they wanted sampled and incorporated into the tracks.

By this time, One Dove had formed and we were using a sequencer, so that instigated a big change in the Orchids' sound. There was a faction – mostly Matthew and [James] Moody – who wanted a more indie-dance sound.'

The *Penetration* EP, which followed in autumn, is similarly diverse, if not outright schizophrenic, going out of its way to emphasize as much when the charmingly simplistic 'How Does That Feel' (which sounds like it could have dated from the *Underneath the Window* sessions) cross-fades into 'Sigh', a dazed, loping groove in which Hackett seems to be singing into his sleeve.

And then, the Orchids disappeared for the better part of a year, reemerging in early autumn to near-simultaneously offer a compact summation of their past (a compilation, *Epicurean: A Soundtrack*, released as a double album, which only a gatefold sleeve would have rendered more contrary to Sarah's initial punk-rock edicts) and a signpost towards their future (a new single, 'Thaumaturgy'). The latter is simply monumental. Its title means 'the working of wonders or miracles', and although the word isn't mentioned in the lyric, it

Figure 5.3 *The Orchids in their tour van at the Port of Dover, August 1990, waiting for a ferry that would take them to Switzerland. Sitting in the driver seat is Joe McEvoy, the Orchids' singer at their very first rehearsal; realizing he couldn't sing, he quit and eventually became the band's occasional driver and roadie. (Photo: John McGowan)*

speaks for the continual upward trajectory of the band's work. A hot blush of a song, whose currents of synthetic orchestra and stop-start beats conjure the full majesty of first kisses and last goodbyes, it revealed that the Orchids had become masters of epic balladry in the midst of grunge's wholesale dismissal of romance. It seems remarkable now, but *Melody Maker* writer Dave Simpson, in a short feature that coincided with the release of 'Thaumaturgy', felt sufficiently troubled about the musical climate of 1992 to ask if the likes of the Beatles, Brian Wilson and the Supremes still mattered to anyone. He also wrote that the Orchids were the 'finest Scottish pop group since Orange Juice'.

Yet while Simpson apparently found the band in good spirits, the *NME*'s John Mulvey, in a feature published the same week, revealed them as mischievous and combative, and with a list of grievances against their label and its audience. Mulvey had flown to Glasgow to meet the Orchids on their home turf; they, in return, took him to a pub in the down-at-heel district of Govan and drank the afternoon away while his cassette recorder rolled. Among their revelations, it was disclosed that 'Thaumaturgy' had sat unreleased for over a year because Wadd and Haynes rejected it, prompting the band to try – and fail – to find a deal elsewhere. (Bob Stanley's mooted label had come to nothing, presumably because his own group, Saint Etienne, had taken off.) Although they were little more business-savvy than when they began, and weren't about to move to London to seek greater fortune, as their aspirational Glasgow forebears had done (Mulvey observed that 'they don't seem to care too much about what happens to them'), the huddled fivesome expressed stinging resentment towards Sarah for, they felt, continuing to propagate the indie stereotypes that prevented the Orchids from being taken seriously. 'The last year's made us a bit cynical. ... Sarah are trying to be naive and honest about it all. They've got a dream about what music is and it's not real,' said Moody, adding that the crowds at Sarah showcase nights were 'congested with white faces and middle-class kids'. Quinn described them as 'a bit fucking twee – *strange* people'.

If Wadd and Haynes were indignant about this public tongue-lashing, they never made it known – which was big of them, especially considering they had paid for Mulvey's flight. ('It was the only time we ever did that,' says Haynes, 'but I remember we were quite put out at the time, because we just thought, "It's the *NME*. If they want an interview, surely they should be paying

for their journalist to go up there." We didn't know this isn't the way it works. It's the record company that pays.') Nor did the Orchids, once their hangovers subsided, actually seem intent on finding a new label. Instead, almost the whole of 1993 was given over to the piecemeal sessions with Carmichael that produced their next album, *Striving for the Lazy Perfection* (a tongue-in-cheek but stunningly accurate description of their work methods). It might not have taken so long if they hadn't had to pause in the middle of the year to say goodbye to Moody, who moved to Sweden to be with his girlfriend. His successor was Ronnie Borland, whose relationship with the band extended so far back that he had been the soundman at their first gig in 1985. Hackett concedes that *Striving* is 'an album in two halves; the second half was harder', and indeed it seems a rather unfocused jumble. It means to be a continuation of *Unholy Soul*'s wide-open eclecticism, but instead it parallels – in form if not scale – Primal Scream's 1991 opus, *Screamadelica*, which was praised for its supposedly visionary genre-splicing but is actually a compilation of random stylistic dabbles. At its best, though, it was as good as the Orchids had ever been: the title track is their pre-eminent dance-floor invasion, and 'Prayers to St Jude' proves they can be as affecting with just guitar and Hackett's spurned-cupid voice as with Carmichael's arsenal of digital embellishments. Mulvey loved the album, rating it eight out of ten in his *NME* review and opining that it was time, 'after years of being the object of totally undeserved apathy, for the world to warm to the Orchids'.

But before the public had an opportunity to either indulge or ignore his wish, a split second of extraordinarily bad luck threw the band's short- and long-term future off course. Driving to London in January 1994 for *Striving*'s potentially auspicious launch gig ('Because it's what you do,' says Wadd. 'You release a new album and you have to come to London and play to the London journalists'), their van hit black ice roughly two hours into the seven-hour journey and overturned twice. Remarkably, only two of the band sustained minor injuries – one of Quinn's ears required stitches; Scally's back was thrown out – and they were released from hospital the following morning. But it left them understandably shaken, and the forced hiatus that followed gave them free time to contemplate whether they wanted to see out their increasingly complicated twenties continuing to pile into yet more vans for yet more

interminable southward treks. 'It changed a lot of things for me, that crash,' says Hackett. 'It kind of put things in perspective'. Adds Scally: 'We were getting older. There were relationships and life changes.'

'I think they thought at that point, "Why the hell are we doing this? We're a Glasgow band"', considers Wadd. '"Why are we having to drive all the way to London to play to some journalists who may or may not turn up and may or may not review us?" I can quite see why they'd had enough.'

Although they recovered and made up the missed London date in March, stopping off to record a Peel session while they were there, the Orchids had stopped thinking about the band's future. Fittingly for a group whose every action seemed to be born of impulse, their decision to call time was amusingly informal. 'I remember one night we had rehearsed in Glasgow, and we had to get the late-night bus because it was a nine-to-midnight booking,' says Scally. 'The three of us – me, James and Chris – because we all lived in the same place, took a bus home, and we just went, "You know what? That wasn't much good tonight. Let's just take a wee break." We were just quite happy being pals and meeting up and doing what we did.' Which meant more pints down the pub – a pastime much less fraught with responsibility, and always with an assuredly satisfactory result.

They reconvened onstage one more time, at Sarah's farewell party in 1995. Otherwise, if only in this regard, the Orchids did unintentionally follow in Postcard's footsteps, bowing out without a word to anyone. 'There was no news of the split. I just never heard from them again,' says Carmichael. 'It was years later when I realised, *Damn, the Orchids never got back in touch*. That was just how they were: couldn't even be bothered to organise their own break-up.'

6

'Another Fucking Harvey Band': The Ubiquitous Harvey Williams

Nowadays, Harvey Williams is happy to have grown up in Penzance, an historic port town in the peninsula county of Cornwall. But at the time, in the 1970s and early 1980s, it seemed to him to be 'the arse end of nowhere', a daily reminder that life – or the life he wanted to be living, at least – was going on elsewhere.

When he thought of that ideal life, he thought of London, three hundred miles and a five-hour train journey away. He had felt 'instantly at home' there since his first visit in the late 1970s, and he subsequently ventured to the capital whenever he could, which was never often enough for his liking. But he had a lifeline in John Peel, whose programme he tuned into religiously. The music he heard simultaneously thrilled and frustrated him: it provided confirmation of another, much more exciting world, but he had no means to access it in a meaningful or lasting way. It didn't matter that he had become a reasonably capable guitarist and pianist; his skills seemed all but useless in Penzance, a locale so far-flung that its neighbour was named Land's End.

'My brother was, for want of a better expression, a punk rocker, in the late '70s', Williams recalls. 'He joined a band – him and his mates would get together at weekends – and I would be the jealous outsider, looking in at this stuff that was going on that I was too young to really be a part of. He was

the guy that introduced me to Peel, and that was the inroad to independent records, and I started buying punk music as well.'

Williams loved punk's belligerent energy and allusions to urban bustle, but he had no interest in its Year Zero rhetoric. A Beatles fanatic from an early age (he considered *A Hard Day's Night* as perfect a record as could be imagined), he devoured with insatiable curiosity every new sound introduced to him by Peel, but he retained a core of determinedly classicist values, unashamedly filing his Orange Juice and Swell Maps records alongside those of 10cc and the Monkees. 'I loved the Clash as much as I loved the Buzzcocks, but I loved Nick Lowe more than either of them,' he says. 'Melodicism is king. The thing I liked about the Clash is that they wrote good tunes. I grew up in a fishing village. What did I know about the riots in W11?'

W11 – the postcode district of London encompassing Notting Hill and parts of Ladbroke Grove and Holland Park – soon came to have great significance for Williams. During a visit in 1984, he walked in to Rough Trade on Talbot Road and caught sight of a surprisingly familiar name radiating from the shop's dense surrogate wallpaper of Xeroxed adverts.

I saw this poster up which was advertising the first issue of *Are You Scared to Get Happy?*, and it mentioned Microdisney, which was one of the bands for me. I thought, 'This guy's writing about Microdisney! No one else knows who they *are*. This is worth picking up.' And that was the moment. That was when all the doors opened.

Signed to the Rough Trade label, Microdisney were a London-transplanted Irish group based around the caustic wordplay of doleful-voiced singer Cathal Coughlan and guitarist Sean O'Hagan's uncommonly pretty melodies. A favourite of John Peel, they nevertheless struggled to amass a sizeable following, seeming too polished and poised for indie audiences whose ears were accustomed to music that always sounded seconds from collapse. Haynes devoted pages of his fanzine to praising them, singling them out alongside Hurrah!, Jasmine Minks and Julian Cope for being one of too few modern acts who 'challenge their audiences' preconceptions'. Williams was smitten. 'He was writing about all these bands I was vaguely aware of,' he says. 'All the

Creation bands, the June Brides, and also bands that I loved from the past like the Buzzcocks and the Undertones.'

Williams sent Haynes a letter, Haynes replied, Williams wrote again, Haynes sent future issues of *Are You Scared* and its accompanying Sha-la-la flexis, which Williams found amazing. The two wouldn't meet for some time, but it felt to Williams like a bona fide – and, within the context of his geographical incarceration, a crucial – friendship. 'I suspect the letters never said much beyond, "Here's 50p for the new fanzine. Have you heard the Jasmine Minks single?"' says Haynes. 'But that's what a lot of letters were like back then. We make a big thing of how, before the internet, everything developed through the exchange of letters and fanzines and tapes. But, in a way, what was important was the *existence* of the letter, not its content. Letters were a way of saying, "Hello, I'm here! Can anybody see me?" so that someone else could say, "Yes, I can see you!" That especially applied to people isolated by geography or age.'

From reading *Are You Scared*, Williams learnt more about the Hit Parade, a mysterious group whose music he had come to know and love through Peel. He discovered that the group's founder, singer, songwriter, guitarist and all-around prime mover was one Julian Henry, a Londoner who released singles through his own eponymous JSH label. Like Microdisney, the Hit Parade were fairly neglected by indie kids, seemingly for having the nerve to sound semi-polished. But unlike the former, whose music was tinged with the darkness of politics and all manner of personal turmoil, Hit Parade songs were troubled with injustices no more consequential than the unreciprocated affections of this week's crush. The punk-born DIY mechanics of their records aside, the Hit Parade's music was a notion of pop from a time long before punk – Edison Lighthouse made with a Postcard budget. Suddenly, Williams realized not only that the music he longed to make was a viable aspiration; someone was already doing it. 'I bought a couple of the singles and I thought, "Well, this is clearly not the Fire Engines. It's someone who really knows what pop is." It was the music I felt more of an affinity with than the more angular sounds that people were making at the time.'

Having moved to Plymouth to attend university, Williams became determined to finally make music rather than helplessly observe others doing

it. He pooled some of his earnings together with two friends and bought a communal four-track portastudio.

> That was the technical inspiration, if you like, and Matt was the artistic inspiration – and all the records he was writing about, more importantly. I'd always kind of dabbled in writing songs, but there was no real means of creating anything substantial. My friends and I each had three months' trial with the four-track, and I got to keep it for the summer. And then, somehow, I got to keep it full stop.

His initial goal had been to form a band, but the self-proclaimed misfit who 'never wanted to be part of the gang' at school quickly discovered he was ill suited to collaboration. 'I did try, but I have no leadership capabilities. It was partly shyness, partly wanting people to get it right. I couldn't tell people, "This is how you do it", even though I'd written the song, because I didn't really have the strength of character.'

Retreating into privacy, he substituted other people with the inexpensive technology that was then launching untold thousands of bedroom troubadours. 'You buy a drum machine, and then you buy a little Casio keyboard, then you're set, really. It's all you need – or all you needed then, anyway.' He then set about documenting his chief preoccupations – women, loneliness and the inextricable relationship between women and loneliness – onto the sympathetic spools of a cassette.

After recording half a dozen songs, Williams had no one to share them with locally whose opinion mattered to him. So he sent them to the distant, unseen friends whose empathic words and shared tastes had, for the past year, been balm to his isolated soul.

> I only ever sent two tapes out: one to Bob Stanley – this was while he was just doing *Caff* fanzine and nothing else – and one to Matt. That would've been '86, so I was twenty, twenty-one. Making records wasn't even on the agenda at this stage. I don't even know why I sent them. It seemed like people who were writing songs and playing live – up to a point, and at that kind of level – that was the next stage. You wrote some songs and then you sent them to Matt, or you sent them to any one of the other hundreds of

people who were writing fanzines: the Legend!, Stephen Pastel or whoever. Matt had been the most inspiring fanzine writer I'd read, and it was a nice, instant response that he gave.

Although Haynes's private correspondence offered sober praise, in the sixth issue of *Are You Scared* he offered his pen pal's inaugural experiments a rather more florid assessment: 'GORGEOUS rough chaotic sub-sub-Primal fuzzjangle with SHAMELESS tendency for the most GENIUS awesome guitarNOISE solos and handclap drumming over drum-machine and chocolate-box made-up tunes and mismatched mix'n'match mish-mashed HARMonies most folk would lack the sheer JOIE de VIVRE to um consider letlone ATTEMPT.' ('We all overreacted horribly in our fanzines,' says Haynes. 'But that was part of the fun. It's what gave the scene energy and excitement.') The songs had been recorded by Williams alone, but they were presented under the name Another Sunny Day, a pseudonym inspired by a blithe observation one of his friends had made when he opened the curtains one perfect Saturday morning.

In the summer of 1986, Williams moved to London – albeit temporarily, to fulfil a four-month work placement as part of his university studies. Instantly he was, for the first time in his life, in his element. 'When you move to London, you think, "Fuck, this is where it's at!" This was the summer of '86, when it was *really* where it was at. It was quite an exciting time in my life. I'd be seeing bands two or three times a week – most of those bands I'd only read about.'

In response to his new environment and the people who populated it, Williams wrote a song quite unlike any other he had written before. It was entirely unserious, fast and comically simple, and its lyrical conceit was a parody of the very subculture to which Haynes, Stanley and he himself were, to varying and arguable degrees, aligned. Its title was 'Anorak City', and it was ingeniously daft.

Take a trip to Anorak City
All the girls, so young and so pretty
And the boys all walking around
Collars turned up and shirts buttoned down
Take a trip to Anorak Station

It's the craze that's sweeping the nation
So don't let your credibility slip
Let's all take a trip to Anorak City

Take a walk down Anorak High Street
Say hello to the people that I meet
I wanna be just like them, 'cause everyone you talk to acts just like a friend
Will you be my anorak baby?
Come on, honey, please don't say maybe
Say you will forever be mine
We'll stay until the end of time in Anorak City

The song was written so quickly, and its subject matter was so transparently ephemeral, Williams barely thought about it after sharing it with others, including Haynes. 'It was always supposed to be just a humourous piece of fluff,' he says. 'It was written with genuine enthusiasm, but at one remove, I suppose. It was warm but knowing; it wasn't arch, it wasn't cynical. I'm a big admirer of Randy Newman, and so many of his songs are, "Well, it's up to you."'

Given its throwaway nature, he was therefore surprised when Haynes told him Sha-la-la was coming to an end and that it was of his opinion that 'Anorak City' should be its final release. The song seemed tailor-made for the format and the label: short, disposable, both a celebration and a lampoon. But then, once Haynes had begun to conceptualize Sarah with Wadd, he decided to keep the song in reserve for a better opportunity. Although Sarah was to be a proper record label, it would still release occasional flexis and fanzines, each of which would be given its own catalogue number – a nod to Factory Records, which was admired for its mischievous practice of applying numbers from its own discography sequence to random entities such as the label's Haçienda nightclub, a custom stationery pad and a lawsuit. Once Sarah's inaugural release schedule had been drawn up, 'Anorak City' – a one-song flexi – followed the Sea Urchins' 'Pristine Christine' and the Orchids' 'I've Got a Habit' as Sarah 3, and it was sold for 50p with a fanzine, simply titled *Sarah 4*.

Being as that it was a flexi and not a proper record, 'Anorak City' wouldn't have the advantage of Revolver Distribution – it would only be available via mail order. But Wadd and Haynes sent it to the music press in the hope

that, as with some of the Sha-la-la flexis, someone would see fit to review it. They accompanied it with a press release that was perhaps more entertaining than the song it was meant to promote. It accused the recipient – ostensibly the journalist reviewing that week's singles – of being 'stupid and jaded and sweetly bereft of all wit' and 'old and confused'. 'You're a JERK, basically, we made this record specially for you... ', it continued, in red type, the better to emphasize its indignation. 'It plays at 45rpm to remind you of something called POPmusic. ... It crackles and fizzes and fucks up your needle to remind you of something called POPmusic. ... We think you're a real fuck-up. ... Just hold it up and gaze in fond loving wonder, don't bother to FUCKING PLAY IT, or you've missed the whole lovely point. ... It's the most important single of the year because it's so utterly POINTLESS, and that's why we love it.'

The effectiveness of their provocation exceeded all expectations. The *NME* made 'Anorak City' Single of the Week in June 1988, declaring it, in reference to flexidiscs' inherent fragility, 'the only single this week that is pleased to exist, because it knows it's going to die'. *Melody Maker* named it runner-up Single of the Week, judging it 'the perfect pop artefact'. Williams, who had graduated from university but was forced to return to Penzance while he sought employment, couldn't have asked for better consolation while he sat in his parents' house and waited for life to acquire forward momentum again.

Sarah promptly sold out of its fifteen-hundred copies of 'Anorak City', which amazed Williams. But at the same time, he recognized that the rave reviews it generated were more to do with the conceptual brilliance of Wadd and Haynes's anti-publicity strategy than the song itself, which was little more than an in-joke created in a moment of unexamined enthusiasm. (It had also helped that the *NME* scribe who wrote about it was his friend, Bob Stanley.) Williams knew there was a risk of him being perceived as a novelty act like Welsh band the Pooh Sticks, whose early songs 'On Tape' and 'I Know Someone Who Knows Someone Who Knows Alan McGee Quite Well' made no sense to anyone beyond an insular clique of record collectors. No one would have assumed that Another Sunny Day – whoever *they* were – had been taking narrative inspiration from Randy Newman, the king of morally ambiguous Jewish-American piano balladry.

Fortunately, Williams was able to redress the misleading image cast by his debut with great speed. Its follow-up – a vinyl EP – had already been recorded, and Sarah released it only a month after 'Anorak City'. Although it consists of three songs, all of them concerned with matters of a broken or unfulfilled heart, its lead track stole the spotlight, not least because it boasts one of the all-time great expositional titles: 'I'm in Love With a Girl Who Doesn't Know I Exist'. Only one minute and forty seconds long, its unashamedly fragile tone and rhyming-dictionary lyric ('So many times this has happened before/But I never knew that love could make you feel this sore') polarized opinion: to some, a laudably pure expression of male vulnerability; to others, the last word in post-Morrissey self-pitying wetness. (The accompanying poster, of a cherubic Williams sitting dejectedly in a graveyard, laid the rest of his cards on the table.) It enraged *Melody Maker*; at the *NME*, Williams was once again in luck. Ever-loyal Bob Stanley made it Single of the Week and called it 'a classic'.

Figure 6.1 *Alone again, naturally: Harvey Williams in 1988. This is an outtake from the photo session that produced the poster accompanying Another Sunny Day's debut EP, 'I'm in Love With a Girl Who Doesn't Know I Exist'. (Photo: Edward Wood)*

Williams remained in Penzance for another seven months, during which time his portastudio became his primary source of entertainment, as well as a barrier against the boredom and loneliness he had so easily shed upon arrival in London. Often he was only amusing himself, constructing covers of Bee Gees and Orchestral Manoeuvres in the Dark songs merely to find out if he could do it, or challenging himself to write something in a single day because the legendary Brill Building writers he idolized – Mann and Weil, Goffin and King – had done it. Occasionally, the frustration borne of his rut – no job, few nearby friends, ghosts of the past everywhere, the memory of London emphasizing all that he was now missing – played out in new songs that quietly seethed with disillusionment and confusion. Occasional letters and care packages from Wadd and Haynes raised his spirits. In late autumn they sent him the debut EP of a new Sarah signing, an outer-London two-piece named the Field Mice. The record's mood of late-night reflection; its references to an 'early morning by the harbour' and a 'cold, cruel, hostile town'; the singer's calm, compassionate voice – it all provided an eerily appropriate soundtrack to his indeterminate sentence of coastal isolation. He sent a letter to the singer and guitarist, Bobby Wratten, to say how much he liked it.

Fortunately, early in the new year Williams was set free from purgatory. A job offer came from London, and in February – just weeks before the release of his third single, 'What's Happened?' – he arrived in the capital to stay. His life was immediately transformed, just as he'd hoped. 'That was when there was some proper social interaction,' he says. 'I started working in cahoots with the Field Mice and seeing Bob Stanley on a regular basis and just hanging out. To have a bunch of friends already there when I moved to London was fantastic.'

As well as an appreciation of each other's music, Williams and the Field Mice – Wratten plus bassist Michael Hiscock – got along famously, so much so that the duo proposed Williams join them as a third member. They had been struggling as a live act and needed another body to fill out their sound and boost their confidence. Williams readily agreed. His already high opinion of them had risen to another level shortly before his arrival in London, when he heard their second single, 'Sensitive', an unexpectedly powerful marriage of Wratten's taciturn-schoolboy vocal and multiple layers of blaring, distorted guitar. The song's lyric, which amounts to Wratten's defiant defence of his

emotional fragility, so impressed Williams that he went away and wrote 'You Should All Be Murdered', whose words amount to a revenge list of everyone who, in the writer's estimation, contributes to the world being a lesser place ('The people who talk too much, the people who don't care/The people whose lives are going nowhere/The people who just give in, the people who don't fight/The people I don't like'). Recorded with the Field Mice's own new-found producer, Ian Catt, and released as a single in October, it ends in a flurry of blaring, distorted guitar.

A perception began to solidify of Williams as Sarah's foremost voice for the lonely, the heartbroken and the misunderstood – he seemed altogether inconsolable, which made it all the more tempting for critics to reinforce their accusations that Sarah was the exclusive province of those who had been run over by life, too weak and unmotivated to rise above their misery. Another single, 'Rio', released in July 1990, found him once again agonizing over unreciprocated affections: 'I know I should forget/But I just can't forget you/I know it's all so pointless/But, honestly, I love you… '. Yet although he had indeed experienced enough alienation and disappointment to last a lifetime, very little autobiography figured in his songs. 'There *was* an element of, I was not loved when I was that age. I was very not loved and didn't really know how relationships worked,' he says. 'But equally, some of those songs are completely 'I'll write a song now' songs. Those are the themes of most great pop music – the templates were already there. "You Should All Be Murdered" – it wasn't intended to reflect my worldview. That's a *funny* song, I think.'

What's more, Williams was now loving life like never before. Having become a permanent member of the Field Mice, who had won considerable acclaim for 'Sensitive', the trio was in the process of expanding to a quintet with the addition of a co-vocalist/guitarist and a live drummer to replace their overextended rhythm box. The social aspect of a collective agreed with him, as did the opportunity to make a creative contribution without being a dictator or shouldering the pressure of writing songs, which he found inherently stressful. At last, he had found a gang to which he wanted to belong. 'I enjoy being told what to play,' he admits. 'I like to know what my role is – "This is where it starts, but now come up with something" – and that's what my role was.'

The Field Mice then proceeded to become Sarah's most active and popular group until a catastrophic confluence of tensions – creative differences, divided loyalties, stage fright and more – led to a premature split at their highest point of success in November 1991. Harvey didn't release a note of his own music during that time. 'He was never the most prolific of writers,' says Bobby Wratten. 'I remember him quoting Dean Wareham about how many songs it takes to make an album and how difficult that is. I suppose that's why there was never an Another Sunny Day album. It would have been too much of an undertaking to write ten new songs with which he was happy.'

Williams did finally resurrect Another Sunny Day in April 1992 with another single, 'New Year's Honours', that adhered dutifully to past themes ('There are so many beautiful girls in this world/There must be one somewhere for me'), but by the time it was released, he had joined Blueboy, a recent addition to the Sarah roster that, like the Field Mice, began as duo in search of a band. He remained with them through to 1995, and Another Sunny Day – the name, if not the activity behind it – was quietly retired. A compilation album, *London Weekend*, acted as its valediction, although few people knew it at the time.

In early 1990, an Another Sunny Day interview appeared in a fanzine bearing the unfortunate title *There Are More Biscuits Than Beverages*. In a combative mood as a result of his inquisitor's preoccupation with chart positions and product formats ('I do feel as though you're *totally* missing the point,' he raged in reply. 'Why are you writing a fanzine?'), he was asked for his thoughts about 'the music/indie scene'. 'The "indie" scene no longer interests me, except for a couple of other bands on Sarah and a couple of other exceptions,' he responded. 'These days I listen to the Carpenters, Glen Campbell, the Beach Boys, Simon and Garfunkel and similar "middle of the road" acts. … The most emotionally intense record ever made is the live version of 'For Emily, Wherever I May Find Her.' So go and listen to that.'

Although there was no identifiable catalyst, it seemed as though the tastes of many other artists of his generation were bending in a similar direction. A new-found (or previously concealed) affection for soft rock from the late 1960s and 1970s was suddenly being revealed in the new music of artists who

had grown up with punk. Whether as a result of mellowing with age, the onset of nostalgia for the sounds of childhood, or liberation from the self-inflicted prejudices of adolescence, a mellow mood was being brought back by some highly unlikely individuals. Epic Soundtracks, formerly the drummer in post-punk experimentalists Swell Maps, surprised everyone in 1992 when he released *Rise Above*, a debut solo album full of introspective piano ballads that boasts shockingly understated guest contributions from members of Dinosaur Jr. and Sonic Youth. Sean O'Hagan rose from the ashes of Williams's beloved Microdisney to form the High Llamas, the mission of which seemed to be to carry on the exploration of skewed orchestral pop that had been prematurely abandoned by Brian Wilson and John Cale. Joe McAlinden, a Glasgow singer-songwriter whose previous band, the Groovy Little Numbers, embodied indie-pop at its most guilelessly childlike, spoke for a wholesale shift in Scottish pop when he reemerged as frontman of Superstar, a veritable tribute act to Todd Rundgren and Alex Chilton. Williams had never met any of these people, but it had been his plan for some time to strike a similar path.

'It certainly helped to convince me that there was no reason why indie acts couldn't make this kind of music,' says Williams. He had also been listening to Gilbert O'Sullivan, Harry Nilsson and Laura Nyro, all of whom spent their heyday sitting at a keyboard rather than standing with a guitar. The shift in his musical interests dovetailed with his own return to the piano – an instrument he had learnt in childhood but had barely touched for fifteen years. He hadn't necessarily intended to write a new record, but before he knew what was happening, his capricious muse gifted him enough music for a mini-album. 'I'd bought a keyboard, just as an accouterment to whatever I did next,' he says. 'And two days later, an album was effectively written. There's nothing quite so inspiring as buying a new piece of gear.'

Another Sunny Day's music had always been basic, but now he was going to aim for the utmost simplicity. His lodestone in the preceding months had been Nilsson's *Nilsson Sings Newman* album: one man, a piano and almost nothing else.

It was a total revelation to me in terms of economy of sound as, say, Buzzcocks' *Spiral Scratch* had been in the past. … You just pare it down until

there's hardly anything left. That's also why I like Kraftwerk so much – you listen to those records and they're just slivers of music, really. They're barely there but they say everything, and I guess that's what I was trying to do.

Williams sent demos of his new material to Wadd and Haynes with the forewarning that if they were to be released, he no longer had interest in hiding behind a pseudonym.

I said, 'How do you feel about doing it as a *me* record rather than as an *it* record?' They didn't take any persuading. It would just challenge people's ideas of what Sarah as a label was. I just thought, well, it's not released a kind of singer-songwriter record before, and this quite clearly is. It would just be nice to release it as something that would've come out in the early '70s on Warner Brothers.

Seven songs, fifteen minutes, and just piano and voice with the bare minimum of embellishments, just like he'd intended. Released in early 1994, Williams

Figure 6.2 *Inspired by singer-songwriters like Randy Newman and Laura Nyro, Williams switched from guitar to keyboard in 1994, and began recording and performing under his own name. (Photographer unknown; courtesy of Sarah Records)*

titled it *Rebellion* – which, within the context of everything else Sarah had released to that point, it very much was. Fans of Another Sunny Day didn't quite know what to make of it, nor did the music press, which uniformly chose not to comment. Williams was undeterred – after all, *Nilsson Sings Newman* had met a similar fate. 'The way the records were perceived was never my concern, really. I never expected anything – once they're out there, they're out there. The fact that they were made was enough. I never thought I'd get to make records at all, so it didn't really matter what people's opinion of them was.'

It would be years before Williams felt compelled to record his own music again, but he had plenty else to occupy him in the meantime. As well as his ongoing role in Blueboy, he had started guesting with his teenage favourites the Hit Parade, whose linchpin Julian Henry had resurrected the group and brought it to Sarah. In response to Williams's unceasing ubiquity in the Sarah fold, Mathew Fletcher, the drummer in Heavenly, remarked with mock annoyance about 'another fucking Harvey band'. It won enough laughs that he then made a T-shirt – 'sarah: another fucking harvey band' – and wore it onstage. Williams was 'terribly flattered, of course'.

7

'Sarah Records Unequivocally Supports a Fully Integrated Light-Rail Rapid-Transit System for the Greater Bristol Area': Expressions of Civic Pride

Guy Debord, the French theorist and founding father of Situationism, defined psychogeography as 'the study of the precise laws and specific effects of the geographical environment, consciously organized or not, on the emotions and behaviour of individuals'. Sarah Records was the medium through which Wadd and Haynes communicated the psychogeographical effect of Bristol upon their playful, wide-eyed minds. It was the supporting player to the label's music – a constant visual presence and, in their writing that accompanied the label's seven-inch releases, the backdrop to whatever they were in the mood to ramble about. Other labels have named themselves after their home base, or made a policy of only signing local talent, but never before or since has civic pride played such a major, unbroken role in the aesthetic and emotional make-up of a label.

They had no apparent reason to be such cheerleaders for their immediate surroundings. Haynes had spent his life in London, one of the most iconic and culturally vibrant cities on earth. Wadd's hometown of Harrogate, renowned for its spa waters and romantic gardens, has long been considered one of the most liveable addresses in England. The pursuit of a university education and a desire to establish distance from their childhood homes had brought them to Bristol, but they could as easily have landed in Cambridge or Manchester or Kent – their choice of institution had been merely practical.

When Haynes arrived in 1983, there was little indication that the music he loved most – scrappy, punk-inflected, guitar-based pop – had very much of a presence within the city limits. Not until 1985 would Martin Whitehead, a native Bristolian, launch the Subway Organisation label, partly as a platform for his own band, the Flatmates, a hyperactive melding of Buzzcocks melody, Ramones speed and a female singer who sounded like a deeper-voiced Pete Shelley. But even they would be the secret of a few, and the rest of Subway's early roster was from elsewhere. For the most part, Bristol's musical heart still beat to a much slower, looser drum. 'Bristol had a healthy reggae and dub scene in the '80s, which Smith & Mighty and Massive Attack grew out of, followed by Portishead and Tricky,' says Whitehead. '[Dub- and jazz-influenced post-punk band] The Pop Group had at least one foot in that camp, and that in turn produced Mark Stewart and the Mafia, Rip Rig and Panic, and Pigbag. When the Flatmates played their first gigs, I felt there was only us, the Brilliant Corners and Blue Aeroplanes who had any kind of profile amongst the indie crowd, and I wouldn't say those three bands had a huge proportion of their audience in common. Bristol wasn't dead musically, but there wasn't a lot of pop coming out of it, much less indie-pop.'

Haynes found out soon enough that there wasn't a lot of interest in it either. When he and some friends launched the EEC Punk Rock Mountain club night, they struggled to draw a decent number of bodies through the doors of the George and Railway pub, despite the host room's small capacity and admission fees that were usually south of £2. Being as that the pub stood upon a traffic island next to a busy roundabout, Haynes would eventually remark, 'To be fair, it was a very difficult road to cross.'

But not even success always guaranteed a pleasant result within Bristol. In 1986, the Groove Farm, a new Bristol group influenced by surf and garage punk, self-released a quite astonishingly rough-sounding debut EP, *Sore Heads and Happy Hearts*, that received heavy airplay from John Peel and Janice Long. The record sold out within weeks. Wadd and Haynes loved the Groove Farm – the band subsequently contributed a track to Wadd's lone *Kvatch* flexi – but locally they became an instant target of hate to other, more established acts, who seethed with jealousy at the astounding luck of the inept newcomers in their midst. 'It made us very much disliked within the local music scene', recalls singer-guitarist Andrew Jarrett, 'so much so that I would often have abuse shouted at me from cars driving past as I was walking down the street. And once I was punched in the face so hard, I blacked out for a few seconds while standing in a queue waiting to buy some milk!'

Fortunately for Wadd and Haynes, they had little interest in drawing attention to themselves. Falling in love with each other and thus becoming as tight a unit as any new couple, Bristol – where they had met and where Sarah was born – couldn't help but acquire an amplified radiance, intensifying the affection they already had for the city's picturesque hills, docks and bridges, and its nearness to both sea and countryside. 'Because the two of us had gotten together, I think it was a very insular thing, setting up Sarah,' says Wadd. 'It was the two of us, and it was almost like talking to other people would've broken some sort of spell.' When Wadd graduated in 1989 and the label was basking in the modest success of its early releases, there was nothing tying them to the spot. London had the potential to provide a much more exciting life and a closer relationship to the music press, whose support Sarah would surely need going forward. They stayed put. 'We also wanted to make the political point that not everything had to revolve around London. You didn't have to move there,' says Haynes. 'The miners' strike in '84 and '85 was still a recent memory, and had to some extent pitted the North and the Midlands and Wales against the government in London.'

'I think it was the summer before I graduated,' Wadd recalls. 'I worked for the government for a summer. I saved £800 and put all of it into Sarah. I worked to fund the label rather than work to go out.'

Leading a dramatically frugal lifestyle, and consumed with the demands of operating an up-and-coming label with a staff of themselves plus zero, it was common for Wadd and Haynes to work for twelve or more hours in their flat without setting foot outdoors. When they did, it was usually for business-related reasons or to acquire basic necessities such as teabags or discounted chickpeas. Lacking a car or a taxi budget, they walked everywhere across Bristol's hilly landscape, or took buses whose routes exposed them to areas they might otherwise never have seen. Their knowledge of the city became much more intimate than motorists who had lived there far longer. 'Everything was about not spending money,' says Wadd, 'so if you could save 10p on a roll of cheaper parcel tape, you would spend an hour walking to a much further shop to do so. That was pretty much the way we functioned. It was all about our time being absolutely valueless and money being money.'

Sarah's releases then became a sort of visual journal documenting their increasing knowledge of neighbourhoods, roads and landmarks. The centre labels of the first 20 seven-inches depicted various scenes from north Bristol ('Mostly Clifton, where we lived at the time,' Wadd points out. 'It was very photogenic – beautiful terraces and views'). The next ten represented a conceptual step up: the labels showed each consecutive station along the railway line that led into town from nearby Severn Beach. Enclosed with each of those singles was a postcard that doubled as a puzzle piece which, when joined with their companions, would reveal Bristol Temple Meads, the line's terminus station. Haynes said it was a gesture to mock 'the capitalist mindset of record collectors,' who either fetishized mere ownership for the sake of it, or had already clued into the fast-rising resale value of Sarah singles. Neither he nor Wadd approved of the practices, so they figured they may as well have fun at collectors' literal expense.[1] Throughout the rest of Sarah's life, each group of ten in the seven-inch catalogue sequence was tied together with a

[1]'What was crucial was that the postcards were randomly distributed,' says Haynes. The idea was that even someone who had all the money in the world, and could buy every copy of every seven-inch they came across, still wouldn't be guaranteed a completed Temple Meads. Anyone who's willing to pay thirty quid for a small piece of purple cardboard that forms one-eighth of a picture of a West Country railway terminus really needs to take a long, hard look at themselves – and hopefully we helped them to do that. Also, of course, we thought it was funny, because it was so un-rock 'n' roll.

label theme, every one bringing some random part of the world just outside their door into the homes of people in other cities, countries and continents. Similar playfulness carried over when Sarah began releasing compilations LPs – *Shadow Factory*, *Temple Cloud*, *Air Balloon Road* – each with a non-sequential, seemingly nonsensical catalogue number: 587 followed by 376 and 545. 'They were all named after places in and around Bristol,' says Haynes, 'and the catalogue numbers are the numbers of the buses that go to these places. We thought it was funny.'

The irony of it, according to Wadd, was that 'Bristol famously had not very good public transport at the time, but we believed in the *idea* of public transport and we wanted it to get better'. When the *Glass Arcade* compilation was issued in 1991, she and Haynes instructed the person who cut the master plates for the LP to engrave a message across the run-out groove, which was so lengthy it had to carry across both sides: 'SARAH RECORDS UNEQUIVOCALLY

Figure 7.1 *The centre labels of Sarah's seven-inch records depict various scenes from Bristol. Catalogue numbers 21 to 30 feature photos of each stop along the Severn Beach railway line.*

SUPPORTS A FULLY INTEGRATED LIGHT-RAIL RAPID-TRANSIT[2]
SYSTEM FOR THE GREATER BRISTOL AREA.' Fortunately, he found it
hilarious.

Wadd and Haynes's resolution to remain in Bristol – and to publicize
their joy in that decision as often as possible – soon produced an unexpected
consequence. Anglophile indie kids from all over the world, who never before
would have considered Bristol a must-visit detour while visiting London,
began making pilgrimages to the city with alarming regularity, often multiple
times a week. And almost invariably, they would make a beeline for the flat on
Upper Belgrave Road, its address prominently listed on every Sarah release.
The couple were flattered. But every time one of them answered the door to
find an excited, awestruck young person from Tokyo or Berlin or Toronto
standing in the garden path, hoping for a glimpse into their magical world of
buses and aerial views and pop music, they knew their workday was going to
extend several hours further into the night. 'They would want a walking tour
of Bristol and a place to sleep because they'd bought some seven-inches,' says
Haynes, sympathetically. Before he and Wadd had an opportunity to move
house and start renting a PO box, they took to sometimes hiding when an
unfamiliar face appeared in the front path. 'Once or twice', admits Wadd, 'we
hid round the corner when we were coming back from somewhere and saw
people.'

'We would occasionally get people coming from abroad who thought all the
bands lived in Bristol,' says Haynes. In fact, Secret Shine and Tramway – both
of which joined Sarah in 1991 – were the only two. 'Back in Postcard Records
days, if you went to Glasgow, you *would* see Orange Juice and Aztec Camera
walking around in the streets. But if you came to Bristol, you wouldn't meet
the Field Mice and Heavenly.' Adds Wadd: 'It was almost like they thought we
lived in a big house party together, like the Monkees.'

The greater burden of their splendid isolation was the effect it had upon
Sarah's standing with the London music press, which tended to move as one
between the pubs and venues where bands and label owners also spent their
leisure time. Wadd and Haynes's inability to raise pints with journalists (which

[2]In error, the cutting engineer wrote 'RAPID-TRANSPORT' instead.

Figure 7.2 *The complete set of postcards that were randomly inserted into Sarah releases 21 to 30. Temple Meads is the terminus station of the Severn Beach railway line. (Courtesy of Sarah Records)*

they would have been loath to do even if they *had* been in London) was a considerable handicap at a time when regular face-to-face interaction could have considerable positive impact. 'It certainly counted against us in terms of getting press and publicity,' says Haynes, 'because it's very difficult to do that when you're not bumping into journalists at gigs every night of the week. And it also means that journalists are free to insult you in print and know they're not going to meet you at a gig.'

The distance could have negative consequences even when the press was primed to show kindness. One day the *NME* phoned Sarah with the news that one of their releases had been chosen as Single of the Week,[3] but a photo was required to accompany the review and the paper was going to press that very day. 'Fine, if you work in London – you can just bike one over – but not so good if you're in Bristol,' says Haynes. 'We offered to 'Red Star' one, which used

[3] The single was 'One Step Forward' by Even As We Speak (see Chapter 15). Unable to secure a photo in time, the *NME* gave their Single of the Week honour to someone else.

to be a railway-based postal service: you'd take a parcel to your local station and someone would collect it from the station at the other end. But no one at *NME* was willing to go to Paddington Station.'

Wadd and Haynes relocated Sarah four times during its eight years, both within their homes and in stand-alone offices, but it always remained in the city where it began. Wadd moved alone to London in 1994, the label's final year, to work for Vital, the distributor that succeeded Revolver following a merger, while still keeping a hand in Sarah's day-to-day operations. When Sarah came to an end, Haynes joined her there. 'We were sort of in this little Sarah world in Bristol,' says Wadd, 'but Sarah only really existed in Bristol for us two. I feel a bit of a Bristol *fraud*, in a way, having left. I'm tempted to retire there.'

8

'A Diary of Sorts': The Field Mice, Northern Picture Library, and the Quicksilver Bobby Wratten

When the Field Mice left the stage following their final live performance, at North London's Tufnell Park Dome in November 1991, perhaps no one in the audience was as emotionally affected as Tim Chipping. Known to Haynes, Wadd and virtually every Sarah-affiliated musician for being among the label's most visible, enthusiastic and committed followers, he was so familiar and welcome a presence at gigs around the country that he eventually transcended the position of fan to become a personal friend to some of the bands. The Field Mice were, in his estimation, not only the crown jewel of Sarah's roster; they were valued peers whose successes and failures impacted him as though they were his own. To watch them onstage that night – visibly deflated, palpably uncomfortable, barely capable of looking at each other – was to witness the death of a dream in which he felt personally invested. It was simultaneously a triumph, in that the band had just played to the largest London audience of its career, and a tragedy, in that circumstances within their circle had become so intolerable, it wasn't enough of an incentive to keep them together.

Leaving the venue, Chipping saw bassist Michael Hiscock standing near the door. 'You know, you were the best band in the world,' he said to him.

'Yeah,' replied Hiscock. 'I know.'

It was a remark almost comically emblematic of the Field Mice's roughly four-year odyssey: hubris, resignation, perversity, earnestness – in the space of a breath.

Among the many motifs that define Sarah's history, arguably the most significant is Wadd and Haynes's recurring ability to detect potential in bands so outwardly unskilled or dilettante that no one else cared. In the instance of the Field Mice, there wasn't even a bona fide band when a cassette bearing the name began appearing in the morning post at various independent labels in late 1987. There were only two friends, Hiscock and Bobby Wratten; the latter sang, played guitar, and wrote lyrics and the bulk of the melodies. The Field Mice – whatever they were meant to be or aspired to become – didn't exist beyond the confines of the pair's bedrooms and daydreams.

Hiscock and Wratten met as sixteen-year-olds in the lower sixth, in their mutual home of Mitcham, a district at the southwest edge of Inner London. Both music fanatics, their bond formed around the principal activities of record shopping and gig-going. Immersing themselves in the manifold pop sounds of 1982, Wratten pressed into his new friend's hands a homemade cassette of the Psychedelic Furs' *Forever Now*, and shortly afterwards they attended a triple bill of Orange Juice, the Farmer's Boys and Strawberry Switchblade at the Lyceum. As early as this, the idea of trying to make music of their own was discussed, but nothing came of it. 'We would just think up names,' says Wratten. 'But being purists, we considered that actually doing anything would be selling out.' Following graduation, they compromised their ideals enough to acquire a guitar tuner and learn some more chords, and eventually they auditioned at a local venue during lunch hour: 'Just the two of us with a very primitive drum machine, playing Felt-esque songs to bikers. Having achieved such heights, we promptly split up.'

Typical of a volatile teenage friendship, for no reason their involvement in one another's lives ended overnight shortly thereafter. Only chance could bring them together again. When it did, two years after their humbling public debut, it was, very fittingly, in a record store: a branch of Our Price in neighbouring Croydon. However else their lives had evolved during the not insignificant

lapse since they last saw each other, there had been very little evolution in terms of Wratten's musical activities. He was still sequestered in his childhood bedroom, still unsure as to how he should advance beyond its walls; the only difference was that he was now making music with another, newer friend. Wratten suggested that Hiscock come round and join in the fun. Hiscock not only took up the offer; in short order, he supplanted Wratten's friend, who was judged excess to requirements and summarily dismissed by the reunited duo.

Determined that it wouldn't be as short lived as its previous incarnation, Hiscock and Wratten set about proving serious intent for their resurrected project. They finished some songs, chose a band name that both of them would come to profoundly regret, and scanned the classified pages of *Melody Maker* to find an affordable studio where they could make a demo. To their surprise and delight, their eyes fell upon an advert for an eight-track facility that had recently opened in a house directly around the corner from Wratten's. Its rate of £50 per day was so reasonable, it overrode any misgivings they might have had about the fact that the 'studio' was an upstairs spare bedroom and the 'vocal booth' the adjacent box room.

The owner of the studio was Ian Catt, a keyboard player and novice producer whose business, like Sarah, was made possible thanks to the Enterprise Allowance Scheme. Only a few years older than the duo, virtually the only commonality he shared with them was that he had attended the same comprehensive school, although their paths had never previously crossed. While the rates and modest technical appointments of his studio – as well as its name, CAT – suggested an affinity with the cheerful amateurism of indie, Catt was a dyed-in-the-wool child of the pop charts who had grown up enthralled by the clean, futuristic sounds of the Human League and Gary Numan. Although he couldn't begin to try to approximate it with the tools at his disposal, his sonic touchstone was ABC's sumptuous and expensive *The Lexicon of Love*. Nevertheless, the Field Mice were among his first paying customers, so he made a point of being as accommodating as possible when they arrived one day in November 1987, despite having serious misgivings about their working methods. 'I was fairly aghast at the basicness of it,' he recalls. 'Not of the music, per se, but of the fact that they expected to come in and record seven or eight songs in one day. There literally wasn't time to think.'

Satisfied with their day's work, Hiscock and Wratten selected three songs from the batch and sent them to three of their favourite labels – Cherry Red, Creation and Factory – plus Sarah. The latter choice was, if not an afterthought, definitely not informed by the deep, long-standing affection they associated with the others. Wratten had indeed thought highly enough of 'Pristine Christine' when John Peel played it that he went out and bought it, and he purchased the Orchids' 'I've Got a Habit' after noting it was from the same label. But of the four companies they solicited, Sarah was the only one whose inclusion was purely for practical reasons. 'I didn't know anything other than here was a new label that had only put out two singles,' says Wratten, 'and therefore they might still be enthusiastic enough to listen to demos.'

It was a shrewd assumption: of the four labels, only Sarah responded. In a letter, Haynes opined that the songs meandered too much, but he encouraged them to send more when they were ready. They were, in fact, so very ready that they returned to CAT almost immediately, in April 1988, and recorded six more songs expressly for Sarah's consideration. Meanwhile, Catt was warming

Figure 8.1 *Michael Hiscock and Bobby Wratten of the Field Mice in 1988, when the group was still a duo. (Courtesy of Sarah Records)*

to the duo's rough-hewn music – especially Hiscock's tuneful, imaginative bass work – and the touching dynamic of their friendship: Wratten introverted and intense, Hiscock respectful of his bandmate's seriousness but always ready to mitigate it with a well-timed joke. 'Michael was Bobby's Andrew Ridgely, inasmuch as he was his buffer to the world,' says Catt. 'Having Michael as a friend I think helped him to deal with the trauma of going into a studio and recording songs he'd written words for – obviously very personal words.'

At the session, Catt took the time to encourage Wratten to sing with ever-so-slightly more force. 'At the time it was very, very fragile, to say the least, and he was very unsure of himself. He tended to be quite sibilant, and the fact that he sang very quietly just accentuated that.'

Wratten did his best, but it was a challenge: as well as shyness and inexperience, he was struggling against vocal cords and nasal passages coated with the viscous emissions of a nasty cold.

The songs from that day landed in the Sarah mailbox shortly thereafter, and it was almost as quickly decided by Wadd and Haynes that, although they would need to be re-recorded, four of them would make up the Field Mice's debut EP. They also decided Catt had done a good enough job that he should produce the record. (Given that the label would be cutting the cheque for the session, his ongoing £50-per-day rate surely was the clincher.) They made arrangements to travel from Bristol to Mitcham to oversee the recording, but just a few days before their journey, they received from Wratten a tape of a new song he felt merited taking the place of one of the others earmarked for the EP. It was titled 'When You Sleep', its mood was as lonely and bereft of hope as the lyric's insomniac narrator, and Wratten had recorded it solo in his bedroom while a neighbour's dog could be heard barking in the distance. After receiving it, Wadd called him to confirm that she and Haynes would be happy to include it. While they spoke, it occurred to her that Wratten sounded as polite and well-spoken as his letters suggested.

Wadd and Haynes rolled up to the doorstep of Wratten's parents' house on the morning of Saturday, 10 September 1988 (a date everyone present seems to have committed to memory) to meet the Field Mice for the first time. Wadd later recalled that as she and Haynes approached the front walk, they had no idea what to expect of the people to whom they were about to grant the wish of

making a record; it had never occurred to them to ask for a photo of the band, or to inquire as to their ages, musical influences, friends they might have in common. … And then, Wratten surprised them by appearing not from inside the house but behind them. He was just coming back from walking the family dog. 'I remember being relieved that they weren't over-confident hipsters, and also, strangely enough, that Matt was older than us,' says Wratten. 'I felt that maybe, at 22, we were too old to be making our first record. I could also tell that Clare and Matt were similar to us in that they were quite quiet and didn't see anything wrong with having good manners. Bearing in mind that we'd had no contact ever with anyone in the music industry and belonged to no scene and had never played live, this was our introduction to showbiz.'

And so, following Hiscock's arrival, four quiet, well-mannered twenty-somethings walked around the corner to CAT. Wadd and Haynes had offered the Field Mice two days to make the EP, but they assured them it could be done in one – and so it proved. As night fell, everyone emerged from the studio with the EP complete. Catt was amused that the music he recorded that day, which was scarcely more polished than the demos, was judged good enough to release on vinyl. For their part, Wadd and Haynes were amused by the unconventionally domestic environs of Catt's studio. The Field Mice had failed to disclose in advance that the house in which the studio resided belonged to the producer's parents, who still lived in it. At one point during the afternoon, Catt had to ask his father to hold off from mowing the lawn until Wratten had finished recording a vocal.

The record, which came to be known as the *Emma's House* EP, after its lead track, was a curious thing within the context of both 1988 and the Sarah discography to that point. Clearly an indie record, inasmuch as its sound is thin and its performances untutored, it possesses none of the scrappy exuberance that typified guitar-based indie music at the time. There is no feedback and little, if any, distortion; the guitars are clean, dry and strummed with sober restraint rather than vernal abandon. In place of the imprecise flailing of a wild-armed drummer is the clockwork *tap-tap-tap* of an entry-level drum machine. Rather than the harsh aural character resulting from an inexpensive studio's egg-carton walls and threadbare carpeting, each instrument sounds as if it had been patched directly into the mixing board, purposely robbed of ambience.

Boosters and detractors alike commonly remark that indie records sound 'small', but *Emma's House* genuinely does. It sounds, appropriately, as though it had been made in a bedroom. Which proved fitting, because the four songs that make up the EP are nothing if not bedroom reveries, decidedly suburban observations about a small life dealing with the seemingly enormous impact of localized change: departed friends, a failing romance, the past casting too long and dark a shadow over the present. The implied communal spirit of indie-pop's Endless Summer worldview is absent. In its place, *Emma's House* evokes the sort of solitary contemplation best suited to autumn as it drifts perceptibly towards winter. Although Cherry Red Records found no use for the Field Mice then, the record would have slipped seamlessly into its release schedule of 1982, when the label was defined by showpieces of introversion such as Tracey Thorn's *A Distant Shore* and Felt's *Crumbling the Antiseptic Beauty*. At least fortuity saw to it that Hiscock and Wratten's debut was delivered into the world in November. (Those who bought it would have no way of knowing that Wadd and Haynes had persuaded them to replace the later, 'proper' recording of the song 'Emma's House' with the original demo, complete with Wratten's mucous-glazed vocal.)

While the nation's fanzine community was left to contemplate the first offering from Sarah's new mystery band (and the mainstream press to let it pass without comment), the Field Mice, displaying a degree of prolificness and eagerness Sarah hadn't witnessed before, had already begun executing their next step. At the *Emma's House* session, Hiscock and Wratten had rather brazenly asked if they could make another record – a request usually not tabled until an artist's current effort has proven to be a worthwhile investment. Their paymasters generously answered in the affirmative, so the duo wrote another set of songs and delivered yet another Catt-assisted demo before *Emma's House* had come back from the pressing plant. Of its five selections, Wadd and Haynes were especially impressed with the fourth: a song that married a lyric confessing to crippling inborn emotional fragility with layers of fuzztone guitar and an assertive rhythm track. As if to serve as a pre-emptive strike against its critics, its title was 'Sensitive'.

Wratten was especially surprised by Sarah's enthusiasm – his placement of the song at the back end of the tracklisting was indicative of how lowly he

rated it amidst the other contenders for the Field Mice's second release. He had written it quickly in reaction to an interview with Spike Milligan, in which the comedian and writer reflected upon the pros and cons of his own thin skin. 'He was talking about being hyper-sensitive and the problems that can arise from this – basically feeling too much and being very easily hurt and so forth', says Wratten. 'Then he said that if it means that he can be moved to tears by a rabbit running across a field, then it was more than worth it. There you have the essence of the song'.

Wadd and Haynes were so emphatic about the potential greatness of 'Sensitive' that they proposed it be paired with only one other song, 'When Morning Comes to Town', as an ostensible double A-side, thus becoming the only Sarah release other than the Sea Urchins' 'Solace' to feature fewer than three tracks – simultaneously a contravention of the label's value-for-money ethos and an implicit underlining of the songs' importance.

Haynes would recount in later years that while travelling back to Bristol from Mitcham with the master tape of 'Sensitive', shortly before Christmas, he thought, 'This is going to change people's lives.' Meanwhile, Ian Catt was in his studio trying to process what had just happened. Flanked by band and label while he sat mixing the song, he was encouraged – more or less commanded, in fact – to raise its many guitars, which took up five of the board's eight available tracks, to a volume that violated his entire understanding of how a pop song should sound. 'Sensitive', it had been decided, was to be an auditory statement as much as a verbal one. If the point of Wratten's lyric – that his vulnerability is worn as a badge of honour; that it makes him more, not less, of a man – was to be interpreted correctly by listeners, it would have to be driven home by music that articulated the latent rage his voice could not. Once the guitars had been mixed to what his clients deemed a satisfactory level, Catt recalls, 'the needles on the master recorder were practically bending on the stops'.

Although it wouldn't have shocked those who were already listening to the contemporaneous work of My Bloody Valentine, Pixies and Dinosaur Jr. (or who possessed a copy of *Psychocandy*), 'Sensitive' seemed so radical within its milieu that it caused a minor sensation when it was released in February 1989. While Wratten had only meant to speak for himself, he had unwittingly written an anthem – for his label, perhaps for an entire maligned genre, and

the like-minded misfits who were its audience – whose sonic forcefulness was very much in tune with the noise-oriented rock that critics believed to be the new vanguard. John Peel played the song (and it ultimately placed in his annual Festive 50 of listener-voted favourites), reviews acknowledged its understated daring, and the Field Mice were summarily raised to the upper echelon of bands that fanzine editors vied to interview. Most noteworthy of all, French music magazine *Les Inrockuptibles*, in making the record its Single of the Month, accompanied its review with the signatures of numerous staff, indicating an office-wide endorsement – something it had never done before and hasn't done since.

Wratten was as bemused as he was pleased. In his estimation, 'Sensitive' was neither his best song nor a harbinger of the band's future. (Its comparatively unsung flipside, 'When Morning Comes to Town', made it clear that the Field Mice had no intention of abandoning the delicate balladry that epitomized *Emma's House*.) Nor did its success negate the problems that he and Hiscock were struggling to overcome elsewhere. Their entrée to live performance at the beginning of the year hadn't been good: it included a politely received debut in Brighton, opening for the London band Bob ('People were too kind to say that we were, in all honesty, pretty poor,' says Wratten), followed by a disastrous slot supporting the ascendant Inspiral Carpets in a spacious student hall at the University of Exeter. Already dwarfed by the venue, its expansive stage and an indifferent audience (one of whom loudly inquired as to who they were, prompting Wratten to reply that they were 14 Iced Bears), it was also too dark for the flustered duo to read their drum machine's digital display. Wratten called out to whomever was in charge of such things to ask if they could be given more stage light, and in response someone turned on the house lights, leaving them to play the remainder of their set to a meagre assemblage standing scattered beneath a mood-crushing fluorescent glare. When a technical snafu sabotaged their final song, Wratten threw down his guitar and stormed off. Thus, Wadd and Haynes, who hadn't been able to afford to come to Brighton, were introduced to the spectacle of the Field Mice in concert.

Hiscock and Wratten's onstage misadventures served to underline what they already knew: that a pair of shy young men and a Dr Rhythm box did not a band make. It likely was too late for them to do anything about the name

they had chosen (already the source of much rueful self-deprecation), but they could still build around them a group that was capable of making the music they imagined but couldn't produce alone. The few people who had interviewed them thus far came away knowing they had little regard for indie-pop. ('It was odd for us because we were never part of the fanzine culture, and the post-*C86* bands particularly were of very little interest to us,' says Wratten.) Instead, the names they most often referenced from their diverse record collections included New Order; the Go-Betweens; an unsung, country-inflected Irish group named the Stars of Heaven; and, surely to the silent horror of their inquisitors, singer-songwriter Jackson Browne.

Not the types to audition strangers, they bided their time while continuing to gig as a duo, including tours of Germany and Switzerland with the Orchids. 'It was the only thing that caused problems within the group. It made me quite difficult to be around,' admits Wratten. 'The early days were just a mass of inexperience – travelling long distances for solitary gigs, and our idea of playing hardball when promoters asked about our fee was to say they needed to cover the cost of our petrol.'

August brought the release of *Snowball*, the second of Sarah's many ten-inch mini LPs, following the Orchids' *Lyceum*. Recorded with Catt for a then unprecedentedly hand-wringing sum of £400, its sleeve caused a minor ruckus in the offices of Revolver Distribution. Forever burned into Wadd's memory is the sight of the company's managing director Mike Chadwick, holding the record up and bellowing to anyone within earshot that it had no hope of selling if the label 'didn't write the fucking band name on the front'. There was, in fact, no text whatsoever on the front; only a field of pastel magenta. It was the most extreme instalment yet in an ongoing homage that likely no one had detected. 'It may not seem like it, but in that sense we were still very much in thrall to Factory Records,' says Wratten, referencing the audaciously minimalist designs of the label's art director, Peter Saville. 'But Factory on a considerably reduced two-colour budget! We just knew that we wanted as little information as possible, and definitely no photos.'

Its sleeve may have disclosed little, but the contents of *Snowball* revealed much about Hiscock and Wratten's wide-ranging influences and their apparently anxious desire to make use of all of them. Factory rears its head again in the

subdued disco of 'Let's Kiss and Make Up', the Byrds are brazenly referenced in the opening riff of 'Everything About You', and 'White' suggests that not even they were immune to the spell that My Bloody Valentine's cacophonic innovations was casting across the land. The record is a product of growing confidence, to be sure, but also of curious boys left to play unsupervised: while it was being made, Wadd and Haynes had elected to stay home in Bristol. 'They were paying to let us loose in the studio for six days,' says Wratten. 'I'm not sure *Snowball* would have been as much of a step forward if Clare and Matt had been in attendance. For instance, I know Clare wasn't keen on "Let's Kiss and Make Up" when she first heard it, so if she'd been there while we were using sequencers for the first time and putting backwards reverb on the drum machine, it could have been awkward.'

February 1990 saw the Field Mice receive their first interview feature from one of the weeklies – a quarter-page brief in *Melody Maker*. It coincided with the release of *The Autumn Store*, a five-song set (spread across two separately issued, near-identical-looking singles) that further consolidated the stylistic restlessness revealed by *Snowball*, spanning Wratten's most ebullient pop song yet ('If You Need Someone') and his most sombre dirge ('Bleak'). Bob Stanley – for, of course, it was he – noted their music's potentially confusing multiplicity, writing that the duo could 'end up collaborating with either Coldcut or Johnny Cash'.

The photo accompanying the *Melody Maker* piece included only Hiscock and Wratten, but in fact the Field Mice's ranks had swelled the previous summer: Harvey Williams had become an honorary Mouse. Having moved from Cornwall to London at the beginning of 1989, he was already smitten with the Field Mice's recorded output (so much so that 'Sensitive' considerably influenced his own next A-side, 'You Should All Be Murdered') and had sent a letter to Wratten to tell him so. When he arrived in the capital, long-distance mutual admiration evolved into a friendship, and within weeks Williams was drafted in as second guitarist, principally to help bolster the band's still fragile live flair.

The trio made their debut in July at the Camden Falcon. It was there that they met Mark Dobson, an extroverted, outspoken club DJ who was as

admiring of the Field Mice's records as he was aghast at their lack of stage presence. 'Michael looked like a pissed-off Beach Boy,' he remembers. 'Bobby didn't just look shy and uncomfortable; he looked like he had been forced onstage at gunpoint.' He and Wratten discovered that they lived near one another, and Dobson was keen to interview him for a prospective magazine article, so Wratten dropped by Dobson's flat a few days later. The interview never materialized, but throughout the weeks that followed they rifled through each other's record collections and spoke of virtually everything to do with music except the Field Mice. 'The general impression I got was that he felt more comfortable talking about other bands as opposed to his own,' observes Dobson. 'It didn't seem to have occurred to him that he was in the same business as the bands he liked, that he had actually already got somewhere and may even go further.'

Dobson remarked to Wratten that he should let him know if he could do anything to help the band move forward. (Dobson secretly meant that he might want to become their manager.) Wratten said he would keep it in mind.

Among the very little information imparted in their brief *Melody Maker* feature, the most revelatory titbit was that the band had initiated a hiatus from gigging, which would continue until they added more members. This was despite having played a well-received set to seven-hundred people in Paris only weeks earlier. In particular, said Wratten, 'We're looking for a girl singer,' to which Hiscock added, 'Someone with the vocal qualities of Natalie Merchant and the lyrical capabilities of Tracey Thorn … not being too choosy!'

They weren't being idle, however, having returned to CAT again – with Williams in tow for the first time – to begin making a new EP. The sessions would bear the subtle mark of their recent recruit: throughout the latter half of the previous year, Williams had been enthusiastically introducing Wratten to music the songwriter had never thought to explore. 'Harvey was less entrenched in post-punk and the Joy Division–New Order–Echo & the Bunnymen–Postcard path that Michael and I had taken,' he says. 'He introduced me to the Beach Boys beyond *Pet Sounds*, and that had a big influence. We later found out that we had a lot more in common than we realized: Kraftwerk, OMD, the Jam.' As well, Williams, who was unashamedly still very interested in the ongoing, increasingly off-the-grid activities of the indie-pop community,

helped his bandmates understand – if not exactly learn to love – the musical hamlet with which the Field Mice had, like it or not, become associated.

Hiscock and Wratten had already made plain that they cared little about indie-pop. Increasingly, they were demonstrating how little they cared about accepted strategies of self-promotion among bands that are striving to build an audience. At the beginning of April, they recorded their first Peel session – an obvious honour, and a crucial means of exposure to an audience largely made up of avid record buyers. It was decided that the four songs laid to tape at the BBC – 'Anoint', 'Fresh Surroundings', 'Sundial' and 'By Degrees' – would be exclusive to the session, never to be made commercially available. Such perversity wasn't unprecedented: the choice was directly inspired by Glasgow band (and Field Mice favourites) the Wake, former Factory signees who had, to the surprise of everyone, joined Sarah months earlier. The Wake's own 1983 Peel session, preserved for posterity by Wratten when he taped it off the radio, was also entirely made up of stand-alone compositions. He and Hiscock covertly nodded to their tribute in 'Anoint', basing its melody upon 'The Drill', a track from the Wake's session. Despite instrumental assistance from Catt and Williams, recording was tense: as was custom, studio time was limited to twelve hours, and it wasn't until they arrived at the BBC that Wratten discovered two songs were in the wrong key for his voice. Yet what resulted was exceptional: 'Sundial' a glistening, instantly memorable love song; 'Anoint' and 'By Degrees' precursors to the band's imminent stylistic breakthroughs. Rarely heard since, the session remains some of the very best music the band made. 'Sundial' was performed once more for a French radio session; the rest were never revisited.

While no one who heard the Peel session could purchase the songs that were broadcast, it seemed to contribute to the band's popularity as a live draw. Subsequent dates as a trio in Manchester, Leeds and Hull (their promised reprieve from the stage proved short-lived) were sold out. In June, the Field Mice again challenged their audience and those who would pigeonhole them. The mini-album *Skywriting* was a curveball in almost every way. A twelve-inch record (Sarah's first, not including compilations), its A-side was given over to 'Triangle', a nine-minute attestation to their love of dance music – in particular New Order's 'Blue Monday', whose double-time kick drum is referenced in the first minute. The reverse side is filled to the very limit of its capacity with more

than half an hour of startling genre-hopping, taking in brisk country ('Canada'); weightless, spectral pop ('Below the Stars', the 'fractured nature' of which, says Wratten, was influenced by his exposure to Williams's bootlegs of the Beach Boys' unreleased *Smile*); and the gleefully mischievous experimentation of 'Humblebee', in which a bed of featherweight guitar modulations is garnished with random samples that are variously haunting (ominous laughter, 'Um … well…') and hilarious ('Chocolate, love, sex', 'I'm not a lawyer!'). Reviewing it in *Melody Maker*'s singles column, Everett True concluded, 'I fear the time is long overdue for Sarah to be afforded serious critical appraisal.'

In keeping with their keen work rate, no sooner was *Skywriting* in shops than the band had returned to CAT, which was becoming busier. The greenhorn duo that first entered Catt's studio almost three years prior had become his foremost calling card. Among recent clients who sought out his services as a result of the Field Mice was none other than Bob Stanley, the *Melody Maker* journalist. Together with his friend Pete Wiggs, a singer named Moira Lambert and a guesting Harvey Williams on bass, they had recorded a shockingly brilliant dance version of Neil Young's forlorn folk lament 'Only Love Can Break Your Heart' under the name Saint Etienne. Done and dusted in a mere two hours, the song was the inaugural release for Heavenly, a label founded by former Creation publicist Jeff Barrett. It caused a sensation throughout the summer among both indie and dance circles, and it seemed certain to chart. For its follow-up, scheduled for release in September, Stanley and Wiggs recruited a different singer, Donna Savage of New Zealand band Dead Famous People. Not yet confident as songwriters, they chose another cover, but one that wouldn't require remotely so radical a reinvention: the Field Mice's own 'Let's Kiss and Make Up'.[1]

The outcome of the Field Mice's divergent influences was that, unintentionally, the music they were making of late arrived perfectly timed to take advantage of the indie-dance crossover being led by the Stone Roses, Happy Mondays,

[1] Hiscock and Wratten had become friends with Stanley, and the Field Mice and Saint Etienne were initially somewhat intertwined. Years later, Wadd wrote: 'The demo of Saint Etienne's version [of "Let's Kiss and Make Up"] actually featured Bobby and Michael on guitar and bass. … And, somewhere, Bobby still has a tape of the very first Saint Etienne demo, with Michael on bass, himself on guitar, and Bob Stanley on vocals.'

Primal Scream and, most recently, Saint Etienne. The compliment implicit in the latter group choosing to cover 'Let's Kiss and Make Up' – other than that Stanley and Wiggs obviously liked it – was that many of Wratten's songs had the potential to be proper hits. Saint Etienne were aiming for the mainstream, and they felt sufficiently confident that Wratten could take them there.

If mainstream success was of interest to Wratten, however, it would have to be the result of the mainstream bending to his will, not vice versa. The next Field Mice record dispensed entirely (for the moment, at least) with *Snowball*'s and *Skywriting*'s dance dalliances. *So Said Kay*, a ten-inch EP, is entirely acoustic, all but one of its five songs a five-minute ballad, often evoking not the teeming streets of London or even the hushed row houses and sodium lamps of suburban Mitcham, but the verdant, rolling countryside. Released in September, there was some sort of symbolism in it winning critical plaudits (the most prominent of which was from Everett True, who proclaimed it *Melody Maker*'s Single of the Week as well as 'Godlike') while Saint Etienne's single, given the truncated title 'Kiss and Make Up', charted inside the Top 100 – a considerable feat in 1990 for a new band signed to a new label.

The habitual shock-of-the-new factor of each Field Mice release was of a piece with their concerts, wherein songs that an audience would recognize – including those from whichever record the band was ostensibly promoting at the time – were regularly dismissed in favour of new material unknown to everyone but those playing it. 'We weren't being mischievous, just true to ourselves,' explains Wratten. 'Post-punk shaped our ideas and aesthetics, and post-punk was very much about constantly moving forward, never looking back. We would go to see New Order and they would sometimes start with a brand-new song, immediately creating a nice kind of tension that separated them from groups that opened with a crowd-pleaser. It was creative rather than re-creative.'

The dates that the Field Mice played in September were no exception. In fact, in terms of delivering the unexpected, they excelled themselves. As well as the conspicuous absence of most of the songs from *So Said Kay* (and every record that preceded it) and the bemusing presence of songs that wouldn't see release for up to a year, there were five people on stage.

The Field Mice's expansion to a quintet had happened quickly, earlier in summer. Following a support slot for the Wake at Sheffield University, Wratten was approached by one Chris Cox, who had travelled to the gig from Manchester. A familiar name to Wadd and Haynes, he had sent them demos of a not-terribly-serious band he had formed named the Purple Tulips. It was one of these demos that he passed along to Wratten, accompanied by a letter from one of Cox's bandmates, nineteen-year-old Anne Mari Davies. Davies explained in the letter that word had reached her about the Field Mice's search for a female vocalist, and that the tape was, to all intents and purposes, her application for the job. What she chose not to mention was that she had been in the audience at the Manchester Boardwalk a year earlier, where the band – still a duo – stood helplessly before an underpopulated room while their drum machine broke down.

Wratten arrived home from Sheffield at 6.00 am and played the tape. When he next saw Hiscock, he put forward a major proposition: not only should Davies join, so should Mark Dobson, who casually mentioned months earlier that he played drums. 'I hadn't heard him drum,' admits Wratten, 'but I liked him a lot'. Says Dobson: 'To this day I have no real idea why he asked and no real idea why I said yes and thought I could pass myself off as a musician.' His inclination to accept might have had something to do with having declined a similar offer from the Sundays, who had since signed to Rough Trade and become the toast of the music press.

Davies and Dobson both received their offer via a letter from Wratten, and soon he, Hiscock and Williams drove to Manchester to meet Davies. The astonished teenager, who hadn't expected her solicitation to lead to anything, offered the group 'a whole new set of colours with which to paint', in Wratten's estimation: in addition to vocals, she played guitar and keyboards. 'There was no interview, no audition,' says Davies, 'just an offer to meet them in Manchester' and a 'vague' suggestion that, as well as their upcoming British dates, she could accompany the band on their debut tour of Japan, coming up in October. Dobson met everyone shortly afterwards at a pub in Mitcham. 'I think it helped me that Anne Mari was joining at the same time and her being nervous, too,' he says. 'Once I met Michael and Harvey, I knew it was all going to be okay and that I wasn't making some huge mistake.'

Davies's memory of the September tour, which spanned roughly ten dates, was 'mainly just laughing and laughing', while Wratten notes that the band, both onstage and off, was immediately transformed by its new arrivals. 'As soon as you have a live drummer, you feel more confident on stage, less vulnerable,' he says. 'Audiences are notoriously conservative and if they don't see a drum kit centre stage, they get suspicious. So it enabled us to relax.' He also welcomed Dobson's 'wonderfully warm, incredibly funny' personality, as well as Davies's mere presence serving to 'break up that boys' club atmosphere, although we were never a testosterone-fuelled beast'. Furthermore, the drummer's relative business savvy helped alleviate the economic woes associated with Wratten's avowed cluelessness regarding promotion and negotiation. 'The first thing I sorted out was getting some T-shirts made up to sell on the tour so we had money for food, which nobody seemed to have thought we might need! I got the impression Bobby thought I was crazy and that nobody would buy them, but we shifted plenty.'

It was customary for the Field Mice to schedule dates around their day jobs (and, in the case of Davies, full-time studies at the University of Manchester), so when they were booked as part of a three-band Sarah festival in Lausanne, Switzerland, towards the end of September, they flitted across the water for less than twenty-four hours. Years later, Wadd would write: '[The] audience hadn't heard of any of the bands and soon drifted away to the disco downstairs, and afterwards we were split up and dumped in different empty apartments in various locations across the city, not knowing where we were, who our hosts were, or where anyone else was.' She also recalled that while everyone else spent the early morning hours trying to sleep, Davies and Wratten took a long morning walk.

It didn't take long for Davies to recognize that Wratten wasn't especially fond of touring, despite the September tour having been his idea as part of a strategy (alongside the recruitment of new members) to help the Field Mice become a more serious proposition. His mood could swing dramatically, and it wasn't uncommon for him to disappear for several hours before a gig. 'Where the others would perhaps just let him get on with it,' she says, 'I would find myself wandering the streets of cities I'd never visited, trying to find him.' Davies's self-consciousness around her bandmates, whom she viewed

to be much more worldly than herself, coupled with Wratten's resolute loner streak and disinclination towards typical on-the-road merrymaking, meant the two of them began spending a great deal of time together. Once the band had returned from Japan in late October (with a drum machine temporarily taking the place of Dobson, who stayed home in anticipation of the birth of his daughter), a relationship was blossoming.

If not for the fact that it had been written before they met, someone privy to the development might easily have assumed that the song the Field Mice recorded in November for their next A-side was Wratten's response to his new romance with Davies. 'September's Not So Far Away' may be the most guilelessly optimistic song in the group's canon, a new-morning declaration of the belief that love conquers all. 'I will, I'll always remember/The days and nights we spent together/The happiness of being with you/The sorrow of parting from you', he sings, Davies's harmony vocal confirming that the object of his affection is in complete sympathy. The song radiates such beaming contentment, it obscures the fact that the session was, according to Wratten, 'disastrous'. The new presence of live drums necessitated recording the song at another studio (Catt's usually permissive neighbours would never have allowed such a racket), so the band booked a facility in Islington, where they and an in-house engineer failed to click. The result, its author says, was 'a rough, live-sounding version with sleepy vocals and radical tambourine. We trudged back to Ian's with tails somewhat between our legs'. Catt rerecorded everything but the drum track. Only after it was complete did everyone discover they had mistakenly rebuilt the song upon an earlier, inferior take of Dobson's four-on-the-floor pummelling. It would have to do – there was no time or money left to start again.

Between the recording of 'September' and its release in March 1991, much happened within the Field Mice camp, but little of it in the public eye. *Melody Maker* published another miniscule feature, its accompanying five-member photo contrasting dramatically with the portrait of a duo that appeared only nine months earlier. Evidently, the forthright Dobson dominated the interview, speaking with a vocabulary of self-belief that was alien to the rest of the band. 'We can do anything – acoustic, dance, rock, whatever,' he said. 'If we'd been American or had a different name, we'd be hugely famous by now. … In ten years' time, people will regard our records as classics.' There

was also a headlining slot in December at the inaugural Sarah Christmas Party at Islington's Powerhaus; and in February there was a festival in Brittany, which saw them promoted to the top of the bill when the day's nominal star attraction, ludicrous goth cowboys Fields of the Nephilim, broke up mere hours beforehand. Standing upon a stage that was 'bigger than the venues we were used to playing', says Dobson, they handily won over a one-thousand-strong audience, and no sooner had they returned to their dressing room than it was crushed full of well-wishers and autograph seekers.

But away from the stage and the studio, the band – so recently a fount of fresh enthusiasm as it entered its latest, largest phase – was beginning to fracture amidst unspoken grievances and a decidedly British fear of confrontation. Wratten and Davies, increasingly besotted with one another, spent the majority of their time away from everyone else, leaving Hiscock dismayed about his best friend's prolonged absences. At the same time, the honeymoon phase of the couple's courtship was tempered with guilt. They had already been involved with each other for some time before they mustered up the courage to extricate themselves from pre-existing relationships: Davies with a boyfriend in Manchester, Wratten with Wadd – the by-product of an agreement between her and Haynes to see other people while remaining a couple, thus alleviating the stress and boredom of living and working side by side seven days a week. Although their break-up was amicable, it nevertheless made band-label relations uncomfortable for a time. 'Neither of us intended it to happen', says Davies. 'I don't think I thought very much about how it would affect the band. I was more concerned about how it might affect my current relationship, and I felt guilty and anxious and trapped. I was selfish in my feelings, but they were pretty strong'.

The band's suddenly strained rapport with their label was compounded by Wratten's increasing despair over the inherent drawbacks of being aligned with Sarah. A *Melody Maker* review of 'September' found Simon Reynolds using the record as an opportunity to build upon a joke he had established when he reviewed 'Sensitive' in 1989, suggesting to unaware readers that the Field Mice were practitioners of profane, futurist noise-rock:

'Death and my cock are the world', intones the lead singer, before plunging into the priapic odyssey to the limits of experience that is 'September's Not

So Far Away.' [It] proves once again that the Field Mice are one of the few groups to grapple with the new technology, yet reinvoke rock's Dionysiac primitivism.

As had become common practice at each of the weeklies, the single was assessed with other recent Sarah releases as part of a 'cluster' review, thus inferring that everything to which Sarah affixed its name deserved to be judged only within the context of Sarah itself.[2] What this meant to the Field Mice was that for however long they remained with Sarah, they could never simply be 'the Field Mice'; they would be 'Sarah Records' the Field Mice'. Wratten could only guess what this might mean to the success or failure of the band's full-length debut, which they were about to start recording. All he knew in the meantime was that Sarah's meagre budget meant both the album and a stand-alone single, which was to precede it, would have to be completed in only ten days.

Wadd and Haynes generously sympathized with Wratten's position; they, too, felt that the Field Mice deserved to achieve greater success and to be evaluated fairly, even if it meant leaving Sarah. But they also questioned whether Wratten, in particular, would be capable of dealing with a larger label. He and Hiscock had been appalled when a representative from Mute Publishing expressed interest in the group, suggesting that they change their name and use *Skywriting* as a demo to attract a better deal. If Wratten struggled to cope with the minor rigours of a short domestic tour, the inevitably greater (and, unlike at Sarah, contractually enforced) demands of another company would surely break him.

In the end, the sessions for the album – most of which took place over Easter holidays, when Davies was free from university – were rushed but successful. Fifteen songs were recorded ('More material than we needed,' says Wratten), ten of them destined for the album, to be titled *For Keeps*, and three for a single. The band had been introduced to most of the songs by Wratten, who continued to write in isolation, at rehearsals throughout the preceding

[2] To be fair to Wratten, he has no recollection of having read Reynolds's review when it was published, and when he did find out about it (while this book was being written), he found it hilarious. He was, however, all too aware of the weeklies' tendency to review Sarah releases together in a single piece.

months. Davies, however, who was hours away in Manchester and usually available only at weekends, learnt the songs from cassettes Wratten sent to her, always accompanied by a letter and handwritten lyrics that made plain who and what was occupying his thoughts. 'It's weird reading about your own relationship,' she says. 'The anticipation as I opened up the letters and read through the words – sometimes it was the way I found out about how Bobby was feeling, or how he had reacted to something I'd said or done. It did make our relationship very public, although many of his lyrics were a bit [oblique]. Most of them were based on the most intimate details of our times together.'

A cassette of the album sessions arrived at Sarah following weeks in which there had been no communication from the band. Unfamiliar with most of the songs, Wadd and Haynes found it challenging to offer feedback because, inexplicably, no tracklisting was enclosed. (In the end, they created song titles of their own, some of which the band ultimately used.) Wadd was, however, able to recognize in Wratten's lyrics that the songs that weren't about the beginning of his relationship with Davies were about the disintegration of his relationship with her. Most transparent of all was 'Willow', a spare guitar-and-voice elegy: 'I said to you I'll always want you and want you only/Now there's another that I want and I want only … I'm sorry if my being honest hurts you/Don't you go thinking I never did love you.' The song was additionally haunting to Wadd given that it was sung by Davies – the result of a snap decision made by Wratten when attempts to sing it himself in rehearsals led him to temporarily discard it. Variously flattered, heartbroken and annoyed, Wadd knew that Wratten's public platform, coupled with mutual friends' knowledge of their affair, equalled an imbalance of power in his favour. 'Having songs written about you seems like it would be great', says Wadd, 'until someone does it, and then you find they have a voice and you don't, their truth stands and yours is lost – forever, actually. Your head tells you that even with a very literal songwriter, your version is lost in the interests of rhyme or a nice turn of phrase or because something scans better, but your heart gets focused on the "That's not quite what I said" stuff, and it irritates you.'

'It was always only my side of the story, so that inevitably introduces an element of unfairness,' Wratten concedes. '*For Keeps* now reads like a diary of sorts: it's my thoughts and feelings from early summer 1990 to late spring

1991. There was certainly no reluctance on my part to write autobiographical songs. It seemed perfectly natural: a lot of my favourite writers at the time explored the deeply personal. I wasn't concerned about going too far or revealing too much.'

Come late spring, before those songs were let out into the wider world, Wadd set aside whatever ill feelings she harboured about Wratten and worked with him to determine the tracklisting for *Coastal*, a compilation culled from the band's discography to date. The purpose of the collection was twofold: it was to serve as a consolation prize for those who hadn't acquired the singles and EPs, many of which had sold out and weren't being repressed; and it would prime the public for the single and album coming in September and October, respectively. Scheduled for release in August, *Coastal* was a metaphorical farewell to the first phase of the Field Mice and an immediate precursor to the second. It likely was no coincidence that its artwork recalled *Substance*, New Order's bestselling house-clearance set from 1987. 'Within the band there was some talk of it being a backward step or a distraction from the forthcoming new records,' says Wratten, 'but what actually happened was that it paved the way for them.'

Indeed, within two weeks of release, *Coastal* sat at the top of the *NME*'s Independent LPs chart, a first for Sarah. In his four-star review for the new monthly magazine *Select*, Graham Linehan wrote, 'The Field Mice have drifted peacefully along for three years now, out of sight and almost out of mind, so obviously the time for world domination is now – or pretty soon, at least.'

Linehan was surely indulging in poetic licence, no matter how fond he was of the group, but from a distance it must have looked as though an unprecedented degree of ambition had taken hold of Wratten and co. In little more than two months, they were bringing three releases to market, cumulatively leading up to a twelve-date tour – their longest yet. And, for the first time, Sarah planned to take out adverts in the weeklies to publicize this relative whirlwind of activity. To Wratten, however, any notions of commercial strategizing would have been an illusion. While the idea of becoming more popular certainly appealed to them, they simply didn't possess the sort of minds capable of mapping out how to achieve it. *Coastal* had been 'just a thought that very quickly became

a reality', he says, and the advances they were making in terms of sales and critical regard seemed too incremental to constitute a great leap forward.

> I don't think we ever thought in terms of 'taking it to the next level'. Clare and Matt would point out bands to us who were doing forty-date tours and hint that that's what we should be doing, but there was no way we could even entertain such things. We were a pretty poverty-stricken band, both in monetary terms and in terms of time.

Instead, they kept their heads down and carried on living their modest lives: day jobs, rehearsals and, in Dobson's case, new fatherhood. But when the new single from the *For Keeps* sessions was released in October, it served notice that the Field Mice had, intentionally or not, taken it to the next level.

Before bringing it to the studio, Wratten had ideas as to how he wanted 'Missing the Moon' to sound, but with no equipment at home other than his guitar and drum machine, he would have to leave it to Catt to interpret and actualize what he heard in his head. Initially, it was 'just one of the tracks we worked on during the making of the LP', albeit seven minutes long, and boasting exquisite major-to-minor vocal melodies that are simultaneously euphoric and heartbreaking. Catt had used sequencers twice before in Field Mice sessions, for 'Let's Kiss and Make Up' and 'Triangle'. New technology at the time, it allowed him to carry out the remarkable feat of transposing a recording of one instrument (say, Wratten's guitar) and realizing it as another (in this instance, an hypnotic loop of electronic pulses). From the moment he put the sequencer to work for 'Missing the Moon', Catt knew it was 'obviously very different from everything else we'd done for the record up to that point'. Hiscock and Wratten had primed him with a handful of long-loved records: New Order's 'Everything's Gone Green', Section 25's 'Looking from a Hilltop', 52nd Street's 'Cool as Ice'. All of them had some degree of affiliation with Factory Records and Manchester, had been an early 1980s dance-floor favourite, and were released as a twelve-inch single. Once finished, it seemed apparent to everyone that 'Missing the Moon', not least because of its length, merited the same format. To convince Haynes, whose entire moral framework seemed built upon opposition to twelve-inch singles, would be no small task.

'"Missing the Moon" would have sounded terrible pressed on a seven-inch,' says Wratten. 'Michael must be given credit for talking them out of that idea. Some songs belong on a twelve-inch single – it's a question of aesthetics and also that the deeper grooves make for a better sound. Sarah were so hung up on the economics of the format, seeing them just as a way to swindle people, that they couldn't see the pros of it. It had nothing to do with wider profit margins, just a sense of what's right. In the end we agreed on a twelve-inch at seven-inch price, so everyone was happy.'

More so than any of the label's releases, 'Missing the Moon' offers a definitive example of the extent to which British music journalists struggled to – or wilfully chose not to – critique Sarah acts apart from their assumptions about Sarah itself. Sleek, of its moment, and entirely divorced from indie guitar music, its relationship to the iteration of the Field Mice that made *Emma's House* is as tenuous as 'Loaded' is to the Primal Scream of 'Velocity Girl.' Yet *Melody Maker* perplexingly dismissed it as 'bedsit disco' (a term Tracey Thorn would happily appropriate years later when it was also used to describe Everything But the Girl's surprise foray into dance music), finding 'the fiddly dance beat distracting annoyingly from the wistful male and female vocals, the song fey and meandering.'

To be judged fairly, it seemed, 'Missing the Moon' would have to fall into the hands of someone who had little to no knowledge of Sarah or its artists. And at the *NME*, it did. In declaring it 'TOTAL ABSOLUTE SINGLE OF THE WEEK', as per its headline, Ian McCann wrote that it was perhaps the first record that merged elements of indie and house music without sounding like an unwieldy juxtaposition of incompatible genres (as per Primal Scream, whom he opined 'either do one or the other'). 'This record is not a great record, but it is, in its own little way, important … The Field Mice: Voice of the Future? No, I can hardly believe it either, and certainly not a hit. But a leading record all the same, available from all slightly peculiar record stores.' Whether McCann had listened to the two B-sides, both country-flavoured acoustic ballads (one featuring a harmonica solo played by Catt), he didn't say. 'That was probably the best review we ever had', says Haynes, 'because it was by somebody who had absolutely no preconceptions. Just completely on its own merits.'

It was an auspicious beginning to September, and there was more good to come: John Peel and fellow BBC DJ Mark Radcliffe played tracks from the imminent *For Keeps*, and *Melody Maker's* Dave Simpson interviewed the band for a promised full-page feature hours before they left for a short French tour with the Wake. Everything boded well for the October release of *For Keeps* and the British tour that followed. But almost no sooner did they arrive in France than their union began to crack. Tensions flared the first night, leading Hiscock to travel with the Wake instead. Meanwhile, Davies was finding it increasingly difficult to get onstage. It would be a long time before she discovered why. 'It isn't easy to remember much of that time', she says, 'and I think that's because, sadly, I was hovering on the edge of depression and anxiety. Although I didn't really get "ill" until the end of the French tour, I hadn't felt right for a year or so before, and I was, looking back on it, heading towards my breakdown for some time. Why? Who knows. The pain of growing up, my inherent guilt, trying to keep on top of a degree and travelling up and down the country every weekend for band commitments, the intensity of my relationship with Bobby, low self-esteem...'

At least there was the consolation that no one had been hurt when their French tour manager crashed the van (save for the manager himself, who broke his ankle).

The band arrived home tense and unhappy, so much so that they were able to draw little joy from the uniformly positive reviews of *For Keeps*, or from the *Melody Maker* feature, in which Dave Simpson demonstrated an understanding of the Field Mice that no journalist had before. In addition to pointing out their parallels with Factory, he noted that they were

> one of the most consistently successful truly independent bands in the country. They've had hardly any radio airplay, no television appearance, zero advertising and a bare minimum of press coverage, and yet have built up a fan base that means they can regularly outsell most of the independent groups that fill up our papers ... and many acts on major labels.

In its final paragraphs, Simpson disclosed that the band were, '[with] much regret', looking to sign to a larger company. Wadd and Haynes requested a meeting with the band to talk about this very issue. It was agreed that they

would do so backstage before the tour's second-to-last date, 16 November at King Tut's in Glasgow.

Throughout the weeks leading up to that day, Wratten had ample opportunity to contemplate everything that disenchanted him about the Field Mice despite their mounting success. En route to a tour date in Leeds, he says, 'I remember listening exclusively to a cassette that had *Laughing Stock* by Talk Talk on one side and *Loveless* by My Bloody Valentine on the other. No one was talking by this point. I was thinking how far behind these records we were and how they were everything I loved about music and, unfortunately, we were not.' And it still rankled him to think about recent clashes with Wadd and Haynes: their stated dislike of various *For Keeps* tracks, a showdown about the album's artwork that saw the label prevail. When the band reached Leeds, Wratten confided in Hiscock that he wanted to quit. To this day, the former isn't sure if the latter thought he was serious.

There must have been at least a glimmer of hope for reconciliation when everyone huddled backstage following soundcheck at King Tut's, because most of those assembled expressed genuine shock when Wratten announced, before anyone else had the opportunity to speak, that he was leaving the band. 'I just saw my chance of escape,' he says. 'I was beginning to feel trapped, and with

Figure 8.2 *A fan (left) meets Bobby Wratten and Anne Mari Davies on the Field Mice's final tour, 1991. (Courtesy of Dave Harris)*

talk of another French tour being lined up for '92, I knew I had to make a move before further plans were made.'

Dobson, incensed, wanted to return home immediately but couldn't afford a train ticket. Davies, already consumed with the stage fright she had to struggle through every night of the tour, became terrified that everyone would blame her for Wratten's decision. Wadd recalled that night's set as 'ill-tempered', and she would envy Williams's decision to travel back to London alone; the agony of a silent, sorrowful van journey was drawn out hours longer due to bad weather and traffic.

But it wasn't quite the end yet. There was still one more gig, five days later at Tufnell Park Dome, that had to be honoured. An Australian fan brought a video camera, capturing for posterity the sight of a band in its death throes, occasionally smiling gamely but otherwise trying to not look like five people bearing witness to their own funeral. 'You could have cut the atmosphere with a knife,' says Davies. 'And I was so, so unhappy.' Urged by the audience to perform an encore, either humour or morbidity moved them to select *Snowball*'s bereft ballad, 'End of the Affair', Davies singing it instead of Wratten. Hiscock punctuated the evening, stepping up to the mic as everyone slunk offstage and announcing, 'The end.'

'I was frustrated on their behalf,' says Tim Chipping, their fan and friend. 'I wanted the Field Mice to be big just to feel vindicated that this band I'd been banging on to everyone about for ages – I wanted to go, "Do you see? I *told* you they were great!" But clearly that would have been awful for them. At the final gig, Island and Virgin, I think, were there in the audience, ready to sign them, and Bobby had said no. Now, of course, that would be the right thing to do, to say no to a major label. But at the time it just seemed like, "But you have *no money*! Do you not *want* some?"'

'They wanted to be as famous as the Go-Betweens, I think,' says Wadd, 'but I don't think you can *set out* to be as famous as the Go-Betweens and succeed. You have to set out to be *more* famous and fail. They wanted it and didn't want it: they didn't want to jump through the hoops they would have to jump through, but they also wanted to be more successful than they were and they felt constrained by us toward the end. There are two ways of looking at it: one is we held them back, and the other is they might not have got ahead at all if it wasn't for us.'

Months after the event, a fanzine asked Dobson why the Field Mice had split. His reply – concise and spoken without forethought – was as vague as it was diplomatic. 'It's hard to say, really. There seemed a tragic inevitability about it.'

When Wratten dropped the bombshell that he was quitting the Field Mice, his disillusionment was such that he had it in mind to never write or perform again. 'That lasted about five minutes,' he admits, 'though I could happily have never played live again.'

Earlier, however, when he had been contemplating various exit strategies, the idea of beginning something new with just Davies seemed especially attractive. They remained a couple following the split, living together and discovering new music that captured Wratten's imagination in particular. 'I remember we were listening to John Peel and he played 'Papua New Guinea, the "Dumb Child of Q Mix," by the Future Sound of London, and we both loved it and it seemed to be a world away from what we could have done in the Field Mice.'

In the new year, he was contacted by Danceteria, a Paris-based label that had been distributing Sarah's releases in France. They inquired as to what he planned to do next, and if he would want to do it for them. In fact, Wratten hadn't been thinking much about what he planned to do next, but since they asked…

Using a four-track recorder Davies had bought, he began demoing new songs, and he signed to Danceteria before the project had a name. He also drafted in Dobson, who had been quick to forget past divisions. But before the trio could enter a studio, Danceteria declared bankruptcy. Quite remarkably, Wratten then ventured to send a demo to Sarah, with whom, for obvious reasons, he had barely spoken for some time. Wadd and Haynes were complimentary about the name he had conjured up for the group – Northern Picture Library – but otherwise, Wratten says, 'they completely trashed the demo, quite graphically pulling it to pieces. They did say we could do a single for them to help get us started, but it just felt like we were being patronised, so we said, "Thank you, but no."'

Dobson surreptitiously sent the tape to Vinyl Japan, a Tokyo-based label that had opened a satellite office in London, and they eagerly offered the

band a contract for a single and an album. It was under this arrangement that Wratten made some of his best, yet least appreciated, music yet. In September 1993, almost two years after the Field Mice's farewell, Northern Picture Library debuted with the single 'Love Song for the Dead Che', a cover of a song from the sole album by late-1960s avant-garde pop collective the United States of America. (Now a widely recognized underground classic, the record's exceptional obscurity at the time showed that Wratten was seeking out left-field revelations with keen aggression.) Both it and the Northern Picture Library album that followed a month later, *Alaska*, are largely given to filmic, nocturnal soundscapes weighted with an indefinable longing and rootlessness – the title of one of the tracks, 'Dreams and Stars and Sleep', evokes their common mood. Wratten's voice doesn't enter until almost four minutes into the third song, and throughout the album's hour-long duration, brief instrumentals lend to an atmosphere of ever-shifting perspective, as if

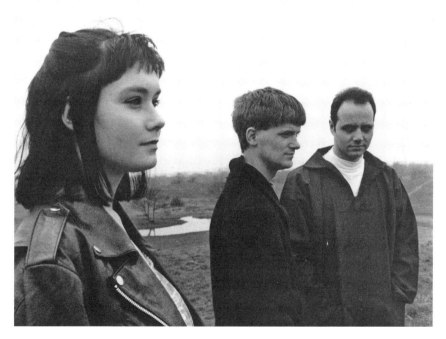

Figure 8.3 *Following the break-up of the Field Mice, Bobby Wratten (right) formed Northern Picture Library with Anne Mari Davies and Mark Dobson. (Photographer unknown; courtesy of Sarah Records)*

the listener is wandering from room to room, each doorway opening onto a new sonic environment. Although reviews were generally kind, the Field Mice's audience largely considered it a step too far from familiar territory, while Wratten felt disappointed in himself for not straying far enough. '*Alaska* is compromised by the fact that I edited myself in terms of making sure there were pop songs on the record alongside the things that I actually wanted to do,' he reasons. 'To a certain degree, I think it was a project that failed.' He remains even more critical of *Blue Dissolve*, an EP released in June 1994 that leads with 'Dear Faraway Friend', an eleven-minute excursion from conventional balladry to a prolonged coda of increasingly dense cacophony. 'It was the first time I'd gone into the studio to make a record knowing I wasn't ready,' he admits, 'and I'm still not certain how that came about. All I know is that when you have to employ a second reel of tape when what you're recording is ostensibly a single, then things are going awry'.

Whatever his thoughts were about the records, Wratten had loved recording for Vinyl Japan – their working relationship consisted of the label giving him a budget and stepping back to let him do as he wanted. But in the wake of *Blue Dissolve* being released to deafening critical and commercial silence, Dobson once again initiated a covert solicitation: he alerted Wadd and Haynes to the fact that Wratten had recently written some of his most melodically and structurally conventional songs since the Field Mice. When the couple expressed interest in hearing them, Wratten immediately felt sentimental, all past turbulence forgiven. 'I always felt Sarah was where I belonged,' he says, 'especially as without Clare and Matt I'd almost certainly have never gotten to make records'.

And so, as swiftly as he, Davies and Dobson had left the Sarah fold, they once again were within. In September, the label released two singles in quick succession, 'Paris' and 'Last September's Farewell Kiss.' They both proved eerily portentous: the latter for its title, the former for its lyric, sung by Davies, in which a woman leaves her beau because 'It isn't that I don't want to be yours/It's that I don't want to be anyone's.' Although the song's jubilant waltz-time rhythm suggests a celebratory sort of liberation, it was released against a backdrop that could not have been more contrary. Between recording it and Sarah presenting it to the public, Davies and Wratten broke up, bringing an

immediate end to Northern Picture Library. Davies rented a room in South London and continued her battle to overcome the issues that had prevented her from joining Northern Picture Library for the few live performances they undertook. 'I think it's fair to say I was suffering a full-blown anxiety disorder,' she says. 'I was pretty agoraphobic: frightened to get on public transport, of being in a crowded place, of being anywhere that wasn't "safe." I remember reading a chapter in *No One Gets Out of Here Alive* that describes a bad acid trip, and it felt like my entire waking hours.'

Wratten, devastated and drained of confidence, 'hid away for practically a year.' When he re-emerged – from another bedroom, in another home and with another set of embryonic songs whose destiny he couldn't yet fathom – Sarah was all but finished. But he, in many ways, had barely begun.

9

'I Sometimes Feel So Lost':
Brighter

At its burdensome peak, Sarah was receiving in excess of a dozen demos per week, each of which required an attentive ear and, more often than not, a polite letter of decline from Wadd or Haynes. These were in addition to the hundreds of letters that were flooding in from as near as London and as far afield as Sydney and Tokyo. Haynes would eventually comment that if he and Wadd neglected to visit their PO box for a few days, the staff would simply hand them a sack.

One of the cassettes auditioned at Upper Belgrave Road during the latter half of 1988 came in a handmade cover that announced its amateurism to a degree that would have elicited only pity and embarrassment from virtually any other label in the country. Crudely rendered in coloured pencil, it could have been mistaken as a parody of indie-pop's most infantilizing clichés: a childlike illustration of a bowlcut-topped figure peeping over a wall. Oddly for a demo, it had a title: *Wot! No Acid?*, meant as a playful elbow to the ribs of Acid House, the musical and youth-culture revolution that the makers of the cassette were evidently sitting out. In terms of first impressions, it didn't bode well. Yet the contents of the tape, after an unusual – and, at times, disputed – degree of creative intervention, would soon prove surprisingly impactful, to the extent that a substantial number of the demos Sarah received in the ensuing years were blatantly in thrall to it.

Wot! No Acid? was credited to Brighter, suggesting the work of a group. But, similar to Another Sunny Day, it was in fact the deceptive alias of an individual, in this case Keris Howard, a 21-year-old native of the seaside town of Worthing. The trajectory of Howard's listening habits through adolescence was similar to that of countless British youth who came of age during the 1980s: early puberty unfolded to a soundtrack of the brooding electronic soundscapes of New Order and Orchestral Manoeuvres in the Dark, until a discovery of the Smiths in the middle of the decade turned his head towards guitar music. The effect upon the bedroom musical experiments of Howard and his schoolmate, Alex Sharkey, was immediate: Howard abandoned the Casio keyboard that had dominated his attention, and he retrieved from the closet an acoustic guitar that had been gathering dust for years. He also stopped trying to sing like New Order's Bernard Sumner.

Howard moved away from Worthing in 1985 to study at the University of Birmingham, leaving behind his girlfriend, Alison Cousens, as well as Sharkey. But when Cousens graduated the following year from the sixth-form college where they had met, she too enrolled at Birmingham, and they moved in together. Chief among their commonalities was a love of *NME C86* and the seemingly non-stop onslaught of new indie bands introduced to them by John Peel. Thus, one of their favourite social activities was going at every opportunity to Birmingham's Click Club to see the likes of Primal Scream, My Bloody Valentine and the Sea Urchins.

Shortly after graduating, Howard made the demo that found its way to Sarah – the only label to which he sent it. Recorded onto a four-track at his parents' house, where he had returned for the summer before rejoining Cousens in Birmingham for her final year of studies, its threadbare sound betrayed the absence of other people, as well as the fact that Howard was still very much coming to grips with the guitar. It also made plain that Howard didn't as yet have a stylistic vision but was willing to try more or less everything in pursuit of finding some sort of authentic expression. Of the more than half-dozen songs on it, each one sounded indebted to a band of the moment – including some who were already recording for Sarah. 'It was *very* affected,' admits Howard. 'It had songs on it which sounded like the Sea Urchins, ones that sounded like the Jesus and Mary Chain or maybe the Primitives – that buzzy

kind of guitar stuff. It had some stuff which sounded like the Cocteau Twins, more instrumental. I was finding my feet playing the guitar, and trying to find my feet is what Brighter sounded like.'

If *Wot! No Acid?* had arrived at Sarah a year later, Wadd and Haynes might have been too busy to listen to it more than once before moving on to the next young hopefuls vying for their attention. But it was early in the label's history, so they had the opportunity to play it numerous times while replying to letters, processing orders and hastily consuming lunches of chickpeas with brown sauce in their windowless kitchen.

Eventually, Wadd and Haynes detected potential lurking within Brighter's musical identity crisis – specifically, some slower songs built upon yearning minor keys, each of which ambled to a conclusion not very different from its beginning. The linearity of the songs' construction – an unintended consequence of Howard's inexperience – gave them a meditative, consoling quality that was unlike anything Sarah had received before. 'There were a lot of bands sending us tapes of upbeat pop songs,' says Wadd, 'and I'm not saying that Keris didn't write good fast songs, but it was the slower ones that leapt out at us. "Different" was quite high up our list of criteria.'

It was with this in mind that Wadd and Haynes offered Howard the opportunity to make an EP, with the proviso that they would choose the tracks. Howard, pleased simply to have the opportunity to make a record, was happy to be collaborative. Given Brighter's lack of a drummer – or of anyone other than Howard – it made sense to book a session at the diminutive home studio of Ian Catt, whose recent work with the Field Mice (as well as his bargain-basement rates) had proved so satisfying. Wadd and Haynes elected to attend the session, partly because Howard had never been in a studio before and they wanted to lend support where and if they could, and also because they had never met him. So it was that Howard arrived at London Bridge station on a Saturday in April 1989 to find his new label waiting for him; after introductions were made, the three of them made their way to Mitcham.

The four tracks selected for the EP – 'Inside Out', 'Tinsel Heart', 'Around the World in Eighty Days' and 'Things Will Get Better' – were laid to tape with little difficulty. As on the demo, each song was accompanied by some rudimentary rhythms Howard had programmed into a drum machine. While

Catt sat mixing the results under everyone's gaze, Haynes put forward an idea that had been tickling his curiosity since he and Wadd first listened to the demo at home: 'What would happen if we turned the drums off?' Catt complied, and then decided, off the cuff, to apply a generous coating of reverb to what little music remained.

And in that moment, the Brighter sound – pretty, promising, but as yet indistinct – became signature. 'Suddenly', says Haynes, 'it was completely magical: this gorgeous, warm but spectral sound, floating through space without a rhythm pulling it back to earth.'

In addition to instantly imbuing them with a sonic trademark, these spontaneous adjustments provided another unforeseen advantage to Howard's songs: they now had a sound that made contextual sense of his lyrics, which were largely concerned with the fear, confusion and displacement that occur in the dying days of adolescence, when everything familiar and safe must be abandoned in order to make one's way in the world. In short, a theme of rootlessness found sympathy in music that, itself, sounded untethered. 'The future stands tall/Yet we are so small/In the face of it all', Howard sings at the beginning of 'Around the World in Eighty Days', and the listener can visualize him, dwarfed and insignificant, surveying the landscape of suburbia from the starlit expanse of a late-night sky, bidding farewell to childhood.

The EP was released in August 1989, and sold decently enough (despite being passed over for review by all of the weeklies) that Wadd and Haynes immediately agreed to fund another. They also suggested to Howard that it might be in everyone's best interests if he formed a band and began playing live. Howard was all too able to oblige: he was unemployed and had little motivation to do anything but fully throw himself into the still-developing notion of Brighter. 'These were the days when you could be on the dole and not be asked any questions', he recalls. 'And I just sat at home and put the Hoover round or wrote songs – loads and loads of them. I was incredibly prolific.'

He returned in October to CAT – once more with Wadd and Haynes in attendance – and recorded three songs for a future release. Although Howard was again the only musician in the studio, Brighter had expanded in the preceding months to a trio. He hadn't needed to look very far to find his new bandmates: Sharkey, his closest friend and the other half of his sixth-form

bedroom duo, was brought on board as bassist; second-guitar duties were fulfilled by Cousens, with whom he was now cohabiting in Brighton. (Drums, when they were required, would continue to come from a box.) Although Howard would have liked them to contribute to the recording session, they simply weren't ready. In particular, before being appointed her role, Cousens had scarcely so much as held a guitar in her hands. 'I picked up an Everything But the Girl songbook, I think', she says, 'and Keris was going, "You can't be in the band unless you can actually, properly play!" So I just practised.'

'It just felt quite a comfortable thing to do with Alison and Alex,' Howard explains. 'If it had been a case that I would've had to advertise [for band members], it would never have happened. It was really important to me that Brighter wasn't a job. I wanted it to remain something that I would enjoy, and the best way to ensure that was to get the two people closest to me. It always used to wind me up when people would say, "Well, obviously Alison's only in the band because she's his girlfriend." Well, there's an element of truth in that, but *that's why bands often get together*, is because it's friends.'

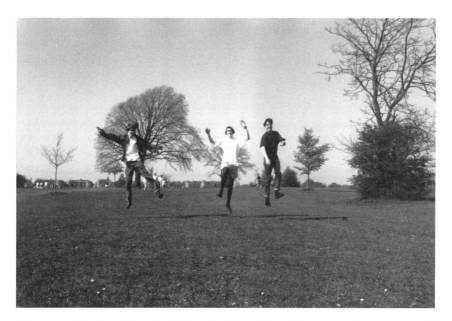

Figure 9.1 *Brighter (from left: Alex Sharkey, Alison Cousens and Keris Howard) on Clifton Down, opposite Sarah's Upper Belgrave Road office. (Courtesy of Sarah Records)*

'The macho, male-dominated music industry increasingly depressed us,' says Cousens. 'Sound engineers who erected a mic stand in front of me without asking because, as the only female, *of course* I was only going to sing; or experiences with recording studios [other than Catt's], which, when we arrived, were plastered with Page 3 pin-ups. … Sexist assumptions were present at every turn, and the worst thing was, when Alex and I officially joined the band, no one questioned Alex's right to be there as Keris's friend, but members of apparently right-on indie audiences couldn't handle a female "girlfriend" guitarist. We were a band of close friends – and that was apparently okay for the boys, but not for me as the girl.'

Howard's magnanimous approach to recruitment, however, meant Brighter's earliest gigs were fraught with palpable stage fright, the three of them unable to hide their inherent shyness behind velocity or volume – after all, the songs had neither. As well, their sad, delicate music tended to stoke hostility in crowds who expected something invigorating to soundtrack their night out; not even indie-pop audiences were above voicing disapproval to performers who failed to deliver sufficient rock-like theatricality. 'People who liked Brighter used to find it frustrating that I exhibited a lack of confidence onstage, which maybe went overboard sometimes,' says Howard. 'I appreciate now that it's not that great when you've got somebody onstage who's basically, "Sorry, there were a lot of mistakes in that." You don't want that constantly pointed out. It was based in the fact that we were really nervous.'

'I think we probably got away with quite a lot because we always looked so alarmingly young – we looked younger than we were!' adds Sharkey. 'It was like a badge of honour a little bit. We just got up there and did our thing, and you either liked it or you hated it; we weren't going to try to change.'

Although their deceptively prepubescent appearance likely wouldn't have helped them had the music press known what they looked like, Brighter's resolute fragility drew similar indignation from the nation's weeklies when the fruits of the October session were released in February 1990. The *Noah's Ark* EP proved an altogether livelier collection than its predecessor. Although the title track is a languid five-minute hymn to melancholy that sounds of a piece with *Around the World*, its companion songs, 'I Don't Think it Matters' and 'Does Love Last Forever?' are, aurally speaking, the arrival of clear skies after

weeks of rain – so comparatively buoyant, in fact, that the inclusion of rhythm tracks was judged necessary by all involved. Regardless, the *NME* assessed that the band 'need some cheering up' and, inscrutably, described the title track as a tardy imitation of the Jesus and Mary Chain's 'Just Like Honey'. (*Sounds* drew a much more unfathomable comparison: Tears for Fears.) *Melody Maker* likened it to 'musical Aero – sweet enough but 50 per cent air', and suggested the time had come for Brighter to learn some new tricks – a perhaps premature counsel, seven months after their debut.

Yet while journalists were demonstrably unmoved, Brighter began making a profound connection with those who bought the records. In Howard's doleful meditations about the plight of a sensitive soul set adrift upon the unforgiving seas of adulthood, thousands of other sensitive souls recognized a kindred spirit – someone else who seemed to feel overawed, paralysed in the face of expectation. 'Keris was singing about all the fundamental insecurities of people like us who, for the most part, weren't allowed to be honest and say, "Actually, I'm quite scared of the real world and life and love,"' observes Cousens. 'We weren't interested in adopting a pseudo-macho confidence – that wasn't who we were. We wanted to present an alternative version of maleness – and, let's face it, post-'80s femaleness – which positively embraced sensitivity, emotion and honesty.'

'There were evenings that I used to spend just writing letters back to people,' says Howard. 'People would be writing to us about their English homework and stuff, because everyone was sort of in their late teens at university, and it was nice connecting with people for whom the music was important, the label was important. When we played gigs, we used to say that *we* probably weren't that important; what was more important was everyone getting together. We were almost peripheral, but we were a catalyst for getting people together.'

While Howard was becoming aware of the impact his music was having in the lives of listeners, Wadd and Haynes were becoming aware of the impact it was having upon aspirant Sarah signees. Increasingly, the tapes they were receiving bore a striking stylistic resemblance to Brighter's two EPs. For the next several years, Howard took pride in recalling Haynes telling him that 'every second demo tape sounds like bloody Brighter'.

Yet Howard was self-aware (and self-deprecating) enough to acknowledge that Brighter's apparently instantaneous influence wasn't entirely to do with

his songs' compositional merits; it was also because, to musicians of quite limited capabilities, their component parts were exceptionally easy to master. 'It was so naïve that I think a lot of people had actually strummed or written songs similar to Brighter and thought, "I can't do this; it's too easy!"'

Thus, for the remainder of the label's existence, the Sarah PO box would be overwhelmed with cassettes containing sad, slow, spare songs played in the key of D. It speaks volumes about the quality of those tapes that virtually nothing else Sarah released sounds remotely like Brighter.

Brighter's next record, however, was very much in keeping with what had come before – and it was for this reason that the band's relationship with Wadd and Haynes began to fray after little more than a year. In keeping with the precedent set by the Orchids and the Field Mice, Brighter's promotion from the confines of seven-inch EPs was to be an eight-song, ten-inch mini-album. For this, it was decided that Cousens and Sharkey were ready to make their debut in the studio. But rather than once again secure the services of Ian Catt (who, Wadd explains, had 'stopped being ludicrously cheap') and try to crowd six people into his bedroom facility, sessions were booked at Bloomsbury Studios in Brighton. Yet the geographical convenience the band enjoyed wasn't reflected in the results of the sessions that took place there in June. After ten songs were completed, everyone was left with no choice but to acknowledge that they sounded terrible. ('The engineer was a drummer who was tone deaf, I think,' Cousens later quipped.) A block of time was booked at another studio in a desperate attempt to remix and, ultimately, salvage their efforts. But all it did was underscore the disastrousness of the project: revisiting the tapes revealed that two of the multi-track channels recorded at Bloomsbury had vanished somewhere between the studio floor and the mixing desk. Everyone made the difficult – and, relative to Sarah's modest bank balance, costly – decision to scrap everything. 'If it had been one specific vocal or guitar line, we obviously could have just redone that, but there was something not right about the whole thing,' opines Haynes. 'I think there was an element of trying for a bigger sound than the first singles, but not quite pulling it off.'

Brighter were forced to cool their heels until October, when new sessions took place at a studio named the Whitehouse, in the Bristol-adjacent town of Weston-super-Mare. Presided over by one Martin Nichols ('A very good

engineer who got a good sound – and quite cheap!' enthuses Haynes, although Wadd notes, 'He wasn't a particular fan of our music'), band and label were delighted with the sound of the eight songs he recorded, six of which were written by Howard subsequent to the ill-fated attempts of four months prior. But then, Wadd and Haynes suggested discarding two songs from the session – the only relatively upbeat, rhythm-led numbers of the lot – and returning to the Whitehouse to re-record a pair of slow tracks that had been abandoned following the Bloomsbury debacle. One of the proposed cast-offs, 'Wallflower', was a live favourite that fans had expressed an eagerness to hear on record. Cousens agreed with the decision, but Sharkey didn't, and Howard, having tired of being a team player, began asking serious questions about how exactly Sarah's directives should be perceived as different from those of a major-label A&R department. The tracklist that resulted would, he feared, merely consolidate the incomplete picture of Brighter established by *Around the World*. 'I know "Wallflower" was always a bone of contention,' Haynes acknowledges. 'But as far as I can remember, it really was just as simple as [Wadd and I] thinking the recording hadn't quite worked, and that the songs

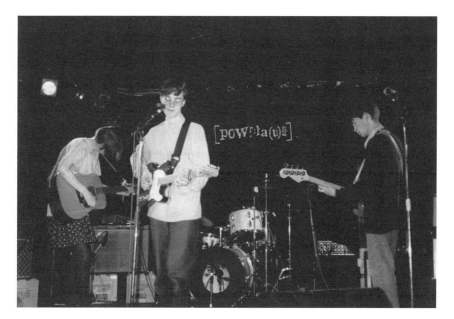

Figure 9.2 *Brighter onstage in London, 1991. 'We always looked so alarmingly young – we looked younger than we were!' (Photo: Dave Harris)*

we did release were stronger.' 'Looking back, perhaps we should have given in on "Wallflower"; it obviously meant an awful lot to the band and wouldn't have killed us,' considers Wadd. 'But we tried to stick to our guns on what we wanted to release and what we didn't. Because if you don't have that, what do you have as a label?'

The record, which was finally released as *Laurel* in February 1991, puts forward a strong argument that Wadd and Haynes knew what they were doing. While the songs do imply an inaccurate degree of homogeneity, they also cast a spell of exquisite sorrow that remains largely unbroken for their total 28-minute duration. When the sole outlier, 'Ocean Sky', arrives at the halfway point, its conspicuously brisk pace and fuzz-guitar coda illustrate how disruptive 'Wallflower' and its fellow orphan could have been.[1] In its final form, *Laurel* comes close to creating the illusion of an exactingly curated statement: a heavy-hearted cry of discontent from someone too cognizant and existentially inclined to find succour in the celebrations happening around him. (The record's first words are, 'I sometimes feel so lost/Stranded here alone'; its closing thought is, 'But one thing keeps on haunting me/All I once believed.') Amidst the mood of beatific optimism that defined the so-called Second Summer of Love that dominated the music press in 1990, *Laurel* could have been construed as either an act of brave contrariness or a stone drag. Luckily, those assigned to review it seemed to understand. *Select* praised its 'eight perfect songs'; *Melody Maker* declared that Brighter's 'honeyed and melting' music possessed the potential to 'heal shattered nerves' (while also noting that the incongruity of 'Ocean Sky' was 'a real shock, as if your grandma had announced she was taking up rugby').

Years later, Howard would say that these reviews prompted the brief period during which Brighter's sense of accomplishment reached its peak. 'For a month or two, we really started to believe we were going somewhere and that we might be able to really define ourselves as a band,' he told the website Mundane Sounds in 2006.

In June, the same month in which a *Melody Maker* live review put forward perhaps the all-time most astute observation about Brighter to appear in a

[1] 'Wallflower' and 'If I Could See' were eventually released on the US compilation *Out to Sea* (Matinée Recordings, 2006).

major publication – 'In their own sweet way, [they] are as extreme as NWA' – the band returned to the Whitehouse and recorded three new songs. Among them was 'So You Said', the lyrics of which seemed to be an admonishment towards a friend who had sold out her ethics.

> You said you'd change the world, or a little bit at least
> Ideas are all you need, and principles come free
> What happened to the things you believed once?
> What happened to the girl?
> She used to have a soul
> But you get a good price for those

The 'girl' in question was Sarah. Howard had used Haynes's and Wadd's money to record a song that rebuked them for what he perceived to be their loss of rectitude. But to their credit – and to Howard's surprise – they happily released the song in September as part of the *Half-Hearted* EP. (Curiously, the record's lead track, 'Poppy Day', is exactly the sort of exuberant-sounding pop song Howard insisted Wadd and Haynes were always consigning to the scrapheap.) 'I think we actually quite enjoyed releasing "So You Said,"' says Haynes, chuckling. 'We couldn't think of any other label that would release a song attacking itself. And obviously, the fact that we released it contradicted some of the lyric! I think we were surprised when Keris wrote it – we genuinely weren't sure in what way we'd sold our souls and lost our ideals. But I also liked the fact that one of our own bands was criticizing us for selling out. Mostly, our bands just complained about not being allowed to do twelve-inch singles.'

'It wasn't simply a resentful swipe at Sarah,' says Howard. 'We cherished the label's original ideals and did genuinely believe they'd loosened their principles disconcertingly quickly. More directly, although their input into the song selection process had originally been quite benign, it increasingly felt that we were losing any control over what Brighter actually was. Married to the increasing pressure on us to promote ourselves through touring, it suddenly felt like we had stumbled into the "real" music business and we were surprised that the label didn't appear to acknowledge that something quite significant had changed. The pressure to play live was probably the biggest tension in the last year of our tenure on the label: the whole idea of promotion, of hawking

yourself up and down the country playing on terrible bills with terrible bands in front of uninterested audiences, horrified us. We hadn't joined the label with any intention of becoming a "proper" band because it was proper bands we were rebelling against.'

'Perhaps the lyrics were a little harsh,' says Cousens, 'but somehow, it didn't feel like it was fifty-fifty anymore. And I guess, because it was their livelihood, Matt and Clare were understandably having to demand more of the bands in terms of a proper business, which we baulked at.'

Released in September, *Half-Hearted* inexplicably failed to capitalize upon the critical momentum set in motion by *Laurel*, which had placed in the top ten of the Indie Albums chart. It was reviewed in none of the papers, leaving Howard with the sinking feeling that Brighter might have already peaked. His frustration was compounded by Wadd and Haynes responding coolly to the vast majority of new songs he had demoed. Always a prolific writer, he had never needed to worry about them finding at least three songs among a dozen that could be earmarked to fill the next seven-inch. 'Things were grinding to a halt in terms of Matt and Clare's love affair with Brighter: the Musical Proposition,' he maintains. 'We had all those songs originally – they were spoilt for choice. And suddenly they weren't. They were struggling to find the next EP.' Howard had addressed this problem the previous year by offering demos of rejected songs to a pair of very small, Sarah-indebted indie labels, which eagerly released them on flexidisc.

Throughout the ensuing months, relations between band and label continued to break down. 'We did have some blazing rows,' says Howard. 'Alison used to have to take the phone because I'd be too furious. I'd be stamping around. And some of the correspondence – there was some pretty horrendous stuff. Horrendous within a certain middle-class constraint.'

Eventually, both parties were able to agree to five songs that would make up Brighter's next release, for which Howard booked time in July 1992 at an untested studio on his native turf of Worthing. For the first time, Wadd and Haynes didn't attend the session.

As it happened, the band's new-found in-studio sovereignty delivered nothing that would have shocked its fans. The EP, mysteriously titled *Disney* and decorated with an enlarged photo of Winona Ryder's eye, proved to be

no more or less than another very good, very Brighter-like Brighter record. Howard's drum programming, which had become more sophisticated, duly enhanced three of the five songs; the others appropriately conformed to the revelation of three years before, when Ian Catt had pressed a button and made Howard's songs airborne. Listed portentously on the sleeve was the title of the closing track: 'End.'

Disney's arrival into the world coincided with a tour – Brighter's first – in late October, alongside recent Sarah signings Blueboy. It encompassed eight cities in eight days, beginning in Nottingham and pinballing comically around the country before concluding in Manchester. The Nottingham date instilled a renewed sense of hope in Howard and co. 'We got there, the place was rammed at about seven o'clock in the evening, people were queueing up,' he recalls. 'We thought, "This is gonna be an amazing experience, doing this tour."' But each night that followed served only to reinforce the key drawback of an audience that consists almost entirely of an obsessive but small, self-contained cult. 'It turned out that everybody travelled to the first gig and nobody came to the other ones. Some places where you would really be expecting to get a decent crowd, it was really, really poor. And I think that also made us think, "What's the point?"'

The trio had already begun weighing the future viability of Brighter against the encroaching realities of adult life that had informed so many of Howard's songs. Poised at the starting block of their professional lives (and, in Sharkey's case, with the added considerations of a new wife and plans for beginning a family), each of them was growing to accept that the band had run its course. 'As you move into adult life, there's a moment of decision,' adds Cousens. 'There was a moment of, "Can we throw ourselves into properly being a band or are we going to have to give it up because it's not going to work?" Looking back, I can see now that we were probably as guilty as anyone of sending out mixed messages in terms of our ambitions, so no wonder Matt and Clare were also frustrated with us.'

Brighter fulfilled a commitment to play in early December at London's Bull & Gate pub, whose capacity of roughly one hundred and fifty cruelly underlined the band's stubbornly modest rank. Supporting them were the Sugargliders, an Australian trio formed around the songs of brothers Josh

and Joel Meadows. New to the Sarah family, the siblings and their friend had come to England for a whirlwind inaugural tour of the country whose pop music they had worshipped from afar since childhood. Freshly out of school, they stayed for more than a month and filled the calendar to bursting with activity: playing gigs with numerous Sarah groups, recording an EP (with none other than Ian Catt), eating authentic British chips in authentic British pubs – in essence, living out a carefree phase of life that Brighter had recently finished passing through. The Sugargliders were only two or three years younger, but to Howard, Cousens and Sharkey, the gap was weighted with significance. Brighter effectively ended after leaving the stage that night at the Bull & Gate. Wadd and Haynes acknowledged a split early in 1993, in one of the first Sarah newsletters. Sharkey, they reported, had bowed out. The next musical steps of Howard and Cousens, if there were to be any, were 'all a bit up in the air at the moment. Fear not though, we shall keep you posted,' it read. Whatever animosity lingered from their many and recent clashes was not remarked upon.

'I know we always had great trouble convincing Brighter that we genuinely did like their music, but I've no idea why that was,' says a bemused Haynes. 'Whenever we said anything nice, they tended to think we were being ironic, or taking the piss, when we really weren't.'

'I look back and I can forgive us all – I mean Matt and Clare as well as us – because we were all so young. We were just kids!' Cousens marvels. 'It's a terrible, terrible cliché, but we didn't know what we had until we lost it.'

10

Safe Harbour: The Wake and the Hit Parade

In June 1989, Keris Howard began quietly worrying. Brighter had recorded their debut EP, *Around the World in Eighty Days*, months earlier, and it was his understanding that everyone was pleased with the results. Yet communication from Sarah had ceased some time ago. Had they changed their minds? Too polite to make an inquiry, lest he annoy seemingly the only people who had any interest in plucking his band from the abyss of invisibility, he was relieved when he finally received an apologetic letter from Haynes towards the end of the month. Amidst a list of reasons for their tardy reply, Haynes explained that Wadd had been preoccupied because she was writing her university finals, placing extra weight onto his already overburdened shoulders. But all was well, and Brighter's record would see the light of day in August. And by the way, he scribbled in the margin, 'Did we tell you we'd poached the Wake from Factory Records?'

Howard was beside himself. The Wake were a Glasgow group of relative veteran status – they formed in 1981 – who since 1982 had been signed to Manchester's epochal, globally famous Factory Records, home to the chart-topping New Order. Their singer-guitarist, the singularly named Caesar (born Gerard McInulty), had been an original member of Altered Images but quit between the band signing to CBS and the release of their breakthrough smash single, 'Happy Birthday'. For a brief time, prior to his successes with the Jesus and Mary Chain and Primal Scream, Bobby Gillespie was the Wake's bassist.

How had two novices in Bristol coaxed this band – a band Howard had loved since his early teens, it so happened – away from perhaps the most admired and successful independent label in all of England?

Bobby Wratten and Michael Hiscock found out a month earlier and were even more incredulous: the two of them owned the entire Wake discography and had made a point of seeing them years before at a rare London gig where they opened for New Order. Wratten had been poised over the pause button of his cassette recorder when their session for the BBC's David Jensen was broadcast in 1984. 'It was a complete shock,' remembers Wratten. 'We had an idealised view of Factory and couldn't conceive of why a band would make the switch. My initial response was, "The Wake? The *actual* Wake?"'

To those unfamiliar with the Lilliputian scale of celebrity that typified indie music during the late 1980s, the awe with which the Wake's arrival at Sarah was regarded may seem worthy of patronizing amusement at best, sneering contempt at worst. This was, after all, hardly tantamount to Queen terminating their EMI contract in order to set up shop at K-tel. But it *was* an unexpected and, in its own small way, impressive development for the still incipient Sarah. And it must have looked to outsiders like a desperate, humiliating step down for the Wake – who, for whatever reason, had parted company with a label awash in credibility and cash, and come to rest at a label that had virtually none of the former and even less of the latter.

It therefore came as a shock (not least to Haynes, a longtime fan himself) that the Wake were unsure if *they* were worthy of their new home. Furthermore, they were armed with enough anecdotes about their tenure at Factory to dispel whatever romance the label – and the band's career to date – invoked for the members of Brighter and the Field Mice.

Although the Wake defected to Sarah in 1989, they had ostensibly left Factory some eighteen months before. Their relationship with the label had always been somewhat fraught: they ranked among Factory's numerous bridesmaid bands who could never elicit from mercurial, provocative label founder Tony Wilson the degree of attention and care he lavished upon New Order, the act who single-handedly kept the enterprise financially afloat throughout the 1980s. This was partly because the Wake had been brought onboard not by Wilson but Rob Gretton, New Order's manager and Wilson's

de facto second-in-command. 'All of our arrangements with the label were made through Rob,' recalls Caesar. 'Tony had to agree, but it was Rob's impetus that got us there. Everything that we wanted to do, we did through Rob.'

Gretton was generally amenable to the band's wishes, but when he began withdrawing his involvement with Factory in the second half of the decade, the Wake felt that Wilson's already waning interest in them evaporated completely. They were never critical darlings either, dogged by accusations of being New Order copyists and of embodying Factory's most time-worn stereotypes concerning humourless young men singing dirges about alienation – a perception not helped by a lyric from 1985's 'Melancholy Man': 'The sun is blazing as I wander into town/A long grey overcoat which trails upon the ground … I think I'll always be a melancholy man.' Caesar had meant it to be tongue-in-cheek, but its humour was veiled amidst the minor-chord synthesizers and cavernous atmosphere of the song and its attendant album, *Here Comes Everybody*. The band at least had the consolation of having amassed a small but devoted cult following, which regarded *Here Comes Everybody* as a masterpiece that harboured sumptuous pop melodies beneath its mood of existential ennui. They had also attracted favourable attention from Dave Robinson, erstwhile co-founder of Stiff Records and then president of Island. According to legend, Robinson was in the offices of Island's publishing arm, to which the Wake had recently signed, when he heard 'Talk About the Past', a Factory single from 1984, playing on the stereo. Declaring it a hit, he offered the band a recording contract with Island, which they then sabotaged when they demanded the same artistic control – approval of artwork and advertising; a guarantee that no singles would be drawn from albums – that was a matter of course at Factory.

During the next two years, whatever aural suggestions of darkness that lingered in the Wake's music fully vanished: a 1985 single, 'Of the Matter', veritably skips towards its three-minute conclusion, keyboardist Carolyn Allen playing a hook more suited to children in a park than overcoated men at the fringes of society. Following a year of relative inactivity, they returned with a four-song EP, *Something That No One Else Could Bring*. Recorded in Glasgow and Manchester with respected producer John Leckie, it couldn't have sounded more 1987 if it tried; lead track 'Gruesome Castle', despite

its foreboding title, seemed custom-made for Molly Ringwald's moment of epiphany in some box-office-busting John Hughes teen dramedy. Factory extended the courtesy of putting the record out (in a manner of speaking; it proved very hard to find) and then turned its attention elsewhere. The music weeklies, having largely made up their minds that the Wake were has-beens inextricably associated with the first half of the decade, all but ignored it. *Sounds'* Dave McCullough, who had been the Wake's only staunch press supporter, had become an A&R man for Blanco y Negro, a boutique label curated by Rough Trade's Geoff Travis and distributed through WEA. He suggested that a deal might be possible. In the end, it wasn't. As if to underscore the band's increasing instability, John Rahim, the band's fourth bassist in as many years, took his leave.

The Wake's last conversation with Tony Wilson had been an argument about the cover art for the *Something* EP: the band's vision ultimately prevailed, but they never spoke to him again. 'We were left in a situation, in 1988, where we probably spent most of that year not sure if we were on Factory anymore,' says Caesar. '"Should we phone them? Should we say we want to do something?" And that very quickly turned into 1989. We thought, "It's over," because two years had gone by and nothing had happened.'

In the meantime, the Wake had made the acquaintance of the fledgling Orchids, one of the only local bands that seemed interested in exchanging more than rote pleasantries with the elder group. (Being in their late twenties, the Wake seemed unfathomably senior to the teenage rookies.) Drummer

Figures 10.1 and 10.2 *The Wake (from left: Caesar, Steven Allen and Carolyn Allen), shortly before their departure from Factory Records in 1987. There was never an official photo shoot while the band was on Sarah. (Photographer unknown; courtesy of the Wake)*

Chris Quinn, in particular, was a great fan. Astonished to discover that his hometown heroes were without a label, he told them about Sarah, although he doubted the Wake would be interested. On the contrary, the Wake doubted that whoever was in charge of Sarah would be interested in them. 'Our initial reaction', recalls Caesar, 'was they probably wouldn't be, because we'd been around for a long time and it was all new, young bands on the label.'

Wadd and Haynes had never considered that Sarah might attract overtures from already established acts. Up to that point, 14 Iced Bears and St. Christopher were the only groups on their roster with a prior discography, but in each case it consisted merely of a few self-released singles. (And 14 Iced Bears left Sarah as quickly as they had arrived.) Sarah's low profile and extremely limited resources seemed suited only to artists who were as inexperienced as Sarah itself. That the Wake seemed not only amenable to, but grateful for, the pittance Sarah could offer left Wadd and Haynes astounded and thrilled. They got to work boasting of their windfall to everyone, and Quinn broke the news to the Field Mice when they and the Orchids shared a bill at the Camden Falcon.

Whatever anyone's concerns might have been, the Wake's acclimation to Sarah proved remarkably seamless. Although sessions with John Leckie or another producer of similar renown was obviously a luxury consigned to the past, they were content in their new working relationship with Duncan Cameron, a Glasgow musician who had been recommended to them by Carolyn Allen's neighbour. Setting up at the studio in his house, they recorded two songs that, had they not been written months prior, others might have assumed were fashioned with Sarah in mind. 'Crush the Flowers' is an argumentative duet between Caesar and Allen: the former rejects the latter's try-to-see-the-bright-side advice, leading her to ask 'Are you really so hard in your heart?' before Caesar offers the riposte 'When the angels come round/They'll stamp us into the ground.' The playfully caustic nature of the lyric is couched in a melody that sounds like nothing so much as the theme for a Saturday morning kids' programme – especially the keyboard part, which recalls early synthesizer novelty hit 'Popcorn'. Released as a single in late 1989, paired with the nakedly nostalgic, almost pastoral 'Carbrain', it bore scant resemblance even to the Wake of 1987. 'If you listen our very first single, "On Our Honeymoon", it's not a million miles away, song-wise, from what we ended up doing on Sarah,'

reasons Caesar. 'And we were working on those songs before we were on Sarah. I think we were heading in that direction anyway. "Crush the Flowers" could just as easily have come out on Factory.'

Despite their hard stand about creative autonomy during the failed negotiations with Island, and the disagreement with Tony Wilson that hastened their departure from Factory, the Wake ceded design of the 'Crush the Flowers' sleeve to Haynes, who adorned it with a pink-tinted photo of a rose (taken by Akiko Yamauchi, a Japanese Sarah fan who would soon provide the label with its iconic cherries logo[1]). When a mini-album, *Make it Loud*, appeared the following year, its cover suggested a wholesale assimilation into the Sarah visual aesthetic: a photo of suburban tower blocks, rendered so high-contrast from multiple passes through a photocopier that it looks more like an illustration. Indeed, it could have come from the pages of *Are You Scared to Get Happy?* But the record's content revealed a substantial break not only from the Wake's past but from the very notion that they were susceptible to the influence of their label or labelmates. Primarily guitar-led and stripped back, its eight songs aren't rock per se, but the overarching tone of indignation that permeates them is much closer to rock's tradition of confrontational dissent than the ambiguous world-weariness of their Factory recordings. The Wake had become adults, and thus acquired the specific targets of rage – both personal and public – that adult experience amasses. The track 'Glider' found Caesar dispensing his own best counsel: 'You are scared to use your mouth/ So make it loud.'

'I felt like it was a time to be quite direct about things,' says Caesar. 'The song "English Rain" is about being governed from England, living with English notions of what being English is while not actually living in that country.' It was inspired in part by the Wake's first British dates after joining Sarah, for which they were teamed up with the Field Mice and the Orchids. Their first venture across the border for some time – as a band and as individuals – it reinforced for them the vast lifestyle disparity between their homeland and

[1] Haynes later credited Yamauchi with fostering an indie-pop scene in Japan 'almost single-handed'. The logo's twin cherries are still widely thought to be a representation of Haynes and Wadd, but the two of them maintain they simply liked the image.

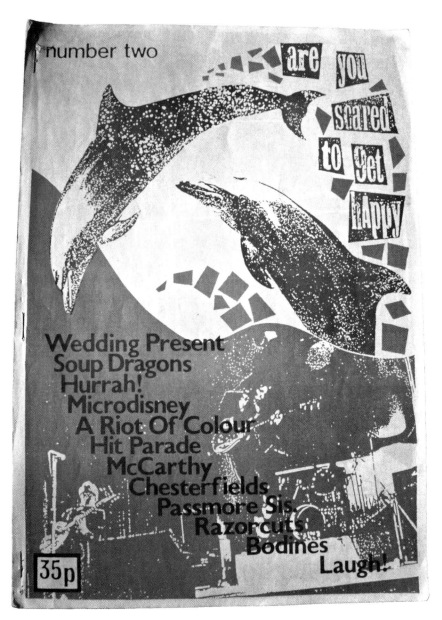

number two

are you scared to get happy

Wedding Present
Soup Dragons
Hurrah!
Microdisney
A Riot Of Colour
Hit Parade
McCarthy
Chesterfields
Passmore Sis.
Razorcuts
Bodines
Laugh!

35p

The visual style of Matt Haynes's pre-Sarah fanzine, Are You Scared to Get Happy?, *comes into its own with issue number two in 1986. (Courtesy of Matt Haynes)*

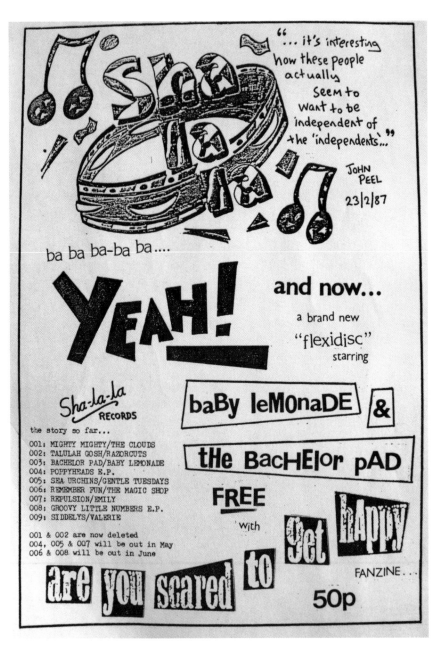

A flyer advertising the series of Sha-la-la flexidiscs distributed with Are You Scared to Get Happy? *and other fanzines. The Baby Lemonade/Bachelor Pad flexi showcased here was made Single of the Week in the* NME. *(Courtesy of Matt Haynes)*

A Sha-la-la flexidisc. The catalogue prefix, "ba ba ba-ba ba," is taken from a refrain in the song "Hip-Hip" by Hurrah!, which also gave Haynes's fanzine its title. (Courtesy of Matt Haynes)

A view from Bristol Bridge. This photo was used for the cover of Sarah's first compilation album, Shadow Factory. *(Courtesy of Sarah Records)*

Matt Haynes and Clare Wadd in their first flat on Upper Belgrave Road, 1988. Behind them is a gallery of the Sha-la-la sleeves. (Courtesy of Sarah Records)

The Sea Urchins' Darren Martin, Bridget Duffy and Robert Cooksey, onstage at the Tropic Club in Bristol, January 1988. (Photo: Wendy Stone)

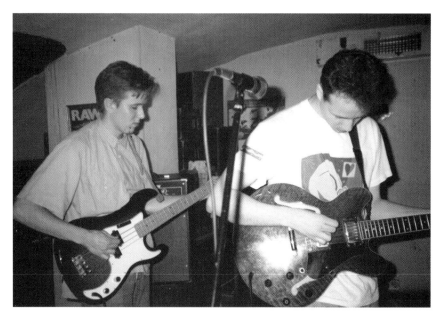

Michael Hiscock (left) and Bobby Wratten of the Field Mice, onstage in Summer 1989. (Photo: Wendy Stone)

Harvey Williams (left) and Blueboy's Keith Girdler. Williams, who had been recording and performing under the name Another Sunny Day as well as with the Field Mice, became a member of Blueboy in 1992. (Photographer unknown; courtesy of Sarah Records)

seven inch single

12", digipak, next-week-buy-part-2, and then the album
- sell the same song over and over to the same few people -
CAPITALISM
Only nobody seems to much notice any more
Because politics is what the government does
not what you or I do, isn't it?
"We're not a political band"
But you are, you are -

This winter we want
7" singles because they're POPMUSIC
[one SONG, one MOMENT]
1 track CDs, 5" flexidiscs, 90 second fanzines
[because they're popmusic]
poetry, socialism, feminism, effeminism, revolutions
[because we're fed up with ugliness and mediocrity]

To come home each night smelling of bonfires -

sarah records autumn releases

fountain island
low-price 16-track singles compilation lp/cd
featuring HEAVENLY, THE ORCHIDS, THE FIELD MICE,
TRAMWAY, GENTLE DESPITE, ST. CHRISTOPHER, THE WAKE,
THE SWEETEST ACHE, EVEN AS WE SPEAK & SECRET SHINE
all songs previously available

the sea urchins
stardust compilation lp/cd

the harvest ministers
six o'clock is rosary 7"

blueboy
if wishes were horses lp/cd
popkiss 7"

the orchids
epicurean compilation double lp/cd/mc
thaumaturgy 7"/cd

brighter
disney 10"/cd

the sugargliders
seventeen 7"

another sunny day
london weekend compilation lp/cd

SARAH RECORDS,
five years old this week.

distributed by revolver/pinnacle
send sae for information/newsletter to
SARAH RECORDS, PO BOX 691, BRISTOL, BS99 1FG

Sarah marked its fifth anniversary with this advert/mini-manifesto in Melody
Maker *and the* NME, *November 1992. (Courtesy of Sarah Records)*

Wadd and Haynes became familiar faces at Hatcher's, a nearby tobacconist. The shop's photocopier was crucial to the creation of Sarah's artwork at a time before desktop publishing. (Courtesy of Sarah Records)

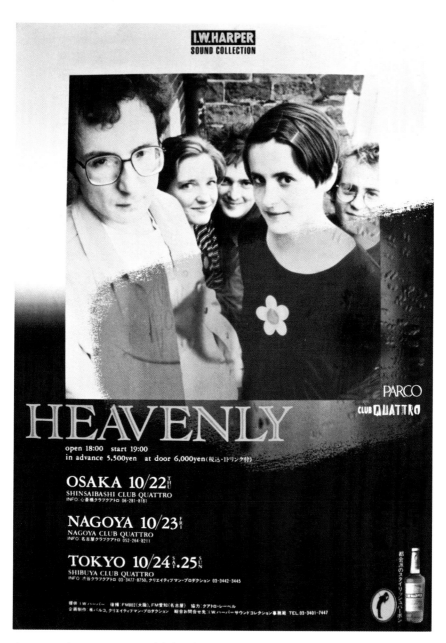

A poster advertising Heavenly's brief 1992 tour of Japan, where the band played to larger and more appreciative audiences than at home. (Courtesy of Sarah Records)

"celebrate with sarah"

NO FRIENDS?
LONELY?
MISERABLE AS HELL?
NOT LOOKING FORWARD TO CHRISTMAS MUCH AT ALL, REALLY?

then you're probably a SARAH fan,

IN WHICH CASE

COME AND SPEND THE NIGHT WITH US!!!

IN ISLINGTON. AND LET

THE FIELD MICE
HEAVENLY
THE ORCHIDS

SOFTEN YOUR SORROW WITH SEASONAL EASE, LIVE ONSTAGE AT

THE POWERHAUS
1 LIVERPOOL ROAD
LONDON N1 (⊖ ANGEL)

on sunday 23rd december (7–11pm)

(AND APOLOGIES TO THE 47 MILLION PEOPLE WHO, LIKE US, DON'T LIVE IN LONDON
– BUT NOBODY ELSE OFFERED)

A characteristically self-deprecating flyer, advertising a pre-Christmas gig at London's Powerhaus in 1990. (Courtesy of Sarah Records)

Sarah's modest success allowed Wadd and Haynes to vacate their rented flat in 1992 and buy this terraced house on the south side of Bristol, as well as the Ford Fiesta parked outside. The car's learner's permit plate was for Haynes, whose mother can be seen here in the house's upstairs window. (Courtesy of Sarah Records)

Sarah's fiftieth release was Saropoly, a board game in which the heads of other indie labels – including Alan McGee (Creation), Ivo Watts-Russell (4AD) and Tony Wilson (Factory) – compete to conceive a new Sarah release and deliver it to the label's distributor. It sold for 50p. (Courtesy of Sarah Records)

The "cherries" photo, taken by Sarah fan Akiko Yamauchi, that became Sarah's logo. Many falsely assumed that the cherries were meant to represent Wadd and Haynes. (Courtesy of Sarah Records)

Even As We Speak with John Peel, 1992. The band recorded three sessions for the legendary BBC DJ. (Courtesy of Even As We Speak)

A ticket for Sarah's farewell party on 28 August, 1995. It was held at the label's favoured local venue, the Thekla, a former cargo ship moored in Bristol Floating Harbour. (Courtesy of Sarah Records)

There and Back Again Lane, a cul-de-sac in Bristol that provided the name for Sarah's final release, a compilation CD that spanned the label's entire eight-year run. Sarah fans have come to Bristol from around the world to have their photo taken next to the sign. (Courtesy of Sarah Records)

A now iconic image of 46 Upper Belgrave Road. The semi-subterranean "garden" flat served as Sarah's first office, as well as Wadd and Haynes's home. (Courtesy of Sarah Records)

various affluent pockets of England during the last gasp of Thatcher's rule. 'When we went further south, we were profoundly shocked by the difference between that culture and the way people lived in Scotland,' says Allen. 'They were just so much better off: better lives, better jobs, more money. And even then, they weren't rich, but compared to up here...'

'It was time for independent music to move on from where it had been. It had been getting too cryptic,' says Caesar. Nowhere throughout *Make it Loud* did he fulfil that directive more explicitly than the lyric of 'Joke Shop', a belated missle of pique aimed at the Wake's erstwhile Factory boss: 'Hey, everyone, have you worked it out/Who do you think we're talking about?/If you know him, you love him, no doubt/He goes on and on, and yet he says nowt.'

The Wake's relative isolation in Glasgow, coupled with their inherently introverted nature, meant they had become used to feeling like outcasts within the music industry. At Factory they had been the target of teasing from Wilson and his hedonistic colleagues for not taking advantage of the party favours that, in the end, constituted virtually their only form of remuneration while on the label. 'We were quite surprised how rock 'n' roll they were', says Caesar, 'how into partying and drinking and smoking dope.' 'We didn't take drugs,' adds Allen. 'They all took *loads*!' Sarah gave the Wake a formerly absent sense of community. Although they rarely ventured outside of Scotland (thus, their face-to-face meetings with Wadd and Haynes would always be restricted to gigs), a palpable air of compatibility and respect emanated from everyone they met within the Sarah fold. The Orchids became bona fide friends, and the Wake considered them peers – at future recording sessions and gigs, guitarist Matthew Drummond and bassist James Moody became auxiliary members.

But the Sarah band with which the Wake would develop the closest and most sustained relationship was the Field Mice. The two groups first met shortly following the release of 'Crush the Flowers', when the Wake and the Orchids travelled to London to play with Hiscock and Wratten, who were still performing as a duo. Wratten made arrangements for everyone to stay with him at his parents' house ('To me, it was like the Beatles were coming to stay,' he says). Allen thought 'we were just meeting up with a band. We didn't know Bobby and Michael had come to see us from school when we'd played with New Order. We were nervous about meeting *them*.' She and Caesar were

immediately charmed by the pair, whose enthusiasm and unfailing politeness were unprecedented among their dealings with other musicians. 'They were really different from Glasgow people,' Caesar fondly recalls. 'A lot more gentle and restrained and sensitive.' Caesar sat up in the Wratten household until the early morning hours, listening under headphones to a test pressing of the Field Mice's forthcoming *Snowball* while its star-struck co-creator anxiously awaited judgement. He needn't have worried: Caesar was hugely flattered to detect the influence of his music in that of another, taken to an individual end result he could never have conjured with his own band. He was also impressed by Wratten's record collection, the wide-ranging contents of which proved him to be far removed from the self-imposed orthodoxies of indie land.

Towards the end of 1991, the Wake and the Field Mice played a short tour of France, during which the latter group entered the terminal phase of its premature disintegration. It capped a year in which Caesar further cultivated his new-found role of gleeful provocateur, penning a single whose two sides, 'Major John' and 'Lousy Pop Group', paired withering critiques of Britain's new prime minister and the entrenched rock aristocracy, respectively, with sing-song refrains designed to resemble playground taunts. The band's music had become ever more spare – as unvarnished and direct as Caesar and Allen merrily harmonizing 'I don't give a shit' about Eric Clapton and Mark Knopfler. Those who had failed to detect their humour in the past would have no excuses now.

The Wake kept a low profile for the next two years, writing new songs in Glasgow and determining how to continue following the departure of drummer Steven Allen, Carolyn's brother and the last co-founding member other than Caesar. Wadd and Haynes had little time to contemplate their absence, nor to process the gravity of their most successful band, the Field Mice, splitting up. There simply was too much work to do. Since the turn of the decade, they had added more than half a dozen bands to the Sarah roster and released upward of thirty records, yet they maintained that hiring an employee would be more trouble than continuing to do everything themselves. Stretched thinner still from the almost daily interruption of unscheduled visitors from across the nation and

around the world, they had resorted to renting a PO box and discontinuing the publication of their home address. And in any case, they and their business had outgrown the upstairs flat at Upper Belgrave Road. In early 1992, they would elect to move again, this time to a house on the other side of Bristol, which they would buy outright.

One of the last records they released in 1991 was the Hit Parade's 'In Gunnersbury Park', a song that held the distinction of being arguably the most musically austere and baldly romantic in the Sarah catalogue to date – no mean feat in the aftermath of the gauntlet thrown down by Another Sunny Day's 'I'm in Love With a Girl Who Doesn't Know I Exist.' Its components limited to a single acoustic guitar, one gentle male voice and a lyric in which 'trees sigh as they watch the lovers pass them', the song ends with its protagonist waiting alone for a vanished lover, the rising crack in his voice portending the futility of his vigil. Many of the Sarah fans who reflexively bought it assumed it to be the debut of a new artist. In fact, it was part of a comeback of sorts for a London singer-songwriter whose earliest work entered the world before Haynes or Wadd had stapled together their first fanzine.

Julian Henry was, more than any other Sarah artist bar Harvey Williams, a lifelong student of pop, enamoured of the Beatles, Carole King and the romance of pop language itself. The very name of his musical project was an attempt to conjure childlike wonder, the lost innocence of a time when the listings of the country's most popular records contained too much magic to be known as something so banal as 'the charts'. Not outspokenly political in terms of party allegiances and hot-button issues of the day, he was nevertheless rigidly specific about the politics of the music industry. Although much of his favourite music from the 1960s and 1970s had been born of corporate cynicism and ruthlessness, what he observed of the major labels during the early 1980s appalled him – especially when they appeared to neuter bands he viewed to have been creatively thriving at indies. 'It was odd watching bands like Orange Juice and Prefab Sprout trying to deal with major-label money and ambition,' he says. 'None of them looked comfortable.' Henry was determined that the Hit Parade – he and two school friends, Matt Moffatt and Raymond Watts – would remain apart from it until they were in a position to dictate everything. Fortunately, unlike the vast majority of brand new bands, Henry

was in a position to allow the Hit Parade absolute autonomy from the very beginning. He had long been making good money working in public relations, so he funnelled his earnings into his own label, the immodestly named JSH Records (his initials). The first Hit Parade single, 'Forever', was issued in 1984, and sent to the music press with a poster-sized manifesto itemizing JSH's 'codes of practice', which included a fifty-fifty split of profits with any future signings, and zero tolerance of cover versions, moustaches and songs lasting longer than three minutes. It must have been amusing for the journalists who received it, trying to reconcile the trio's hard-line proclamations with 'Forever' itself, which one could easily imagine Davy Jones having sung at the height of Monkeemania. John Peel played it, and Henry, caught by surprise, almost crashed his car.

Henry proved an intriguing – and, perhaps to himself, a frustrating – contradiction. He distrusted large record companies but regularly sought their attention; in addition to making demos for EMI and CBS, he was 'like a groupie' of Andy McDonald, the founder and president of Go! Discs, home to the Housemartins and Billy Bragg ('They had a social heartbeat and were so good at designing record sleeves'). More problematic, he proved a natural in the world of publicity, repping the likes of Blondie and Buzzcocks when he was barely out of his teens, but 'if anyone asked me about the Hit Parade, I just shut up. I was embarrassed that we weren't successful, and wasn't confident enough at that stage to go beyond superficial gestures.'

But he was confident enough to continue financing and issuing singles: five more between 1984 and 1987, during which time he developed a sideline writing about other people's music for *Melody Maker*, the *NME* and others. Cath Carroll, a journalist at the *NME* who was pursuing her own dream of pop stardom as frontwoman of Miaow (a group which would soon experience its own anticlimactic accord with Factory), befriended Henry and contributed vocals to two of his singles. Both of the records on which she appeared defied the Hit Parade's rulebook, running well past the three-minute mark. It was progress of a sort. But when Watts and Carroll separately left the country in 1989 – he to record his own music in Berlin; she to be with her new husband in the United States – Henry felt adrift without 'the fellowship of being in a band', and so fully turned his attention to a now fast-rising PR career with

fashion publicist Lynne Franks. For the next two years, the spectre of the Hit Parade would trouble him only once, when he decided to release a compilation of the JSH singles, mostly because he could present the finished product to a woman he was wooing. He titled it *With Love from the Hit Parade* and it sold next to nothing.

The 1990s arrived and so did Henry's thirties. He had essentially consigned his pop ambitions to the scrapheap of a spent decade when he received a call from Rhythm Records, an independent shop in Camden. Japanese kids had come in and depleted the store of its Hit Parade stock, and still more were asking for their records – any of them. Unbeknownst to Henry and his erstwhile bandmates, the Hit Parade had been discovered in Japan and co-opted as part of a recently defined genre known as 'neo-acoustic,' a broader interpretation of indie-pop that allowed for the inclusion of major-label bands whose music was similarly rooted in gentleness and bright melodicism, such as Haircut One Hundred, Aztec Camera and the Pale Fountains. Vinyl Japan, the London-by-way-of-Tokyo label that eventually became a home to Northern Picture Library, reissued *With Love from*, and suddenly Henry had the incentive to, in the vernacular of rock cliché, get the band back together. Within months they were overseas to fulfil a whirlwind itinerary of sold-out concerts, in-stores and TV appearances. Henry's fantasy of mass adulation was playing out in front of him, but in a country and for an audience he didn't yet understand. 'Our fans were so shy and awkward that they would burst into tears as soon as we went over and said hello,' he recalls. 'I wonder now if they might have had other issues in their lives that drew them to us. I remember thinking that our music had a cathartic effect for them. Like the U.K., they're an island race, and they're bound by conventions and what's expected of them.'

It was in the midst of these disorienting developments that Henry considered how he might go about releasing new music at home. Vinyl Japan secured the rights to the Hit Parade's first album of all-new material, *More Pop Songs*, but the band were free to record for others, too. Sarah had held Henry's attention from the beginning: Haynes had written enthusiastically about the Hit Parade in *Are You Scared to Get Happy?* and then sent Sarah's early releases to him. 'Sarah was like any other indie label then, even though it was clear that Matt in particular was a thoughtful fellow with a vision for what he wanted to

Figure 10.3 *Julian Henry, the founder and only constant member of the Hit
Parade. (Courtesy of Julian Henry)*

do', says Henry. 'I liked his intellectual ambition and his references to obscure
geography' – a predilection that chimed with the songwriter's own tendency
to reference various locales that had figured in his life (the Hit Parade's third
single, 1985's 'The Sun Shines in Gerrards Cross', is a tribute to the small town
in Buckinghamshire where Henry was born). As well, Harvey Williams had
mentioned in casual conversation with mutual acquaintances that he was
a longtime Hit Parade fan, so Henry phoned him out of the blue. Williams
was too caught off guard to say much, so Henry, having accumulated years of
experience placing cold calls, chattered at length about music – his, Williams's,
everyone else's – until a bond was sealed. When Wadd and Haynes agreed to a
single, Henry recorded 'In Gunnersbury Park' at Watts's flat in a single take. Its
B-side, 'Harvey', was named for his new friend and labelmate, its lyric a fiction
about a terminally lovesick young man whose life is a series of heartbreaks,
songs written for an audience of one, and fits of tears. When the Hit Parade

previewed it at a gig, a member of another Sarah band struggled to suppress laughter.

Like the Wake, Henry had come to Sarah after years of social famine within his artistic milieu, so he was cheered by the warm reception he received from the musicians he met, many of whom were as much as ten years his junior. 'A lot of bands can be intimidating or cliquey when you get to know them; they make you aware that you're an outsider and talk down to you because you're not in their gang. But the Sarah bands weren't like that. They were always friendly and some of them were surprisingly brainy, even though they pretended not to be.' Although his primary focus remained Japan, where the Hit Parade had signed to the major label Polystar, the band's first release under their new contract, an album called *Light Music*, made it plain that Bristol remained prominent in his thoughts: guest musicians include Williams and Heavenly's Amelia Fletcher, while an ersatz country-and-western shuffle about the absurdities of the music business is titled 'Are You Scared to Be Happy'.

The song was a lark, three and a half minutes of sugar-coated spleen before Henry returned to the more familiar subject matter of love's inscrutability. By comparison, the Wake returned from their hiatus with an album, *Tidal Wave of Hype*, whose myriad grievances and overarching tone of simmering disgust bewildered much of the band's audience. Among the subjects Caesar and Allen addressed in voices of blasé detachment – as though life's disappointments had left them too exhausted to conjure emotion – were the crumbling moral structure of their neighbour nation ('Britain'), cowardly deference ('Down on Your Knees') and another of their former Factory overseers ('I Told You So'). In 'Solo Project', Caesar sings from the point of view of a habitual masturbator who uses self-pleasure to escape from thoughts of his meaningless existence, comparing his state to that of a vain musician wanting to break free from the suffocating democracy of a band. The album ends with forty seconds of a tolling bell. Given the songs that precede it, it would have been anyone's guess as to whose demise – physical, spiritual or both – it was meant to represent.

Obsessed with notions of indefinable, melancholic yearning and the struggle to retain a sense of wonder in the face of adult drudgery, Sarah and

its never-ending campaign for principled, idealistic living came to represent a safe harbour to Julian Henry while his professional life became increasingly corporate and stressful. He had no financial incentive to succeed in music – a luxury that simultaneously relieved and troubled him. Consequently, many of his new songs in 1993 were unprecedentedly reflective. A five-song EP, *Sixteen Weeks* (released only in Japan, although three of its songs were repurposed for a Sarah single), documents life from Christmas holidays through to the return to work, then a seaside getaway and home again; it ends with 'Now the Holiday's Over', in which Henry laments having to re-engage with reality while still shaking the sand from Brighton beach out of his shoes.

Then there was 'House of Sarah', recorded for the album *The Sound of the Hit Parade*, which followed early the next year. It begins with Henry paraphrasing a quote from *Brideshead Revisited* narrator Charles Ryder:

I had a lonely childhood. To the solitude of adolescence, the premature dignity and authority of the school system, I added a sad and grim strain of my own. Now, suddenly, it seemed as if I was being given a brief spell of what I'd never known: a happy childhood. And though I knew that the excitement wouldn't last, and that the moments would soon be gone, there was an essence of happiness in my life that I felt would belong to me long after the autumn leaves had fallen from the trees. Soon it would all be over.

Then, atop a mournful cascade of keyboard-generated strings, Henry sings of a vision in which he arrives at the Upper Belgrave Road garden flat and finds it empty, abandoned: 'So I watch the sky in the passing years/Now I've said goodbye, I can't hide the tears/Thinking that there's no one there.'

'It struck me that there was something faded and charming about Matt and Clare', Henry explains, 'and that the label they developed was like a Victorian ladies scrapbook, full of beautiful ideas, poetic declarations, dead flowers and secret longings. I wanted the song to be sad and poignant, like a gravestone. I think Matt and Clare were embarrassed. It was probably too explicit for their tastes.'

Sarah would live on for some time still, but Henry's premonition of a fleeting moment – the impermanence of the sanctuary that pop had granted him – proved oddly prescient. Once promotional obligations for *The Sound of the Hit Parade* were done, he stepped away from music-making, and there was no indication that he would return to it again. The advancing demands of the real world – marriage, fatherhood, work – required too much time and attention for him to continue disappearing into reverie. And the following year, when Sarah did indeed disappear, the Wake followed Henry's lead.

11

'I Am Telling You Because You Are Far Away': Internationalism and Sarah's Written Communiqués

Those who found themselves in the company of Matt Haynes often struggled to reconcile the personality they thought they knew from his fanzines – blunt, righteous, hilarious, opinionated to such a degree that he occasionally seemed enraged by the limits of his own articulacy – and the man who stood before them: not soft-spoken so much as an embodied mumble, reluctant to make eye contact, his thin frame appearing to try to disappear inside his oversized jumper.

One regular attendee of gigs in late-1980s London vows to have had the following conversation when he approached Haynes in a club to buy one of his fanzines:

'Can I have three, please?'

'Um…'

'Sorry?'

'Um … I can't really afford to … um … give any away.'

Figure 11.1 Sunstroke, *one of numerous Sarah fanzines. None carried the same name twice. (Courtesy of Sarah Records)*

'No. I want to *buy* three.'

'Um…'

'One for me for the train back, one for my friend and one for my girlfriend.'

'Um…'

'Look, can I buy one?'

'Er … okay.'

'Can I buy another one?'

'Er … okay.'

'Guess what? Can I buy another one?'

'Okay.'

Wadd, although comparatively more forthcoming, was shy, too. It was one of the common denominators that brought them together, and that allowed them to exist happily as an army of two when they would spend days at a time working at home without seeing or speaking to another soul. Their respective fanzines had introduced them to the liberation of the written word, its inherent ability to let them transcend and control that which they struggled to express face-to-face with others. By no means were they the first writers whose true, full selves could only be expressed on paper, but they likely were the first who used a record label as a platform through which to communicate with the world – not as businesspeople to customers, but as like minds to like minds. As much as for its music, Sarah Records was – and continues to be – loved for the relationship it cultivated with its followers through its sleeve notes, record inserts, fanzines, newsletters and the handwritten replies Wadd and Haynes sent, without exception, to every single person who took the time to write to them. The task robbed them of thousands of hours of potential free time, but to them, their commitment to maintaining direct communication was a key part of Sarah's identity, and a means of putting into practice a founding principle of post-punk that there should be no barrier between those who make music and those who purchase it.

'My personal circumstances when I was a teenager, in the late '80s, were not terribly happy for all sorts of reasons, and I think I was just desperate to communicate with people who liked the same things as me. By the time you got into buying fanzines and flexis, you had gone a stage beyond the other kids who liked indie music at school – who liked the Cure or something like that. Nobody else liked this stuff, so I would write to Matt all the time, and he would always write back. I found this out fairly recently: this is what he and Clare would spend all day doing. They were just sat indoors in Bristol, writing back to people they didn't know. Matt had nothing to gain by writing back to me to the extent that he did. I was a sixteen-year-old kid in Buckinghamshire, and he took the

time out to talk to me. In retrospect, that seems unbelievable; he must've had other stuff to do with his life! When you're that age, you've got no sense of the hierarchy of the music industry, so I thought, "This famous person is writing to me!" Of course he wasn't famous. But the way he corresponded, the amount of time and effort he put into it. … I would've bought the records anyway; he wasn't doing it to butter me up. And the letters could be argumentative; it wasn't like, "Please buy our new single." He made my life, which was pretty miserable at the time, quite a lot less miserable by his actions, and he didn't have to do that.'

–Alexis Petridis, The Guardian

How soon after Sarah began did you start receiving correspondence from fans?

HAYNES: I don't think there was a time when we *weren't* receiving letters, to be honest, because we weren't starting from cold – people were already writing to us because of the fanzines and the flexidiscs. The Sarah correspondence carried on from that, and we picked up new people as we went along. Obviously, our habit of including a personal note with each mail order, and the chatty nature of the inserts, encouraged this.

It's probably hard for the post-internet generation to grasp how important letter-writing was in creating a self-supporting scene. And it wasn't just Sarah, obviously; this was just the world we were part of. People entered into correspondence with people who wrote fanzines, or were in bands, or that they'd bumped into at gigs. It was like having a school pen pal, only you were writing to a person who actually shared your interests. And if you were stuck in a village or small town, or were just too young or poor to go out much, these letters were what plugged you into the world. These days, the internet fulfils the same role, but with one huge difference: with the internet, you can be friends with, and chat to, hundreds of people all over the world. When you have to physically write the words down, put them in an envelope, and pay for stamps, you can really only have a handful of friends, so you choose them more carefully, and each of those relationships is far more important.

Another thing people might find surprising was how un-international everything was. With the internet, writing to someone in New York is as

easy and cheap as writing to someone in York, but it's a different story if you need to pay airmail postage. And before PayPal and online credit-card sales, actually buying a record or fanzine from abroad was often a non-starter: not only were the postage costs horrendous, but the only way of paying was a bank draft or international money order. We used to get self-addressed envelopes from the States with U.S. stamps on, and U.S. cheques with the dollar sign scribbled out – they weren't a lot of use. If you started a label now, you'd expect correspondence and sales from all corners of the world, and for the biggest single source to be the U.S., just because it's a big market. But back in 1987, because of airmail costs, the Atlantic was a real barrier.

WADD: Prior to Sarah, we both exchanged a lot of letters with a lot of people because we were both fanzine writers, and we wrote off for other people's fanzines and records. And, of course, writing to people was how we publicized the label initially. There wasn't always a clear distinction between the people writing to us who were in bands and writing fanzines, and those who weren't; people who weren't often were later, or were planning to. One day someone was a school kid writing us letters, the next they went to university and started putting on gigs or writing for the student newspaper. To some degree, part of the politics of Sarah was about breaking down the 'them' and 'us,' the producer versus consumer, the special versus ordinary, guest-list versus paying punter – so this all made sense. Equally, some people would make a big deal about their relatively minor contribution to the 'scene', while other, shyer types were quietly doing lots of stuff fuss-free. You couldn't tell.

I think the way it worked was, someone would write a little note saying 'Send us a record', and then we would write a little note back saying 'Here it is' and maybe something about the next record or a gig local to them, or did they know the other person who wrote to us from their town. And if this kind of engagement appealed to them, they would write more and we would write more and so on. There were probably things in common with the people we chose to have correspondences with – the people we enjoyed writing to and who became our friends – but the letters we received varied enormously. You felt you knew each other really well. That was kind of how I'd lived my entire life – that you'd go and meet someone at the station and you'd be holding, usually, a twelve-inch record mailer so they could recognize you, and you

Figure 11.2 *A letter from Matt Haynes to the author, 1989. (Courtesy of Michael White)*

would feel like you knew them really well because you'd been exchanging letters for two years. These people *would* be friends and they *would* be your support group.

Why did the two of you remain committed to answering every letter throughout Sarah's existence?

HAYNES: I think the simple answer is that it never occurred to us *not* to. They were personal letters, handwritten, and the writer had gone to the trouble of

addressing an envelope and buying a stamp, so not replying would just have been rude. It takes very little effort to email someone, and even less to copy the same email to someone else and pretend it's especially for them. But you can't do that with letters, so if you get one, you know it's genuine.

WADD: It seemed polite and decent and normal to answer every letter. It was what we would have wanted had we written off for records, and I think that attitude governed most of what we did. I don't think, coming from the fanzine backgrounds we came from, it occurred to us not to. And, of course, the volume of mail grew gradually, so we didn't know what we had taken on at first, and some of our replies were much more brief notes than full letters – we weren't *totally* mad. It's also worth remembering that Sarah was incredibly insular once it was up and coming: we didn't go out much, we didn't see a lot of people other than the bands, so this was our social life, really. We made friends through the post and we maintained those friendships through the post. Some of those people are still my friends. Sometimes you'd meet them, either by accident or design, and that could be quite exciting. We also both wanted to be writers, so here was an outlet for our writing – plus a good way to market our records.

How did you divide the responsibility between the two of you?

HAYNES: The division was pretty random, I think. But after we'd replied to someone once, they tended to reply to whichever of us wrote the first time.

WADD: Sometimes people picked us, sometimes they had met one of us at a gig, sometimes one of us particularly liked someone's letter and grabbed it. Often it was just whoever had slightly less to do at that point. We had to divide up everything: who was going to the photocopiers', the post office, to Revolver, to get some more Letraset, to Sainsbury's. It was just one more thing. Some of it fell to role allocation and some never did. Letter writing never did.

I remember trying to write one hundred letters in a day once – when, I think, Sarah 32 [a ten-page, ten-pence fanzine titled *Sunstroke*] came out and the orders were backed up. They ended up being crappy notes and I don't think I quite made it to one hundred. Others were a joy to write and might get saved for Saturday night – it just depended, really. We spent half an hour a day, on average, in the post office; probably an hour opening and reading the post, but

that was generally over breakfast; probably half an hour packing up mail order every day; and then maybe another hour on letters that were part business, part pleasure – or all pleasure. We wrote to the bands, too – especially in the early days, before we had a phone.

I had a friend – a great girl called Debbie – who would make me all these amazing indie mix tapes. But she knew I was very resistant to what I perceived as this thing called Sarah Records, and so she never included any of their music. But I was at a record fair in '89 and I found the Lemonade *and* Cold *fanzines [sold in tandem as Sarah's fourteenth release], and I thought, 'I'll buy her that as a present.' I was on the bus on the way home and I started reading the fanzines, and I just fell in love with the people who were writing them. They just sounded like – it's a cliché – the friends I'd not met yet. Matt's sense of humour, Clare's politics, both their poetry and their attachment to their surroundings – I just got it. So, Debbie didn't get the fanzines. My next trip up to London – I was living in Dorset at the time – I bought* Shadow Factory *and the Field Mice singles, and never really looked back.*

– Tim Chipping

Had you decided from the beginning that the label wasn't just going to be about records, that you were going to incorporate things like fanzines and flexis into the catalogue?

HAYNES: Yes. You should get the same feeling from reading a fanzine as you do from listening to a record. Therefore, all those things would be given catalogue numbers. They were all equivalents as far as we were concerned.

WADD: We had quite intricate plans. I seem to remember spending quite a lot of time walking around Clifton that summer, just kind of deciding everything the label was going to do and what it was going to be called and what the labels were going to be like.

HAYNES: I'd done a bit of that in my old fanzine; I would have articles about catching the bus from Bristol to Glastonbury and walking around Clifton in the rain, because I thought walking around Clifton in the rain should give you the same sort of feeling as hearing the Lovin' Spoonful playing 'Rain on the

Roof' or something. It's a three-minute pop song or it's a three-minute piece of writing in a fanzine.

WADD: I think it was a bit about the idea that you're not a pop fan in isolation. When you're a teenager or in your early twenties, you kind of want to pretend the real world away. I think we wanted to bring life into stuff so that you're not a pop fan in a void. … I think maybe we wanted to write the things we would write pop songs about if we'd written pop songs.

HAYNES: When we were writing the more sort of poetic-type inserts, I think there genuinely was a feeling that this was our version of the three-minute songs on the record. This was something that would take you three minutes to read and think about.

Your fanzines and single inserts, although they could be quite ambiguous, disclosed quite a lot about your everyday lives and emotional states, individually and collectively. You had already done that to varying degrees in your pre-Sarah fanzines, but why did you want to share such personal information with an audience that wasn't necessarily paying for it – especially with regard to the inserts, when most people thought they were merely buying a record?

HAYNES: The first Sarah inserts were just mail-order lists, but even then we tended to add jokes and comments; it livened them up and was something that came very naturally, and obviously we were aware that people liked it. Often the jokes would allude to things in our everyday lives, or the everyday life of a record label. When we stopped hand-folding our single sleeves and had them manufactured already sealed, we could no longer stuff inserts into them ourselves, but we were worried about losing that personal touch. So we expanded the insert into something a bit more substantial: an actual seven-by-seven square, which obviously gave even more scope for rambling. And by the time we'd reached Sarah 41 [Heavenly's 'Our Love is Heavenly'], the rambling had taken over and occupied an entire side. By that stage we'd got used to the idea of writing about ourselves and had the confidence to just go for it, which is what we did from 41 to 60, and I suppose those are the ones that people think of as the archetypal Sarah inserts: they're just us, with no mention of record labels. I loved writing them – Clare wrote slightly more than me, I think – but they did take an awfully long time, and from 61 onward

we seemed to revert slightly to more label-based anecdotes, probably because it was less stressful.

I think this is a very long-winded way of saying that the nature of the inserts changed over time as we realized what was possible and what we had the confidence to do. It probably helped that we were so insular and didn't really discuss this side of things with anyone. But because it was just us, we simply got on and did it. As for why we wanted to share, I guess we just thought that people might be interested or that they'd like the writing for its own sake. With the inserts from 41 to 60, I quite like the idea of each insert being a miniature fanzine, or a print version of a seven-inch single – for both, the limited time and space makes you concentrate and focus your thoughts. But that's probably a bit pretentious!

WADD: I think what we saw was a medium to express ourselves and a readymade audience for what we wanted to say. It seemed terribly dull and commercial and a wasted opportunity to just use the space to try to flog more records. We wanted to be different and interesting, and we had that weird self-confidence of youth that isn't entirely contradictory to a deep shyness. Both of us individually always wanted to write, and we had up to five thousand people willing to read what we wanted to write, and we could be as freeform as we wanted. Some of it was very literal, some wasn't. I think the personal nature of it made sense in the context of what some of the bands were saying: perhaps one of the things some of the Sarah bands had in common was how willing they were to be open about their feelings, and we echoed that. To some degree I don't think we cared what people thought – if they wanted to just throw the writing away, that was fine; if they thought we were idiots, well, we were used to that; and if they liked it, a bonus. Either way, they had a great record.

'Hullo, and welcome to the first-ever (tara!) SARAH NEWSLETTER, hopefully jam-packed full of interesting news, gossip and snippets, though at the moment I couldn't say precisely what on account of this being only the first sentence. But I shall now plunge into SENTENCE TWO and hopefully things will begin to hot up and become a little more purposeful.'

– Sarah Newsletter no. 1, October 1992

Were the newsletters you introduced in 1992 partly strategic, in that they preemptively answered many of the questions you had come to expect from the letters you received?

HAYNES: Not really. We just liked the idea of doing a newsletter, and I really don't know why we didn't do it earlier. As with the inserts, though, the newsletters quickly became a vehicle for rambling. I suspect part of the reason for doing them was that space had become so limited on the inserts.

Who were your most obsessive letter writers? Did you sense some of them were fragile people who, as much as being fans of the label, were seeking meaningful human contact?

WADD: We did encounter a lot of lonely young people, and of course some were fragile, but others weren't. Some clearly had lots of friends and others were quite isolated, and sometimes we could put people in touch with one another – for instance, someone else nearby who liked the same music, someone to go to gigs with or whatever. I think over the eight years of the label, people came and went, literally grew up – as did we – and the correspondents at the start weren't the same as those at the end. There was certainly an element of young people in their mid-teens who were looking for something beyond their family and school friends, mainly those in smaller towns who felt a little isolated and who found something in Sarah.

HAYNES: I know it's a dull answer, but I think most were just fairly ordinary people who liked talking about pop music. And when you don't have access to internet chat rooms or whatever – because it's the 1980s or early 1990s – letters are the only way of doing that.

One thing I don't think we really appreciated at the time was how exciting it was for someone who's really young – and some people who wrote were as young as thirteen or fourteen – to receive a letter from a record label. We might have been only a few years older than them, but when you're thirteen or fourteen, even five years is a huge gulf. And I suppose for a fourteen-year-old to receive a letter from someone running a record label and to get treated like an adult – we wouldn't necessarily have known how old they were, and

sarah newsletter

October 1992 no. 1

Hullo, and welcome to the first-ever (tara!) SARAH NEWSLETTER, hopefully jam-packed full of interesting news, gossip and snippets, though at the moment I couldn't say precisely what on account of this being only the first sentence. But I shall now plunge into SENTENCE TWO and hopefully things will begin to hot up and become a little more purposeful. We'll start with some tour-dates...

Well, **BRIGHTER** and **BLUEBOY** go off this month on a joint-top co-headline mutually-supportive our-drummer's-bigger-than-your-drummer-no-he's--not-yes-he-is-BIFF type tour, calling at:

Saturday October 24th: NOTTINGHAM Narrow Boat
Sunday October 25th: HULL Adelphi
Monday October 26th: SOUTHAMPTON Joiner's Arms
Tuesday October 27th: OXFORD Jericho Tavern
Wednesday October 28th: LIVERPOOL Planet X
Thursday October 29th: SHEFFIELD Hallamshire Hotel
Friday October 30th: LEEDS Royal Park
Saturday October 31st: MANCHESTER Swinging Sporran
(+ support from Boyracer in Leeds/Manchester
 and Mrs.Kipling in Sheffield)

And **BLUEBOY** do a few without BRIGHTER, namely:

EUSTON Rails on 16th October [at the WAAAAH! 2nd Birthday Party (together with The Haywains, Mark Speed, Serious Drinking (?) and Chantelle. "Balloons, cakes, sweets and a special guest celebrity comedian" it threatens. Hmmm.)]
CAMBERWELL UNION TAVERN (The Chocolate Factory) on November 19th - that's with **SECRET SHINE** and **THE SUGARGLIDERS**.
READING Rising Sun Cafe on November 21st, just with **THE SUGARGLIDERS**.

And **BRIGHTER** and **THE SUGARGLIDERS** play The Bull & Gate in Kentish Town hopefully on December 4th - but we've still to confirm this.

And hopefully some other things too - we're especially looking for more gigs for **THE SUGARGLIDERS**, who fly in from Australia in mid-November and go back just before Christmas and we'd really rather not have them twiddling their thumbs in our kitchen the whole time - it's distracting, and upsets the cat. So, if anybody has any bright ideas, or would like *their* thumbs twiddled briefly instead, please get in touch! They'll do anything - you know what Australians are like. If not, now's your chance to find out.

Meanwhile, if any of you are going to Germany in October, bear in mind that **THE ORCHIDS** are doing a short tour over there, and that everything will be incredibly expensive. There should be a few French dates too, and hopefully a Radio Session for Bernard Lenoir (or "The French John Peel" as he is customarily known), to be broadcast on France Inter which you can pick up in parts of the UK... And **HEAVENLY**, recently returned from supporting Beat Happening in the USA, are off to JAPAN in October for gigs in Osaka (22), Nagoya (23) and Tokyo (24/25) plus lots of Virgin Megastore etc. signing sessions because they are finally MEGAPOPSTARS, with their own carrier-bags and BADGES (still available).

October 5th is the release-date for "London Weekend", the compilation LP by **ANOTHER SUNNY DAY**, featuring all the songs he/they/it ever released on SARAH including the legendary "Anorak City" flexidisc. Sadly no **new** ASD songs look imminent as - following the demise of **THE FIELD MICE**, who were previously taking up so much of his time and draining his creative juices to a dangerously low-level - Harvey has now joined **BLUEBOY** as Other Guitar AND has just got back from Japan where he's been playing guitar for **THE HIT PARADE** (who are also MEGAPOPSTARS over there) - he's a basically very busy person. There are no

Figure 11.3 *The first of a dozen newsletters Sarah published between late 1992 and the label's closure in 1995. 'I really don't know why we didn't do it earlier', says Haynes. (Courtesy of Sarah Records)*

I don't think it would have made any odds if we had – must have been quite something. But I don't think that crossed our minds at the time.

Sometimes people would send gifts: someone in Thailand once sent me a hammock – that was a bit weird – and someone in Berlin sent us a piece of the Berlin Wall that he'd hacked off the night it came down. I also remember being disconcerted one year by the fact that we'd received a couple of hundred or more Christmas cards, as most people don't tend to send Christmas cards to record labels.

'The thing that made Sarah so enjoyable was the communication aspect of it: getting letters and meeting people. It made it all so great – for me, at least. I'd always been a misfit, partly by choice, but also because I had all this stuff that I really liked which no one else was really interested in. And to all of a sudden meet all these other people that shared one's passion was a relief, but also really a joy. Journalists' opinions of what we were doing didn't really matter.'

– Harvey Williams

12

'Atta Girl': Heavenly, Riot Grrrl and Feminism

'Are you *really* twee people?'

The assembled members of Talulah Gosh steeled themselves. The question was probably inevitable, but it was an annoyance nevertheless.

They knew they were lucky: together as a band for little more than eighteen months, the interview they were giving for *Melody Maker* would result in their second full-page music press feature – a rate of development that hundreds of other bands surely envied. They also held the dubious but perversely impressive distinction of being one of the most polarizing indie bands of their time, a force to be either loved or hated or nothing at all. Talulah Gosh made a virtue of not entirely knowing what they were doing, earning rafts of goodwill by way of sheer enthusiasm and charm, selling thousands of records containing music that occasionally sounded held together with little more than twine and crossed fingers. Talulah Gosh, in 1987, were the greatest current embodiment of the promise made by punk: that anyone *could* do it, and maybe acquire some small measure of fame in return.

But *twee*. That fucking word. It clung to them like sodden robes. It had never figured much in the vocabulary of pop criticism before. Pop could be sweet or innocent or childlike; it could also be admiringly bereft of testosterone, the primary (and, to some, the most tiresome) component of rock. But *twee*. None of its connotations were good. It implied affectation, a preciousness too

extreme to bear. Yet even among their boosters, it seemed no other word was used more often in reference to Talulah Gosh.

Many said the band asked for it. In person they were articulate, worldly students from the University of Oxford. On record and especially onstage, they were capable of playing with quite heroic incompetency: loose and frenzied, inclined to doubling their speed between the beginning and the end of a song, all of them collapsing in a heap of embarrassed giggles. Frontwoman Amelia Fletcher sung in demure but excited tones about boys (pointedly not men), best friends, crushes and broken hearts, all the while wearing a kinder-punk collision of stripes, polka dots, headscarves and army boots, her hair either an androgynous bowl cut or shorn to almost nothing. (In early 1988, the *NME*'s resident professional agitator, Steven Wells, described her look as 'Super Aryan', to which the half-Jewish Fletcher understandably took great offence.) Her three male colleagues each gazed out from behind thick-framed glasses that suggested the bookworm at the back of the bus. Informed naysayers also pointed out that Talulah Gosh had taken their name from a pseudonym conjured up by Clare Grogan, the Altered Images singer whose uber-naïve persona had been criticized in some quarters as a paedophile fantasy. Grogan was Fletcher's favourite pop star.

The band took their interview in stride. Fletcher patiently explained that Talulah Gosh were less infantile than the Beastie Boys (whose *Licensed to Ill* had been *Melody Maker*'s 1986 Album of the Year) and that too much attention was being paid to their 'tongue in cheek' clothes. She added, '[The] pop music I like just affects me in certain ways and I'd like to affect other people in those ways. I do seriously think about how people might feel when they listen to the records, and I don't think you need any more justification for making music than that.' Meanwhile, bassist Chris Scott made it known that the guitar-playing of Faust was much more interesting to him than that of the Wedding Present.

In the end, Talulah Gosh's efforts to defend their corner were for naught. The resulting feature carried the headline 'CUTIE PRIZE', the subhead beneath it referring to their reputation as 'Britain's most twee pop group'. They broke up within months, having released only five singles.

'They eventually gave up, I think, just because they got fed up banging their heads against the wall,' speculates Haynes. The reality was much more complicated.

'It was a variety of reasons,' says Fletcher, 'one of which is boring: I wanted to concentrate on doing my end exams at university. But also music – the whole house scene was getting really popular and everyone seemed to be going off indie music. Even all the people that had been into indie were getting into dance music. And I thought, "Everyone who likes us at the moment" – most people hated us – "are going to go off us and like dance music. And maybe *we're* going to like dance music."'

As 1988 wore on following her graduation, Fletcher still didn't like dance music very much. But she was eager to try, and it occurred to her that the best way to do so might be to play an active role. So she recorded a solo single, 'Can You Keep a Secret?', which sounds like the core of a Talulah Gosh cast-off grafted onto a low-budget electro backing track. Released by Fierce, the Welsh micro-indie whose knowledge of the dance world was equal to 4AD's familiarity with grindcore, it proved too elusive an artefact even to be declared a flop. It was a non-event – deservedly so, says Fletcher. 'It was a completely contrived attempt to be a pop star, and therefore absolutely doomed to failure. It was very silly. I didn't have a burning passion for success – and maybe not enough talent either. I've only ever been talented at things I really love.'

Her one-off foray onto the dance floor passed with such little notice that there was no need to hide out in shame. Instead, Fletcher reconvened with some of her former Gosh colleagues – guitarist Peter Momtchiloff; founding bassist Rob Pursey; and her younger brother, drummer Mathew Fletcher – and proposed they start again. But there would be some changes, the most important being that their new, as-yet-unnamed project would be, in Momtchiloff's words, 'a less shambolically democratic band'.

'I didn't like singing everybody else's songs,' admits Fletcher. 'I wanted to be the dictator'.

Talulah Gosh was originally meant to be driven by Fletcher's love of sixties girl groups and solo singers like the Ronettes and Sandie Shaw, as well as the early-eighties female post-punk bands that bore those influences, such as Marine Girls and Dolly Mixture – all of them melodic and proudly feminine.

But as the band continued, Talulah Gosh became faster, louder, the vocals more strident. Mathew Fletcher, a Ramones fanatic, lobbied for brevity and speed. His sister became a team player, but she longed to reclaim a gentler concept. Now she would have it, and there would be no half measures.

'There was a slightly more considered and deliberate approach,' says Rob Pursey, 'a more feminist approach, I suppose, which is, "This music scene is full of rubbish, macho rock bands. Let's not be one of those. Let's make it something really good that isn't that, and let's name it something so fey that it'll annoy those people to even say the word."'

The name they chose was Heavenly. An embodiment of decorous femininity. A word *real* men are never heard to say.

Talulah Gosh had sold enough records and generated enough column inches that Heavenly could have had the ear of dozens of independent labels, and likely some majors. Yet they sought to keep a deliberately low profile at first. 'The original plan, in a very D.I.Y. indie way, was that Rob and I were going to start a label,' says Fletcher. 'We even went down to Bristol to speak to Revolver about it, and we thought we'd start with flexis because they were cheaper'.

But before they could follow through, they were made an offer by Wadd and Haynes at the Camden Falcon. Heavenly were there to play only their second gig, as opener for Television Personalities. Haynes had been at the venue the night before and was tipped off by Mark Dobson – who had yet to join the Field Mice – that the new incarnation of Talulah Gosh would be the following evening's support act. He and Wadd had been fans from the beginning – one of Talulah Gosh's songs had graced Sha-la-la's second flexi – so they made a point of arriving early. Hugely impressed with what they saw, they were ready to make an offer, but Fletcher had a question for them first. 'I went up to Matt and said, "You did flexis on Sha-la-la. How did you go about it? Where do you get them done?" When I explained why, he said, "Are you sure you want to do that? You could just be on Sarah."'

The band asked to take some time to make up their minds, and in the interim Haynes followed up with a letter to reiterate Sarah's interest. 'I suspect it was probably apologetic,' he says. 'Something like, "I'm sure you've had better offers, but if you haven't, we'd really like to put out your record."'

Fletcher replied by phone to accept their offer, but it wasn't until the word "yes" passed her lips that Wadd and Haynes understood the intention of her call. 'She's so self-assured, she'd ring up just to say "No,"' says Wadd. 'I'm *still* surprised that they came to us'.

'We could have played the field, I suppose,' says Pursey, 'but we liked them and we trusted them. Because the thing about Sarah, whatever you thought about the bands – and we certainly liked a lot of them – it felt like they were running a *genuine* indie label, the right principles of doing it. None of us, I think, were in it to try to become super-famous or rich. We were more into the idea of doing something that could sustain itself. Sarah was very anti-corporate in a gentle way, and I think the fact that through them we could play, record, be on the radio, do all the things that a band does, without having any contact with the mainstream or corporate music industry, made it make a lot of sense. … Compared to most people in that business, they were both distinctly not creepy.'

Heavenly's debut single, 'I Fell in Love Last Night', arrived in the spring of 1990, and it showed that the singer's vision for the group had prevailed. Easily recognizable as an outgrowth of Talulah Gosh, it smoothes over the rough-and-tumble amateurism of the former group and casts its eye towards the poised, romantic mood of Fletcher's beloved girl groups. In the soft call-and-response between her lead and backing vocals and the purposefully innocent perspective of her lyrics ('You took me out for long walks in the park…'), it harks all the way back to the Dixie Cups' 'Chapel of Love', when chasteness was still the dominant language of female-led pop.

Wadd found a review of the record in a local Bristol magazine – the first she saw anywhere. '"Yet another twee Sarah record with twee girl vocals,"' she recalls it reading. 'It was the *first* record we'd done with a female lead vocal and it was our thirtieth release!'

Wadd and Haynes had become all too accustomed to the explicit and implied sexism and homophobia that characterized Sarah's negative press. Whether the music being described as twee or fey or slack-wristed, or characterizations of the bands themselves as sissies or virgins or remedials, it was no longer surprising when their detractors chose such loaded terms. Casual, unconscious

sexism even pervaded the label's daily operations, leaving Wadd no choice but to resign herself to almost daily disappointments with regard to her role as a female co-proprietor. Early profiles of Sarah made reference to it being run by 'Matt Haynes and his girlfriend'; when she answered the telephone, the caller would ask to be passed along to whomever was in charge.

Sarah's gender politics had always been purposely subtle – an extension of the stealthy gestures Wadd and Haynes deployed when they were publishing their fanzines. Theirs were some of the only 'zines in their supposedly progressive medium whose pages weren't filled with 'generic sixties chicks' in miniskirts and blunt bob haircuts. The policy extended to everything Sarah did. 'We didn't bother to explain those feminist aspects to anybody. We just did it,' says Haynes. 'Like not putting women on record sleeves, like not having women at the front of photos. Obviously most people wouldn't be aware of this.'

'And we spent quite a lot of time with the Field Mice, for instance: one woman, four men,' says Wadd. 'Photographers would want the photo to be "symmetrical," putting Anne Mari at the centre. They would say, "It's not sexist; it's symmetrical!" And we'd say, "It isn't if you think of all of them as people!"'

'As with Talulah Gosh, Heavenly's gender configuration and their calculated lack of lasciviousness had the ability to stoke curiously powerful indignation from the overwhelmingly male music press. 'I think it did have to do with gender and sexual politics,' says Pursey. 'A predominantly male audience staring at a girl singing – that context is pretty charged, isn't it? You're not normally allowed to stare at women.'

'A lot of people were irritated by the way Amelia presented herself, because most women in bands at that time would either have been lurking in the background playing the bass or would be at the front playing the sex kitten or vamp act. Because she was doing neither, I think it just pissed people off. It was genuinely seen as provocative, although it wasn't particularly intended to be.'

For a band of such harmless personalities making such approachable music, Heavenly became inordinately hated – the lightning rod for every resentment Sarah's detractors had about the label as a whole. But for their part, the band

found the degree of vitriol directed at them refreshingly tame compared to Talulah Gosh. 'I was actually surprised that we didn't get that same abuse again,' says Flecther. 'Some people didn't like Heavenly and some did, but it wasn't like in Talulah Gosh, where people literally came to the gigs in order to scream at us and tell us how crap we were. I remember before I used to go onstage at Talulah Gosh gigs, I basically used to say "Fuck you, fuck you, fuck you" to myself about the audience, so that I was brave enough to face them, whereas I didn't have to do that in Heavenly.'

Heavenly's response, then, was to carry on in joy, their releases becoming increasingly proud anomalies. The songs' titles telegraphed what listeners could expect: 'Our Love is Heavenly', 'Wrap My Arms Around Him', 'Cool Guitar Boy'. They titled their debut mini-album *Heavenly Vs. Satan*, as if they were the opposing force against all that was dark and evil. Momtchiloff's growing fondness for tremolo and note-bending meant his guitar-playing evoked another of the Sixties' great escapist, anachronistic genres: surf music. Another woman, Cathy Rogers, joined as keyboardist and co-vocalist in 1991, exponentially boosting the band's onstage party atmosphere with her humour and confidence.

Heavenly were having so much fun, in fact, that all they could do was laugh when their second mini-album, 1992's *Le Jardin de Heavenly*, brought about reviews of quite astonishing venom. 'It takes a real effort to sound this small, this timid; to resist the effort to rock out and kick pedal', wrote *Melody Maker*'s Simon Price before asserting that Fletcher 'has spent her entire adult life pretending she doesn't menstruate' and that her lyrics are 'emotionally retarded in the extreme'. In the same week, Shampoo, an aspirant Top 40 duo of teenage girls, guest-reviewed the album for the *NME*, declaring it a 'horrid mess' and concluding with a rating of one out of ten. 'Mathew actually saw them at a gig a few days later', says Fletcher, 'went up to them and said, "Hello, I'm from Heavenly. You gave us one out of ten for our album. Why did you do that?" And they said, "That was one more than you deserved." Which he thought was hilarious!'

But then, within weeks of their drummer's encounter, Heavenly's tragicomic existence chanced upon another, very different world. Their music – and their estimation of their own worth – couldn't help but change as a result.

Figure 12.1 *Heavenly, clockwise from top left: Amelia Fletcher, Cathy Rogers, Mathew Fletcher, Robert Pursey and Peter Momtchiloff. (Photographer unknown; courtesy of Sarah Records)*

Shortly after *Le Jardin de Heavenly* had assured its status as one of the most critically reviled releases of the year (but placed in the top five of the Indie Albums chart regardless), it became the first Sarah record to gain release in the United States, finding a perfect home at K Records. Founded in 1982 by Calvin Johnson, then the singer of Beat Happening – a trio whose thrillingly odd collision of punk malevolence and lullabye tenderness was a sort of suburban American response to UK indie-pop – K is based in Olympia, Washington, a progressive-minded college town

near Seattle with an historic reputation as a magnet for outsider artists. Johnson already had an affiliation with the members of Heavenly; he had produced Talulah Gosh's final single, 'Testcard Girl', in 1988. When he offered to release *Le Jardin*, K was in the midst of enjoying its most successful period, thanks in part to the very public support of Kurt Cobain, such a fan of the label that his forearm bore a self-inflicted tattoo of its logo. Heavenly flew Stateside to play some dates (also a first for a Sarah group) and discovered they were greeted everywhere they played with a warmth and open-mindedness they hadn't experienced at home. 'People didn't come to us with any preconceptions,' says Fletcher. 'I think they just felt we were a good alternative pop band. We seemed to be viewed as less radical, I think, and were simply enjoyed.'

During an extended stay in Olympia, they witnessed first-hand the early developments of Riot Grrrl, a movement of female-led, punk-influenced bands who emphasized strong alliances to feminism and queer culture. The bands' names were humorous but impassioned: Bikini Kill, Bratmobile, 7 Year Bitch. Their music was rudimentary but spirited. They published and wrote for fanzines, adored seven-inch vinyl and dressed in a decades-straddling hotchpotch of colourful thrift-shop garb. In short, they were each, in their own way, an openly politicized Talulah Gosh (although most of them hadn't heard the group), augmented with blazing American self-assurance. Observing Heavenly – a K-approved group of thoughtful early twenty-somethings helmed by the benevolent dictatorship of a woman – the Riot Grrrl upstarts recognized kindred spirits. It mattered not that their music drew more from the Shangri-Las than X-Ray Spex: it was scrappy, proudly feminine and anti-corporate. They were allies. 'It was brilliant. It was really exciting,' says Pursey. 'I'm sure I didn't think very hard about it at the time, but some of those arguments or postures we made – of being deliberately un-macho or calling our band a very girly name – suddenly they became much more dynamic because we were with bands who were much more aggressively feminist than Heavenly had ever been.'

In the US, where knowledge of Sarah and Talulah Gosh was limited to a miniscule scattering of Anglophiles, *Le Jardin* was reviewed without prejudice, and the verdict was largely positive. 'We were very much seen as part of the

K roster', says Fletcher, 'and then the K roster itself became associated with Riot Grrrl.'

The effect of the grunge phenomenon in North America was similar to that of punk in late-1970s Britain: it temporarily acclimated the mainstream to cultural activity that usually would have been restricted to the underground. As a result, Riot Grrrl, which was geographically and ideologically intertwined with grunge, spread within months from its isolated Pacific Northwest epicentre, becoming a hot topic in glossy magazines and on TV news programmes. Partly owing to a lack of videos, the bands were rarely heard beyond college radio, but journalists thrilled to the very idea of a grassroots movement of confident, visually striking women making confrontational rock music. One result was that before long, the UK had cultivated its own scene of Riot Grrrl-style bands. One of the first, and by far the most intriguing, was Huggy Bear.

Heavenly had known the members of Huggy Bear for some time. Three women and two men from Brighton and South London, they were children of *C86* and its attendant fanzine culture. Thrilled by Riot Grrrl's progressive politics and its lack of barriers to entry (none of them could play instruments very well), they were first out of the gate and unexpectedly became a media sensation in London, which then radiated out into the rest of the country. Their notoriety occurred with such breathtaking precision, sceptics assumed the band were an ingenious fabrication, but it had simply been a glorious accident. Hard-line counterculturalists, Huggy Bear refused to talk to any mainstream press, including the music weeklies, which of course only inflamed the weeklies' fascination. It also helped that their first three singles were accidental brilliance – raging and unpredictable and full of quotable wit ('They want to make a T-shirt out of your dreams!') that appealed greatly to disillusioned youth.

At the end of 1992, with their third single, 'Her Jazz', being declared an instant punk classic, Huggy Bear decided to accept an invitation from the enemy and perform the song on the Channel 4 talk show *The Word*. One of the greatest broadcasted performances of the decade, it revealed the band to be naturally fearless performers and a fount of electrifying noise. Standing on stage with them – dancing with wild abandon and joining in the shouted

refrain of 'Boy-girl revolutionaries!' – was Amelia Fletcher. The demure singer of Heavenly was – for those three minutes, at least – quite a different creature.

'The Riot Grrrl scene, in America and in Britain, was very small,' says Pursey, 'but it spoke louder than its size'. Its impact in the UK was brief but profound. Topics such as fanzines, the role of women and politics in popular music, and the virtuousness of anti-commerciality became valid talking points in the music press for the first time since the post-punk era. The week following Huggy Bear's appearance on *The Word*, *Melody Maker* ran a cover feature that was half think-piece, half eyewitness report from the Channel 4 set (where the band were ejected by security after their performance for heckling the programme's next guests, two American blonde-bombshell models named the Barbi Twins). 'There's a genuine need for a fanzine culture', wrote Everett True, 'for a musical consciousness that realises women still get short shrift on many fronts – and for bands who understand that too. An underground, if you will.' This sort of discourse was highly unusual for a cover story in any of the weeklies. It also sounded like the points Heavenly and Sarah had been making for years.

Fletcher was no less impacted by Huggy Bear and the bands she and the rest of Heavenly had befriended in the States. 'We started organizing our own things,' she says. 'We played shows [in the U.K.] with Bratmobile, Huggy Bear, Calvin Johnson and Lois [Maffeo, a singer-songwriter on K]. We were excited about playing with them, and they needed someone to set up tours in England. Every time we went to America, we imbibed the current culture that was going on, in the K scene and the alternative scene. We then kind of made it our own.'

The two singles that Heavenly released back to back in August 1993 are indeed a 'kind of' response to Riot Grrrl and the band's experiences among their new-found American peers, yet their core identity remains. Musically, 'Atta Girl' and 'P.U.N.K. Girl' are scarcely more abrasive than anything the band had done before. The more significant transformation is to be found in Fletcher's lyrics. The unfailingly optimistic view of romance that defined her previous songs – the bliss of existing love or hopefulness for love to come – is replaced with a withering view of the behaviour of men (they don't seem like

boys anymore) and the capacity in women to indulge it. In 'Atta Girl', Fletcher plays the role of both jealous male begging forgiveness for the umpteenth time ('Honey, please come back, I miss you/Yeah, come here so I can kiss you') and a fed-up female issuing her final, enraged dismissal ('Fuck you, no way!'). 'Hearts and Crosses' seems a bubblegum-light portrait of a woman named Melanie's unrequited crush, until it reaches a calmly spoken middle eight in which the object of her affection rapes her ('He never smiled, he never whispered/He bit her hard but never kissed her'). 'So?' explores similar territory in little more than a minute, Fletcher singing a capella – possibly from the perspective of Melanie – to a would-be suitor who misread her signals. It seems mild enough, a sympathetic plea for forgiveness. And then her voice almost imperceptibly breaks before she issues her parting words: 'But nothing I did, or could ever have done, would justify what you did to me last night.'

'When we did those records, they were absolutely conceived to be a part of what the likes of Bikini Kill and Huggy Bear were doing,' Fletcher acknowledges. 'It was very direct and more daring in some ways. And in a funny way, I think there are more similarities with Talulah Gosh, and in Talulah Gosh we really couldn't play at all. So I think it's more about rediscovering that particular straight-ahead, dynamic spirit.'

'The lyrics of Heavenly changed pretty dramatically and were more clearly influenced by other bands who were a lot more outspokenly feminist,' adds Pursey. 'The lyrics went from being fairly whimsical to fairly dark.'

In the US, where the two singles were combined into a single release by K Records, the songs were received as feminist anthems that could be considered of a piece with other Riot Grrrl releases. At home, the *NME* made it a joint Single of the Week and acknowledged the band's often overlooked 'darker and more complex twists'; *Melody Maker* declined to address the music, only referencing Heavenly as 'forebears of short-haired girl bands stomping around onstage and irritating the shite out of everyone'. Clearly, Riot Grrrl's carpet-bombing campaign hadn't resulted in a consensus vote.

'I think the songs on the "Atta Girl" and "P.U.N.K. Girl" singles are the best songs to come out of Riot Grrrl, and they're great because they were made by a great pop band,' says Haynes. 'If Riot Grrrl is essentially saying "Women

can do this, too," then Heavenly were one-hundred-per cent Riot Grrrl – and so were Talulah Gosh, and it's frustrating that they rarely get any credit. But because Heavenly existed before Riot Grrrl, the ideas were injected into what was already a fully functioning pop band. The music was never going to be just a vehicle for the politics, whereas it often felt like some of the US bands had formed in order to make a political statement and get the ideas into circulation. Obviously that can work, but if the ideas are more important than the tunes, it can just end up with po-faced ranting – which is why I never find myself whistling any Crass.'

By the time Heavenly returned with their third mini-album, *The Decline and Fall of Heavenly*, in September 1994, Riot Grrrl had more or less retreated to the underground community of true believers that first gave it life. The music press had quickly tired of the movement's uncooperative personalities and what was perceived as its killjoy sociopolitical agendas. Britpop had ushered in a national mood of celebration, material pursuit and uncomplicated populism. The notion that a band might deliberately recoil from the chance to be famous had never seemed more absurd. The title of Heavenly's new record was a play on the famous history book *The Decline and Fall of the Roman Empire* (the album's cover photo is a kitten flanked by Roman pillars and wearing a laurel wreath), but it was also a self-deprecating comment about the band's perennial position. In a small *Melody Maker* feature coinciding with its release, Cathy Rogers bitterly joked that it was a pre-emptive strike against 'everyone who'll slag it off'. The story's subhead begins: 'Heavenly, the Band We Love To Hate'. Fletcher surely saw it and flashed back to when her younger self was preparing to go onstage with Talulah Gosh: 'Fuck you, fuck you, fuck you…'

The Decline and Fall is the best record the band had made to that point: bright, fuller sounding than before, and bursting with good humour built upon the new-found brashness of the previous year's singles, from the pregnancy-scare scenario of 'Sperm Meets Egg, So What?' to the independent woman of 'Modestic', who cheerfully informs her latest fling that she just wants him out so she can wake up alone. Their next album – their first full-length one – would be even better, but it fell to another label to release it. Before it could be completed, Sarah was gone.

13

'Sadness is Unisex': Blueboy and 'the Best Album' Sarah Released

Sixteen-year-old Paul Stewart took a seat in the pews of St. John's Church alongside his older brother, and Sunday service began. While the pastor gave his sermon, Stewart's eyes drifted to a boy sitting nearby, who was using his thumbnail to scratch something into the bench in front of him. He withdrew his hand to reveal the small act of vandalism he had just committed: it read DEXYS.

Stewart whispered to his brother. 'Who *is* that?'

'That's Keith. He wants to meet you, actually.'

Stewart had heard previously about Keith Girdler. Four years older than Stewart, he was the singer in a local band of minimal renown named Emotional Jacuzzi. A poster for one of their gigs had read 'Bring a towel', which stoked Stewart's curiosity enough to see them at a pub in Woodley, a suburb of their shared hometown of Reading. They were as their name suggested. 'Quite awful. Quite funky,' remembers Stewart.

But Stewart was intrigued, and not only because of their apparently mutual love of Dexys Midnight Runners. A guitarist and writer of throwaway 'one-minute pop songs' who had rarely played for anyone other than family and schoolmates, he was desperate to join a band. The older boy's interest flattered

him, so he was only too eager to talk to Girdler in the street after service, while the congregation filed out around them. 'We talked about the bands we liked,' says Stewart. 'I was quite into 4AD, he was very into Factory. He loved New Order and Stockholm Monsters. Very soon after that I took my guitar round and we played a few songs.'

Girdler, asserting his senior status, saw to it that his influences took precedence. At his suggestion, they became a duo and, with no little subtlety, named themselves Isolation, after the Joy Division song. 'We did our one and only gig in this church hall at the end of some awful party or something,' Stewart recalls. 'We did a cover of "Blue Monday" – really cheap keyboards and I played drums. I think we split up that night as well.'

Humiliated but unbowed, they agreed to tear up their blueprint and try again. They also conceded that they needed help, so Stewart used his lunch hour at a graphic-design company where he worked part-time to fashion a flyer calling out for a rhythm section, and he posted it in a record shop. 'Must like the Smiths and Lloyd Cole,' it demanded. And so it followed that bassist Phil Ball and drummer Lloyd Haggar phoned Stewart, to be greeted by the voice of his mother, who called the young guitarist down from his bedroom.

Throughout their fitful existence between 1987 and early 1991, the duly christened Feverfew ticked the box of every accomplishment that could be expected of a local band that lives and dies without setting foot outside of its immediate environment. They gigged solidly around Berkshire, were the subject of a handful of dry paragraphs in the local papers and – what with it being the 1980s and Feverfew being cash-strapped indie youth – they released a flexi. They even competed (and were runners-up) on a regional, celebrity-judged TV talent competition, where comedienne Faith Brown and has-been pop star Paul King looked on with bland amusement while Girdler tentatively danced like Morrissey in a tightly enclosed space. (King had, in fact, been impressed enough to approach the band afterwards and offer the use of his recording studio.) Their music, which suggested the influences of the Smiths and Lloyd Cole without sounding much like either, was competent enough to not offend and altogether pleasant enough to not be remembered. 'Feverfew was very naïve,' says Stewart. 'I look back on it affectionately because I had

good friends and we loved playing and we had a good laugh. It was just an uncomplicated, great time. It was our youth.'

After Feverfew wound down, Girdler moved to Brighton but returned to Reading most weekends; he had lost his father recently, and his mother, who had given birth to her son while in her forties, was elderly and fragile. Stewart would usually meet him at the train station each Friday and then see him off Sunday evening. At some point between arrival and departure, they continued to make music. 'We realized that Feverfew was only our first venture,' says Stewart. 'We wanted to do more.'

There had been little about Stewart's guitar-playing in Feverfew to suggest his capabilities and interests extended beyond noble but deficient attempts to mimic Johnny Marr or the Commotions' Neil Clark. But his grounding was in classical playing, and he counted among his favourites the 'hot jazz' legend Django Reinhardt and bossa nova pioneer Marcos Valle; some of his favourite modern sounds included the Pale Fountains' Flamenco-like flourishes, and the vast, intricate soundscapes Robin Guthrie created for Cocteau Twins. These hidden depths finally came to the fore in early 1991, when Girdler and Stewart – a duo once again, but a wiser one – entered a friend's garden shed that had recently been equipped with a four-track portastudio. There they recorded three songs, one of which had been languishing since Feverfew. 'We'd had it in our back pocket,' says Stewart. 'It didn't need crashing drums and bass and backing vocals, so we banked it.'

Combining the echo-laden, arpeggiated style of the Cocteaus with stately acoustic fingerpicking, 'Clearer' bore virtually no resemblance to Feverfew's undistinguished strumming. New, too, was the content of Girdler's words: the lyricist who only a year before had sung the trite anti-drug diatribe 'Give it Up' ('Don't take those nasty things/Up your nose or in your veins/They make you sick') had written a deeply personal, devastatingly sad protest against Clause 28, a controversial Conservative government amendment (passed in 1988 and not repealed until 2003) that discouraged the promotion of homosexuality as normal or acceptable: 'For all the pubs and all the clubs/There's still no love/ Let me be, please let me be … free.' There had never been anything like it, in any genre.

'Clearer' and two other tracks were recorded in the shed that day. Stewart considered it a successful experiment and put the cassette to one side while contemplating what they should do next. Girdler, in secrecy, sent it to Sarah. 'And then one Sunday – I think we were having Sunday dinner. I was still living at home, so I'm seventeen, eighteen,' Stewart recalls. 'Keith called and said, "Are you sitting down? I've got a letter from Sarah Records saying they want us to record "Clearer."'"

'We replied straight away after listening,' says Haynes. 'I know it sounds glib, but whatever unfathomable 'something' a band has that makes it special, it pretty much always hits you first time. We'd had demos from Feverfew but not been bowled over – they fell into the 'OK' category. Whereas this had that extra ineffable something – it was effortlessly magical.'

He and Wadd dispatched them to the Whitehouse studio in Weston-super-Mare, the site of some Feverfew sessions and where Brighter had gone to salvage *Laurel*. While on their way, Stewart brought up a topic that had been causing him distress for weeks: the demo Sarah had been sent bore a band name that was chosen without a great deal of thought or sober intent. Now that they were about to become proper recording artists for a proper label, the name would have to go if they were to be taken at all seriously. 'I said, "Keith, I *can't* be in a band called the Art Bunnies."'

Wadd and Haynes had, in fact, liked the name. But they also liked its proposed replacement, Blueboy – particularly when it was explained to them that it was nothing to do with the Orange Juice song, and everything to do with the Picasso painting and an American gay men's magazine. Stewart, a heterosexual, enjoyed its provocative nature, although he knew it was likely subtle enough to go over the majority's heads.

When 'Clearer' was released as Blueboy's debut single in October, the accompanying mail-order insert featured the entirety of the song's lyrics, at the insistence of Wadd and Haynes. They had never done such a thing before, but nor did they think a Sarah band had written anything to merit such a gesture before. It seemed to escape the notice of at least one reviewer, whom Haynes remembers dismissing the song as 'a "limp-wristed song about being sad." Extraordinary, really, that a reviewer in the 1990s could still use that

sort of language.' *Melody Maker* praised it, albeit with a familiar postscript of contriteness: 'Blueboy may turn out to be this stupidly ignored little label's forlornest, finest semi-acoustic romantics yet. God I love Sarah. God I felt embarrassed writing that.'

Almost a year passed before another Blueboy record emerged. In the interim, Girdler and Stewart formed another band around them – the humiliating lesson of Isolation had not been forgotten. Feverfew drummer Lloyd Haggar returned, and Stewart discovered that one of the residents of a shared house he had moved into, Mark Cousens, was a bassist. 'Keith and I knew that we wanted to play live and bring in more instruments, like piano and cello', says Stewart, 'so we were keen to explore the creative process beyond the two of us.'

As luck would have it, a new philosophy student at the University of Reading, one Gemma Townley, was a pianist and cellist as well as a singer. Had she not seen the notice that Cousens pinned up in the student union, Girdler and Stewart's vision for Blueboy's expanded sound likely would have gone unrealized. She was the only one to reply.

The second Blueboy single, and the first to feature the five-piece line-up, arrived in August 1992 carrying the optimistic title 'Popkiss'. The song entirely fulfils the promise of its name, its restrained verses bursting into a euphoric wordless chorus full of flailing drums and briskly strummed guitar, as though a romantic suitor's tentative advances are suddenly rewarded with a welcome assault of limbs and lips. 'Because I wanted to hone a strong live sound and was regimental about performing as tightly as possible, guitars, drums and bass would be rehearsing for weeks before Keith was drafted in,' explains Stewart. 'That's why "Popkiss" is more ferocious. It really was a live band recording.' The two B-sides showed that he and Girdler would be sure not to exploit their new bandmates at every opportunity, instead giving careful consideration to what best suited each song. 'Chelsea Guitar' is just the core duo, while the use of bass and drums on 'Fearon' is distinctly understated.

Had they not possessed such thick skins, the band might have fallen apart as soon as reviews for 'Popkiss' appeared, for they remain among the most vitriolic in Sarah's history. No one can say at this distance why it provoked such a uniformly hostile response, but 1992 was the year in which grunge and American rock in general dominated the British musical landscape. Suddenly,

the country's long, proud history of outsider pop – its capacity for gentleness, camp, vulnerability – had never been perceived as a greater offence to popular and critical taste. Girdler's virginal choirboy tones, especially, were the antithesis of the shredded voices of rage that were thrilling journalists and record buyers. Significantly, the late-1980s shoegaze bands whose vocals struck a similar note of omnisexual ambiguity fell swiftly from favour that year, most of them either breaking up or making over their sound in a manner more decidedly alpha male. So … '*Acoustic strumming, feeble, breathless posho whining about being sad (ATTACK! ATTACK! RENDER LIMB FROM LIMB!)… . Henry Rollins has been informed of their home address,*' raged the *NME*. '*Everything about this song is as irritatingly twee as the name of the group suggests. The vocals are particularly pathetic,*' griped *Melody Maker*.

Blueboy, having begun as they meant to go on, responded by making a mini-album even more defiantly contrary to the tenor of the times. The cover photo of *If Wishes Were Horses* is of children playing at the beach, engrossed in the sand and sea or gazing skyward. The record's complementary mood is one of blissful suspension; even when its lyrics speak of discontent, as on the seething political monologue 'Fondette' (spoken by Gemma Townley), the music is all sweetness and light – Spanish guitar, male-female harmonies, Townley's cello (occasionally resembling a violin), drums struck with a buoyant hand. 'Everything was planned out well in advance, but it was important to allow for some magic to happen,' says Stewart. 'There was a reassuring amount of improvisation and on-the-hoof work done in the studio.'

Recorded again at the White House, the record was completed in five days, everyone sleeping overnight on the studio floor so they could begin promptly at 9.00 am. Joining them to provide some backing vocals was Harvey Williams, who had previously done the same for the single B-side 'Chelsea Guitar'. Williams had got to know Blueboy when they supported the Field Mice on what would prove to be the latter's final tour. He instantly fell in love with their music, and recognized Stewart as a guitarist whose skills were miles beyond those of most of his peers. 'Paul is a remarkable musician, with a very specific idea of what he wanted – and also possessed of the ability to get it,' he says. 'He had a broader range of influences than many Sarah bands. That isn't intended as a slur against any specific Sarah bands, but if you only

want to sound like generic indie-pop, that's a fairly attainable ambition. If you want to sound like an obscure Astrud Gilberto album track or a rococo string quartet, that's a little trickier to achieve.'

Shortly after the sessions, Williams joined as second guitarist.

When it was released in September 1992, *If Wishes Were Horses* didn't elicit the outrage summoned by 'Popkiss'; it generally was deemed too inconsequential to merit notice. But *Melody Maker*'s Dave Jennings at least proved he had been paying attention: making note of its sly juxtaposition of sweet melodies and bitter words, he described the record as 'something of a Trojan My Little Pony'.

When it came out in Japan at the beginning of 1993, Blueboy were invited to fly over for a short February tour, and thus became the next Sarah band to experience the stark, disorienting contrast between the label's status there and at home.

'We did quite a big gig in Tokyo; there were about 2,000 people,' says Stewart, still incredulous. 'We got taken to this kind of sports stadium that was empty. We were walking through with our gear and there was this big stage

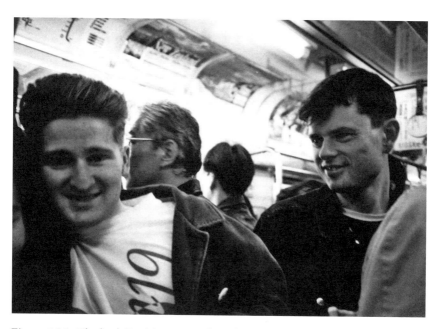

Figure 13.1 *Blueboy's Paul Stewart and Keith Girdler in Japan, 1993. (Courtesy of Sarah Records)*

at the end. We said, "Where are we playing?" "Here." "*Here*? It's going to be empty!" "No, it's sold out." And there were people in the front row singing along. A week later, we'd flown back, we've got a gig at the Camden Falcon, it's a rainy Wednesday, probably a fiver to get in. There's about fifteen people there. That was real life.'

The remainder of the year saw encouraging progress at home – there would be nothing else quite as dispiriting as the sight of a near-empty Camden Falcon. A single, released in April, showcased the band's stunning versatility and soaring confidence within six and a half minutes total. 'Meet Johnny Rave' is the band's most exuberant performance, a spry waltz whose major-chord melody implies boundless optimism while Girdler sings of 'a boy built just for pleasure' and London being 'full of itself and such misery'. The B-side is ostensibly two songs, but they merge seamlessly into one, the solo-guitar instrumental 'Elle' giving way to 'Air France', an aptly weightless-sounding prayer for escape. The *NME* described it as 'smock-swinging jangly ramble, the kind of thing Sarah bands knock out in their sleep'. What could one do? The *Some Gorgeous Accident* EP followed in July and somehow fell into more attuned hands at the same publication, where it was declared joint Single of the Week, together with new releases from Heavenly and Even As We Speak, under the headline SECRETLY HUGGABLE LABEL OF THE WEEK. 'Three more spunky records from the label you hate to love,' it began.

A seven-date UK tour closed out the year while Blueboy prepared to make their first full-length album. There wouldn't be very much time or money (of course, there never was for Sarah recordings) but Girdler and Stewart were determined to make it count. 'I wanted every song to be as different as possible but within a certain style,' says Stewart. 'The newer material outshone the previous songs quite considerably. Keith and I still worked on the songs in the same way as before [away from the rest of the band], but we now presented our ideas to the others and took things to the final stage collectively.'

While they wrote and rehearsed, a new *Melody Maker* contributor named James Slattery became the first voice at the weeklies to speak in unreservedly ecstatic terms about Blueboy. Suede and the forerunners of Britpop had begun reintroducing a musical vernacular that was, in its own way, as conservative as

grunge, and Slattery saw in the Reading sextet something that stood bravely apart from the follow-the-leader impulse that was serially gripping a so-called alternative realm. Reviewing a set at the London Monarch, he wrote, 'At a time when retrograde glam racketeering and barely articulate fury are the most fashionable musical currencies, Blueboy are a delicious anomaly.' He followed it with a report from another London date, which led him to declare, 'F*** your escapist nostalgia, this is genuine liberation… . The future's in the hands of the wider audience that surely awaits them.'

Shortly before the album's arrival in shops, Sarah tinkered with chronology and released a trio of songs that had been recorded more recently. The *River* EP is Blueboy's most radical stylistic digression. The title song, originally named 'River Phoenix' but truncated in the aftermath of the actor's death, features programmed drums, synthesizer and undulating swells of noise modelled after the 'glide guitar' innovations of My Bloody Valentine. One-man cheering section James Slattery, granting the band what would be their only feature in the weeklies, compared it to 'the Pet Shop Boys at their most grandiose'. The enormity of its sound carries over to the B-sides, 'Nimbus', an ambient instrumental (complete with sampled rainfall) and 'Hit', a bass-heavy, downtempo tale of celebrity burnout more suited to the mirrorballed nightclubs of Soho than the dim backroom venues of Camden. '"River" never worked as a "band" song, so it ended up being a studio song, as did the other tracks on the EP', says Stewart. 'It wasn't a conscious decision, but then we never had a master plan. It was played by Gemma, Keith and myself. "Nimbus" was Keith and I, and "Hit" was Harvey and Keith reworking a song I had.'

River would be a one-off, a tantalizing glimpse of an alternate way forward that the band, for whatever reason, chose not to pursue. But when the album, titled *Unisex*, arrived in May, it justified every claim Slattery had made about Blueboy. In its press release, Wadd and Haynes declared it the best thing they had released to date. 'We always made a point of not having favourites – it was the only time we publicly used that phrase,' says Haynes. 'It was probably borne of frustration. We just really wanted someone to take the album seriously. We obviously loved every record on Sarah, but it would be daft to think all of them could have been top ten hits. But others could and should have been loved by anyone, of any age, who loves music, and *Unisex* would be one of those.'

I think that's what we were trying to get across: don't review this as a 'Sarah album' or an 'indie album'. Just review it as an album, full stop.'

For its melodic beauty alone, *Unisex* is special: a notion of baroque pop devoid of the self-conscious quaintness that eventually made the use of violins and classical guitar a target of parody at the end of the psychedelic era. 'I was able to write for the specific instruments and sounds that I now knew we could achieve,' says Stewart. 'The goals we had for *Unisex* weren't set in stone, but I wanted to fully utilize the strengths among us. We now had the luxury of saying, "That would be great with some cello or piano" and seeing how it sounded.' This heightened sense of adventurousness is apparent from the album's first minute: a grand (and grandly anachronistic) cello-and-violin fanfare, played by Gemma and her sister, that dovetails into the melancholic opening chords of the ballad 'So Catch Him'.

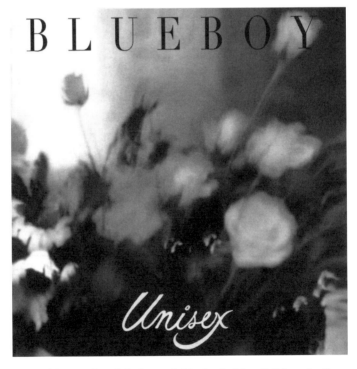

Figure 13.2 *A 'classic of English fop pop': Blueboy's debut full-length album,* Unisex. *(Courtesy of Sarah Records)*

Every song feels equally considered, whether the creeping, footstep-like strings that lend a note of menace to the verses of 'Marble Arch' or the liberal use of reverb that makes 'Lazy Thunderstorms' sound as though it's being transmitted from the lonely expanse of space. Even the uncharacteristic attack of distorted six-string that drives 'Imipramine' is deployed with purpose.

What makes *Unisex* especially incomparable, though, is Girdler's lyrics. From the beginning of Blueboy, he had used Stewart's music as a vehicle with which to explore subject matter rarely broached in a pop song: the oppressiveness of sexuality, the fluidity of gender and desire, the simultaneous thrill and sadness of romantic and sexual thrill-seeking. *Unisex* explodes these preoccupations into a virtual State of the Physical Union address. Ambiguity remains a hallmark – Girdler never confirmed if he was singing from his own viewpoint or that of a character, the gender of those characters or whether he was drawing from experience or formulating a fiction – but the scenarios are more explicit and cinematic than before. While Suede's Brett Anderson was drawing praise for words that celebrated society's underbelly with the non-specificity of an obvious tourist, Girdler's lyrics bore the fine details and palpable heartbreak of a participant. 'Marble Arch' recollects selling one's flesh 'with eager glee' to an older man, its protagonist betraying neither joy nor regret for having done so. 'Boys Don't Matter' would appear to be a straightforward love song to a disinterested would-be paramour (but who is the mysterious 'Carol' for whom he would 'wait forever'?), the singer taking stock of years of romantic disappointments ('… all those evenings running home in tears'). 'I guess I'm kind of shy/But I'll give anything a try', he sings, and the essence of the album – and of Girdler's simultaneously mischievous and unguarded perspective – is summed up.

'Keith never presented his lyrics to me,' says Stewart. 'I would only get a glance at them. They were evolving almost all the time – in the studio he'd be crossing things out when we were recording. I trusted him completely. He was quite clever in that you couldn't make the lyrics fit what you wanted. People did start to say that we were a pro-gay band, and I used to get a little annoyed at that because although I certainly wasn't anti-, I didn't feel Blueboy were a "gay band" at all, in the same way that we weren't anything else. But I never asked him to change a single word.'

Stewart had suggested the album's title (taken from the lyric 'Sadness is unisex' in the song 'Fleetway'), feeling that it reinforced Girdler's themes while respecting their overall sense of mystery. 'Everyone seemed to like it,' he says, 'and Keith found some reassurance with it, I think, as it wasn't being too obvious but affording the notion of "playing for both sides." If anything, the content of the album deals with the doubt, fear or sometimes guilt with being true to yourself.' (Remarkably, some years later Girdler criticized *Unisex* for having been 'written whilst drinking too much and being too negative. ... [It was] a very self-indulgent LP, which I regret.')

An eight out of ten review in the *NME* declared it 'a classic of English fop pop', but this was as much attention as *Unisex* would receive from the major music press. Released halfway between the twin Britpop eclipses of *Parklife* and *Definitely Maybe*, it may be that its timing couldn't have been worse.

A tour of France followed, but Lloyd Haggar wasn't with them. He had bowed out two weeks prior to the first date, citing day-job commitments. A flurry of panicked phone calls resulted in Martin Rose, a member of fellow Reading band the Rileys who had occasionally sat in with Feverfew, taking over. He was presented with a set list, copies of the records and the bombshell that there would only be two rehearsals before everyone boarded the ferry.

Despite his lack of preparedness, the tour was a success. Rose, who was accustomed to playing to handfuls of people in pubs, observed with astonishment the considerable popularity Blueboy had achieved across the channel.

'I remember one day we soundchecked in a venue – I can't remember which town but I'm pretty sure it was the last night of the tour. We decided to pop out to get a bite to eat before we went on stage. When we drove off there were a few people at the door queuing to get in. When we returned an hour or so later, the queue was around the building. Moments like that were new to me.'

But it wasn't enough of an enticement to retain Mark Cousens, who announced at the end of the tour that he was leaving. He had become a father the previous year and was finding it increasingly burdensome to balance both responsibilities. Blueboy had been fine when it was a hobby,

but recent developments, rather than cheering him, made it feel like a second job.

He did return to the fold once more, though, when Blueboy recorded a Peel session in October. Of the four songs they recorded, two were as far removed from the chamber-like delicacy of *Unisex* and the electronic excursions of the 'River' EP as could be imagined. During their French tour, the band had especially enjoyed playing 'Imipramine', the *Unisex* finale that offers the album's sole moment of velocity, volume and abandon; on stage, they would extend its instrumental coda and, says Stewart,

> 'everyone went mental, in a good way. Harvey and me and Mark, we just turned our amps up to full and just went crazy. Keith had heard somebody say the lyrics were gay – something like that – so he put on a bit of lipstick, then he leant over and he kissed my guitar while we were thrashing out the ending, and then he kissed *me*, just to really annoy people. Which worked quite well.'

The euphoria of the experience bled into a pair of songs, 'Dirty Mags' and 'Loony Tunes', that Peel listeners heard that night, and which audiences would bear witness to at future gigs. It then became two-thirds of their next EP. Blueboy had arrived to the rock 'n' roll party after all, but in their own time and on their own terms. And with 'Dirty Mags', Girdler had brought with him his most bristling vocal performance and his most obliquely provocative verse, describing a tattooed, faux-gold-ring-wearing symbol of male, British emotional repression; 'borstal sex'; and selling one's story to 'a dickhead from the *Star*'. 'I want to come inside your life/Oh, you're so mean', he taunts in the chorus, seemingly half appalled, half desirous.

The EP was received with confusion, shock and, in some instances, disgust by those for whom Blueboy were meant to be the antidote to such boorish accoutrements as power chords and snarled profanities. But Girdler and Stewart weren't bothered. The anguished departure of Cousens had mystified them – the band was never meant to be so serious a concern that it could be perceived as having the potential to take over a member's life, which is why its founding duo felt free to challenge their audience even if it meant losing them. Girdler would later declare that Blueboy had only ever aspired to be 'as big as

Fantastic Something', a cult Greek duo that released one single and one album before vanishing.

'We weren't egotistical. We didn't want fame. We didn't want money. We were the band to go on first so that we could get home. Didn't do the drugs thing at all. Never got pissed,' says Stewart. 'Seriously, I've got to say this: Every day, we just couldn't believe our luck. We never took it for granted. From Matt and Clare doing the first single to going abroad and having our studio fee paid for – it was just alien to us. Maybe that's why the songwriting was like it was: because we were in this really privileged position that could end at any time.'

Which it did. A farewell compilation aside, 'Dirty Mags' was the last thing Sarah released.

14

An Economy of Ambition: Sarah's Short-term Visitors

Speaking to Simon Reynolds about the flood of independent records he received following punk's great demystification of music production, John Peel enthused about the very attributes they exhibited that previously would have given consumers and tastemakers pause. The records – almost without exception singles – couldn't help but betray the frugality and haste with which they were made: the sleeve and label designs were minimalist and as nakedly cut and paste as a home craft project; the music within seemingly made no effort to conceal its creators' inexperience; and the addresses accompanying them were not in London or New York or any other metropolis known for its role in the cultivation of pop stars. They came from second- and third-tier cities and provincial nowheres whose only claims to fame were perhaps heavy industry or a university or a disproportionately high crime rate. Nothing about these efforts suggested a bright future for their makers, nor necessarily the desire for one. They looked like a lark. 'You'd get records sent in by these stroppy lads from tiny towns in Lincolnshire, places you had to look up on the map,' Peel said. 'And I'm a great sucker for cheerful amateurism. Another thing I liked was that a lot of these bands were almost entirely without ambition. Their goal was often just to put out a single'.

Wadd and Haynes, having come of age through post-punk and its lingering influence, had long thrilled to the reality of hit-and-run bands who would invest one vinyl artefact with the full extent of their joy and inspiration, and

then disappear. This, they felt, was creative expression in its purest form, endeavoured not in the hope of a career or money or adulation, but for its own sake. Haynes had, of course, co-designed Sha-la-la in accordance with the notion of 'throwaway pop', and he and Wadd saw no reason why Sarah should hold any of its bands to a greater expectation of longevity simply because their music would be pressed onto hard vinyl rather than a feeble flexidisc.

'One record at a time was the Sarah way. Even some great bands only have one song worth releasing,' says Haynes. 'None of the bands were full-time, and gigs and recording fitted around when work or school would allow, and I think that was quite healthy. There was certainly no way we were going to tell anyone they should give up their job. I also don't think we would have enjoyed it if they had; it would have changed the dynamic of the relationship and put huge pressure on us to give them success in return. In a sense, Sarah was that most perfect of things: a full-time – *very* full-time! – hobby that actually made money.'

In the beginning …

Of Sarah's first eight releases, all but one of them in some way carried over from Sha-la-la (Another Sunny Day's 'Anorak City' having initially been earmarked as the latter's final release). The odd band out among the pack was 14 Iced Bears. Hailing from Brighton, their unfortunate name – easily the greatest invitation to ridicule of any indie group bar Trixie's Big Red Motorbike or Grab Grab the Haddock – obscured the impressively rounded influences of founder Rob Sekula, a philosophy student who loved Burt Bacharach and Scott Walker as much as the Pastels and Josef K. Shortly after forming in 1985, the band came to the attention of former Television Personalities drummer Mark Flunder, then in the midst of launching his own label, Frank. 'He saw us play live and thought a song of ours, "Jumped in a Puddle," was a mod classic,' recalls Sekula. 'We never recorded that one in the end.'

14 Iced Bears did record two EPs for Frank, in 1986 and 1987, that handily revealed Sekula's preternatural ability to write unforgettable choruses; John Peel was instantly won over when he heard their debut, 'Cut', in which Sekula

sings (in a spectacularly dispassionate drone), 'Don't call me ever again/I think I've lost my only friend/A friend who happened to say she loved me' – as succinct and anthemic a statement of romantic hopelessness as indie-pop has ever produced.

Sekula has no recollection of how the band parted company with Frank and came to join Sarah – possibly a side effect of the creeping psychedelic influence that was taking hold of him and his immediate surroundings ('There was quite a '60s atmosphere amongst us and our friends in Brighton by about 1988,' he says. 'The main club had become the Sunshine Playroom, and a lot of time was being spent dancing to the Beatles on acid'). Wadd and Haynes were delighted to welcome them, however; given that Sarah had only released the Sea Urchins' and the Orchids' seven-inch debuts thus far, it seemed to augur well for the label's future that an already established band had come to them.

Given that their Frank recordings were unified by the sound of a band whose instruments always seemed to be half a step ahead of them, the three songs 14 Iced Bears turned in for Sarah's fifth release proved a not insignificant step up (although this is purely relative; the rhythm section, as before, apparently was in a race with one another). This was partly due to the circumstances in which the new songs were made ('Van Morrison's drummer was the engineer!' says Sekula. 'I think we did it over two or three days, and Sarah weren't too happy with the cost'), but mostly it was because Sekula had written a triumvirate of jewels. Best of all – and eternally deserving of top billing, despite being given nominal B-side status – is 'Sure to See', a meandering, intoxicating (and possibly intoxicated) evocation of love-induced delirium. In its final minute, Sekula stops singing and each player seems to temporarily take leave of his bandmates in order to follow a song only he can hear. Yet, like all great music that aspires to the psychedelic, their unhinged collective effort somehow makes sonic sense. It remains one of the loveliest songs Sarah ever released.

Released in May 1988, it also marked the end of 14 Iced Bears' association with Sarah. 'We were looking to record an album and that simply wasn't in the Sarah philosophy at the time,' says Sekula. 'There were no hard feelings.' The band wasted no time. Before the end of the year, they had completed a self-titled debut album whose blurred cover art and saucer-eyed contents

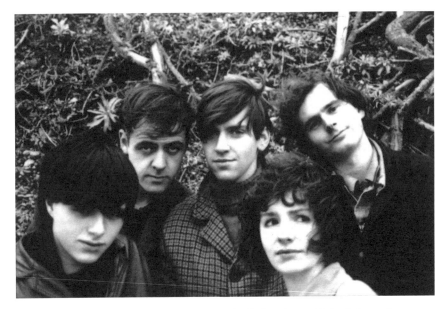

Figure 14.1 *14 Iced Bears, from Brighton, had already established themselves at another label before releasing their* Come Get Me *EP on Sarah in 1988. Before the end of the year, they had switched labels again as well as significantly changed their sound. (Photo: James Duncalf)*

anticipated the neo-psychedelic revival that the music press would celebrate as 'shoegaze' in little more than a year's time. In 1991, the band, perhaps as an act of contrition, slightly formalized itself to become 14 Iced Bears, and then released *Wonder*, an immaculate-sounding, perfectly titled LP of immersive rock songs for the sort of people who might like to dance to the Beatles on acid. It sold poorly and they broke up soon after. A journalist speculated that they might have become huge if not for that name.

The Poppyheads are responsible for one of the most amusing anecdotes in all of Sarah Records lore. Made up of a quintet of students from Cambridge, the unashamed artlessness of their first recording, which was released as a Sha-la-la flexi titled *Postcards for Flossy*, so offended an anonymous buyer that he returned it to Haynes in the post accompanied with a smear of his own faeces.

So incomparably inept are the four songs that inspired this act of postal terrorism – each less than two minutes long, in which a male and female

compete to sing more atonally than the other – even those who had been conditioned from years of John Peel's programme to accept the subjective appeal of the host's beloved 'cheerful amateurism' dismissed it as a joke.

In fact, it was a quite deliberate study in simplicity. The Poppyheads' founder and frontman, David Barbenel, had played cello from an early age, and at age sixteen could be found busking in his native Glasgow, playing mandolin and singing Sam Cooke and Buddy Holly songs. But once he heard the Jesus and Mary Chain (their *Psychocandy* album 'was playing everywhere' in the city, he recalls), he became fascinated with the potential for subversion in 'everything being stripped back to the essentials'. Rob Young first caught sight of him onstage with the nascent Poppyheads – 'Very tall, a big mop of hair, singing in a kind of growl' – when they supported the Flatmates. All of them were familiar faces from around Cambridge: 'They used to walk around wearing what looked like their grandma's old anoraks.'

Soon after, Young discovered they were looking for another guitarist. He could barely play, but he did at least *own* the instrument in question. 'I thought it was a chance to meet these quite interesting-looking people. I went to an audition; it was up in a student room at the top of a very tall, old building like you have in Cambridge. It was very dark inside, candlelit, posters on the walls of the Velvet Underground.'

Postcards for Flossy was recorded within weeks of their first meeting, in a 'rundown studio behind a supermarket,' says Young. 'The attitude in the group was to be quite mocking of the idea of musos and musicianship. Nigel, the drummer, wasn't in any way a musician – he was just a good friend of David who wanted to be involved. It was very hard to get him even to play in time.' Barbenel recalls 'asking the engineer to keep increasing the treble until the drum sounded like a biscuit tin being hit. I don't think he was very impressed.'

No one in the band had any plans for the fruits of that day's session other than to hand it out on some cassettes. If not for a chance introduction between Young and Haynes at a Biff Bang Pow! gig in Bristol, the songs likely never would have been heard beyond their circle of student friends. Haynes adored it, describing the Poppyheads' music in his fanzine as 'almost EDIBLE glowing POP tunes whirling through a swirling beat-haze of summer-stripes and crashing wide-eyed arms-spread into your HEART… '. Not even being

the recipient of someone's shit would deter him from granting them the opportunity to make a record for Sarah.

Like 14 Iced Bears, the Poppyheads entered the studio little more than half a year after their previous effort having somehow improved to a disproportionate degree. The hurried, wilfully juvenile tone of *Flossy* has been discarded for a trio of songs that bring to mind a rough-and-tumble garage-punk band from a *Pebbles* compilation attempting to play folk-rock but creating a uniquely beautiful failure.[1] 'What I wanted was for the group to develop toward something like Buffalo Springfield,' says Barbenel, 'with great tunes, harmony singing and exciting guitar playing – although this was beyond what we could really do.'

The crown jewel of their Sarah debut, 'Dreamabout', suggests they were on their way to realizing that goal, at least in terms of compositional strength. Complemented with drifts of keyboard, acoustic guitar that sounds like a banjo and a mood relaxed enough to allow the song to surpass the four-minute mark, the song's bucolic beauty forgives the fact that the band's performance is so unsteady as to make them sound drunk.

Alas, it was the last record the Poppyheads would make. Barbenel and Young continued to play together in other projects, but their three bandmates left Cambridge to continue their studies. It was the musical equivalent of a graduate-year romance.

Noise annoys

'… Knowing that SARAH 9 is the most important record we've released because it annoyed people.'

– Clare Wadd, in the Sarah fanzine Lemonade

The above-mentioned Sarah 9 is the Golden Dawn's 'My Secret World': two minutes and eighteen seconds of entirely era-appropriate noise and melody, in which a fey male vocal boasts about the exquisite exclusivity of his

[1] Rob Young's subsequent career as a music journalist (and as editor and, later, editor-at-large of experimental-music magazine *The Wire*) led to the publication in 2010 of *Electric Eden*, an exhaustive study of Britain's myriad forms of folk music.

misanthropic perspective while four young men allow their guitars to feed back and tangle up in each other atop a metronomic beat. In the aftermath of the Jesus and Mary Chain, there were countless groups making a similar cacophony. Yet among the dedicated following Sarah had already cultivated just nine months after launching, for some reason many of them considered the Golden Dawn's introductory salvo an affront. And the band themselves suspected this is exactly what Wadd and Haynes wanted.

'I'm not sure whether Matt and Clare had an eye on casting us as the anti-heroes of the label from the start or if it just developed that way,' muses Ulric Kennedy, the Glaswegian five-piece's bassist and co-vocalist, 'but the feedback we got from them from a very early stage was kind of "Everyone who loves our label hates you." After they asked us to record for them, I wrote them a cheeky letter outlining our demands and saying we thought all their other bands were shit, and they seemed to warm to that.'[2]

Bob Stanley, until then unceasing in his praise of everything Sarah had issued, wrote in the *NME*, 'As if to prove that everyone's fallible, Sarah put out this; a poor man's Groove Farm on the A side, coupled with some half-baked Meat Whiplash[3] outtakes that really set the teeth on edge. Doubtless they are very nice people but, come on, what's the point?'

The Golden Dawn repaid their critics in kind. 'Do you feel any affinity with the other Sarah bands?' a fanzine writer asked three assembled members. 'Not in the slightest,' replied guitarist Kenny Forte, drummer Peter Claughan adding, '*All* the ones I've heard have been really weedy and insipid.'

'I personally had no time for the endless whimsy of our label-mates and we certainly enjoyed being cast as the enfants terrible of Sarah,' Claughan says now. 'In our estimation, we were sonic pioneers who hoped to cross the bridge between distortion freakout and pop – maybe the dream was the Velvet Underground covering Simon & Garfunkel.'

[2]Wadd and Haynes maintain that they always sincerely loved the Golden Dawn. Says Wadd: 'I'm extremely upset that there's now a Greek fascist party called the Golden Dawn. It's almost like every Sarah kid has been looking for a reason to justify their hatred of the Golden Dawn for 25 years, and now they've got it.'

[3]A short-lived Creation Records act who were first out of the gate to mimic the sound of *Psychocandy*-era Jesus and Mary Chain.

A second single, 'George Hamilton's Dead', did little to redress divided opinion, seeming, if anything, to take great glee in multiplying the discord of its predecessor, as the band screams 'Dead! Dead! *Fucking dead!*' while the song falls apart around them. (A shockingly tender B-side, 'The Sweetest Touch', revealed that the Velvet Underground that made 'Pale Blue Eyes' meant as much to them as the one that made 'I Heard Her Call My Name'.)

The arrogance of youth meant the band expected everything but would work for nothing. They played live fewer than half a dozen times, never outside of Glasgow. ('There was a bizarre expression of interest from, I think, A&M Records at one point,' recalls Claughan. 'I was down in London seeing my brother and went in to play them our tape. Never heard from them again.') When they presented their proposed third single, 'No Reason Why' – a 'pure provocation', says Kennedy, of repetition and overlong guitar abuse – Wadd and Haynes rejected it. The Golden Dawn almost immediately ceased to be. 'I think when we parted company with Sarah we also parted company with ourselves, to a large extent,' says Forte. 'It seems we had a self-destructive streak in us. Personal differences, long-term unemployment, an expanding world of music, growing up – they all had their say.'

It would be more than three years before Sarah found another band that polarized its audience to such a degree. The Golden Dawn had at least *looked* as if they were meant to be a Sarah band: narrow-waisted, long of fringe and striped of tee. Boyracer cared nothing about clothes nor about projecting effete mannerisms to try to convince onlookers of their endearing vulnerabilities. Theirs was the unassailably heterosexual male demeanour and sound of three ordinary blokes whose ideal of short, sharp pop was early Hüsker Dü or fellow Leeds guitar-scratchers the Wedding Present at their most distorted and agitated. Like the latter group's David Gedge, Boyracer frontman Stewart Anderson would sing as if through a rictus of slow-simmering impatience, rendering many of his lyrics indecipherable. Brevity and simplicity were the trio's core values; their second EP for Sarah, *From Purity to Purgatory*, contains six songs yet demands less than ten minutes of a listener's time.

'We always thought that Matt and Clare had asked us to do a record just to upset some people – which I think was true for a certain proportion of the audience,' says Anderson, laughing. 'Although a lot of those people were *very*

easy to upset anyway – lots of sensitive souls. Which is fine too, of course. We were young and brash. I remember one Sarah Christmas party, we had played and we were at the bar trying to get a drink, and we overheard someone say, "Oh, god, I had to stand through Boyracer because I wanted to be down the front when Harvey played." We encountered a lot of that.'

Indifferent to the disapproving glares of audiences who had come to hear one of their labelmates, Boyracer would share a stage anywhere and with anyone, happy simply for the opportunity to make a noise in public. 'There was some wonderful graffiti left in a toilet after we played a show with Blueboy,' Anderson recalls. 'Someone had written on the wall, "May your boys be blue but never racing." We thought that was hilarious.'

Boyracer remained with Sarah until its end, releasing three EPs for them and playing at the label's farewell party (as well as contributing one of the best songs in the latter half of its catalogue, 'He Gets Me So Hard'). But this was but a small fraction of their activity. Free to record for as many other labels as they wished,[4] Anderson and his fluctuating cast of supporting players became a British equivalent of Guided by Voices, embracing prolificness seemingly as an end in itself. Before the end of the decade, they churned out at least 20 more releases, including in the US, where they attracted a larger and more enthusiastic following. 'We definitely pushed ourselves,' says Anderson. 'We didn't rehearse. We would write stuff in the studio. I'm able to look back at that now and say, if we had edited ourselves a bit better, those records would've been better overall, but most of the time it worked – for us, anyway.'[5]

Action Painting!, from the south coast city of Gosport, initially seemed perfectly suited to people's expectations of Sarah. Their 1990 debut, 'These Things Happen', is a dazzlingly lovely acoustic lament about the myriad disappointments of youth. But in singer Andrew Hitchcock's voice is the germ of something – a discontent, a fracturing restraint – that seems slightly at odds with the carefree music eddying around him. When the band finally followed it up after three long years, he had stopped holding himself back, and so had

[4]Sarah had no contracts and didn't demand exclusivity from any of its bands.
[5]Although Boyracer's association with Sarah was brief, the band's lifespan has not been. Anderson was still releasing new music under the name in 2014.

the rest of them. Action Painting! had become worthy of their name, and were now the latest (and least likely) contributors of controversial racket to the Sarah roster.

'I'd started writing more songs whilst at uni in Leicester,' explains Hitchcock. 'I was really fucked off with people, myself, and also the post-Summer of Love, crappy, Orb-y, chilled-out, neo-hippie fuckwit vibe going on musically and politically. We were fucked off at the E-driven fake love around, and the perpetual feeling of decay from umpteen years of Tory rule. There was nothing to look forward to if you were young, working class and male. But even if there were apprenticeships to be had – which there weren't –we felt alienated from the kind of males we would be expected to be in order to take them.'

Sheer luck ensured that the two singles they released in 1993, 'Classical Music' and 'Mustard Gas', arrived perfectly timed to be swept up in a new press-conceived hype. Having observed an influx of guitar bands who, in opposition to the apolitical lethargy of rave and grunge, were reaching back to the targeted rage, volume and energy of punk, journalists collectively dubbed them the New Wave of New Wave (NWONW). Every band to whom the term was applied resented it (indeed, none of them survived it), and Action Painting! were no exception. But Hitchcock knew to take advantage of the attention, and his natural motor-mouth tendencies thrilled the writers dispatched to interview him. When a *Melody Maker* scribe filed a feature about the band to his editor, he had merely written an introductory paragraph and then turned the rest of the feature over to the endlessly quote-worthy singer (who claimed to have been inspired to stop being an aimless introvert when he saw a vintage performance clip of 'Soul Man' duo Sam and Dave).

'It shows you what a metro-centric boys club the music biz is, really,' says Hitchcock. 'Steve Lamacq gave us Single of the Week on his Radio 1 show, and a bunch of people who booze in the same London hostelries chased each other's tails talking up a load of shite bands into a completely fake movement, useful only in bundling up a brand they felt they could control and skim off the booty from.

'But we had the best of both worlds at the time: a very simple mode of production and the press to get us noticed that wasn't available to other Sarah groups. Happy days.'

For reasons unknown, Action Painting! failed to capitalize on the windfall of attention. They made one more single – but for the London-based label Damaged Goods – and declined to appear at Sarah's farewell party. 'I was a bit bored of it all by then,' Hitchcock admits. 'I felt we were going to implode and it would look a bit crap if we did happen to split when Sarah was also shutting down. It would create a false impression.'

New romantics

Perhaps the two most tenaciously delicate bands in Sarah's discography are St. Christopher and Gentle Despite. The former came from York and had been self-releasing records in various configurations (initially under the name Vena Cava) for almost a decade when they landed at Sarah in 1989. Their hallmark was singer-guitarist (and sole constant member) Glenn Melia, who aspired to the poised, theatrical projection of easy listening crooners; rare was the verse in which he didn't feel moved to hold the lyric's final syllable for an extra second or two.

'To this day, I consider Scott Walker to be the best singer ever. His solo albums are on a higher plane to most other stuff,' says Melia. 'I was always into big sounds and arrangements, although I grew up with the punk ethic of "anyone can do this" and appreciated the fact that one didn't have to be a master musician to write a good song.'

During their tenure at Sarah, each record St. Christopher released – all of them complemented with a title of stunningly antique courtliness ('You Deserve More Than a Maybe', 'All of a Tremble', 'Antoinette', a mini-album called *Bacharach*) – reached for an ever-loftier standard of cinematic grandeur. By the time of their parting shot for the label, 1991's 'Say Yes to Everything', they had begun incorporating samples of kettledrums. Appropriately, St. Christopher were especially loved in France.

Gentle Despite own the distinction not only of having made the most fragile recordings in the Sarah canon, but of being the label's most mysterious act. Lasting barely a year, they performed live only a few times, were officially photographed

just once (although the results never circulated in their time), and are believed to have given one interview, to a fanzine that was even less seen than most.

Paul Gorton and Simon Westwood had been friends in their native Leeds since the age of twelve, playing together in a succession of teenage bands that followed the trajectory of 1960s rock from speed-fuelled garage-punk (the Cavemen) to acid-damaged psychedelia (the Emptyhearts). Westwood had been the drummer in both groups, but stepped out front to become a singer after parting company with Gorton and joining a 'knockaround joke' endeavour named Esmerelda's Kite.

Ashamed of the throwaway nature of their music (which was destined only to be heard on a couple of flexis), Westwood reconnected with his friend and proposed trying to produce something that was not only serious, but that could make a virtue of his extremely rudimentary guitar skills. 'A lot of the music I was listening to was two-chord stuff anyway: Syd Barrett, the Velvet Underground,' he says, 'so I thought, well, you only *need* two or three chords'.

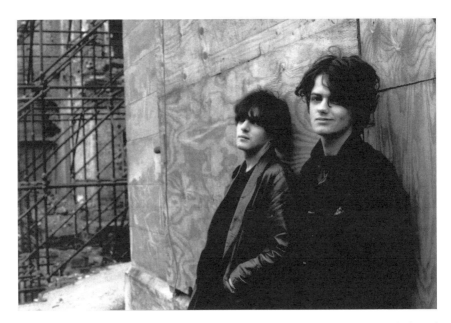

Figure 14.2 *Simon Westwood and Paul Gorton of Gentle Despite. The Leeds-based duo made two EPs for Sarah between 1990 and 1991, and then vanished. (Courtesy of Simon Westwood)*

Wadd and Haynes had been encouraging to Westwood about the Esmerelda's Kite demos, so they were familiar with his name when he sent them the first trial recordings of Gentle Despite. These were songs that seemed almost too slight to exist: whispered, tentative, as though they were being written while played. They became barely more forceful when the duo – aided by their Leeds friend Ian Masters, whose band Pale Saints was newly signed to 4AD – entered a studio early in 1990. 'We were both getting into the sound of reverb and space as a spectral effect rather than having a fuzz box set to 11, which we did in our earlier bands,' says Gorton. Masters's additions of vibraphone and Ebow lent the songs a weightless, drifting quality that the duo happily noted was similar to the Velvet Underground's 'Sunday Morning' and Tim Buckley's melancholic masterpiece, *Blue Afternoon*.

The *NME* savaged the record (in tandem with St. Christopher's 'Say Yes to Everything') in typical fashion: 'Who are these sad people? Can't even believe how shite these two records are. Jangle, moan, jangle, moan…. . Clueless dickheads, every one of them.' When Gentle Despite acquiesced to Wadd's suggestion that they try playing live (despite Westwood's considerable reluctance), their efforts with a hastily thrown-together backup band drew even worse notices. '[A] disaster', opined *Melody Maker*, 'tune-ups take longer than songs, songs themselves are exercises in chaos and, hey, if I want to hear Wedding Present 45s at 33rpm then I'll play Wedding Present 45s at 33rpm, okay?!'

'I'd never intended Gentle Despite to be a live band,' says Westwood. 'I was pissed off with bands. I just wanted to do music and get it out there. I wish I'd had the courage of my convictions and said no.'

Gorton suspects this review, combined with their inability to find committed bandmates to fill out their membership, was the primary factor in Westwood calling time on Gentle Despite after just one more single, the recording of which was beset with problems, including their drummer breaking one of his sticks and not having a replacement. 'For years I sort of beat myself up about both singles; I never thought they were as good as they could have been,' says Westwood. 'But I've sort of come to terms with them now. I can hear what's good about them rather than what's bad.'[6]

[6]Westwood was interviewed for this book in early 2014. He passed away after a brief illness in December of that year. He and Gorton remained friends until his final days.

Destination: Oblivion

At a distance of more than a quarter century, those who were witness to it likely still marvel at the speed with which My Bloody Valentine became the most imitated alternative band in Britain in the late 1980s. More or less ready to give up after years of creative aimlessness, poverty, nomadism and thankless slog, the Dublin-spawned group's chance discovery of an unprecedented sound – classic pop melodies made uniquely disorienting and sexually charged from the addition of seemingly infinite layers of roaring, undulating guitar – simultaneously gifted a future both to them and to indie music. Futuristic yet rooted in tradition just enough to be approachable to young ears, their beautiful noise made the imminent 1990s seem pregnant with sonic promise. The nation's youth acted fast: within months there were scores of new groups who were paying tribute (some more blatantly than others) not only to My Bloody Valentine's trailblazing fusion of calm and chaos, but to their quite unintentional image: that of a once-innocent indie kid having been beatifically corrupted by carnal and narcotic pleasures. Two of the most successful exponents of their influence – Ride and Slowdive – were snapped up by My Bloody Valentine's own label.

Sarah was widely perceived as belonging to a time prior to this Big Bang, a time before the Smiths had split and guitars were meant only to jangle or to violently feed back. But the movement unintentionally set off by My Bloody Valentine – now forever known as 'shoegaze', owing to a journalist's innocent observation about the bands' shared tendency to not look at their audiences – reached all corners of the nation.

Eternal, from Reading, were the first shoegaze acolytes whose cassette landed in Sarah's PO box. Textbook correct according to the newly issued rules of the genre (vocals buried to the point that consonants vanish; distortion invading the proceedings like a solar flare), their song 'Breathe' sounds remarkably like Slowdive. It was Eternal's first and last record – released posthumously, singer-guitarist Christian Savill had disbanded the group in order to join the fledgling Slowdive.

Secret Shine were one of only two Sarah bands to actually come from Bristol. Beginning as a studio-bound duo, Scott Purnell (who played all of the

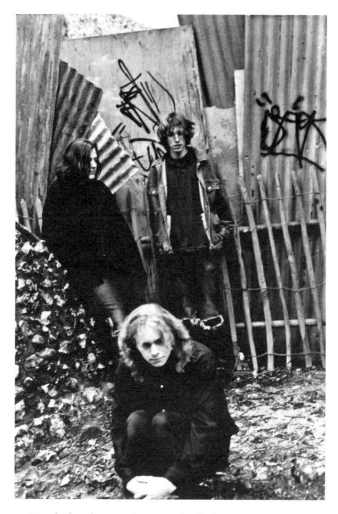

Figure 14.3 *Very little is known about Reading's short-lived Eternal, other than that singer-guitarist Christian Savill joined Slowdive following the band's dissolution in 1990. Eternal released only one record, the* Breathe EP. *(Photographer unknown; courtesy of Sarah Records)*

instruments) says he and singer Jamie Gingell 'came together in a mutual respect of the emerging shoegaze sound, and we were both very passionate about the Cocteau Twins, too. We tried to create this kind of dreampop/ electronic sound in our first band, the Dreamscape, but we wanted to do something a bit more noisy in Secret Shine.' When Gingell began dating a woman named Kathryn Smith, she too joined the band as a co-vocalist despite never having sung before. Eventually swelling to a five-piece, the band made

consistently engaging music, although 'Liquid Indigo', from their immodestly named 1994 EP *Greater Than God*, is so similar to My Bloody Valentine's 'Only Shallow', one can only laugh at its audacity. In the US, where shoegaze was never subject to the critical backlash it received in the UK, Secret Shine are one of Sarah's most popular bands.

The Sweetest Ache followed the trajectory of Ride, gradually stripping away the forward-thinking characteristics that defined their early sound and pursuing a classic-rock path in search of some notion of greater artistic purity. Singer Simon Court left the band in disgust, but not before recording with them a gorgeous folk ballad, 'A New Beginning', which Wadd and Haynes rejected. As with St. Christopher, the upstart Vinyl Japan label was happy to scoop up what remained of the group, facilitating the release of an album with the illustrative title *Grass Roots*.

Outliers

It became so commonplace for critics to assert that there existed a 'Sarah sound', but then point to *one* group who, in their estimation, deserved to be excluded from the stereotype, that Wadd and Haynes eventually had no choice but to respond with perversely cheerful resignation. It was that or commit murder. 'Our reviews acquired a surreal tinge,' Haynes later recalled. 'The good ones all began, "Unlike most Sarah releases…" – and the exception was always a different band. But then, most of the typical Sarah bands weren't on Sarah. People hear what they want to hear.'

Yet there *were* a few collectives who seemed to stand apart from all others on the label, who seemed to mistakenly stumble into the Sarah fold while on their way somewhere else and decided they might as well stay.

This was actually the case for Tramway. The first Bristol band to record for Sarah, their original intention had been to join forces with Cosmic English Music, a label co-founded by former Razorcuts singer-guitarist Gregory Webster (who also happened to be their producer). Webster extended the courtesy of convincing the trio to make history of their original name, the

Panda Pops ('He thought that, ironic or not, it was not cool,' says singer Matthew Evans), but ultimately decided not to release their music, instead passing along the tapes he produced to Wadd and Haynes, who were pleased to finally be able to shore up their municipal patriotism with actual local talent. 'We didn't look to have a presence in Bristol,' says Evans. 'We made collage posters and photocopied them for gigs and stuck them up in shops. You would usually get the same people turning up. Once we had three bands on for fifty pence and more people turned up for that.'

Tramway's sparse, mournful singles – 'Maritime City' and 'Technical College' – are rather like Brighter divested of all hope, exhausted physically and emotionally. Bleakly beautiful, for some reason they roused little enthusiasm among the Sarah faithful. Footage survives online of the band taking the stage at the 1991 Sarah Christmas party aboard the Thekla, whereafter Evans announces to the assembled, 'Don't worry, we've not been given a soundcheck. No one likes us and we don't fucking care.' Nervous laughter ripples through the audience. (Evans recalls: 'I remember someone at the front said to their friend, "Oh, Tramway are next. They're not very good."')

A year passed and they had re-emerged at a Spanish label, but were now playing buoyant, careering country-pop embellished with organ, harmonica, and Evans's new-found southern American accent. A stunning reinvention, but few people were lucky enough to chance upon it.

Dublin's the Harvest Ministers were brought to the attention of Wadd and Haynes by Ken Sweeney, a fellow Irish musician who recorded under the pseudonym Brian (and who would have been perfectly at home at Sarah if the London-based Setanta label hadn't already snapped him up). Led by Will Merriman, the elegantly grizzled-looking sextet knew nothing of Sarah and possibly little more about notions of indie-pop. Steeped in folk and the tradition of barfly singer-songwriters whose problems most twenty-year-olds couldn't begin to understand, they were arguably the wildest card in the Sarah deck – violins, saxophone and all. Those who bought and were then taken aback by their full-length debut, *Little Dark Mansions*, when it came out in 1993 hopefully held onto it: it would probably come to make great sense to them in their forties.

BBC *Evening Session* DJs Steve Lamacq and Jo Whiley thought so highly of Ivy's 'Wish You Would' that they played it more than a dozen times despite the Norwich band being unsigned, and then John Peel phoned singer Spencer Harrison at home to say he looked forward to seeing them live. (Alas, he never did.) Wadd and Haynes, knowing that Sarah was in its home stretch, released two Ivy singles – the above-mentioned 'Wish You Would' and 'Avenge' – back to back. Wadd reckons Ivy (who were forever being confused with a same-named New York band who emerged almost simultaneously) were underappreciated for having looked 'a bit goth', but in fact only their sleeves did. Their music couldn't have been less so – it was metallic Blondie fronted by an aspirant Elizabeth Fraser.

One of Sarah's best, most individual and least regarded releases was saved for second to last. Shelley was Tim Chipping – Sarah's number-one fan, and long-time friend to the Field Mice, Blueboy and others – and his new-found chum Dickon Edwards, and the 'band' as such only lasted for as long as it took to make their record. Edwards had seen Chipping fronting, in the latter's words, 'a kind of terrible Riot Grrrl band' and invited him to be a guest vocalist with his own band, Orlando, when they supported Heavenly in Bristol. Haynes was in the audience and felt adamant that what he'd just witnessed should be captured in a studio. Chipping, in grave doubt about his abilities, repeatedly declined. 'But then we found out that Sarah was ending and I had a bit of a panic,' he says. 'I thought I might regret missing out on my chance, so we agreed to do it, but under a different name so it would be a unique thing; it wouldn't have any other history and it would just be that.'

Chipping and Edwards were the 'oddballs of the Sarah scene', as enthusiastic about Stock Aitken Waterman's hyper-commercial dance-pop productions and Stephen Sondheim as they were about *C86*. They also relished the idea of being properly famous at some point, which is why they adopted a one-time-only name for Sarah, so the record they made could be swept under the rug if someone with the potential to make them stars decided to research their past.

Shelley's lone offering, 'Reproduction is Pollution', finds Edwards reciting dispassionately about the futility of human breeding and the notion that any

couple has the ability to be better parents than one's own in a world where 'the sun is getting whiter every day. ... Don't talk to me about natural instinct/We've spat on nature for far too long.' Meanwhile, layers of cheerful arpeggiated guitar sugar-coat the toxic thoughts being calmly put forward. (Only on the B-sides does Chipping step forward to reveal his own enchanting voice, like a whispering, heliumated Marc Almond.) It became the most expensive single Sarah ever made, simply because the duo, having never been in a studio before, exceeded their allotment of time and weren't familiar with the policy of overtime fees.

'I think we always assumed that everyone thought the record was terrible because no one ever said anything, and I think we suspected it probably was,' says Chipping.

'I think "Reproduction is Pollution" is one of the best things we ever did – it still makes the hairs on my arm stand on end,' counters Haynes. 'But hardly anyone shares my view simply because the band had no profile – they came and went. And then, just to compound the issue, the label itself disappeared! Obviously you could argue that every band should have left a bigger body of work, whether they did one single or six, because you can't have too much of a good thing. But part of me quite likes the fact that some bands just came and went without anybody really knowing who they were – including us.'

15

'We Had an Outsider's Perspective': Sarah's Foreign Visitors

Ric Menck affectionately recalls: 'Alan McGee once said to me, "You were just a British indie kid, but you lived in America." I really *was* into that shit.'

Menck was indeed at odds with his geography. Living in Champaign, Illinois – a small university city just far enough from Chicago to not absorb any of its radiant metropolitan energy – his very tall, very thin frame could be seen walking its streets in the late 1980s, usually clad in stripes or paisley or polka dots beneath a fringed buckskin jacket like Neil Young might have worn in 1967. His bowl cut brought to mind Byrds drummer Michael Clarke after rolling out of bed. Menck, too, was a drummer, as well as a guitarist, songwriter, singer and voracious follower of the UK indie scene. Eventually, after years playing music together, he and bassist Paul Chastain signed to Creation Records in 1991 under the name Velvet Crush. But first, the two of them recorded as the Springfields, and in 1988 they became the first foreign music-makers to be a part of Sarah.

It hadn't yet occurred to Wadd and Haynes that their very new label might attract interest from bands outside of the United Kingdom, never mind from another continent. The modest proportions of their venture – and of their exposure to the world – would have made any such notions seem goofily fanciful. 'My whole musical experience was British at that point,' says Wadd.

'I can't think of anyone I'd seen other than Nico who was from outside of the U.K. at that point. I barely even knew anyone who'd been beyond mainland Europe in the '80s – people just *didn't*. So, it was fairly unthinkable that we'd have bands from far away.'

Haynes adds that, in retrospect, 'We could almost literally name all the people in the U.S. who had copies of our early records, and the same with Sweden or Japan. Posting fanzines or records was prohibitively expensive, and that included promotional copies – sending records to radio stations in the U.S. was a non-starter. So, really, very few people outside the U.K. had heard of us. It often felt like pretty much everyone who wrote to us from abroad was writing a fanzine or getting a band together or setting up some little scene of their own.'

Had there not been an ocean between them, the Springfields might have found themselves in a rivalry with the Sea Urchins as to which band was most beguilingly able to import the rhapsodic jangle of 1960s pop into the late 1980s. The Springfields were simply too perfect to be true, and for a moment Wadd and Haynes were in a panic that they'd lost their chance to have them.

'We'd been sent a tape by Ric, and it had the Springfields on one side and Choo Choo Train' – which was the same duo, but with Chastain taking over vocals – 'on the other. We wrote back to Ric asking to release the Springfields' "Sunflower."' And then we were listening to the local radio in Bristol, which had an indie show on Sunday evenings. The host was interviewing Martin Whitehead, and he said that he was very excited because he'd just signed to Subway some great new band from Illinois.'

Not yet in possession of a telephone, Wadd sprinted to a call box with a pocketful of ten-pence pieces and called Menck. All was fine: Whitehead had signed Choo Choo Train; the Springfields belonged to Sarah. While Menck nonchalantly explained this in his 'slow, American, laidback drawl', Wadd continued to frantically feed coins into the slot.

Thus began the first of five relationships Sarah had with international acts, each of which came to the label with a perspective untainted by the hothouse atmosphere and often provincial prejudices that coloured Britons' perspective of the label and indie music as a whole.

RIC MENCK, THE SPRINGFIELDS: I was slowly immersing myself into that whole British indie thing. I had begun a fairly aggressive letter-writing campaign to anyone I was interested in, both in bands and at labels, and I would just inquire as to what they were doing. Me and Bobby Gillespie used to write back and forth, me and Stephen Pastel, me and Alan McGee – all these people that were, at the time that I was writing to them, struggling nobodies, just passionate music fans that were taking the first tentative steps of having their labels and clubs and bands and stuff.

'As Bobby was doing Primal Scream, I was simultaneously in Champaign with Paul and a few other people doing our little singles. I think we were probably referencing some of the same influences. I walked into a record store in Champaign – I don't remember what year; it probably would've been 1986 – and there was a guy who worked there and he would play singles all day long, whatever they had just gotten in. And as I walked in he was playing the

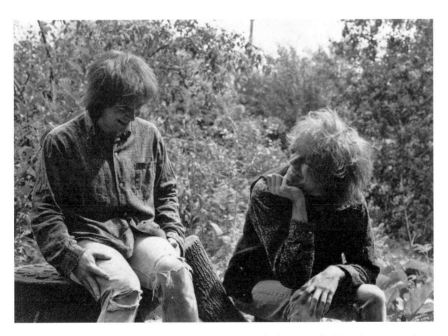

Figure 15.1 *From Illinois, the Springfields – Paul Chastain (left) and Ric Menck – were the first non-UK group on Sarah. The duo also recorded for another Bristol label, the Subway Organisation, under the name Choo Choo Train. (Photographer unknown; courtesy of Sarah Records)*

first Primal Scream single, and I just flipped out because literally two or three weeks earlier we'd recorded 'Sunflower' and I could not believe the similarity. What was really great about it was I recognized that Bobby was not a good singer. His voice had a feeling and a tonal quality, but he was not technically a good singer, and that for me was huge because I didn't ever consider myself to be good either.

The next two overseas acts to join Sarah were Australian: Even As We Speak (a five-piece group from Sydney) in 1990; and the Sugargliders (a Melbourne duo made up of brothers Joel and Josh Meadows) in 1992. Each had released records in their homeland before coming to Wadd and Haynes's attention.

JOSH MEADOWS, THE SUGARGLIDERS: While I was at uni, I had a Saturday job at a small indie record shop in Melbourne called Exposure Records. Inside the front door was a table with a tablecloth over it, and in neat rows on it were new seven-inches, most of which had arrived from the UK and US in the previous week or two. It was there I first came across the early Sarah records. I was already a fan of bands like Orange Juice, Aztec Camera, the Housemartins, and Lloyd Cole and the Commotions. To me, the singles on the Exposure table were a sneak preview of the next wave of guitar-pop bands.

Even As We Speak, in earlier configurations, had twice made extended visits to England to try to find a better audience than at home, thus following in the footsteps of the Go-Betweens and the Triffids, fellow Down Under collectives whose hyper-melodic pop was largely unappreciated in hard-rocking Oz. Fortunately, Even As We Speak had an admirer in John Peel, who offered them sessions and repeatedly played their records (he was especially fond of their minimalist acoustic cover of New Order's 'Bizarre Love Triangle'). The exposure not only attracted the attention of a London-based management team who agreed to take the band on; when the same managers approached Sarah about licensing some tracks, Wadd and Haynes were only too happy to oblige – they'd already heard them on Peel.

MATTHEW LOVE, EVEN AS WE SPEAK: We hadn't heard of Sarah. In terms of indie-pop, our influences were really coming from elsewhere. We

were influenced early on by [New Zealand label] Flying Nun, in particular. But the pop sensibility of the two labels was very similar in a lot of ways.

RIC MENCK, THE SPRINGFIELDS: I knew who Sarah were, but to me, it was just another British label in the same way that Subway was. But then I got a sense, because I was reading all these fanzines that I'd gotten my hands on, that Sarah had a very specific aesthetic and that they had almost a political thing, a passion that was based in 'We are not gonna compromise in any way, shape or form.'

JOSH MEADOWS, THE SUGARGLIDERS: At first I thought Sarah was just another of the little English labels that was releasing great pop music. But as Clare and Matt's philosophy emerged through their fanzines, newsletters and the inserts, it became clear Sarah was different. Much of our early songwriting was fed by things that made us angry: greedy property developers slicing up the hills where we grew up, politicians who lie, sexism, the rape of the environment, inequality. Sarah, it seemed to us, was a label that didn't expect you to leave your brain at the door – pop songs could be fuelled by political passion as well as personal passion. This appealed to Joel and me, and made us feel a bond with Clare and Matt even before we talked to them.

In January 1993, Even As We Speak moved as one to England to try once and for all to make themselves a success, taking possession of a shared flat in Hove. Sarah was about to release *Feral Pop Frenzy*, their debut album – only the third full-length (excepting compilations) the label had released to date, and the first to be presented with full-colour artwork, at the band's urging.

MATTHEW LOVE, EVEN AS WE SPEAK: We said, 'There's more for us in the U.K. than there is in Australia, and if we're gonna do anything, it's gonna be there, so we may as well base ourselves there for a while.'

MARY WYER, EVEN AS WE SPEAK: We left our jobs, left our *children*! We said we'd stay there until we got on the front of the *NME*. I remember the day we arrived, we went to [our managers'] and got the first several weeks' list of what we had to do, and we were playing almost every night. I cried.

MATTHEW LOVE, EVEN AS WE SPEAK: It was quite an eye-opener because I remember, at the first gig we had, there were all these kids in the front with anoraks and bowl haircuts. Sydney's a very different scene from

that, so I was wondering where I'd landed at that point, to the extent that I think we wanted to call our next single on Sarah 'Anoraknophobia'.

At roughly the same time as Even As We Speak were promoting their album, Wadd and Haynes received a package from New York containing three singles. Credited to East River Pipe, they were the work of one F.M. (Fred) Cornog, a singer-songwriter with an astonishing gift for melody and words, a panoply of influences (Lou Reed to Warren Zevon to the Monkees to Pet Shop Boys), and a backstory seemingly modelled after a screenplay. Raised in New Jersey, he had struggled throughout adulthood with alcoholism, drug addiction and depression, and eventually he was sleeping in the streets. Barbara Powers, the friend of another musician with whom Cornog had been trying and failing to be productive, heard the vagabond's music and was so impressed she took him into her home, becoming his de facto manager and, eventually, his wife. Furnishing him with a four-track portastudio, he filled cassettes up with songs whose spectral beauty provides balm for lyrics that reflect his then-recent lucklessness. Powers then released them as singles on a label she created especially for him, Hell Gate.

F.M. CORNOG, EAST RIVER PIPE: Barbara and I frequently went into Pier Platters, a record store in Hoboken. They had been selling the East River Pipe singles on consignment, so every other week or so we would go over from our little apartment in Queens to see if they wanted more of the damn things. On one trip we met Tom Prendergast, who ran the store; he said he'd listened to the singles and liked them a lot. And then he asked if we'd ever heard of a label in England called Sarah Records. We never had. Tom suggested we send our singles over to them. We'd been rejected by every small indie label in the States, so we thought, 'Why the hell not? Let's start getting rejected in England, too.'

On the same day, we bought the only two Sarah releases that Pier Platters had in stock: one was by Brighter and the other by the Orchids. We were blown away. These bands were using many of the same elements I was using: the slow tempos, the repetition, the reverb and delay effects. There was no over-singing, there was an existential ache and a sense of longing, there was an anti-macho vibe, there was an anti-professional vibe, and there was no phony white-boy blues-guitar playing and no phony white-boy anger. This was not music made

by alpha males; this was music made by beta males, and I was definitely a beta male. I remember just staring up at Barbara from the apartment floor and saying something like, 'There is nothing, *nothing*, like this in America. Fuck America. This little British label is where we belong.'

Aberdeen, a trio from the California desert that barely existed outside the imaginations of its misfit members, had a similar reaction to Sarah's music when it, too, unexpectedly fell into their laps.

BETH ARZY, ABERDEEN: John [Girgus, guitar and keyboards] and I were living in the Palm Desert area. He had a band called the Void – he was fifteen or sixteen years old – and they were just instrumental, but he was influenced more by Joy Division and Skinny Puppy; he used to skulk around the desert. I was like, 'Come eat lunch with us. You're cute.' And he was like, 'You write bad poetry. Come and be our lead singer.' The Void plus me became Black Star Carnival, named after the Primal Scream B-side. We would hang out with this guy called Brant Larson, who was this music freak in Claremont, which is about an hour away. He made us loads of cassettes, and they would have the Field Mice and Heavenly and the Sea Urchins on them. It was a whole new world – we loved everything we heard. One day he called Matt and Clare to place an order, and he said to me, 'Hey, do you want to talk to them?' We started chatting. John and I had some demos that were absolutely vile, and I sent them to Matt and Clare and said, 'Could you please pass this on to Amelia Fletcher?' because I was a huge Heavenly fan. I knew full well Matt and Clare were going to listen to it! And I got a letter a few weeks later asking if we wanted to do a single. I sang for attention – I wasn't any good at it and I'm still not. You live in the desert and you're bored. I didn't expect anyone to say, 'Do you want to put a record out?' I was like, 'Shit. What do we do?' They just said something like, 'You have four-hundred dollars. Go record a single.'

JOSH MEADOWS, THE SUGARGLIDERS: Although we were a long way away and although they both seemed shy – especially Matt – I always felt they communicated very well with us. I think there's about eleven hours' difference between Melbourne and Bristol. Our calls to and from Sarah often happened quite late at night, our time. I can remember some pretty long chats, which must have added significant weight to their phone bill!

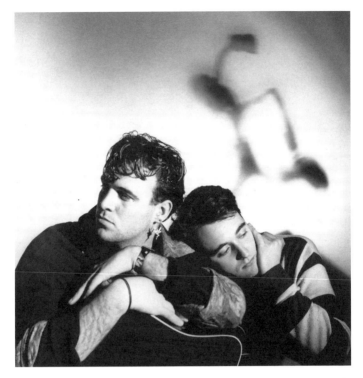

Figure 15.2 *The Sugargliders – Josh (left) and Joel Meadows – in 1992. They were the second Australian group to join Sarah, following Even As We Speak. (Photo: Sharyn Bant)*

RIC MENCK, THE SPRINGFIELDS: Matt was *incredibly* shy. I just remember him being sort of like a giggly kid, which seemed to go against the crazy diatribes that he would write in the fanzines, which were very aggressive.

JOSH MEADOWS, THE SUGARGLIDERS: We finally met Clare and Matt when we tumbled out of a National Express coach at Bristol station. We had, a little cheekily, proposed a Sugargliders U.K. tour and then, very cheekily, asked if Sarah could help arrange the gigs for us. They were pretty much as we thought they would be: shy, humble, diffident, practical. They showed us around Bristol on foot and let us sleep on the sofa bed in their lounge.

Menck and Chastain never performed live as the Springfields – with one exception, they never played the group's songs again – but in the late 1980s they

undertook a brief UK tour as Choo Choo Train, and in the process became the first Sarah-affiliated foreigners to be subject to the music weeklies' frequently reflexive antagonism. The Sugargliders, Even As We Speak and East River Pipe were, in the grand scheme of Sarah, relatively well received by critics, although even positive reviews would invariably make ostentatious mention of the label and its supposed shortcomings.

RIC MENCK, THE SPRINGFIELDS: All the reviews of our shows were terrible. [The British music press said] we were just wimpy: you know, the normal shit that we would think they would say. It was a cool vibe among the fans, but the writers, as is well-documented, had this snooty-ass attitude. Matt and Clare got so much crap from the British press. I remember at the time being really angry about that.

JOSH MEADOWS, THE SUGARGLIDERS: Clare and Matt had arranged a whole string of gigs for us, up and down the country, many of them with other Sarah bands. The band we hit it off with best was probably Blueboy. To be honest, I hadn't taken a lot of notice of their music before we went to England, but seeing them live I was completely won over. I have very fond memories of one particular gig we did with them at a place called the Rising Sun Institute in Reading. The crowd seemed to be one hundred per cent Sarah fans. Everyone sat on the floor and soaked up every note and every word from the stage. It was a beautiful night.

F.M. CORNOG, EAST RIVER PIPE: I never came to the U.K. while I was on Sarah. I was unable to travel. My mind and body were totally shot from over a decade of very heavy alcohol and drug abuse, as well as years of untreated depression and other mental crap. I was epically fucked-up, totally lost. So, when Sarah first started releasing my records, I was fully engaged in just trying to keep myself alive – survival had to take precedence over everything at that point. The thought of travelling to England to meet people or to promote a new release was just completely inconceivable. When our first release came out on Sarah, the 'Helmet On' EP, and Everett True made it Single of the Week in *Melody Maker*, I was trying not to think about plunging the knife on the kitchen countertop into my chest. ... So, anyway, it's been a long fuckin' climb out of a very deep hole. I'm still making deals with the monkey. You have to if you're a person like me or it'll eat you alive.

MATT HAYNES: The distance made no real odds – we never really met some of our U.K.-based bands either. And there was no way we were going to tell a band to come over and play gigs. All publicity is cumulative, and dragging East River Pipe over to play a showcase gig that, at best, would probably have got a half-column review in the *NME* just wouldn't have made any sense.

JOSH MEADOWS, THE SUGARGLIDERS: Most of our reviews in the U.K. press were pretty fair, although quite a number of them spent half the review making excuses about why the reviewer was giving a positive review to a Sarah band. Pathetic, really. Mostly I think it was the tenor of the times that worked against Sarah getting a fair go. Grunge was big and most of the favoured English indie bands had an arrogant swagger to them. I don't think arrogance was a word you could use to describe any of the Sarah bands. Of course, the macho era passed and a time came when the music press was prepared to champion sensitive, beautiful music again. But by then, Sarah had gone.

F.M. CORNOG, EAST RIVER PIPE: Who gives a fuck what label a record is on? Evidently the British press cared a lot. The reviews were generally very good, but often there was some kind of indirect dig at Sarah. Journalists would sometimes mention it in a snide, dismissive way, almost like most of the music coming from the label was barely worthy of consideration. Barbara and I didn't give a shit. The whole thing just seemed like another version of high school to us: the cool kids, the uncool kids, the jocks, the burnouts, the cheerleaders, the nerds. And here we were with the uncool kids again. I basically thought of the British press as lazy cynics. I still do.

BETH ARZY, ABERDEEN: Matt faxed us the *Melody Maker* review of our first single, 'Byron'. ['*Just what you'd expect from a group who draw stickpeople pictures of themselves on the sleeve. What dull lives they must lead.*'] He was like, 'Don't get mad, but…'. In my true spirit, I drew a very non-twee picture of stick people with their fingers up and faxed it to *Melody Maker* – and got told off by Matt for doing it.

MATT HAYNES: The main problem with the non-U.K. bands was the utterly basic one of communication. International calls were *expensive*. We used to use faxes a lot, but that meant typing up a letter at home, then taking

Figure 15.3 *Singer-songwriter F. M. Cornog (seen here in 1993), who records to this day under the name East River Pipe. (Photo: Barbara Powers)*

it to a local shop that had a fax machine. We bought our own in the end – I think pretty much all communication with East River Pipe and Aberdeen was via fax.

After settling in the UK, Even As We Speak made perhaps the most concerted effort of any Sarah band to cross over to mainstream success, gigging at every opportunity, recording three BBC sessions in less than seven months, and taking meetings with major labels. *Feral Pop Frenzy* and a single, 'Blue Eyes Deceiving Me', each charted in the indie top ten. John Peel enjoyed their company so much, he invited them to his home. ('The story I like to tell', says singer Mary Wyer, 'is when he said to me, "You know, you remind me very much of a young Germaine Greer – and I should know because I fucked her."')

MATTHEW LOVE, EVEN AS WE SPEAK: We were always at a little bit of a cross-purpose with Sarah in some regards because we'd done indie-pop, in a sense, and by the early 1990s we were looking for new directions – the next thing, whatever that was. But Sarah, to their credit, were actually a lot more

flexible than they're perceived in hindsight. They were supportive of the new, experimental things we were playing with. We used to describe ourselves as the naughty kids at the back of the Sarah classroom, sending them stuff that was kind of out-there, and then there'd be silence for a while, and eventually they would accommodate what we were wanting.

JOSH MEADOWS, THE SUGARGLIDERS: The only time I can remember a disagreement with Matt and Clare was over the artwork for our single 'Trumpet Play'. Joel's etchings, ink drawings and sculptures featured on most of our sleeves. For 'Trumpet Play', which is a song with lots of ocean and marine references, Joel presented a pen-and-ink drawing inspired by the Go-Betweens song title, 'Man O' Sand to Girl O' Sea'. In Joel's drawing, a man, emerging from the sand, reached out to a girl, emerging from the sea. It was a good drawing; it tied in with images on our previous releases and made a subtle nod to the lyrics of the A-side. It wasn't a sexy picture, but there were breasts. Matt and Clare gently explained to us that they didn't want a Sarah sleeve to feature a picture that anyone might perceive as objectifying women. Privately we thought they were being a little over-sensitive, but we also respected a principled stance, so we came up with an alternative sleeve: an uncontroversial grainy photo of a train, with accompanying coastal motifs.

ROB IRWIN, EVEN AS WE SPEAK: When we opened for Heavenly at the Powerhaus in Islington, we wrapped ourselves in aluminium foil and came onstage to the *2001* theme, just for a bit of theatrics. What we didn't realize is that when you're dressed in foil under lights, it's kind of like baking fish. Not only that, we had silver buckets on our heads; we'd cut out little holes so we could see, but we couldn't find our instruments because there was so much fog. From the audience, I can imagine it was quite a spectacle.

MARY WYER, EVEN AS WE SPEAK: One of the members of Heavenly came up to me and said, 'I wish I was in *your* band!'

BETH ARZY, ABERDEEN: We weren't accepted by the other people on Sarah, I don't think. We played with Heavenly and they probably thought we were terrible, and we didn't say much to each other. We played with Boyracer and they thought we were terrible. We were neither here nor there: we weren't as twee and happy – and as good musicians – as Heavenly, and we weren't as edgy and Riot Grrrl as the other ones. We didn't fit anywhere. We would've

liked to be part of the Sarah scene, but we were always on the outside, which was a bummer.

After ten months in England, Even As We Speak elected to return to Australia, Mary Wyer no longer able to bear being separated from her young son for an extended period, and all of them ill-equipped to continue enduring the indignation and poverty of a band whose success, they were forced to admit, was largely illusory.

JULIAN KNOWLES, EVEN AS WE SPEAK: One of the things you realize as an indie band when you make it to the top ten of the indie charts, as we did quite consistently – then you go, 'Well, we're still not able to earn a living from doing this. We're still all sharing a flat, driving around the country in a van, we can barely scrape money together to do the next recording'. You realize there's actually a very big gap between what was the indie charts and the mainstream charts, and the difference is investment. In some ways, it's remarkable that we got as much mainstream Radio 1 airplay as we did. There was some interest from major labels in London, particularly when we played them a song like [album track and fan favourite] 'Falling Down the Stairs', which is so obviously commercial, but we would've had to base ourselves there indefinitely.

If you want to know why a band gives up and falls into exhaustion, you can imagine being in Brighton, driving for five to six hours or more to get to Manchester, having had a guarantee that no matter what happened the promoter would pay you at least fifty pounds, which would probably pay your petrol, playing a completely sold-out show where there were probably three-hundred, four-hundred people, and at the end the promoter comes up to you and hands you fifty pounds.

MATT HAYNES: Even As We Speak dipped their toes in the water – they moved to the U.K., bought a second-hand van, did gigs, did four sessions for the BBC, but it still didn't make them household names. And they still had to mend their exhaust pipe with a used Coke can when it broke in Leeds.

Even As We Speak's surrender – they disbanded more or less immediately upon return to Australia – at least spared them the possibility of being left at a loose end when Wadd and Haynes brought Sarah to an end in August 1995.

The Sugargliders, having accumulated a discography of ten singles by 1994, took that as their cue to do something else, and so were similarly absolved.

F.M. CORNOG, EAST RIVER PIPE: I wouldn't say Barbara and I were sad when Sarah shut down. It just *was*, you know? We both respected Matt and Clare immensely. We knew fundamentally that Sarah Records was *their* table; it was not our table. They had been kind enough to ask us to sit at their table for a brief and beautiful gathering of other like-minded souls. It only reminded us that the thing we really loved was Matt and Clare. And that goes on.

BETH ARZY, ABERDEEN: Matt knew I'd flip out, and I did. We were playing a gig that night or the night after, and I just remember the guys taking the amps out of the back of the van, and tears were just flooding down my face: 'This whole thing is stopping! Now we really have *nowhere* to go!' Matt did say, 'We're starting a new label; we're not closing the door on you.' But I was a complete drama queen, so I was standing in North Hollywood, crying my eyes out as we were about to play a gig.

RIC MENCK, THE SPRINGFIELDS: I must mention this: They are two of the only people that have ever completely honoured a contract that I had with a record company. The only thing I asked for when we agreed to do the first single was I said, 'I want one copy of everything you do.' At that time, I didn't know they'd put out as many things as they did – there were only eight or nine singles before mine. But long after we ceased our letter writing, I would get a package in the mail of the most recent batch of records and a little note from Clare. I got everything up until they stopped.

16

'A Day for Destroying Things...': The End of Sarah

When Sarah's as-yet-undetermined fiftieth release was approaching, early in 1991, Mike Chadwick at Revolver asked Wadd and Haynes if they were planning anything special to mark the occasion. They replied that they were thinking of shutting the label down.

Chadwick was alarmed. The couple who, four years earlier, had come to him with no money and few plans other than to release some singles packaged in 'those stupid plastic bags like Subway' had become one of Revolver's most reliably profitable labels – an outcome neither he nor any of his colleagues could have foreseen. But now that it had come to pass, he wanted their nonsensical yet mystifyingly charmed two-person enterprise to carry on indefinitely.

He was lucky: in that moment, Wadd and Haynes were very much inclined to continue with Sarah. But the notion of stopping had, not long before, been seriously considered. 'We always intended the label to have a specific end,' says Wadd, 'but I don't think we thought beyond ten releases at the outset. I've always referred to it as a hobby that got out of hand, but it was never designed to be a business. We always figured we'd stop at a nice round number.'

Fifty seemed as nice and round as any, but once its arrival was within view, Wadd acknowledges that she and Haynes found that Sarah 'was too much fun. It was all on the up. Things were selling. It was all great.'

Indeed, although they continued to work punishingly long hours, the label was about to afford them two acquisitions that, to a casual observer, might have seemed luxuries inconsistent with Sarah's perceived aesthetic of dignified austerity: a car and a house. The former was a red Ford Fiesta hatchback; the latter a modest – but, compared to their previous addresses, fantastically palatial – row house in Windmill Hill, on Bristol's south side. Yet even these purchases could be justified as practicalities that were as much, if not more, for the good of Sarah than for the gratification of their owners. 'If we had a car, it was to move records and T-shirts and to get to gigs with merchandising and because hitching was just too time-consuming,' Wadd later wrote, 'and if we had a house it was because that meant we weren't renting both a flat and an office, and it was cheaper and less hassle, and a house in Windmill Hill was £45,000 then, which is kind of unimaginable now.'

Haynes reasoned that their Fiesta had been an indirect reward for 'the money we'd saved from buying stale bread and not having full-colour sleeves'.

'The point of Sarah was never to make money,' says Wadd. 'I mean, obviously we needed to make money to live, but we were never trying to maximize the money. We were trying to maximize the *record sales*, but within our confines of what we thought was acceptable and what we were willing to do, and the fact that we had to like and believe in the records. So you'd never put something out because it would sell; you'd do it because you loved it. And you'd never *not* put something out because you were worried it wouldn't sell.'

So, in the end, the milestone of Sarah 50 was marked with Saropoly,[1] a Sarah-themed board game printed upon a fold-out sheet of paper. This struck Chadwick as characteristically deranged – especially insofar as the label, having insisted it sell for fifty pence, lost money each time it sold. Despite ongoing demand, Wadd and Haynes discontinued Saropoly after 1,500 copies, simply because the hand assembly it required – just like their early seven-inch

[1] In keeping with Sarah's ongoing promotion of Bristol, Saropoly requires each of its players – whose game pieces represent the founding 'moguls' of other indie labels (among them Alan McGee, Ivo Watts-Russell and Tony Wilson) – to scamper around the city in the pursuit of making a Sarah release. 'Various branches of JCR News feature on the board', Haynes points out. 'These were stationers that used to sell cheap parcel tape. Our lives revolved around sourcing cheap parcel tape.'

sleeves, only worse – was taking them away from everything else. 'We needed to spend the time doing something more worthwhile before we went mad,' says Wadd.

Resolving to continue past 50 ensured that Sarah would go on to foster recent and future discoveries Blueboy, the Sugargliders, Even As We Speak and others; release landmark records such as 'Missing the Moon' and *Unisex*; and facilitate the overseas critical success of East River Pipe (as well as stoke the indignation of those who would forever point to Boyracer as proof of the label's inexorable decline).

But throughout much of the second half of Sarah's lifespan, the question always hung above Wadd's and Haynes's heads as to which nice round number should mark its end. 'I suspect it was an idea that gradually solidified, rather than some overnight decision,' says Haynes. 'I think it was there from 50, and as we got closer to 100, it became an actual fact rather than just a vague idea.'

Throughout Sarah's final four years, during which Wadd and Haynes would intermittently steer conversation back to the subject of its demise (not only when, but how), the label became subject to various circumstances that gradually made the idea of a voluntary exit seem more and more attractive. Not least was the reality that success had become literally exhausting and that they continued to do themselves no favours, still refusing to delegate to others so that they might take some time to enjoy the spoils of their labours. From their hard-won house, they worked alone as before, despite now having the space to accommodate at least one more body during conventional office hours.

'We thought about it,' admits Wadd, 'but it was hard to think of someone who would be able to do things in the probably slightly peculiar way we wanted to do it, and it was so intense with us working from home. I think also the commitment of being responsible for somebody else and paying their wages every month was quite daunting. We could have got somebody to go to the post office for us, because we went there every day and probably spent half an hour or an hour in there. But on the other hand, that was the bit where we went off and got some fresh air and got some shopping for tea on the way home, so that wouldn't have been a nice thing to take away.'

'It was such a personal label,' adds Haynes. 'There's so much you really couldn't have got anybody else to do because we wanted to oversee everything. There's no way anybody else could have done the mail-order, because we would have wanted to put the letters in and things like that. I suppose, at the end of the day, the point is that we could just about do it ourselves, therefore we *did* do it ourselves.'

It was, however, the intensely personal nature of Sarah, Wadd and Haynes were growing to realize, that might eventually be Sarah's undoing if they didn't take a pre-emptive strike and bow out in their own time and on their own terms. Seemingly everything about music, independent or otherwise – its sound, its technologies, its means of exposure, its tug-of-war between idealism and capitalism – was at the cusp of dizzying transition. They were not so insular as to be unaware that Sarah's charming anachronisms were becoming liabilities in farther-reaching ways than some nasty reviews in the weeklies.

There was, for instance, the matter of Sarah's devotion to vinyl. Initially rooted in the conviction that pop music should be accessible, affordable and aesthetically pleasing, as the 1990s rolled onwards it became a romantic ideal that contradicted itself. 'CDs were luxury items when we started – they were this expensive, flashy thing for Dire Straits – but they weren't anymore,' says Wadd. 'It didn't make sense politically anymore to deny them. I don't think anyone in my student halls of residence in 1986 had a CD player, but I don't suppose by the time we got to 1992, '93, that there was any student who didn't. It would be a much more sensible thing to have than a record player.'

Beginning in September 1992, with the Orchids' 'Thaumaturgy', Wadd and Haynes issued the majority of Sarah singles on CD as well as vinyl, having reached a point at which it would have been at best arrogant, at worst contemptuous, to ignore the increasing number of customers who voiced a new-found preference for CDs. At a stroke, singles – the very artefact upon which Sarah had staked its identity and, to a great extent, its raison d'être – stopped being profitable, owing to the cost of splitting production between two formats. But they refused to abandon vinyl, despite it being dismissed by the music business and the majority of music buyers as finished (except

in the club world, where dance and hip-hop DJs almost single-handedly kept pressing plants from shuttering).

Wadd acquired a front-row seat to vinyl's decline, as well as other seismic events in her industry, in 1994, when she took a job at Sarah's distributor. No longer Revolver, after having merged with another company in 1992, it was now named Vital, and it was the second largest independent music distributor in the UK. Although Revolver had been invaluable to Wadd and Haynes for schooling them in many of the fundamentals of operating a record label, it too had always been small and amusingly chaotic – an embodiment of the greenhorn, seat-of-the-pants enthusiasm that defined post-punk and everything that grew out of it. In its place, Vital offered admirable but often joyless professionalism.

'It became much more organized,' observes Haynes. 'At the start, if we wanted any of our records that were in the warehouse, we just would sort of wander in and take them! And the idea of us just bringing our records down to them and saying, "Can you get these into the shops next week?" and them saying "Yes, no problem" – by the end, you sort of had to give a three-month advance notice of any new release. They wanted you to present a marketing plan. It was really difficult trying to come up with something to explain why shops should buy the new Sugargliders or Boyracer single, other than saying John Peel might play it.'

Wadd's frequent absences from home while at Vital – which was deemed a useful experiment to help foster a better relationship between companies, as well as to develop a stronger understanding of what was happening to the music business – meant she and Haynes were busier than ever. 'There was a bit of time-saving with it, in the sense that I could have a meeting with our label manager or the production manager about some artwork on my lunch break before they took their lunch break,' says Wadd. 'I'd present our releases at a sales meeting, then listen to the rest of the labels presenting their records. It was a low-level job, so it didn't consume me outside of work hours, and it enabled some money savings for Sarah. The job was in London for the first six to eight months, then back in Bristol.'

Meanwhile, at home, Haynes continued seeing to tasks such as designing artwork, calculating the VAT return and upholding Sarah's reputation for never failing to reply to a letter.

'For us, it wasn't just about not going bust,' says Wadd. 'It was about all the different ways that indie labels stop: they just fizzle out or they get bought out or they go really crap. We had to pick a different way. If you don't stop at 100, when *are* you going to stop? When is the next logical point? At 1,000, we'd still be doing it today.'

'The one question that always annoys us', Haynes continues, 'is "Why did Sarah go bust?" We didn't. Almost uniquely among small record labels, we did function entirely in the black. We never went into debt. The main reason we kept going for one hundred releases is because we were sensible, basically. We didn't send bands into the studio and say, "Spend as much time and money as you want."'

Judicious allocation of profits had indeed been key to Sarah's survival, yet when Wadd and Haynes confirmed between themselves that the label's one hundredth[2] release would be its last, among their first resolutions was that they would lavish a considerable amount of cash upon announcing that decision to the public.

'I don't think I've ever enjoyed spending stupid amounts of money more than when we did the advert for the end of Sarah,' says Wadd, gleefully.

The advert, which took up half a page, appeared in the 26 August 1995 edition of both *Melody Maker* and the *NME*. Visually, it harks back to Sarah Records' fanzine roots: words pasted willy-nilly against a distorted photograph (in this instance, Bristol's Clifton Suspension Bridge), although the Letraset of yore has been replaced with professional typesetting. Headlined 'a day for destroying things…', it abstractly sets out justification for Sarah's dignified death: 'Nothing should be forever,' it reads. 'Habit and fear of change are the worst reasons for ever doing ANYTHING. Stopping a record label after 100 perfect releases is the most gorgeous pop-art statement ever. … Sarah Records is owned by no-one but us, so it's OURS to create and destroy how we want and' – emphasized in larger type – 'we don't do encores'.

[2]Although most histories of Sarah report that the label stopped after one hundred releases, its final release was actually the hundredth in its primary catalogue sequence, which doesn't include mini- and full-length albums. The total number of Sarah releases is 138.

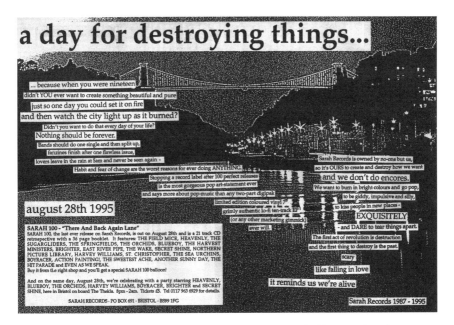

Figure 16.1 *Sarah announces its self-destruction with a half-page ad in the 28 August 1995 edition of both* Melody Maker *and the* NME. *(Courtesy of Sarah Records)*

A bookend of sorts to the statement of intent presented in the liner notes of *Shadow Factory* in 1988, the advert ends: 'Sarah Records 1987 – 1995'. To its left are announcements of a farewell party in Bristol on 28 August, aboard the Thekla, at which seven Sarah acts were booked to perform; and Sarah's final release, a compilation titled *There and Back Again Lane* (whose cover, not coincidentally, also features a photo of Clifton Suspension Bridge – chosen because it had long been Bristol's most recognizable tourist attraction. And because it was a popular destination for suicides).

Costing a combined five-thousand pounds, the advert was by some distance the most costly promotional endeavour in Sarah's history, and yet its basic purpose was to make it known that Sarah essentially had nothing left to sell, and that this was a very good thing. Triumphant, in fact.

'I think it was a "Fuck you" to the music establishment,' says Wadd. 'It was like: one, "We've got five grand to spend on two half-page ads *despite you*"; and two, "We're better than all of you." I suppose we felt we hadn't got the message across as widely as we wanted to about what we'd been trying to do for the last

eight years, and we really didn't want anyone to think we'd gone bust. It was a statement for the wider public who kind of knew who we were and were either vaguely interested or not interested or hated us. In a funny sort of way, maybe that's one of the reasons that a lot of people finally seemed to find us just as we were shutting down, because we actually spent more money on advertising than we ever had before.'

Haynes considers: 'I think we liked the idea that most people would think, "What the hell *is* this? Who *are* these people? What is this *about*?" You have to be slightly arrogant about these things, but I sort of think if I was an eighteen-year-old, opening a copy of the *NME* and reading that, I would be wanting to go out and find out what this was, or just do *something*. It would fire me up.'

It was all the more perverse for the fact that those who were inclined to care most about Sarah's self-destruction – its long-dedicated global fan base – had, by and large, already known for some time, thanks to a final newsletter mailed to the label's mailing list. ('[This] really is IT,' it read, amidst five pages of very small type. 'We're not going to do a Postcard or a Factory or a Rough Trade and resurrect Sarah in 5 years time because that's pathetic. The master-tapes aren't for sale and the label name's not for sale and we're not for sale … and we want the end to be The End.') The advert was, in fact, the final component of a staggered, weeks-long dissemination that required careful planning and a great many assurances of trust.

Initially, not even Sarah's own bands knew of the label's upcoming retirement. Wadd and Haynes wanted everyone to find out simultaneously – a wildly impractical aim, given everyone's scattered locations and the absence of email. 'I became an incredibly artful – not exactly *liar*,' says Wadd. 'But, you know, someone would say, "I heard a rumour you're stopping at Sarah 100." And I'd say, "Oh, I heard that rumour off someone as well." But you'd kind of sidestep the question. In the end, I think we had to ring round all the bands on the same day.'

'We were really strict,' says Haynes. 'I think there were a couple of bands right at the end who wanted to do new singles, so we had to tell them and swear them to secrecy.'

Wadd approached Mike Chadwick at Revolver, having not forgotten his distress four years prior when she and Haynes told him Sarah 50 might be the

label's swansong. At this distance, she can fully appreciate the comedy of his reply. 'By that time, Vital was distributing the entire Creation catalogue, which at that point included Oasis,' she says. 'He said, "What are you doing for 100?" I said, "We're stopping." He said, "Oh, all right."'

Wadd and Haynes were relieved that none of the bands voiced despair or resentment in response to the sudden loss of their label – at least not to their faces. They half-suspected some of them had known it was coming: Sarah's release schedule had for some time been glaringly absent of new additions past number 99. And Wadd recalls that throughout Sarah's final months, she and Haynes had 'refused to engage with any of them about next records. I think it was probably quite devastating for some of them. I mean, record labels expect bands to call it a day, but bands don't expect record labels to.'

Whatever ill feelings existed in the short term appeared to have evaporated once 28 August, the day of the farewell party, arrived. The event's 400 tickets sold out quickly, some to people who would have to board an intercontinental flight to attend. 'I've still no idea if they all came,' says Haynes. 'There was a boy in Northern Ireland who'd bought pretty much all our records but, because of where he lived, he'd never seen any of the bands play live. So when we announced the final party, he wrote to say there was no way he was going to miss it. He told us he'd be catching the overnight ferry to Holyhead and arriving in Bristol first thing in the morning, so we told him he could come along to the Thekla and help blow up balloons, which he duly did.'

Closer to home, Tim Chipping, whose duo Shelley had provided Sarah with its second-to-last release, recalls that the publishers of the fanzine *Waaaaaah!* 'chartered a bus to take the London Sarah contingent to Bristol. They booked it early so people could go sightseeing – a mistake, upon reflection, as most of us spent the day in the pub.'

The evening proved to be a whirlwind. Between 8.00 pm and a strictly enforced 2.00 am curfew, seven acts were to perform: Secret Shine, Brighter (a one-time-only reunion), Boyracer, Harvey Williams, the Orchids, Blueboy and Heavenly. Most were limited to a half-hour onstage. 'It can't have been any fun for them, in a way, because it was absolutely regimented,' says Wadd.

'Ten minutes between bands, all of them using the same backline. I think we actually ended early because we'd been so efficient'

She and Haynes, having insisted upon working the door on the Thekla's lower level so they could greet those coming in, missed the first half of the night. (Keeping them company was Bobby Wratten, who had been persuaded to attend at the last minute by Ian Catt. He could not, however, be persuaded to perform, as per an earlier request while the party was being organized.) Upon arrival, everyone was handed a balloon and a sheet of paper detailing 'TONIGHT'S EXCITING LINE-UP OF EVENTS', which, in keeping with the blurred division between fact and fancy that defined most of Sarah's literature, made mention of numerous extracurricular attractions that obviously would never happen. Among them was a Sarah Wet Boxer-Short competition to be judged by Boyracer's Stewart Anderson. A male attendee approached Wadd to earnestly express his discomfort about this and to ask for a refund. Wadd explained that it was a joke, and the night continued without serious incident, save for an in-his-cups Tim Chipping trying to initiate the first and last serious physical altercation that would ever take place at a Sarah gig. 'A singer with one of the many bands that formed in the wake of Sarah was touting a fanzine that ridiculed the Shelley sleeve,' he explains. 'We got into an argument about the fact that I chose to appear on the cover and had credited my hairdresser. It was the twee-est row in history. But my alcohol level had clearly tipped me into fight-or-fuck mode and, for the only time in my life, I lashed out, connecting meekly but effectively with his glasses. That was the end of the party for me. Despite Keith Girdler's valiant attempt to smuggle me back in via the artist's entrance, I was forced to sit the night out on a harbour bench in the company of the Orchids. I don't know why they weren't inside. Maybe they'd been thrown out, too.'

Blueboy's Paul Stewart, who spent part of the evening in a panic due to the non-appearance of drummer Martin Rose (he had been arrested the night before in Reading due to 'a very minor matter involving a taxi booking', but materialized at the Thekla just in time), recalls observing a scene of 'slight frenzy among some audience members who, at the loss of their saviour label, wondered how they could go on living, and so fanzines were hastily exchanged,

badges were purchased, and mini-recorders were set up. One band had already photocopied a flyer with the header "Post-Sarah Happenings."'

'It was festive and properly drunken, but it did have a sad undertone,' says Amelia Fletcher. 'Upbeat pop music prevailed over the sadness, though – just like a lot of the best Sarah releases, in fact.' Conversely, Heavenly – or rather, Amelia herself – encored in the early morning hours after Heavenly's headline set (and thus provided the party's valediction) with 'So?', her chilling a capella B-side about date rape. 'Much as I love Amelia, it was a slightly odd choice,' concedes Haynes. (For whatever reason, it seemed not to occur to Heavenly to reprise their encore from a Sarah Christmas party in 1990, 'We Are the Champions.')

That done, everyone filtered out into the late-summer air. Spirits were generally high, although Wadd remembers, 'Some people cried. *We* probably cried. It was a really tough thing to do. We basically threw away our livelihoods and our lives. The fact that the bands would come and do this, knowing that they're not going to get to put any records out again on their label and we'd essentially just stitched them up, was lovely.'

Of a piece with their farewell manifesto and its celebration of 'destroying', Wadd not-entirely-jokingly suggested to Haynes that they should set fire to all of Sarah's master tapes. 'But Matt wouldn't let me because he didn't think it would be fair to the bands, which is probably true.'

'If we had been absolutely purist,' Haynes reasons, 'we would have said, "Right, it's over. No more sales. We've destroyed everything."'

Instead, common sense prevailed, and they did their best to liquidate remaining stock and ensure proper attention was paid to *There and Back Again Lane,* Sarah's farewell release. Made available only as a CD, the 21-track, eight-year-spanning collection was also the most elaborately packaged item in the label's history, boasting a 34-page booklet littered with photos and unattributed reminiscences. At the booklet's conclusion, it was pointed out that the final lyric of the final track of Sarah's final release – Blueboy's 'Toulouse', a resigned acoustic ballad that served as B-side to 'Dirty Mags' – is 'I don't want to change the world anymore.' Keith Girdler and Paul Stewart had written the song in the eponymous city shortly before a gig in May 1994, and they played it for the

first time that night. It materialized in little more time than it took to perform, and to this day Stewart can't account for what inspired Girdler's words.

Haynes can't help but laugh. 'Pure fluke', he says, 'but those are the words we went out with: "I don't want to change the world anymore."'

The morning after the party, he and Wadd woke up, bid farewell to the dozen or so people who had slept overnight in their house, and began making plans for life after Sarah. Their act of destruction complete, it was now time to build something new.

17

The Afterlife of Sarah

*So all we'll say is this: thank you, to anybody who's ever written or
phoned or whatever, thank you because … it really is all that – all the,
um, heck – the, um, well – YOU – that makes it all worthwhile. And even
if it's true that most of those who used to write to us when we first began
have, over the years, gradually disappeared, wandered off into … what …
jobs, marriages, babies, the backstreets of Naples – it doesn't really matter,
because you were there at the time and – well, we've still got all your letters,
because we never were very good at throwing things away. So there.*

– FROM THE CLOSING PARAGRAPH OF SARAH'S FINAL NEWSLETTER, AUGUST 1995

There had been a dual aspect of self-deprecating mischief in *There and Back
Again Lane*. Not only is the bridge that adorns its cover infamous for being
the perch from which an undocumented number of disconsolate souls have
leapt to their extinction; its very title is taken from yet another Bristol locale,
and it happens to be a cul-de-sac. Possibly the least picturesque street in the
city, usually There and Back Again Lane's only inhabitants are rubbish bins
and perhaps some hobos. Not even in its final moment of victory could Sarah
Records enjoy a reprieve from its owners' sidelong humour.

This didn't escape the notice of *NME* writer Johnny Dee, who, in his review
of the compilation, concluded, 'Faced with banging heads against a brick
wall or turning round to find a different route (be mourned or continue to be
scorned), Sarah Records and all it entails made the right decision.'

But it was in the middle of his critique that Dee made his most intriguing
observation: 'Sarah's closure signals a far-reaching decline in the British

independent scene. Now indie is a type of music collected on compilations called "Shine Too" [a reference to a series of major-label-backed "alternative" albums featuring the disparate likes of Oasis, the Cranberries and Green Day] and you have to look far beyond HMV to find any label that survives without big cheese funding. But to Sarah, and to hundreds of labels at the time of its inception, "independent" meant just that.'

Among various journalists who hadn't been comparing notes, Sarah's departure conjured a similar sentiment. Whether a backer or a detractor, seemingly every writer charged with eulogizing the label couldn't help but acknowledge that what Sarah had represented would be missed, even if its music wouldn't. 'Sarah may have been maligned for their "wimpy, anorak-wearing" music', wrote *Melody Maker*'s Dave Simpson, as part of a full-page farewell, 'but they were making a statement as defiant as any issued by The Sex Pistols'. His colleague Victoria Segal said of *There and Back*: 'Sarah are a valuable testament to lives lived through a certain kind of pop music, with good ideals and a collection of songs that can often crack your heart like an egg.' Pete Paphides, then at *Time Out London*, judged the album 'a final gesture of purity in an idiom long since overtaken by commerce and expediency'.

It had been mere coincidence that the 'a day for destroying things…' advert was positioned in *Melody Maker* directly opposite an advert for Oasis's 'Roll With It', the song made famous for its tabloid-worthy battle against Blur's 'Country House' for the national chart's top spot. Oasis were the flagship – nay, the saviour – band of Creation Records, the label whose formerly low-budget, post-Postcard, punk-meets-psychedelia mien had been one of Haynes's greatest inspirations and a partial template for the infant Sarah. In 1992, Alan McGee had sold 49 per cent of Creation to Sony Music, thus saving his label from financial ruin (while *just* retaining its legal status as an indie), but forever dulling the rebel lustre it had enjoyed throughout the 1980s. McGee was now wealthy to a degree Haynes could barely conceive, and Oasis were, at that moment, not so much a band as a consensual symbol of British high times. But Wadd and Haynes considered theirs the greater victory. Having begun as they meant to go on, so too had they ceased. In 1999, exhausted by the unwieldiness and compromise of his relationship with Sony, McGee abruptly folded Creation and founded a new label that attempted in vain to rekindle

the oddball magic of long before. The oddball magic that Sarah maintained to the end.

One conspicuously vague disclosure in Sarah's final newsletter had been the promise of some sort of second act. '[We've] decided not to turn our backs on pop entirely,' it read. "[There] is going to be a new label, but it won't be Sarah Part 2, because we want to do something new. Not quite sure what just yet, but it'll be fun figuring it out. All we can tell you is that it's called METROPOLITAN.'

In August 1996, subscribers to Sarah's newsletter received one more unsolicited envelope: a monochrome four-page leaflet titled 'Sarah Obituary', which caught up those who otherwise hadn't read about the Thekla party, and detailed future plans for Wadd, Haynes and many of the Sarah bands who had been left to scrounge for a new home. Here it was revealed that there would, in fact, *not* be a new label called Metropolitan – that name, it turned out, was taken. Instead, there would be Shinkansen Recordings, in tribute to the Japanese bullet train (and carrying on Metropolitan's intended railway theme). Public transit still loomed large in Haynes's affections.

And it *was* just Haynes, for the most part. Wadd, having continued to work at Vital, grew 'bored and frustrated' with the distributor simultaneous to feeling increasingly drawn to London. She took a job there early in 1996 with Caroline Music, a label and distribution company that had grown out of Richard Branson's Virgin empire, and regularly travelled home to Bristol on weekends. Come the summer, she and Haynes sold their house and moved to London, where they shared a small flat.

But first, they broke up.

'There's no big story to this,' says Wadd. 'Like any couple who got together really young, we just ended up wanting different things. Running Sarah was a very intense eight years – mostly working from home, mostly just with each other, very insular. It was time to do something different. I found I wanted to go out to work and then go out and spend money – parties! – and Matt didn't want to so much. But we never fell out.'

Haynes moved out of their shared flat in May, at which time Shinkansen began in earnest. The label became an incubator for a handful of new,

unknown groups, but more prominently it provided a soft landing to some former Sarah acts who were happy to rekindle their alliance with Haynes. The label's inaugural release was from Trembling Blue Stars, a new project led by Bobby Wratten; following close behind was Blueboy (reduced for the time being to the founding duo of Keith Girdler and Paul Stewart), East River Pipe, Harvey Williams and, much later, Fosca, featuring Dickon Edwards of Shelley. (Edwards and his former Shelley cohort, Tim Chipping, briefly pursued mainstream fame as Orlando, making a vastly expensive, cruelly unsuccessful album, *Passive Soul*, for the major label Blanco y Negro.)

At Caroline, Wadd was placed more or less in charge of Vernon Yard, an ostensibly independent label majority owned by Virgin. From its offices in Notting Hill, she worked hard for every band placed in her care, despite having to metaphorically hold her nose in the presence of some of them. She was thrilled to facilitate UK releases for the first three albums from

Figure 17.1 *Blueboy, once again reduced to its founding duo Keith Girdler and Paul Stewart, regrouped in 1996 for Shinkansen Recordings, the label formed by Matt Haynes after the shutdown of Sarah. (Photo: Trisha Purchas)*

Low, a wondrously atmospheric, deeply melancholic American group at the beginning of a career that continues to this day. It proved to be a rare highlight. 'I did their press and radio very successfully,' she says. 'But it didn't look like the funding for the U.K. operation would get renewed and I had to consider my options, and really I just couldn't see anyone I wanted to work for or anything I wanted to do in the music industry. I was also struggling to see many women succeeding in it at that point.'

As the turn of the century approached, Wadd formulated an exit strategy. 'I sent a couple of spec letters out to accountancy firms, because I had two maths "A" levels and an economics degree, and I lucked into a job when someone had dropped out of a training contract.'

But before departing for a new professional life in financial management, Wadd's tenure at Caroline afforded her an interesting – and, at the time, unprecedented – insight as to the reach and endurance of Sarah. 'I went to South by Southwest', the annual music festival and conference in Austin, Texas. 'It was in '97 – the first time I'd ever gone to the States. And Austin's quite a strange place to go if it's your first time. But I was quite surprised that quite a lot of people came up to me and went, "Oh, you used to run Sarah Records? I love Sarah and 4AD!" It was often Sarah and 4AD.'

While she and Haynes had been busying themselves with the present, Sarah's past had continued to radiate out into the world, facilitated greatly by the emergence of the internet, which had only started arriving into people's homes in 1995. An early online presence, the Indiepop Mailing List, served as a forum in which fans of the genre from around the globe instantly exchanged information and celebrated their shared enthusiasms in a manner that, only months previously, would have required handwritten correspondence and weeks of anticipation for its arrival in the post. Inasmuch as it transformed everything about modern communication, the internet forever changed the ability of music obsessives to dialogue with each other. In death, Sarah became more ubiquitous, more discussed, more appreciated, than it had ever been while functioning. At the urging of one of the Indiepop Mailing List's participants, one dozen Sarah fans contributed short essays about their relationship to the label; the results were published as a fanzine, *This August's Farewell Kiss*, which revealed that there were people in the UK, Germany, Texas, California,

Michigan, Singapore and elsewhere for whom Sarah had been a key part of their young lives. 'Matt Haynes, Clare Wadd. Thanks a million for everything,' wrote Steve Thornton of Seattle. 'If it's possible to love someone you've never met (though you've written me lovely letters), I love you. ... [Those] records have taught me how to think about my life and my world and the people who inhabit it. I'm a better person for Sarah.'

Haynes continued to receive letters and, increasingly, email offering praise about his former label, as well as inquiring about the availability of long-deleted releases. (Sarah's Bristol PO box, which he and Wadd continued to rent for roughly a year after leaving the city, was for several months the recipient of demo tapes from bands who hadn't heard the news.) Shinkansen, however, was his primary focus. It enjoyed a reasonably prolific release schedule, particularly from 1999 onwards, and Trembling Blue Stars (whose line-up at various times included former members of Aberdeen, Blueboy, Brighter and the Field Mice[1]) attracted considerable acclaim; their third and fourth albums were licensed for North America by Sub Pop Records, then in the midst of finally shedding its identity as the home of grunge. But Shinkansen was often a struggle. Unlike Sarah – which, despite its troubled relationship with the press, had a fiercely devoted following that was at least curious about virtually every release – it failed to engender an ongoing relationship with record buyers. Shinkansen signings who had no relationship to the Sarah roster – bands such as Tompot Blenny, Cody and Monograph – sold in meagre numbers. By far the best-seller of its approximately forty releases was *Where'd You Learn to Kiss That Way?*, a compilation of the Field Mice's recordings (original copies of which had begun selling for three-figure sums). In summer of 2003, Haynes quietly closed Shinkansen down, possibly to be revisited at a later time.

'I'd tried to move away from the idea of having a strong label identity', he says, 'partly to avoid Shinkansen being just Sarah Part Two, and partly to see what difference it would make: I was actually quite excited by the idea of Blueboy being reviewed as Blueboy, rather than 'a Shinkansen band'.' But Shinkansen never caught the public imagination in the way that Sarah had. In

[1]In early 2015, Wratten unveiled Lightning in a Twilight Hour, a new project featuring contributions from Beth Arzy, Anne Mari Davies and Michael Hiscock.

Figure 17.2 *Trembling Blue Stars – made up of former Field Mice and Northern Picture Library members Anne Mari Davies, Michael Hiscock and Bobby Wratten – became Shinkansen's most critically and commercially successful group. (Photo: Alison Wonderland)*

doing away with a strong label identity, I'd lost one of the aspects of running a label that I enjoyed most: the chance to do stupid things like matching seven-inch labels and postcards of railway stations. It was a much more orthodox label and so, by definition, much duller. As a result, I'd succeeded in getting the bands judged – or ignored – on their own merits, but people who bought Trembling Blue Stars records saw no reason to buy Cody or Fosca records, too. The label never officially stopped – I'd actually got as far as mastering a second compilation album, but then couldn't summon up the enthusiasm to press it. Possibly the label had never really caught my imagination either, although I still think all the music is fantastic.'

'Shinkansen also differed from Sarah in that it had a website, though by the end it was mostly about the Iraq War and "what we should do about it", and I used to get angry emails from people in Chicago telling me they didn't buy Trembling Blue Stars singles in order to get a lecture about U.S. imperialism. So, maybe I could blame the demise of Shinkansen on Tony Blair and George W. Bush.'

While Haynes turned his attention to self-publishing *Smoke*, a magazine dedicated to romantic musings about London (and whose tone and visual style frequently harked back almost two decades to *Are You Scared to Get Happy?*), the internet was in the midst of making its innovations of only a few years prior seem amusingly primitive. File-sharing, high-speed streaming and downloading, and social media allowed everyone to broadcast their likes and dislikes to a limitless audience, and entire music collections were suddenly being shared globally like a mix tape passed between friends. Bands and entire sub-genres that had historically been the secret of a few found vast new audiences, and emerging musicians could present for judgement their latest work without having to pay a cent for manufacturing. It was – and is – stunningly convenient, awesomely efficient, unprecedentedly egalitarian and, by and large, utterly bereft of charm.

In July 2010, two teenagers – Katy (then eighteen) and Gene (sixteen) – posted a three-minute clip to YouTube: 'Our Sarah Records Documentary Video'. Soft-spoken, well-mannered and wearing the uniforms of cerebral, culturally savvy outcasts ('nerd' glasses, stripes, unisex haircuts), they come from Marietta, a city of fewer than sixty-thousand in the state of Georgia. They begin by acknowledging that Sarah almost predates their births, and then go on to talk about discovering Sarah in their freshman year and the victory of acquiring some of the records. Katy discloses the memory of 'taking, like, winter walks, like, alone and, like, listening to Blueboy and being, like, "This is *awesome*."' 'What's special about the label and the bands is that their music is just a personification of so many things', says Gene, 'and different seasons to me, and it never really gets old.'

Katy and Gene strike the viewer as being each other's best friend, and possibly each other's life raft: unusual people living in an ill-fitting environment during a challenging time of life. Their video is, within the grand scheme of YouTube, not at all popular (forty-five-hundred views at the time of this writing, almost five years after it was posted), but it speaks volumes about the way young people in the twenty-first century go about cultivating an identity and seeking out passions, in an age when even the most obscure corners of

music, film, fashion, literature – anything and everything – can be effortlessly perused. Gene stumbled upon the Sea Urchins and, by extension, Sarah after discovering proto-Britpop band the La's and then engaging in 'further research' to find similarly exotic sounds.

Stories like theirs are legion now, and they have everything to do with Sarah Records' unlikely afterlife. Whether their entry point is Belle and Sebastian (who could easily have become a part of Sarah if it had still existed when the band formed in early 1996) or Britpop or shoegaze or the Byrds, the infinite niche-interest rabbit holes of contemporary media seem to lead with little effort to the Field Mice or Heavenly or the Orchids.

In early 2015, as this book is being put to bed, renewed interest spurred by online activity has prompted more than half a dozen previously dormant Sarah bands to reform for tours or new recordings. The Orchids are now three albums deep into a reunion that has produced their best music, the Hit Parade have released a combined seven singles and albums (plus a compilation) since 2003, and the Wake returned in 2011 to find that in their absence they had become reassessed as a bona fide Great Lost Band; when the *Guardian*'s Alexis Petridis found himself backstage in Brighton that year after a performance by Brooklyn buzz band the Drums, he was astonished to note that the Wake was providing the dressing-room soundtrack. 'Their reaction to the fact that I'd *seen* Sarah bands', he recalls of the barely post-pubescent Drums, 'you would have thought I'd said I saw the Velvet Underground playing live with Nico, and Andy Warhol doing the lights'.

Most significantly, in May 2014 the Arnolfini, a contemporary arts centre at Bristol's harbourside, just a stone's throw from the Thekla, hosted *Between Hello and Goodbye*, an exhibition of Sarah artefacts, alongside the premiere of *My Secret World: The Story of Sarah Records*, a three-years-in-the-making documentary that went on to screen for sold-out houses in Barcelona, London and New York. As in 1995 at the farewell party, there were people who flew thousands of miles to be there, to stand among and perhaps gain a greater understanding of something that still feels slightly mysterious, somewhat private, defiantly different.

'Sarah was a complete piece: very much the music, but more than the music – a piece of art with a beginning, a middle and an end,' reckons Wadd. 'There's a circularity and completeness about it'.

'It isn't just a hundred records,' says Haynes. 'It's all the inserts and posters; it's the pictures of buses; it's that the postcards build up into a picture of Temple Meads station. The more you delve into it, the more there is to uncover'.

The Sarah Discography

Singles/EPs

1	**THE SEA URCHINS** 'Pristine Christine'
2	**THE ORCHIDS** 'I've Got a Habit'
3	**ANOTHER SUNNY DAY** 'Anorak City'*
4	**FANZINE** *Sarah 4*
5	**14 ICED BEARS** 'Come Get Me'
6	**THE POPPYHEADS** 'Cremation Town'
7	**ANOTHER SUNNY DAY** 'I'm in Love With a Girl Who Doesn't Know I Exist'
8	**THE SEA URCHINS** 'Solace'
9	**THE GOLDEN DAWN** 'My Secret World'
10	**THE SPRINGFIELDS** 'Sunflower'
11	**THE ORCHIDS** *Underneath the Window, Underneath the Sink*
12	**THE FIELD MICE** 'Emma's House'
13	**CHRISTINE'S CAT** 'Your Love is…'*
14a	**FANZINE** *Lemonade*
14aa	**FANZINE** *Cold*
15	**ST. CHRISTOPHER** 'You Deserve More Than a Maybe'
16	**ANOTHER SUNNY DAY** 'What's Happened?'
17	**THE GOLDEN DAWN** 'George Hamilton's Dead'
18	**THE FIELD MICE** 'Sensitive'
19	**BRIGHTER** *Around the World in Eighty Days*
20	**ST. CHRISTOPHER** 'All of a Tremble'
21	**THE WAKE** 'Crush the Flowers'
22	**ANOTHER SUNNY DAY** 'You Should All Be Murdered'
23	**THE ORCHIDS** 'What Will We Do Next?'
24	**THE FIELD MICE** *The Autumn Store* (Part 1)
25	**THE FIELD MICE** *The Autumn Store* (Part 2)
26	**GENTLE DESPITE** *The Darkest Blue EP*
27	**BRIGHTER** 'Noah's Ark'
28	**ACTION PAINTING!** 'These Things Happen'
29	**THE ORCHIDS** 'Something for the Longing'
30	**HEAVENLY** 'I Fell in Love Last Night'
31	**ETERNAL** 'Breathe'
32	**FANZINE** *Sunstroke*
33	**THE SEA URCHINS** 'A Morning Odyssey'

34	**ST. CHRISTOPHER** 'Antoinette'
35	**ANOTHER SUNNY DAY** 'Rio'
36	**THE SWEETEST ACHE** 'If I Could Shine'
37	**EVEN AS WE SPEAK** 'Nothing Ever Happens'
38	**THE FIELD MICE** *So Said Kay* **
39	**THE SWEETEST ACHE** 'Tell Me How it Feels'
40	**THE SPRINGFIELDS** 'Wonder'
41	**HEAVENLY** 'Our Love is Heavenly'
42	**THE ORCHIDS** *Penetration****
43	**TRAMWAY** 'Maritime City'
44	**THE FIELD MICE** 'September's Not So Far Away'
45	**GENTLE DESPITE** 'Torment to Me'
46	**ST. CHRISTOPHER** 'Say Yes to Everything'
47	**THE SWEETEST ACHE** 'Sickening'
48	**THE WAKE** 'Major John'
49	**EVEN AS WE SPEAK** 'One Step Forward'
50	**BOARD GAME** *Saropoly*
51	**HEAVENLY** 'So Little Deserve'
52	**TRAMWAY** *Sweet Chariot*
53	**SECRET SHINE** 'After Years'
54	**THE FOREVER PEOPLE** 'Invisible'
55	**BLUEBOY** 'Clearer'
56	**BRIGHTER** 'Half-Hearted'
57	**THE FIELD MICE** 'Missing the Moon'***
58	**THE HIT PARADE** 'In Gunnersbury Park'
59	**EVEN AS WE SPEAK** 'Beautiful Day'
60	**ANOTHER SUNNY DAY** 'New Year's Honours'
61	**SECRET SHINE** *Ephemeral*
62	**THE ROSARIES** *Forever*
63	**THE SUGARGLIDERS** 'Letter from a Lifeboat'
64	**THE HARVEST MINISTERS** 'You Do My World the World of Good'
65	**BLUEBOY** 'Popkiss'
66	**THE ORCHIDS** 'Thaumaturgy'
67	**THE SUGARGLIDERS** 'Seventeen'
68	**THE HARVEST MINISTERS** 'Six O'Clock is Rosary'
69	**BRIGHTER** *Disney*
70	**BLUEBOY** 'Cloud Babies' (live)*
70a	**FANZINE** *Just As Good As I Should Be*
70b	**FANZINE** *Nice Boys Prefer Vanilla*
70c	**FANZINE** *I Am Telling You Because You Are Far Away*
71	**SECRET SHINE** 'Loveblind'
72	**THE SUGARGLIDERS** 'Ahprahan'
73	**ACTION PAINTING!** 'Classical Music'
74	**BLUEBOY** 'Meet Johnny Rave'
75	**EAST RIVER PIPE** 'Helmet On'

76 **BOYRACER** *B is for Boyracer*
77 **THE SUGARGLIDERS** 'Trumpet Play'
78 **EAST RIVER PIPE** 'She's a Real Good Time'
79 **EVEN AS WE SPEAK** 'Blue Eyes Deceiving Me'
80 **BLUEBOY** *Some Gorgeous Accident*
81 **HEAVENLY** 'P.U.N.K. Girl'
82 **HEAVENLY** 'Atta Girl'
83 **THE SUGARGLIDERS** 'Will We Ever Learn?'
84 **THE HARVEST MINISTERS** 'If it Kills Me and It Will'
85 **BOYRACER** *From Purity to Purgatory*
86 **THE SUGARGLIDERS** 'Top 40 Sculpture'
87 **ACTION PAINTING!** 'Mustard Gas'
88 **BLUEBOY** 'River'
89 **SECRET SHINE** *Greater Than God**
90 **THE HIT PARADE** 'Autobiography'
91 **IVY** 'Wish You Would'
92 **IVY** 'Avenge'
93 **ABERDEEN** 'Byron'
94 **NORTHERN PICTURE LIBRARY** 'Paris'
95 **NORTHERN PICTURE LIBRARY** 'Last September's Farewell Kiss'
96 **BOYRACER** *Pure Hatred 96*
97 **ABERDEEN** 'Fireworks'
98 **SHELLEY** 'Reproduction is Pollution'
99 **BLUEBOY** 'Dirty Mags'

*All 7" vinyl except * (flexi) ** (10") *** (12")*

Mini-Albums (10")

401 **THE ORCHIDS** *Lyceum*
402 **THE FIELD MICE** *Snowball*
403 **ST CHRISTOPHER** *Bacharach*
404 **BRIGHTER** *Laurel*
405 **EAST RIVER PIPE** *Goodbye California*
406 **HARVEY WILLIAMS** *Rebellion*
407 **EAST RIVER PIPE** *Even the Sun Was Afraid*

Albums (12")

601 **THE FIELD MICE** *Skywriting*
602 **THE WAKE** *Make it Loud*
603 **HEAVENLY** *Heavenly Vs. Satan*

604 **TALULAH GOSH** *They've Scoffed the Lot*
605 **THE ORCHIDS** *Unholy Soul*
606 **THE FIELD MICE** *Coastal*
607 **THE FIELD MICE** *For Keeps*
608 **THE SWEETEST ACHE** *Jaguar*
609 **THE SEA URCHINS** *Stardust*
610 **HEAVENLY** *Le Jardin de Heavenly*
611 **THE ORCHIDS** *Epicurean: A Soundtrack*
612 **BLUEBOY** *If Wishes Were Horses*
613 **ANOTHER SUNNY DAY** *London Weekend*
614 **EVEN AS WE SPEAK** *Feral Pop Frenzy*
615 **SECRET SHINE** *Untouched*
616 **THE HARVEST MINISTERS** *Little Dark Mansion*
617 **THE ORCHIDS** *Striving for the Lazy Perfection*
618 **THE WAKE** *Tidal Wave of Hype*
619 **THE SUGARGLIDERS** *We're All Trying to Get There*
620 **BLUEBOY** *Unisex*
621 **EAST RIVER PIPE** *Poor Fricky*
622 **THE HIT PARADE** *The Sound of the Hit Parade*
623 **HEAVENLY** *The Decline and Fall of Heavenly*

Compilations

587 **VARIOUS** *Shadow Factory*
376 **VARIOUS** *Temple Cloud*
545 **VARIOUS** *Air Balloon Road*
501 **VARIOUS** *Glass Arcade*
583 **VARIOUS** *Fountain Island*
628 **VARIOUS** *Engine Common*
530 **VARIOUS** *Gaol Ferry Bridge*
359 **VARIOUS** *Battery Point*
100 **VARIOUS** *There and Back Again Lane*

Index